IMAGES OF ENCHANTMENT

IMAGES OF ENCHANTMENT

Visual and Performing Arts
of the Middle East

Edited by
Sherifa Zuhur

The American University in Cairo Press

Dar el Kutub No. 11371/97
ISBN 978 977 424 467 4

Dar el Kutub Cataloging-in-Publication Data

Zuhur, Sherifa
 Images of Enchantment: Visual and Performing Arts of the Middle East / Sherifa
 Zuhur.—Cairo: The American University in Cairo Press, 1998
 p. cm.
 ISBN 978 977 424 467 4
 1. Magic-Middle East 2. Magic in art
 I. Title
 704.94

1 2 3 4 5 6 14 13 12 11

Printed in Egypt

CONTENTS

History, Memory, and Reimaging in Middle Eastern Music

Contemporary Painting: Subject and Frame

Political and Gendered Imagery in Film

ACKNOWLEDGMENTS

It would be difficult to thank adequately all those who inspired this volume, following a trail back from the American University in Cairo Press to my mother, who showed me that musical performance is a way of life, and my father, who taught me how to read libretti with a flashlight and a snack in the top balcony at the opera, like a 'real Italian.' Let me begin by thanking members of the American University in Cairo Press—Pauline Wickham and Mark Linz for their commitment to this project, Toby Macklin for his hard work on the manuscript, Neil Hewison, and the reviewers of this volume for their comments and suggestions.

Marjorie Anne Franken shared in the generative stages of this project when we originally began work some years ago. I badgered her into agreeing to serve as coeditor, but my relocation from California to Egypt precluded this arrangement. However, she served at various crucial points as a very important communications link for many of our globally disparate authors, and was an integral part of our initial development of the ideas linking the various contributions.

The other authors have been equally gracious in sharing their work and time with me. As with all edited collections, there are many other scholars whose work could not be included for reasons of timing or space. Acknowledgments are due to Salwa Nashashibi and Sondra Hale for their help in obtaining the reproductions, the artists for their permissions to reprint, and William Young for the photograph of the Rashayda.

I want to thank Dean Joseph F. Sheley, Vice President and Provost Jolene Koester, and Professor Rita Cameron-Wedding of California State University, Sacramento, for allowing me an extended leave of absence.

Many thanks to the Department of History and Acting President Frank Vandiver of the American University in Cairo. I also wish to thank the Department of Arabic Studies, Dean Cynthia Nelson, and Dr. Mahmoud Farag of the American University in Cairo for part sponsorship of this project through a mini-grant. Other friends at the American University in Cairo also helped in various ways.

ᶜAfaf Lutfi al-Sayyid Marsot, my mentor as a doctoral student, has always been a source of support, and Professor ᶜAli Jihad Racy encouraged my interest in Arabic music and made helpful comments on my initial work on Asmahan's songs. Professor Nikki Keddie demonstrated her own interest in photography and film to students like myself. Other specific acknowledgments regarding institutional support for authorial research are included in the notes to individual chapters.

I have been very fortunate in my many friends and colleagues who have shared with me their interests in aspects of the arts or who encouraged my work on this project. My amazing family members put up with my extended inattentions and gypsy-like lifestyle and are a source of constant support and reassurance.

Certain friends have helped me continue to work when academe cast a dark shadow—Harriette Walker, Lynne Wilcox, Brad Nystrom, Ayad al-Qazzaz, members of the Sacramento Arab-American Association, Sondra Hale, Sherry Vatter, Jonathan Friedlander, Martha Plettner, Tonia Rifaey, and Carmel Kooros, and the Cairo Choral Society.

A Note on Transliteration

We have conformed to the transliteration system used by the American University in Cairo Press. It differs from the standard form used by Middle Eastern specialists mainly in the omission of diacritics, including those denoting long vowels. A more detailed transcription is provided for extensive quotations from the lyrics of songs.

INTRODUCTION

Sherifa Zuhur

Over the course of the twentieth century the Middle East has experienced tremendous upheavals. Former provinces of the Ottoman empire and colonies for Western expansion were transformed into national entities engaged in the processes of defining and defending their own interests. These independent nations struggled over a host of issues, with outside powers, with each other, and with their own populations. In some cases, stateless populations or minorities within states were faced with the difficult task of maintaining their own integral identities.

Simultaneously, state regimes took on the task of fostering both artistic production and national consciousness. In certain country settings discussed in this volume, it appears that the state has created, or allowed the creation of, structures for arts education. Civil society, however, sets the tone for artistic production or for performance as part of traditional celebrations. In at least three countries—Iran, Saudi Arabia, and the Sudan—state policies aimed at Islamization have affected and hampered artistic production. In Lebanon, civil war disrupted artistic life for sixteen years. Yet, artistic production responded in a creative manner to these limitations and is reviving with the return of many artists and new energy.[1] Throughout the region the production of culture through the visual and performance arts has interacted with historical change. This cultural production has expressed the concerns of individuals, and has also enriched and broadened visions of the Middle East as a whole.

Artistic production of what some chose to present as 'the Middle East' and 'Middle Eastern' also took place in the West—a fantastic and not-so-innocent means of describing and containing the region, for which the West constructed its own vocabulary. Meanwhile, in their efforts to

1

reproduce their homelands away from home, in the ideal, the remembered, or the imaginary, emigrants from the region have created a parallel, but subaltern, discourse.

The volume contains considerations of four categories of visual and performance arts of the Middle East or that reflect the Middle East. The 'Images of Enchantment' of the title refers to an aesthetic particular to these art forms—*tarab*, loosely translated as 'enchantment.' By contrast with the Western term 'appreciation,' *tarab* involves a reflexive process, a more active response on the part of the viewer or audience member, and is most often associated with music. Here we extend the concept somewhat.

This introduction will set out some of the themes and concerns addressed in this volume, and its rationale. Certain aspects of the history of dance, music, painting, and cinema in the region will then be discussed in more detail so that readers who are less familiar with one or another area may better understand the authors' concerns.

The reasons for exploring developments in cultural history are simple, and formulated in response to our postcolonial environment. Negative aspects of political and social culture in the Middle East are those most often portrayed in English—violence, authoritarianism, and modern versions of 'Oriental despotism.' Edward Said has alerted us to the scholarly, media, and popularized means by which the "inferiority of the Oriental spirit" is verified.[2] Cultural forms and debates of the Middle East remain further away from the headlines. While the stereotyped violence and power asymmetries in the region fill the press and the reading matter of the general public, a glorious artistic flowering, past and present, is relegated to the attention of the occasional scholar or aficionado.

We hope to introduce certain areas of cultural production to those who may be newcomers to the topics of Middle Eastern dance, film, painting, or cinema, while at the same time providing new sources for those who study these specific areas, or who teach Middle Eastern studies. We cannot hope to cover the entire range of performance or visual arts; instead we have limited ourselves to contemporary aspects of dance, film, painting, and music. Other visual or performing arts—the nearly 'lost' art of the *hakawati* (the traditional storyteller), contemporary theater, religious music and performance, pop music (for example the *rai* of Algeria), television production, sculpture, ceramic and textile arts—are all areas of interest that we have been unable to address in this volume. It is to be hoped that these areas of artistic output will be explored in a subsequent volume.

In the same vein, this work is not intended as a representative sample of artistic output in all the countries and groups of the Middle East. Limitations of space and other considerations have prohibited the inclusion of much worthy work. A relatively large portion of the volume

concerns Egypt. This emphasis reflects the country's high proportion of the total Middle Eastern population, its historical role as a center for entertainment and recording, and the interests of the authors. And even as regards these art forms in Egypt, we have had to be selective in the interest of including work on other Middle Eastern countries. Readers are invited to consult the bibliography for works of immediate concern to the authors, and others that fit into the categories of dance, painting, cinema, or Arabic music.

Another special aspect of the volume is the inclusion of several selections intended to express the concerns or observations of those personally engaged in these contemporary art forms—an artist, two musicians, and a film maker—to provide some balance to scholars' analyses. These selections demonstrate that those who create art, film, or music are also very conscious of the social and intellectual questions that may concern their work, and of the history of their métiers in the region. Some of the scholars' analyses have also been informed or enriched by their authors' engagement in teaching, or collecting, these art forms.

What then links our topics? Dance, music, painting, and cinema are related to some degree by their freedom from written texts. This is least true perhaps of cinema, with composed Arabic vocal music (not improvisation) a close second. It was for this reason that materials concerning creative literature or drama were not included. The past emphasis on the Islamic world's constant relationship with written texts, or its scripturalism, needs to be balanced with some concern for the visual and oral forms of expression, or those which combine these forms. These areas of visual and performing arts also exhibit commonalities illustrated through the authors' anthropological, sociological, and historical approaches, which in turn reveal the impact of gendered and political concerns. Another key and common denominator is the modernity of these art forms.

On the rare occasions that Islamic architecture or metalwork appears in media or print, they are generally situated as the product of a past, rather than a living, civilization. The tourist industry in the Middle East promotes a consumption of ancient rather than modern culture, and continues to associate the 'traditional' with the 'primitive'; this is not only regrettable, but misleading.

Growing interest in the West and the Middle East in specific areas of contemporary artistic production is manifest in important collections, exhibitions, the inclusion of Middle Eastern music and dance within the rubric of world music, and discussions of modern Arab cinema in film studies, for example. The focus on contemporary production is entirely deliberate and should form a counterpoint to the materials on traditional art forms of the region. Nevertheless, readers will see continuities in the art forms of certain regions, for example in the traditional place of dance

among the Arabs of the Arabian Peninsula, or the Rashayda Bedouin of
the Sudan. The musical forms underlying the work of Asmahan and
Umm Kulthum (Chapters 5 and 6) stem, at least in part, from a centuries-
old musical tradition. We will, however, illustrate new and shifting
cultural boundaries emerging along with forms that may traverse the
distance between the 'authentic' and the thoroughly modern, or polyglot.
Some of these new forms comprise a synthesis of local and world
influences. The manifestations of postcolonial identities and expressions
in certain artistic areas deserve such exploration.

Questions about honor and the body, and the commodification of
performance, run through the selections concerning dance, and the authors
were alerted to consider these issues by reading each other's work.
Questions about identity, imagery, and audience are at the heart of the
materials on painting and cinema. The role of politics and toleration for
change in gendered images, or images of social institutions, may be
found at the heart of other selections. In several of the selections on
music, readers will note the tension, balance, or discord in the use of
Western or Middle Eastern musical forms, stage etiquette, and various
sorts of hybridization that have developed along different paths in the
Middle East, or among Arabs in the West.

Comparisons made between the various forms of artistic expression
may also be useful to the reader. This collection sets out to blur the lines
between 'high' and 'low' arts, elite art forms and popular artistic
expressions. Just as we learn to think of textile arts as a 'craft,' in
comparison with the 'high' art of painting or Western classical music, we
inscribe Western and Middle Eastern identities into these categories. As
William Young writes in this volume (Chapter 2), many in the region
(and scholars as well) may not think of unpaid dance as an 'art' form, and
we are likely to un-read the professionalism necessary to many
'traditional'-style dance and music performance events. When we, or
audiences, deprofessionalize these activities, there are social, artistic, and
scholarly consequences. This is also true within genres: the *hajj* paintings
of rural Egypt, or the brilliant paintings decorating houses in Yemen, are
'folk' art, understood as a 'low' art as opposed to oil paintings in the
region, collected and displayed in national museums. Arabic music is a
popular ('low') concern, appealing to a local audience, versus Western
classical music, which is considered to be a universal canon, but which
possesses an elitist and 'foreign' aura in the Middle East.

This distinction between 'high' and 'low' arts has sometimes created
friction, given state sponsorship of the arts in the region, especially when
a correspondence is drawn with Western or indigenous origins of various
art forms. Global connections in the arts are undeniable, and not all stem
from Western Europe and North America. For example, one could
mention the Eastern European dance instructors, or coaches, who

influenced the training, staging, and movements of folkloric dance in Egypt and in Lebanon, particularly in the newly adopted symmetry and athleticism of the Lebanese *dabka* (a traditional line dance), or in Egypt, in the choreographic dimension of regional and urban folk-dance movements. In these cases, a 'low' art, folkloric dance, was glorified due to its popular roots and the political orientation of the period. Yet, it was affected both by balletic movements and training (a 'high' art) and movements from Eastern European folkloric dance with its complex foot patterns, kicks, leaps, and jumps.

A more antagonistic engagement is revealed in Cecil Hourani's account, in *An Unfinished Odyssey: Lebanon and Beyond*,[3] of his building of a center for artistic development, the International Cultural Center in Hammamet, Tunis, funded initially by the Gulbenkian Foundation. Hourani's vision of a free-flowing 'cultural fermentation' from a summer festival with an open-air theater, an orchestra, a summer school for actors, and a children's workshop in the arts was perceived as a challenge by Tunisian officials, who soon interfered, and promoted 'nationalized' art in place of 'cosmopolitan' art.

The four particular forms of art dealt with here (and also theater) have earned the suspicion of conservative and newly Islamist observers, although the Western belief that image and performance are therefore 'forbidden' in Islam is somewhat ahistorical. The supposed prohibitions against imagery were motivated by the Muslim battle against idolatry. Yet, representation and decoration developed vibrantly in the Arabo-Muslim world. The concern about performance arts is also the result of safeguarding against sin, whether through loosening of inhibitions, forbidden contexts, or simply in the performer's sensual attractiveness to his or her audience.

A geographic blurring encompasses migration, exile, and also globally shared concepts and concerns of artists and performers. The oceanic boundaries separating the Middle East from Europe and North America do not neatly delineate the subjects or the processes of Middle Eastern artistic culture. The coverage in this volume is thus a postmodern examination of the fluid and contemporary facets of these art forms.

Middle Eastern Dance

Middle Eastern dance has several significant features, the first being its musicality. Unlike Western modern dance, or modern ballet which may be choreographed against or in counterpoint to a musical background, or without any accompaniment, Middle Eastern dance does not occur without music. It is closely linked to rhythmic structures, and has its own special movement vocabulary, including 'isolations' of the hips, shoulders, rib cage, the head, and even, in *raqs sharqi*, solo Oriental dance, the muscles of the abdomen.

Considerations of Middle Eastern dance, folkloric, and 'Oriental' dance vary at the outset according to the context of the dance performance, and the professional or amateur status of the dancer. Dance may be performed in groups, as a solo, or in some cases, by couples.

Middle Eastern dance predates the Islamic conquest and derives from a variety of ethnic traditions within the region, whose distinctions (Arab, Berber, Persian, or Turkic manifestations) have received little attention. It has been proposed that certain features of women's dance in particular may derive from fertility cults of pre-Islamic deities.[4] Depictions of dance in the Egyptian dynasties also contribute some information about dance as entertainment, as well as sacred rite.

For centuries dance existed in tribal groupings as a form of entertainment, sometimes used in courting, and in celebrating rites of passage. Kay Campbell (Chapter 3) shows us that where the tribal basis of the Saudi state has served to maintain its social traditions, women's dance and music constitute a special expression of romantic and poetic traditions as well as a recognizable national identity through sound and movement. However, this rich body of women's music, and dance in particular, must be restricted to a female audience. Whereas musicians are generally hired professionals, dancers are guests, and no social stigma attaches to their performance.

William Young (Chapter 2) also describes dance in a tribal setting where women's and men's performances are distinct, yet not segregated. Here, he contends, the dancers perform significant ritual work—providing symbols essential to the wedding process—and are therefore exempt from the sinful connotations of dance when it is performed in a commercial setting, or in solo form.

A historical dispute has ensued over the origins of solo dance performance, identified in Egypt as *raqs baladi* (dance of the country) and converted through a long process into the cabaret forms of *raqs sharqi* (Eastern, or Oriental dance) or *raqs baladi* as observed today in Arab cities and nightclubs in and outside the Middle East. Some Western dancers and dance historians credit gypsies with the origins of many dance elements to be found (the use of cymbals, arm and head movements) and social elements (the association with prostitution, or at the least out-class/caste status).[5] The gypsies of Spain were surely influenced by Middle Eastern movement vocabulary, but are unlikely to have been single-handedly responsible for all the dance influences claimed (upon the *ghawazi* for example). Indigenous dancers and aficionados credit the ancient Egyptians, Bedouin culture, and cross-cultural influences flowing through the Ottoman empire.[6] We cannot sidestep the problematic association of eroticism and women's dance and music due both to the formation of the harem system, and to noble and courtesan/entertainer traditions within and alongside it.

Authors van Nieuwkerk, Young, Campbell, and Kent and Franken (Chapters 1, 2, 3, and 4) evaluate aspects of performance aesthetics, the social status of performance, and the consequent influence on the image of the Middle East. While performance aesthetics function in each case, the audience perceives basic differences in the social status of the performers. Aesthetics are also locally created and determined; elements of Sudanese or Saudi dance performance (and folk music) are distinctive from Egyptian, Lebanese, or other Maghribi counterparts. The social status of the performer appears to derive from the particular history of solo dance (as compared with tribal or rural folk dance). When paid performance is involved, the performer may be highly appreciated by her audience, yet her social status is downgraded due to her public revealing of her body in movement.

Contemporary dance in Cairo has a specific social history, writes van Nieuwkerk,[7] featuring links to the art and function of the ^cawalim (the almehs), who danced for women in the harem, taught music and dance, and sang for, but were unseen by, men. Dance fulfilled new functions as it became a common element in film, writes Marjorie Franken, a medium that allows for the preservation of performance. Live or filmed dancers continued to create images linked to questions of female virtue.

Folkloric dance exists alongside the solo dance tradition and has also been disseminated through film. Franken shows how the disreputable image of dance, and its cinematic reduction, was reclaimed through nationalist symbolism, a tasteful transfer to theatrical format and aesthetics, and the participation of elite performers such as Farida Fahmy. The Mahmoud Reda troupe was a prototype for other folkloric groups in the region that served to catalogue and transfer popular dance forms to the stage. Although such troupes in Egypt and elsewhere (for example, the Karakella troupe, or the national ensembles in Syria, Jordan, and Lebanon) were actually composed of 'professionals,' we may note a transference of the 'tribal legitimacy' of group dance to their performance, as compared with the sinful, yet appreciated, solo dancer.

It is certainly not the intent of the volume to downplay the artistic value of well-performed solo dance. *Raqs sharqi* has an international fame. Top performers in Egypt have attracted Arab audiences visiting from other parts of the region for decades, and a particular echelon of performers earn their reputation with skillful choreography and dynamic performances. The dance itself spread to Europe and North America in two waves of popularity, the first in the sixties and the second since about the mid-seventies. Dance tours are conducted to the Middle East, and the international enthusiasts are interested in the historic and 'authentic' aspects of dance as well as its commercialization.

Van Nieuwkerk, however, has carefully studied the lower echelon of solo performers in Egypt, who live in lower-class, conservative,

neighborhoods. She explains the basis of religious objections to solo dancers and the arguments by which contemporary women defend their employment with the argument of economic need. They sometimes employ strategies (or defenses of their honor) which may include covering their bodies more than other entertainers, or "employing the image of the *banat al-balad*,"[8] the 'daughters of the country' whose dancing tradition is authentic, and thus less eroticized. Other aesthetics have applied to hired entertainers at weddings, who perform social and symbolic functions (as Franken and Kent illustrate in Chapter 4), and have urbanized and particularized the tradition of the wedding procession. In these cases, the solo dance performer, or, in more recent versions, troupe performances of young men, are key to the status of the wedding itself, demonstrating a process in which families secure community respect (or envy) for the celebration honoring their children's union.

Music in the Middle East

Music has a lengthy history in the Middle East. Middle Eastern music is made up of Arab, Persian, Turkic, Berber, Hellenic, and other musical elements. While secular music is the concern of this volume, we should note that important linkages of past and present occur in the music (composed and traditional) for the pilgrimage (the *hajj*), exhibiting the secular in service of the sacred. Religious uses of music include the recital of the Qur'an, the *adhan* or call to prayer, the music for the Prophet's and saints' birthdays, Ramadan and the *mawlids*, the eulogies for the Prophet *(mada'ih)* and the music for the Sufi *dhikr* (a ceremony particular to these Muslim mystics).[9]

In the contemporary Middle East, the various musical forms have undergone processes of separation and refinement, as well as blending or interaction. The focus of contributions to this volume are, firstly, the Arabic music known in Egypt as *al-gadid/al-jadid* or the 'new' Arabic 'classical' music, as opposed to the pre-twentieth-century forms, or the modern 'pop' genres of Arabic music. Secondly, we have considered the performance and composition of Western music in Egypt, and thirdly, Arabic music as performed and composed in America.

Arabic (and Persian) music is built on modes rather than scales and is monophonic, which means that a single line of melody is the basis of the music. The modal structures, the *maqamat* (similar in some ways to the *raga* system in Indian music), must be represented in Arabic music; the melodies should be composed either entirely in these *maqamat*, which contain microtones, or modulate away from a main *maqam* and return to it. The use of improvisation[10] as well as composed musical texts, and rhythms that do not exist in Western music, together with the *maqamat*, make up the distinctive elements of all Arabic music played on instruments that either originated in the Middle East, or were adapted to

musical use there. The important indigenous instruments are: the ᶜ*ud* (a lute); the *buzuq* and the *nashat kar* (regional variants of the ᶜ*ud*, with a higher range, smaller bodies, and metal pegs); the *qanun* (a zither, often with 144 strings); the *simsimiya* or *tanbura* (a Red Sea coast, Sinai, and Nubian based lyre); the *nai* (a wooden flute, of which the *salamiya* is a soprano version); the *mizmar* or *arghul* (a double-reeded pipe, or double pipe, played with circular breathing); the *rabab* (a one- or two-stringed, bowed instrument); the *kamanja*, a bowed and spiked stringed instrument; the *tabla* or *darbakka* (a clay or metal drum played with the palms); the Lebanese *tabl* (a giant drum played with sticks); the *daff/duff* or *mazhar* (frame drums, or tambourines, with and without cymbals); and the *sagat* (metal finger cymbals).

Examples of imported and adapted instruments include the European violin, which replaced the *kamanja* in urban music from the late Ottoman period onward, the viola, the cello, the double bass, and various wind instruments. Specially adapted brass and keyboard instruments such as the saxophone, accordion, organ, and even the piano were sometimes introduced. Some composers borrowed other instruments such as the guitar, or the stationary castanets employed in Muhammad ᶜAbd al-Wahhab's compositions.

Selim Sednaoui (Chapter 7) describes the problems that have faced classical composers who seek to incorporate elements of Arabic music into their composition. Likewise, the basic features of Arabic music create particular problems and possibilities for integration with the principles, forms, instruments, or aesthetics of Western music;[11] these are reflected in some of the compositions sung by Umm Kulthum and Asmahan, as well as more modern compositions.

In the twentieth century, Arabic musicians and vocalists developed and transformed their repertoires and performance styles, and the recording and cinema industries spread the fame of performers beyond their local audiences. At the turn of the century, the harem system still existed and performances were segregated affairs. The small orchestra was known as the *takht* (after the raised platform on which it performed) and its repertoire was dominated in most urban areas by Ottoman compositions and performance norms of the late nineteenth century. These compositions formed the basic musical vocabulary to be learned by performers, composers, and singers, whose order and aesthetics were understood by a musically literate audience.

In rural areas, musical performance reflected other integral folk traditions, whether in singing style, as in the vocal improvisations of rural Lebanese and Syrians (which Asmahan's mother brought with her to Cairo), in the playing of instruments mentioned above, such as the *buzuq*, the *arghul*, the Syro-Lebanese *tabl*, the *salamiya* and the *simsimiya*, or even in the clapping patterns *(tasfiq)* specific to the Gulf

region or to rural Egypt. These very specific musical sounds, along with particular musical forms, identified the regional basis of music.

The introduction of musical theater, the establishment of music halls or clubs, the growth of the recording industry, the addition of sound to cinema (and thus musical films), and the introduction of many Western instruments and compositional forms were all factors which transformed music over the century. The blending of regional with urban musical elements, and the continuity of regional music, represent other trends.

Singing stars made their first appearance in this century. The most famous and important musically were the Egyptians Sayyid Darwish, Umm Kulthum, ᶜAbd al-Halim Hafiz, and composer Muhammad ᶜAbd al-Wahhab; the Syrian brother and sister Farid al-Atrash and Asmahan; and the Lebanese singer, Fairuz. Those who were able to bridge the diverse elements of musicality required of them in the twentieth century tended to be associated in the public mind with particular 'images' of contemporary history or modernity, as Virginia Danielson and I explain in this volume (Chapters 6 and 5). They were also linked with particular subgenres within Arabic music—'colors' *(alwan)* of music, to use the local terminology of aesthetics (see Zuhur, Chapter 5).

A recent painting, *One Hundred Years of Enlightenment* by Salah Enani, an artist born in 1955 and well-known for his posters, depicts Umm Kulthum holding her handkerchief and surrounded by aging musical and literary figures, all of whom qualify as national symbols. The image appears on the cover of an issue of *Teen Stuff*,[12] an English-language magazine for Cairo's hip youth, who would sooner die than be caught listening to Umm Kulthum. Although Enani explained to the magazine's editors that the painting represents his pessimism over the current cultural situation, the editors juxtapose the image with the article title "Celebrating the Generation Gap: Oum Kalthoum *[sic]* vs. Hakim, Artists and Artificials?" (Hakim is a currently popular singer of Arabic 'cross-over' pop music) and include inside the magazine a discussion entitled "What is art?" We read that youth understand the meaning of a trend (i.e., their favorite music) but hold varying definitions of art. Sadly, the music in question, Arabic music, will be lost to most of these young people, as it is sufficiently difficult to learn, and, for most, neither a lucrative nor a stable profession. They are unlikely ever to learn to play Umm Kulthum's music, either as amateurs or professionals, and thereby come to appreciate it. They have not learned to appreciate the older music or the *maqam* tradition as listeners, for their 'period ear,' a term Rasmussen (Chapter 8) uses in this volume, is attuned to cross-over Western electronic music with Arabic lyrics and percussion.

The role of the musician then is vital and circumscribed in the region, and is, to an extent, that of a cultural guardian. The themes of politics, populism, and the preservation of artistic heritage are relevant to Virginia

Danielson's comparisons of the construction of Umm Kulthum's and Gamal ᶜAbd al-Nasir's heroic public images. Through the intervention of time, we understand that their performances did not, in the end, belong to them personally, but to their public, and now to a generation who understands their political and artistic meaning in accordance with contemporary norms and issues.

Some have promoted the study of Arabic music through the use of Western or Western-style facilities. These include the conservatories of Cairo and Damascus, and musicians and scholars who are based outside the region, such as ᶜAli Jihad Racy of Lebanon, who has influenced a younger set of scholars to examine the music of the region.[13] Outside the academic sphere, yet resisting the appeal of commercialism, we find the Palestinian Simon Shaheen,[14] who is notable for his virtuosity in a generation that has lost some of its regard for this tradition. His response (Chapter 9) focuses on music education and the encouragement of local talent. Yet for individuals and large, state-supported ensembles in the region, the musical standards of professionalism and standardization have been raised at just the time that the future of *al-jadid*, modern Arabic music, is somewhat uncertain.[15]

Egyptian performer Selim Sednaoui is also a critic of Western classical musical performance in the Middle East. The topic has several interesting aspects, first being the benefits gained from its inclusion in musical pedagogy. A second aspect concerns the role of Western cultural forms in the Middle East and how classical music and its reception have been adapted and influenced by Egyptian performers and composers.

Painting

Painting is in some ways a truly contemporary art in the Middle East. On the one hand, studio art and techniques were relatively new to the region and were officially introduced through state sponsorship.[16] Just as Western artistic and cinematic techniques heavily influenced the establishment of cinema in Egypt, Syria, Algeria, and throughout the Arab countries by the 1960s, the development of art training in the various countries of the Middle East also reflected an era when governments sent artists to train in Western academies, or native artists returned from their own self-launched foreign careers to train others. In some cases, as in Iraq, Middle Eastern artists were directly influenced by local and Western artists; first by officers trained in military college in Istanbul, and later by Polish artists in the military who came to Baghdad during the Second World War.[17]

According to Wijdan Ali, nearly all Arab artists passed through a stage in which European traditions and aesthetics in art were taught, followed by a period of "self-discovery" during which they chose "local subjects and themes." When they then entered a "search-for-identity" phase,[18]

many investigated their own visual heritage. The Islamic arts, including painting as portraiture, illuminations of manuscripts, and painting as decoration of various surfaces, have as lengthy a history as the other art forms discussed in these volumes. Painting in the region also represents the interaction of many different currents of representation, whether the images of Coptic art, the paintings on glass and ceramics produced in the Levant, the outstanding Safavid miniatures that reflect Persian, Turkic, and even Mongol influences, or the uses of calligraphy and geographic form in the decoration of architecture and objects. Artists therefore discovered a wealth of interesting subjects, motifs, and techniques with which to experiment.

The tensions between the individual and the national 'framing' or contextualizing of art are intensely experienced in the visual arts, and have to some degree displaced the earlier focus on tradition versus modernity. These issues are also nuanced through class and politics. The fact that an artist like the Moroccan Chaïbia Talal (see Chapter 11) did not recognize her own artistic production as 'art' at the outset of her career, or that the singer/actress Asmahan was socially criticized for her participation in the entertainment world, tell us something about the integration or separation of artistic culture from societal norms. In these cases, social class, gender, and prejudices against artistic occupations combine. We may now note a new or renewed entry of female musicians into Western classical music (a less pronounced presence for contemporary Arabic classical music) in many countries of the Middle East, and a strong female presence in the visual arts. Salwa Nashashibi further explores women artists' experiences in her contribution (Chapter 10), presenting information that is especially relevant to the issues of gender, politics, and exile in their work.

Gender and Politics
Gender has been a primary source of identity for many artists, although it has been superseded at times in the Middle East by political issues and the imagery of the nation. Liliane Karnouk has described artistic emphases on the region and "the search for a distinctive local art" as characteristics of the Egyptian art scene of the 1930s.[19] The tension between internationalism and localism has continued and combined with political events. Artists have chosen styles, symbols, irony, and pathos through their linkage—or bondage—to events, as in the stylized images of Sheik Bashir or Mahmoud Abu Askar, the surrealism of Mohammad Hijazi, or, in the Palestinian context, Naji ᶜAli's cartoons.[20]

Salwa Nashashibi (Chapter 10) has chosen several examples that highlight the confluence of gender and nation—for example in the woman's face superimposed on the map of Beirut, with a river of note-written blood defining the Green Line in Ginane Bacho's *The Image of*

the Word: The Image of the Picture (1985), or in the women's figures in Houria Niati's *No to Torture*, and in Inji Efflatoun's well-known *The Cell*. Female images create metaphors for the loss of individualism, national rights, and political suppression. The artistic transformation of social issues and the social transmutation or amalgamation of artistic symbols render such boundaries flexible through the processes of social, economic, and political change, emigration, exile, return, and cross-fertilization.

In Egypt alone, visual production has, according to Karnouk, continued to produce a new pluralism of contemporary Egyptian painting styles.[21] Beyond the artists she mentions there are others such as Huda Lutfi, who focuses on visual aspects of women's history in a manner that complements Nashashibi's discussion of artists' inspiration and aims. Many intriguing male painters, such as Chant Avedissian, also contribute to this pluralism.

In the context of Sudan's political struggles, Sondra Hale (Chapter 12) discusses the imagery of political alienation and oppression in the work of the Sudanese artist Mohamed Omer Bushara. He views himself as an artist of the Left, and a child of the people, and is resistant, as Hale shows, to the notion of painting as elite culture. Hale discusses her own need to classify his work as relatively 'abstract' as opposed to more (or less) 'political' and reflects on the meaning of such imagery within the overarching postcolonial discourse.

The social connotations of an artistic identity have been a problematic dimension of these art forms—dance, music, cinema, and painting—in the period when Arab socialism, or postrevolutionary values, were thought to hold formative value. Artists struggle to define their own identities in nation states that have iterated the battle for autonomy in ways incongruent with those artists' own political views. Consequently, as Sondra Hale describes, another Sudanese artist Musa Khalifa, remains an elusive figure, creating images and refusing to be firmly classified as a 'national' artist.

Cinema

Cinema is the youngest of these art forms, predated by shadow plays featuring puppets and the art of the *hakawati*, the traditional storyteller, who recited (or sometimes read) to popular assemblies, and the twentieth-century advent of musical theater. Cinema also plays an important political role in modern Middle Eastern culture. The 'seventh art form' is realized in commercial film and in what are known, chiefly outside the region, as 'art films,' or what Hamid Naficy (Chapter 15) refers to as "quality films."

The first cinema showings in the region were privately arranged events for an elite audience. Special matinées *(séances)* were held for female

audiences and there was opposition to these showings on the part of local religious leaders. Over time, 'talkies' replaced early silent films, and the private cinema showings were replaced by large public theaters. Then, as elsewhere in the world, films could be replayed on television or, with the advent of the videocassette recorder, could be viewed privately. The commercial potential of cinema was unquestioned. Film actresses and actors were often singers, and the filmed musical was a lucrative sector of the industry.[22]

The *cinema verité* or neorealism, and populist themes heavily influenced Arab film makers. For example, Youssef Chahine's work spans neorealism to surrealistic, documentary to historical epic, from his *al-Ard* (The Earth, 1970), to *al-Qahira munawara bi-ahlihi* (Cairo Illuminated by Its People, 1991), to the banned *al-Muhajir* (The Emigrant, 1994).[23] The social consciousness of film also influenced the evolution of documentary film making including the portrayal of Chahine's career made by the late Mohamed Shebl. As the zenith of Arab socialist and populist 'framings' of the cinema passed on, other political functions for film have emerged: in dark satire or comedic commentary, the medium provides some space for allowable critique that may reflect state boundaries, or defy them, thus providing a means of defusing public frustrations. Cinema has its own regional market and history: Egypt has been a center of cinematic activity, a notable state-sponsored cinema has existed in Algeria, and some very interesting films emerge from the Arab East.

Raymond Baker has commented on the Egyptian "combat" of "cultural politics" waged through cinematic themes of resistance, habituation, and interference.[24] Film has challenged existing political propositions, and may continue to do so. Yet, as Walter Armbrust shows in this volume (Chapter 18), false claims may also be made. His opinion of the film *Terrorism and Kebab* (1992) is that it underscores the government's critique and denial of Islamist strength through a comedic and ironic plot which upholds the aims of commercial film behind the veneer or facade of an 'art film.' Armbrust shows how the film and the talents of ᶜAdil Imam bear some resemblance to the 'screwball comedies' of Frank Capra, director of *It Happened One Night, Mr. Smith Goes to Washington,* and *Meet John Doe.* Armbrust also compares Imam's *Terrorism and Kebab* to an earlier film *Ramadan on the Volcano* (1985) in order to demonstrate that the actor is not primarily serving as a social critic, but is arguing for modernism and a coherent national identity. ᶜAdil Imam is particularly suited to this task due to his keen imagery of the absurd employed in earlier films.

Commercial film also provides fascinating comments on the changing attitudes toward women in the Arab world (Chapter 14). While 'art films' have provided stronger critiques of traditional gender practices, I was

interested by the broadening range of topics and script treatment in Egyptian commercial films of the 1980s—films produced for the *shacb* (the people), and the middle class, not sophisticated elite viewers. Did these films chiefly represent female protagonists as actors or victims? Does the melodrama of the plots stand in for the resolution of gendered questions? Or does it signal the Arab world's intent to define questions of gender in its own way, and in its own good time?

The positionality of the Middle Eastern artist or performer and his or her connection to contemporary issues have a further effect upon the artistic or musical images and motifs created. Sometimes this is expressed in terms of identity, or of the relevance of culturally reflective art versus that which introduces 'universal' issues. The influences of traditional art, musical, dance, or dramatic forms from centuries past distinguish artistic expression, or are employed to convey specific popular messages. Conscious deployment of cultural issues, iconography, and folkloric themes may not be accorded equal value on the postmodern measuring stick. Some artists, musicians, film makers, and dancers have been wounded by the charges that they are manipulating their own culture, and try to explain their need to reflect the settings, origins, or themes that distinguish the region from the world outside.

Farida Ben Lyazid (Chapter 13) describes her own involvement in the cinema, and tensions that ensued in her personal life due to her determination first to see, and later to create cinema. I became familiar with her work through her film *Bab al-sama' maftuh / Une porte sur le ciel* (1987), which I have regularly screened for students. The film explores the bicultural dilemma of her Moroccan generation, and her own fascination with the Islamic social and urban structures that transform the film's heroine. Ben Lyazid addresses some of the problems of creating what she calls a "cultural cinema," one in which local environment determines both subject matter and visual interest. Although this project requires a deep familiarity with the region, and could be seen to limit cross-cultural explorations, or perhaps 'ghettoize' Middle Eastern film makers, Ben Lyazid defends the deployment of Middle Eastern identity in modern cinematic work for in the variations of world cultures "lies the wealth of humanity. It is the unfolding of all the possible human futures. And that is perhaps why I want to display my own culture and its subtleties."

Hamid Naficy has written extensively about Iranian cinema made in Iran and Iranian cinema and television produced in exile. Film can be a vehicle for the creation of the absent homeland, for motives similar to those that encourage the performance of Arabic or Iranian music in America. The medium allows even more selectivity and creativity, permitting the conveyance of very different images of Iran, a process, Naficy writes, that creates both "liminality" and "exilic syncretism."[25]

These concepts that are not unlike the historical reimpositions suggested by Jung's notion of 'syzygy,' which I have described elsewhere.[26]

Naficy (in Chapter 15) examines the production of a new Iranian cinema following the revolution, under what are surely difficult, if not insurmountable, circumstances. We learn from him that Islamization, even in radical form, need not obliterate the work of talented cineastes who created a new film vocabulary through the issues of relevance in Iran of the 1980s and beyond. The Islamic ethics promoted by the Iranian regime for popular government are reflected in the subject matter and treatment of many of the films described. There are parallels here to the 'quality' films produced in Egypt after the 1952 revolution, and in Syria and Algeria, which enlisted revisionism, social analysis, and inquiry along particular lines—lines that could be deliberately blurred on occasion by the film maker.

The Middle East of Outsiders and Exiles

Some of the work in this volume concerns the ways in which the Middle East eludes and defies its borders. One important aspect is how the Middle East imprinted ideas and images on early Hollywood, or rather, as Rebecca Stone (Chapter 16) shows, how Middle Eastern sources attracted Hollywood for its representations of the region. From that time on, the industry, as well as the popular culture of entertainment surrounding it, subverted images of the Middle East for various reasons. Although this work concerns the appropriation of the Middle East rather than its own creations, we wanted to alert readers to the irony of a representational circle—for Middle Eastern films of the 1930s and 1940s implemented many norms of cinema conception and production from Hollywood. Spectacles of the Middle East in official international exhibitions were carefully constructed,[27] just as they were in film. The unacceptable aspects of Middle Eastern dance were recorded and then filtered out of Hollywood's own imagination. The images of eroticism, and ahistorical themes, whether Bedouin, 'Oriental,' Biblical, or pharaonic, profoundly shaped early Hollywood itself, and subsequent filmic comments on the Middle East, a site, as Stone writes here, of extremes.

Middle Easterners emigrated within the region, to Europe, and further, to North and South America, where they recreated and retained various components of their own culture and national identity. Early diasporas in the nineteenth century created a Levantine presence in Egypt, which in turn left its mark on the business and entertainment communities.[28] Asmahan and her brother Farid al-Atrash were exiles, and she experienced some of the pain, disorientation, and syncretism described by Hamid Naficy in his work on Iranian exiles, due to her shuttling between two countries and dual identities, entertainer versus respected wife.[29] Other

Syrians, Lebanese, and other non-Egyptians made their way to Cairo, where stiff competition resulted in regional impact along with success; examples were the singer Tauhida, Badiᶜa Musabni,[30] Mary Jibran, Faiza Ahmad, Farid al-Atrash, Fahed Ballan,[31] Muhammad ᶜAbdu, Majida al-Hinawi, and Walid Toufic. Acclaim in Cairo was valuable to entertainers who built their careers outside Egypt, like the Syrian singer Sabah Fakhri, or the great Lebanese singer Fairuz, whose voice, and the compositions of the Rahbani brothers, are inextricably linked with a Lebanese image. The significance of displacement within the region is usually de-emphasized in area studies, yet such displacements have had a profound effect upon the arts.

Middle Eastern immigrants to North America comprised several waves of immigration, and many nationalities and religious identities. The Syrian immigrants to New England were among the earliest Arab groups to build communities in North America. They met with discrimination as well as opportunity. The task of upholding alien social norms, importing familiar foods, music, and eventually cinema, linked Arab communities in the United States and elsewhere in the West. These communities, like their Iranian counterparts, consciously recreate the stories of exile, or celebrate their musical past.

Anne Rasmussen (Chapter 8) relates insiders' views on the history of Arab-American music, since that community idealizes and interacts with the *bilad* (homeland), yet is thoroughly distinctive from its past or forbears. According to these musicians and community members, entertainment has been professionalized, and former performance standards and structures have been sacrificed as new aesthetics were created. Entertainment has been a significant focus for small communities, allowing them to create safe havens away from political, national, and religious divisions. One may contrast the role of Middle Eastern culture in these communities with its centrality in the lives of other performers who maintain links to the Middle East (Shaheen, Chapter 9), or with artists who live and work both in the Middle East and in Europe or America (Sednaoui, Chapter 7, and Nashashibi, Chapter 10).

We hope through this work to provide a sampling of the various questions related to the nature of contemporary performance and visual arts, and their relationship to culture and history. History demonstrates that the Middle East affects the world, as do the issues raised in these contributions.

Notes

1 Sarah Gauch, "Lebanon's Renaissance of the Arts," *Aramco World*, vol. 49, no. 1 (January/February 1998), 2–11.

2 Edward Said, "Comment l'Occident voit les Arabes," *Le Monde* (Paris) 3 December 1996, 16, translated by Dominique Eddé and Eglal Errera from a lecture given 28 November 1996 at the Collège de France; Said's *Orientalism* (London: Routledge, Kegan & Paul, 1978), *Covering Islam: How the Media and Experts Determine How We See the Rest of the World* (London: Routledge, Kegan & Paul, 1981), and *Culture and Imperialism* (London: Chatto & Windus, 1992) explore different aspects of the 'reading' and 'misreading' of the Middle East, and the Islamic and the colonial worlds.

3 Cecil Hourani, *An Unfinished Odyssey: Lebanon and Beyond* (London: Weidenfeld and Nicolson, 1984), 123-145.

4 The material locating dance in the history of spirituality is part of the mythology of Middle Eastern dance (Wendy Buonaventura, *Serpent of the Nile: Women and Dance in the Arab World* (London: Saqi Books, 1989), 25–38). This work links dance to goddess worship and theories of preexisting matriarchy in the ancient world once proposed by Briffault, *The Mothers: The Matriarchal Theory of Social Origins* (New York: Macmillan, 1931), or W. Robertson Smith, *Kinship and Marriage in Early Arabia* (Cambridge at the University Press, 1885). Although feminist theory has produced sounder versions of these ideas—Marija Gimbutas, *The Goddesses and Gods of Old Europe* (London: Thames and Hudson, 1974) and Gerda Lerner, *The Creation of Patriarchy* (New York: Oxford University Press, 1986)—the field of dance history still awaits a study more verifiable than Buonaventura's.

5 Buonaventura, *Serpent of the Nile*, 39–41.

6 Sabry Ashmawy, "The Future of Oriental Dance," *al-Gawhara*, Issue 1 (October 1996), 4, a Middle Eastern counterpart to American-published cabaret dance journals, *Habibi* or *Arabesque.*

7 Also see Djamila Henni-Chebra and Christian Poche, *Les danses dans le monde Arabe: ou l'heritage des almées* (Paris: L'Harmattan, 1996); Karin van Nieuwkerk, *"A Trade Like Any Other": Female Singers and Dancers in Egypt* (Austin, Texas: University of Texas Press, 1995, and Cairo: The American University in Cairo Press, 1996).

8 Sawsan el-Messiri, *Ibn al-Balad: A Concept of Egyptian Identity* (Leiden: E. J. Brill, 1978).

9 Habib Touma, *The Music of the Arabs* (Portland: Amadeus Press, 1996), 152–167; L. Jafran Jones, "The ᶜIsawiya of Tunisia and Their Music," Ph.D. diss., University of Washington, Seattle, 1977; Kristina Nelson, *The Art of Reciting the Qur'an* (Austin: University of Texas Press, 1985).

10 Touma, "The Maqam Phenomenon," in Touma, *The Music of the Arabs*; or see ᶜAli Jihad Racy, "Music," in J. R. Hayes, ed., *The Genius of Arab Civilization: Source of Renaissance* (Cambridge: MIT Press, 1983, 2nd. ed.).

11 As Salwa el-Shawan demonstrated recently in an overview of the new trends and approach (*al-jadid,* lit. the new) in twentieth century Arabic music in Egypt, in which lengthy or impromptu improvisation is discouraged in the 'new' aesthetics of the state sponsored orchestras. Salwa El-Shawan, "Thinking the Past, Shaping the Present: Perspectives on Arab Music in Twentieth Century Egypt," a lecture at the American Research Center in Egypt, 2 September 1996.

12 *Teen Stuff*, no. 7 (October 1997).

13 Susan Rivers, "Playing in Interesting Times," *Aramco World*, vol. 46, no. 5 (September–October 1995), 12–15.

14 Kay Hardy Campbell, "A Heritage Without Boundaries: Simon Shaheen, Tradition and Creativity," *Aramco World*, vol. 47, no. 3 (May–June 1996), 2–5.

15 El-Shawan, "Thinking the Past."

16 Wijdan Ali, "Modern Arab Art: An Overview," in Salwa Nashashibi et. al., *Forces of Change: Artists of the Arab World* (Lafayette, California and Washington, D.C.: International Council for Women in the Arts and the National Museum of Women in the Arts, 1994).

17 Ibid., 87–88.

18 Ibid., 73.

19 Liliane Karnouk, *Modern Egyptian Art: The Emergence of a National Style* (Cairo: The American University in Cairo Press, 1988), 30.

20 Ismaᶜil Shamut, *al-Fann al-tashkịli fi Filastin* (al-Kuwayt: by the author, 1989).

21 In the work of Farghali ᶜAbd al-Hafiz, Moustafa al-Razzaz, Ahmad Nawar, Fathi Ahmad, Awad al-Shimi, Noha Tobia, Salah Enani, Reda ᶜAbd al-Salam, Adel al-Siwi, Mohammed Abla and Chant Avedissian. Liliane Karnouk, *Contemporary Egyptian Art* (Cairo: The American University in Cairo Press, 1995).

22 George Sadoul et al., *The Cinema in the Arab Countries* (Beirut: Interarab Centre of Cinema and Television, 1966) shows the state of Arab cinema in the 1960s and the values attached to the development of 'political' film, or cinema of social commentary. Other early critiques like Qussai Samak, ed., *Cinema du Moyen-Orient et du Maghreb* (Montreal: Le Cercle de la Culture Arabe, 1979) were compiled to accompany film showings in the West. More contemporary critiques or explorations of the history of Arab cinema include Ibrahim al-ᶜAris, *Rihla fi-l-sinima al-ᶜarabiya* (Beirut: Dar al-Farabi, 1979), ᶜAli Abu Shadi, *Classics of the Arab Cinema,* and Jane Gaffney, "The Egyptian Cinema: Industry and Art in a Changing Society," *Arab Studies Quarterly*, vol. 9, no. 1 (Winter 1987). Also Viola Shafik, *Arab Cinema: History and Cultural Identity* (The American University in Cairo Press: 1998).

23 Maureen Kiernan, "Cultural Hegemony and National Film Language: Youssef Chahine," and Susannah Downs, "Egyptian Earth between the Pen and the Camera: Youssef Chahine's Adaptation of ᶜAbd al-Rahman al-Sharqawi's *al-Ard,*" *Alif: Journal of Comparative Poetics,* no. 15 (1995); Hala Halim, "The Signs of *Saladin*: A Modern Cinematic Rendition of Medieval Heroism," *Alif: Journal of Comparative Poetics*, no. 12 (1992). Christian Bosseno, ed., "Youssef Chahine l'Alexandrine," *Cinémaction* 33 (1985).

24 Raymond Baker, "Combative Cultural Politics: Film Art and Political Spaces in Egypt," *Alif: Journal of Comparative Poetics* 15 (1995), 6–38.

25 Hamid Naficy, *The Making of Exile Cultures: Iranian Television in Los Angeles* (Minneapolis and London: University of Minnesota, 1993), 16–25.

26 Sherifa Zuhur, *Revealing Reveiling: Islamist Gender Ideology in Contemporary Egypt* (Albany: State University of New York Press, 1992).

27 Timothy Mitchell, *Colonising Egypt* (Cambridge: Cambridge University Press, 1988).

28 Thomas Philipp, *The Syrians in Egypt 1725–1975* (Stuttgart: Franz Steiner, 1985); Mervat Hatem, "Through Each Other's Eyes: Egyptian, Levantine-Egyptian, and European Women's Images of Themselves and of Each Other (1862–1920)," *Women's Studies International Forum* 12, no. 2 (1989).

29 Sherifa Zuhur, *Asmahan's Secrets: Woman, War, and Song* (Austin, Texas: Center for Middle East Studies, University of Texas, and London: Al-Saqi, 2000), Chapters 2 and 5; Naficy, *The Making of Exile Cultures*.

30 However, Danielson shows us that although it was believed that most singers in Egypt were of foreign origin or non-Muslims, earlier in the century, most were in fact of native origin. Virginia Danielson, "Artists and Entrepreneurs: Female Singers in Cairo during the 1920s," in Beth Baron and Nikki Keddie, eds., *Women in Middle Eastern History: Shifting Boundaries in Sex and Gender* (New Haven: Yale, 1991), 301.

31 Samim al-Sharif, *al-Musiqa fi Suriya: aᶜlam wa tarikh* (Damascus: Wizarat al-Thaqafa wa-l-Irshad, 1991); Fumil Labib, *Farid al-Atrash: Lahn al-khulud* (Cairo: Dar al-Shaᶜb, 1974, 1st edition; Cairo: Dar al-Shuruq, 1975, 2nd edition); Personal interview with Fahed Ballan, 18 August 1993, Suwayda, Syria.

1

CHANGING IMAGES AND SHIFTING IDENTITIES
FEMALE PERFORMERS IN EGYPT

Karin van Nieuwkerk

Introduction
In the late eighteenth century, Egyptian female performers, the ^cawalim, were described as follows:

> They are called *savantes*. A more painstaking education than other women has earned them this name. They form a celebrated community within the country. In order to join, one must have a beautiful voice, a good possession of the language, a knowledge of the rules of poetry and an ability to spontaneously compose and sing couplets adapted to the circumstances . . . There is no fete without them; no festival where they do not provide the ornamentation.[1]

While it still holds true today that a celebration without performers is not a real celebration and that entertainers are central to the most important occasions in peoples' lives, female performers are no longer a celebrated community of learned women. On the contrary, in present-day Egypt, female performers are generally regarded as 'fallen women.' A tailor, talking about female singers, and dancers in particular, told me: "These jobs are shameful and detestable. I don't like it . . . but I do like to watch it. Once in a lifetime we invite them; it is *haram* (taboo), but the fault is theirs."

Only a few women working in the circuit of performing arts—radio, television, and theater—such as Umm Kulthum and the folkloric dancer Farida Fahmy[2] escape such moral stigma. For most female singers and dancers, however, prostitution is the measuring rod by which they are reckoned.

What are the main reasons for this drastic transformation of the image of female performers from learned women to fallen women? How is this ambivalence concerning women as performers related to cultural constructions of gender? How do female performers relate to these images about themselves?

In this chapter, I shall first explore the historical transformations of the image of female performers and clarify the most important reasons for these shifting images. I limit myself to the circuit of weddings and saint's day celebrations, and that of the nightclubs.[3] Secondly, I shall discuss the underlying notions of gender and the image of the female body as one of the main reasons for the moral stigma attached to female performers. Lastly, I shall discuss the manner in which female performers themselves relate to these constructions and the way they try to deconstruct the gendered images.

Changing Images

The entertainment activities of women in the late eighteenth and early nineteenth centuries were confined to singing, dancing, poetry, and music. All acting roles were played by men, even women's roles. The only source of information on female performers of the period—travelers' accounts—is not very reliable, yet it can be reconstructed that there probably existed two broad strata of women performers.[4]

The first stratum consisted of ᶜawalim, whose main activities were writing poetry, composing music, improvising, and singing. They also danced, but only for other women. They often played instruments to accompany their songs, and they were greatly esteemed for their *mawwal*, or improvised songs. The ᶜawalim performed for women in the harem. Women's areas for receiving were screened off but overlooked the main, male reception space. The ᶜawalim were audible, but not visible, to men. These educated ᶜawalim were highly appreciated for their art, and respected as well, since they did not perform for men.

The second group of female entertainers were the *ghawazi*. They were mainly dancers who performed unveiled in the streets and in front of coffee houses. The *ghawazi* danced especially at saint's day celebrations and migrated from one *mulid* to another. These dancing girls were the most accessible to foreigners since they performed publicly. The most striking element of their appearance was that they were unveiled. Several travelers remarked that the *ghawazi* used to smoke the water pipe and drank considerable amounts of brandy. Due to these associations and the fact that they danced in public for men with unveiled faces, they were generally not regarded as decent women.

There was also a category of female performers between the ᶜawalim and the *ghawazi*. This group consisted of lower-class singers and dancers, common ᶜawalim who performed for the poor in working-class quarters.

Prostitutes were registered as having a separate profession. However, public dancers could be found who combined dancing and prostitution.

With the opening of the nineteenth century, this group of common ^c*awalim* and the number of dancer-prostitutes seem to have increased. The reasons for these changes in the activity and status of female performers should be understood in the light of political events at the time.

At the end of the eighteenth century, Egypt was divided and politically insecure. Although formally part of the Ottoman Empire, Egypt was in practice ruled by several Mamluk beys who quickly succeeded one another. All had weak internal power bases and had consequently to depend upon their own militias. In order to finance their armies, they levied heavy taxes. During the French Occupation (1798–1801) and the rule of Muhammad ^cAli (1811–1849) the control over female performers was strict.

Governmental restrictions encouraged many heavily taxed common ^c*awalim* and *ghawazi* to leave Cairo, since state control was less effective outside the capital. Foreigners, who came to Egypt in increasing numbers, provided a new opportunity for employment. Foreigners were mainly interested in dancing. The ^c*awalim* were increasingly described as singers and dancers, the *ghawazi* as dancers and prostitutes. It is not clear whether higher class ^c*awalim* started to work for foreigners, or if women from outside the profession started dancing and singing to earn a living. At any rate, the number of female entertainers who danced and sang for foreigners at the time was considerable.

This new development met with fierce opposition from the religious authorities. In 1834, the ruler, Muhammad ^cAli Pasha, issued an edict prohibiting public female dancers and prostitutes from working in the capital. Women who were convicted of violating this new law were punished and deported to the south of Egypt. The ban was an attempt to marginalize most public women and to keep them out of the view of foreigners. It proved, however, to be counterproductive. European eyes followed them to the south, to Upper Egypt, where they became the center of attention. There, too, tourists were the main source of income. A number of entertainers turned to prostitution. The move to prostitution was not solely due to the requests of foreigners. It was also caused by the poverty and insecurity performers experienced in Upper Egypt.

The word ^c*alma* (^c*alima*) lost its original meaning of 'learned woman.' At the beginning of the nineteenth century, its meaning changed to 'singer-dancer.' By the 1850s, the word denoted a dancer-prostitute. Dancing sometimes became stripping and dancers increasingly worked as prostitutes. The fading of the distinction between the ^c*awalim* and the *ghawazi* and the growing number of common singer-dancers led to the expulsion of all to the south. The banishment further erased the distinction between performers and prostitutes.

The ban was apparently lifted around 1850. Female performers were allowed to return to Cairo, but not to practice their occupations publicly. For those who once sang and danced in the streets and markets, a new opportunity arose, the *café-chantants*. Female performers were now concealed inside music halls. Gradually these developed into the nightclub circuit.

Performances at weddings had continued through the century. Famous singers were no longer called *cawalim*, since the word had become too tainted in the course of the nineteenth century. This word was now used for the group of common singers and dancers who performed in working-class quarters.

The heyday of the common *cawalim* was at the beginning of this century.[5] They performed on festive occasions, particularly for other women, as they had done in the nineteenth century. In contrast to that period, however, at the turn of the twentieth century, they increasingly sang and danced for the lower and middle classes. The Westernized elite mostly invited well-known nightclub entertainers to perform at their weddings.

At the beginning of this century, wedding celebrations were still segregated, and for that reason women were prominent in the entertainment market. They formed groups that regularly performed together under the leadership of an experienced performer, the *usta*. She taught the trade to family members and new girls. Female performers often lived in the same house and most *ustawat* clustered together in the same neighborhood of a town. In Cairo, the performers often lived together on Muhammad cAli Street.

At the turn of the century there seems to have been a distinction between the performers for the women's party and those for the men's party. The men's party was not usually attended by *cawalim*, who performed mainly for women. From the 1940s onward, however, the difference between the two groups was only a semantic distinction. The performers for the women's parties and wedding party itself were called *cawalim*, whereas the entertainers at the *sahra*, the men's party, were called *artistes*. Most of the older performers I spoke with were both *cawalim* and *artistes*, that is, they first performed for the women upstairs and afterwards they sang and danced for the men until the early morning.

In the late 1940s, the *cawalim* vanished from urban weddings because the weddings became less extravagant and, more importantly, less segregated. This development was related to social changes in the wider society, where the separation of the sexes became less strict. The separate women's parties lingered on in the countryside, but by the 1960s they had disappeared. Even before that time, people did not hire professional entertainment at the women's party, and often allowed women to be present at the men's party. Women then usually sat apart with the bride

and groom, and left early, after which the all-male party continued until dawn. This is still the case with weddings in working-class quarters.

From the 1940s through the 1970s, women of the families of Muhammad ᶜAli Street remained active at weddings and saint's day celebrations. At weddings they chiefly performed as singers and dancers, but several women managed to build up a male clientele as well. Some again resumed the position of *usta*, but their groups less strictly resembled a regular company and performers started working with several male and female employers. Yet entertainers still formed a relatively small society of loosely related groups. During the 1970s, however, these organizational patterns changed.

During Sadat's presidency (1973–1981) Egypt adopted an open-door policy in order to attract foreign investments. With the changes in the economy, a middle class emerged and exploited the new situation. This class of newly rich spent part of their wealth on recreation and brought about a flourishing period for entertainers. The growing demand for entertainers resulted in higher wages. Prices had been on the rise from the 1950s on, but under Sadat they increased tenfold. Not only the wages for entertainment rose, but also the tips.

The increased profits attracted many individuals from outside the profession. They started not only working as musicians, singers, and dancers, but also as impresarios and employers. The band was no longer a group that regularly performed together, sharing experiences and expertise over the years. Instead a group was increasingly composed of individuals working for the highest bidder.

During the late 1970s and the 1980s, the economic boom came to an end. In economic terms, it had benefited only a small segment of society. For most people of the lower and lower middle classes and those living on fixed salaries, such as government employees, the growing inflation and rising food prices caused hardship. The recession has continued up to the present and has negatively affected the entertainment industry.

Muhammad ᶜAli Street performers complain that professional ethics have been abandoned at weddings since their monopoly was broken. Proper conduct of female entertainers with male customers and colleagues used to be maintained by the *usta* and their relatives who also worked in the trade. The older generation claims that presently the women's success is mainly based on fraternizing with customers and wearing scanty costumes, not on their artistry. A few female performers of Muhammad ᶜAli Street decided to leave the trade altogether and most kept their children out of it. Former performers of Muhammad ᶜAli Street were insulted when I asked them whether they had worked in nightclubs. For them, it was synonymous with an accusation of prostitution. But now, with the loss of esteem in the wedding circuits, a number of them try their luck in nightclubs.

The nightclubs started to develop in the late nineteenth century. As a result of the Egyptian government's efforts to institutionalize the entertainment places, in connection with the British presence in Egypt and the expansion of tourism, the existing variety theaters grew into the present nightclub circuit. The Western cabarets left their mark on their Egyptian counterparts.

In 1910, only three nightclubs existed. The number quickly increased and a concentration of foreign and Egyptian bars and nightclubs developed in the Ezbekiya Gardens in the center of Cairo. The main task of female entertainers was to sit and drink with customers (*fath*). They usually sang first, or danced on the stage, and if they were admired by a client, he ordered them to sit at his table and opened bottles of champagne, whiskey, or beer for them. *Fath* was the most profitable part of the job for the nightclub owner as well as the woman.

Between 1900 and 1956, several laws regulating entertainment places were issued. The laws became more and more severe concerning the moral behavior of the employees. After 1949, the year in which prostitution was made a criminal act, the government tried to purify the nightclubs. Although sitting and drinking with customers was officially forbidden in 1951, *fath* went on, with red lamps and ringing bells warning the women of a vice-squad raid. In 1973, *fath* was eventually abolished. The government initiated a new system of registration and licenses, and checked more closely. To receive a license, the performer had to pass an examination in which she proved herself to be an actual singer or dancer. In addition, she was listed by the police, taxed, and her behavior with customers was closely watched. Moreover, her conduct on stage and costume were prescribed. The belly had to be covered (with netting oe material), the slits in her skirts closed, and talking or laughing with customers was no longer allowed.

Some of the cheapest nightclubs, however, still resemble those of the old days of the *fatihat*. The difference is that the socializing is done not by performers but by hostesses or waitresses, who are not allowed to sit with customers at their tables—they must walk around and converse with them while standing. Female performers are still supposed to make long-lasting contacts with customers but, in contrast to the past, mainly after, instead of during, working hours. They are expected to have their own customers and bring them to the club. Customers still try to make contacts with female performers. Because they can no longer invite them to their table, they sometimes write their name and address on a tissue and give it to the performer with a tip. Some entertainers, particularly the less talented ones working in the cheaper clubs, use their time on stage for talking, joking, and holding hands, to persuade the men to take out their purses. In the better nightclubs the entrance fee and the wages of the entertainers are much higher. Owners and performers are therefore less

dependent on tips. In the course of time, there has thus been a trend toward 'respectability' in the nightclubs, but this development has been largely restricted to the five-star nightclubs.

Gender Images

The last two centuries thus witnessed a dramatic change in the status and image of female performers. In the nineteenth century, Western influences were one of the main reasons for the negative changes and loss of esteem. The ᶜ*awalim* were no longer seen as learned women, and increasingly became common singer-dancers for the lower and lower middle class. In the twentieth century, internal factors caused the disappearance of the ᶜ*awalim* and the lowering of the common singers' and dancers' reputation. The most important reason for the disappearance of the ᶜ*awalim* is that weddings are no longer celebrated separately. This means that female performers either sing and dance for mixed parties or for all-male parties. Performing for men stains the reputation. Moreover, while Muhammad ᶜAli Street until the middle of this century formed a tightly-knit community with strict social control that protected women's reputations, this is no longer the case. Since the monopoly of the traditional performing families was broken and newcomers entered the trade, the reputation of all entertainers, but especially women, is no longer safeguarded.

In the nightclubs, there has been a tendency toward 'respectability,' yet in the eyes of the general public, the attempts have failed. Nightclubs are still perceived as the worst place for women to work, and being a nightclub dancer is almost synonymous with working as a prostitute.

Whereas the changing image from learned women to fallen women can partly be explained by historical transformations and current practices affecting the trade, there is more to it. Female performers were also met with great ambivalence in the past. Only the early ᶜ*awalim* seemed to have escaped moral stigma, by being talented and educated, and more importantly, by being concealed and invisible to men. The unveiled *ghawazi*, who performed publicly for men, were not respected. Similarly, the ᶜ*awalim* lost esteem when they started to work for men in the public arena.

At present, all female performers are regarded with ambivalence. Although female singers and dancers working at weddings are considered more respectable than nightclub performers, they are all immoral. Also, the difference between the reputation of female singers and that of dancers was smaller than I had expected. An Egyptian girl remarked, "A female singer at a wedding is also not good. Men at the party are interested in how she moves and what she wears, not in how she sings. For male singers it is no problem, they don't move." Female singers are first assessed visually, and only secondly for their voice. Regardless of their

artistic standard they are first and foremost classified as women with (or without) attractive bodies.

I was struck by the fact that female performers working in the respected circuit of 'higher' performing arts did not totally escape society's disapprobation. Although female singers working in television are highly esteemed, dancers and folkloric dancers, even those working in theaters, may be regarded with ambivalence. As Danielson and Franken show in their contributions to this volume, extremely gifted artists such as Umm Kulthum and the dancer Farida Fahmy were the exceptions who managed to be respected as female artists. Even they had some difficulty in successfully manipulating their image as respectable female artists by creating an aura of simple *baladi* or *fallahi* mores, appearing as women who follow local, conservative values and by covering their bodies accordingly in performances.

The reason that female singers and dancers are generally regarded as immoral is related to the prevailing cultural construction of femininity and particularly of the female body. These constructions of gender and the body are grounded to a great extent in religious discourse.

According to the strictest religious groups, singing by women is *haram*, taboo. One phrase is often cited to discredit female singers—*sawt al-mara'a ʿawra*, 'the voice of women is a shameful thing [lit. 'pudendal'].' For this reason a *shaykh* I spoke with claimed that even listening to the voice of a woman on the telephone is unlawful. If female singers were concealed, as in the past, they could still seduce the male audience. Presently, they are visible and even more seductive because the excitement aroused by looking is considered more powerful than excitement aroused by listening.[6] Since it is believed that visual rather than aural arousal is more disturbing, the consequences for the various forms of female entertainment differ. Female musicians have an aural audience, female singers have both audience and spectators, whereas dancers are solely viewed, not heard. Thus it is commonly thought in religious opinion—and also in public opinion—that dancing is the most shameful form of entertainment.

Dancers' gravest transgression is that they move. There is a strong association between movement and morality. Lightness of movement stands for lightness in morals.[7] Moving is immoral for women since it draws even more attention to their shameful bodies. When I asked a *shaykh* whether female folk dancers (who wear more clothing than oriental dancers) are less *haram*, he replied resolutely, "No, they also move." Female singers were also described as 'moving' in their performances.

Men, as the girl quoted earlier said, do not 'move.' And even if they do, they are not viewed as having exciting bodies. Male singers and musicians are evaluated with regard to their voices and skills, not their

bodies. I asked the same *shaykh* why male dancing is not *haram.* The answer was easy: "A man's body is not shameful (*ᶜawra*)," and regardless of how it moves and shakes, "it cannot excite."

What female performers hold in common is that they are women who use their shameful bodies in public. Their bodies stir others, while male bodies neither move nor stir. Why is the female body considered exciting and shameful?

The discourse on sex and gender in the Muslim world is not an easy thing to describe. It should be borne in mind that there is not just one discourse, and that the multiple discourses do not define actual behavior. In addition, discourses are neither stable over time, nor undisputed. That said, there are two fundamental discourses on gender and sexuality, the orthodox or explicit discourse, and the implicit or erotic discourse.[8] Despite the difference between the constructions of gender and sexuality in the two discourses, it is striking that they converge in their definition of women primarily as bodies, particularly sexual bodies.

According to Leila Ahmed, who traces the varieties of discourses and how they have altered in the history of Middle Eastern Arab women, it was in the Abbasid era that the word 'woman' became almost synonymous with 'slave' and 'object for sexual use.' Marketing of women as commodities and objects for sexual use was an everyday reality in Abbasid society. It is no wonder then that Muslim scholars of that period, including al-Ghazali, mainly define women as sexual beings. This period was, however, crucial for the formulation of Islamic laws and thus has had a profound impact up to the present day.[9]

Sabbah argues that Muslim culture has a "built-in ideological blindness to the economic dimension of women, who are ordinarily perceived, conceived, and defined as exclusively sexual objects. The female body has traditionally been the object of an enormous erotic investment, which has clouded (if not totally hidden) woman's economic dimension."[10] In addition, the relations between the sexes are generally eroticized. As a result, women's work outside the home is often considered as erotic aggression.

The definition of women as sexual beings and the female body as enticing is thus a very powerful discourse. It explains why female entertainers are shameful and bad, while, for instance, their male colleagues are not condemned for similar activities. The female body is shameful because it is by definition eroticizing and enticing, whereas the male body has several dimensions and is not seductive by nature. The male body, although sexual in the presence of a female body, has other dimensions—for instance in the economic or political field. The construction of gender and the body explain why the body of male performers is a 'productive instrument' whereas that of female performers is by definition a 'sexual body.'

All women have the power to seduce men by their sexual bodies. Female performers mainly differ from 'decent' women because they publicly employ their potential to seduce. Instead of using their feminine power in the legal and private context of marriage, they tempt male customers in public. Female performers are more immoral than other women working in the male public space because in entertainment the bodily dimension is central. They use their sexual bodies as an instrument for earning money. Female performers are perceived as being closely related to prostitutes because both use their sexual bodies in public space to make a living.

Shifting Identities

Since the bodily dimension is focal in entertainment, it is an extremely sensitive field for women to work in. As was previously explained, the early ᶜ*awalim* were respected because they did not show their bodies to men. Similarly, a few extremely gifted artists managed to retain public respect by utilizing a combination of tactics.

What options do ordinary female performers have to change the image of the 'fallen woman'? How do they relate to the prevailing notion of gender and the female body? Women now use several strategies in an attempt to counter the negative image of female performers and the prevailing constructions of gender and the body.

Firstly, female performers divert attention from the fact that they are working women in public to the private facets of their lives: they speak of being mothers and housewives forced by unfavorable circumstances to earn an income. Motherhood is an important identity they employ to claim respect: "If I do not dance, then my children have to dance."

Secondly, they use degrees of body covering as a means to claim dignity. Female singers often criticize dancers for wearing revealing costumes and consider themselves to be more respectable. Some religious singers, who are covered up and wear the *hijab,* refuse to work while dancers are on stage, in order to protect their reputation. The older generation accuses the younger of wearing scantier costumes and lowering the image of the trade. Folk dancers accuse belly dancers of tainting dancers' reputations by the type of costumes they wear. Even belly dancers comment among themselves about the extent of covering of their colleagues' costumes and claim respect by pointing out that they themselves wear respectable costumes. Yet, most dancers feel impelled to wear more revealing costumes at their employer's request for fear that they will be replaced by a more obedient girl.

Female performers are well aware of their power to bewitch and seduce by showing their bodies. A dancer of Muhammad ᶜAli Street stated, "A man, regardless of how tough he is, even if he is praying on his prayer mat—it is beyond his power to resist a dancer moving in a revealing

costume." A nightclub performer commented, "The customer wants to see a woman, not a man . . . If he drinks and gets drunk and sees a dancer or a female singer in a nice dress . . . they will bewitch him." Wearing a revealing costume clearly brings in money, and for most female performers, dancers in particular, it is not easy to cover up.

A third strategy that I encountered during my fieldwork, as was also demonstrated by Umm Kulthum and Farida Fahmy, was employment of the image of the *bint al-balad* (pl. *banat al-balad*, the daughter of the country). Female performers use this model as a way to gain respect. The image of the *bint al-balad* is also used in a very specific way, mainly by female performers of Muhammad ᶜAli Street, as a means of deconstructing notions about the sexual body.

The *banat al-balad* belong to the lower middle class and live in the working-class neighborhoods of Cairo. Many work outside the home; some in traditional jobs such as bath attendant, others in factories, or tailors' shops. A few are employed as servants. Many work in other shops or have their own small businesses. Some now work as government employees. Others have an active role at home in their husbands' businesses—for instance in the food trades. However, they think of themselves mainly as housewives and mothers. Although many work outside the home, they would prefer to be full-time housewives.[11]

Among the *awlad al-balad*, lower-class urban Egyptians, there is more freedom in association and conversation between women and men, in the neighborhood as well as at work. Women are not secluded from men. This makes the *banat al-balad* vulnerable to gossip that might harm their reputation. They must therefore defend their good name when challenged, by whatever means necessary. Sawsan el-Messiri notes that a young *bint al-balad* who expressed her fear of being molested by men in the street received the following reply from one of the men present: "Do you really fear men in the street? I am sure that if any man dared to bother you, you would immediately take off your shoe and beat him."[12]

Working women who interact daily with men must display strong, fearless, tough personalities. Their work requires foresight, intelligence, and experience in dealing with all kinds of people. They must be 'men' among men. It is said that "one *bint al-balad* equals twenty men in trading."[13] The *muᶜallima* (in colloquial Arabic, *miᶜallima*), the master or the chief, is similar to the *usta* of the entertainment field, and is a strong character. The title refers to important women merchants in the quarter, whether they work in the *suq*, as butchers, hashish merchants, or coffeehouse keepers (jobs usually performed by men).

While some *banat al-balad* are therefore tough, strong, and do masculine work, they are also feminine, care for their appearances, and are coquettish. Female performers display behavior similar to that of the *banat al-balad*. On the one hand, they must be quick-witted, gay, free,

nice, feminine, and responsive. On the other, they must be alert, experienced in anticipating problems, strong, tough, and manly. Female performers must be able to deal with aggression and with drunken men. They sometimes face situations involving violence, theft, and kidnapping. If their employer does not pay them, or if a male customer bothers them, they must be able—and usually are able—to defend their rights and protect themselves.

Most female performers are quite adept at defending themselves by cursing. A dancer described herself as having a rude tongue, which she had used effectively the evening before I interviewed her. Another dancer had publicly called her a prostitute, after which they started fighting, first with abusive language and later with fists. 'Son of a bitch,' 'ass,' 'bastard,' 'your mother's cunt,' are common curse words used in disputes. Female performers occasionally resort to physical violence as well. They are sometimes in dangerous situations and have to use physical violence in self-defense. In particular the past generation of leaders, the *ustawat*, were seen as *gid^can*, a word usually applied to men, meaning noble, tough, and courageous. If necessary, they resorted to violence to protect the female performers and themselves. A former *usta*, for instance, related: "I was *gad^ca*, honest, courageous, and tough, I was haughty and respectable. I did not like to talk or to make jokes with people. I immediately beat up anybody who spoke to me. I carried a knife with me. Once I used it in self-defense—that was only once. After that, whenever people saw me, they said: "*Ahlan ya fitiwwa*" (*futuwwa* in literary Arabic—'Hello, bruiser').[14]

It is not always danger that prompts female performers to describe themselves as tough, strong, ready, and able women. These traits help them to maintain an image of respectability: "If a woman is not strong in this trade, she will be lost," a dancer said. The women sometimes use violence or terms of abuse against men who compromise their reputations.

Female performers identify in other ways with the existing model of the *bint al-balad* in order to obtain respect. Many performers told me that they regarded themselves as ordinary *banat al-balad* who had been forced to work in the entertainment trade. They noted that, except for work, they wear *baladi* style clothing. A Muhammad ^cAli Street dancer included in her routine a special part called '*bint al-balad,*' in which she balanced a basket with fruit on her head while dancing. The performers' conduct differs slightly from that of the *banat al-balad*, but it is a matter of degree rather than content. Firstly, female performers are more frequently confronted with dangerous situations; they must deal with drunken men and persistent lechers, situations in which they have to behave in a masculine way in order to defend the integrity of their bodies. Secondly, they have to remove stronger suspicion with regard to their respectability.

Female entertainers, particularly dancers, are more vulnerable to accusations of immorality and prostitution. The fact that they publicly exhibit their bodies for profit makes them dishonorable. Consequently, they have to make stronger claims to honor and respect than other women working in male public space. Female entertainers therefore frequently adopt the 'masculine' characteristics of the *banat al-balad*.

To remove the suspicion of female weakness and looseness, they present themselves not only as masculine and tough but also refer to themselves as "a man among men." A female musician explained:

I am a man among men. Not a woman whom they [male colleagues] have to treat in a different way. If a woman has a strong personality, she knows how to survive in this work. If she is weak, she doesn't. If she has a shaky personality or if she is weak, she will stray from the narrow path. But if she is straight and does not engage in relationships with men, no one can talk. You observed my behavior with men. It is man to man. It is not indecent. I try not to be feminine and soft. I am serious and straight like a man.[15]

The expression "I am a man" bears several layers of meaning. Female performers are men because they work in the male public space. They often say, "Inside the home, I am a woman, outside I am a man." Outside they are men because they earn a living. They engage in an activity that expresses the essence of manhood—labor. A female singer of religious songs called herself "the son of her father," because she provides for him. The expression "I am a man," however, also implies a denial of their femininity. Or, more precisely, they deny the femininity of their bodies.

Since the female body is primarily perceived as sexual, this negation means a denial of the sexual dimension of their bodies. A dancer of Muhammad ᶜAli Street remarked, "I used to drink beer and smoke hash [with men and other women] but we were all polite, we were like men together. It was not like women and men together, it was like we were all men." If they are men, how can they be suspected of having affairs with other men—clients or colleagues? They try to disclaim the source of their dishonor by redefining themselves as men. The negation of their femininity is thus ultimately related to their efforts to be perceived as respectable women. The expression "I am a man" finally means "I am a respectable working woman."

Whereas in the private sphere female performers stress their feminine identity, in public they shift to a masculine identity. By defining themselves as men among men in the public sphere, female performers are trying to neutralize and redefine the femininity of their bodies. They themselves as workers and their bodies as a productive force. It is not sexual and shameful, but a means to earn a living.

Conclusion

The changing image of female performers from learned women to fallen women can partly be explained by historical transformations and current practices in the entertainment trade. Yet, the explanation for the image of the 'bad woman' is more profoundly related to the prevailing construction of gender and particularly to the construction of the body. The crux of the gender issue is that women are generally viewed as sexual beings. Their bodies are enticing, regardless of what they do. These constructions of gender and the body pertain to all Egyptian women. Female performers differ from 'decent' women because they use their bodies to make a living, instead of hiding them as much as possible. Women who work in male public space are all to some degree suspect. Female performers are more immoral than the other women working in public space because the bodily dimension is central in entertainment. Female performers publicly employ the sexual power of their bodies, hence the poor ranking of entertainment as a field for women to work in.

Female entertainers are ambivalent in their attitude to their bodies. Their femininity and sexuality provide them with a living, yet they pay for it in terms of status and respect. Female performers accordingly try to neutralize and even deny the femininity of their bodies in order to counterbalance the image of looseness or immorality. They try to negotiate the meaning of the body and reduce its sexual dimension by taking on aspects of the male gender in public. For them, their bodies are neutral productive instruments, like the male body.

According to female performers they are women like other women— that is, respectable daughters of the country. Through their self-presentation as ideal housewives and mothers in private, and tough women and "men among men" in public, they try to protect their reputation as respectable women. Female performers consider singing and dancing a livelihood and, for women as well as for men, a respectable trade.

Notes

1 M. Savary, *Lettres sur l'Égypte,* 3 vols. (Amsterdam and Leiden: Les Libraires Associés, 1787), vol. 1, 124–125.
2 See the contributions by Virginia Danielson and Marjorie Franken in this volume, Chapters 6 and 17.
3 The three main contexts of Egyptian entertainment are, first, the circuit of weddings and saint's day celebrations; second, the nightclub circuit; and finally, the performing arts circuit, consisting of performances in concert halls and theaters, on radio and television. My research focused on the first two sorts of venues.
4 Karin van Nieuwkerk, *"A Trade Like Any Other": Female Singers and Dancers in Egypt* (Austin: University of Texas Press, 1995 and Cairo: The American University in Cairo Press, 1996), Chapter 2. The main sources for this chapter

were W. G. Browne, *Nieuwe Reize Naar de Binnenste Gedeelten van Afrika, Door Egypte, Syrië en le Dar-Four waar Nimmer te Voren Eenig Europeaan Heeft Gereisd-Gedaan in den Jaare 1792–1798* (Amsterdam: Johannes Allart, 1808); J. L. Burckhardt, *Arabic Proverbs, or the Manners and Customs of the Modern Egyptians, Illustrated from Their Proverbial Sayings Current at Cairo* (1875; reprint, London: Curzon Press, 1972); V. Denon, *Reize in Opper-en Neder Egipte Gedurende den Veldtocht van Bonaparte* (Amsterdam: Johannes Allart, 1803); Lady Duff Gordon, *Letters from Egypt* (London: R. Brimley Johnson, 1902); G. Flaubert, *Flaubert in Egypt,* F. Steegmuller, ed. (Chicago: Chicago Academy Limited, 1979); E. W. Lane, *Manners and Customs of the Modern Egyptians* (1836; reprint the Hague, London: East West Publications, 1978); C. Niebuhr, *Reize Naar Arabië en Andere Omliggende Landen* 2 vols. (Amsterdam: S. J. Baalde, 1776); M. Savary, *Lettres sur l'Égypte*; M. Villoteau, "De l'état actuel de l'art musical en Égypte," in *Description de l'Égypte* XIV (Paris: Panckoucke, 1822).

5 This information is based upon oral histories collected during fieldwork completed in Egypt between 1987 and 1990.

6 See al-Ghazali on this topic. Looking at female performers is always forbidden whether temptation is feared or not. He reasons that looking at a beardless young boy is only forbidden if there is a danger of temptation. He then likens the lawfulness of listening to a concealed female singer to looking at a beardless young boy. Arousal of temptation is the condition to be avoided, yet only if this state is feared is it unlawful. "Ihya ᶜUlum ad-Din of al-Ghazali," trans. D. B. Macdonald, *Journal of the Royal Asiatic Society* (April 1901), 235–237.

7 Also see W. Jansen, *Women without Men: Gender and Marginality in an Algerian Town* (Leiden: E. W. Brill, 1987), 183. Algerian men are considered to be 'heavy,' in control of their movements, whereas women have to overcome their natural tendency to be 'light.'

8 Fatima Mernissi, *Beyond the Veil: Male-Female Dynamics in a Modern Muslim Society* (New York: Schenkman, 1975) and Fatna A. Sabbah, *Women in the Muslim Unconscious* (New York: Pergamon Press, 1984). Mernissi compares the explicit and the implicit discourses, Sabbah the orthodox and the erotic discourses. The explicit discourse is comparable to the orthodox, while the erotic discourse is an extension, and exaggeration, of the implicit discourse.

9 Leila Ahmed, *Women and Gender in Islam: Historical Roots of a Modern Debate* (New Haven and London: Yale University Press, 1992).

10 Sabbah, *Woman in the Muslim Unconscious*, 16–17.

11 Sawsan el-Messiri, *Ibn al-Balad, A Concept of Egyptian Identity* (Leiden: E. J. Brill, 1978); and Sawsan el-Messiri, "Traditional Urban Women in Cairo," in *Women in the Muslim World*, Lois Beck and Nikki Keddie, eds. (Cambridge, Mass.: Harvard University Press, 1978), 522–541.

12 el-Messiri, "Traditional Urban Women," 534.

13 Ibid, 532.

14 A *fitiwwa* is usually the strong man of the neighborhood.

15 Personal interview, Cairo, 14 November 1988.

2

WOMEN'S PERFORMANCE IN RITUAL CONTEXT: WEDDINGS AMONG THE RASHAYDA OF SUDAN[1]

William C. Young

Contradictions in the Moral
Evaluation of Women's Performances

In this article I want to discuss the ways in which women performers, in particular, are evaluated in Middle Eastern societies. I am especially concerned about the moral judgments that Middle Easterners make about women dancers, singers, and actresses. One frequently hears—in Egypt, for example—that it is not honorable for a women to perform on stage. Those who disagree with this judgment are often put on the defensive during discussions of the subject and can only assert, as Karin van Nieuwkerk does, that dancing is 'a trade like any other.'[2] But is it? Do most Middle Easterners believe that, on the contrary, dancing is 'a shameful exhibition of the body for money,' to paraphrase A. Blok?[3] And if they do, then why do so many Middle Eastern women train their daughters to dance?

This question came up when I discussed dancing with friends in Cairo during the 1970s. Although I suggested that it was 'an art' (following the lead of Egyptian folklorists and patrons of the theater), one of the women present laughed and said "But everyone knows how to do it! It doesn't take any special training; we learn from our mothers!" She concluded, with an ironically arched eyebrow, "So it's not 'an art,' ya^cni [you know]." She was implying that since dancing was such an easily acquired and universal skill it should not be paid for. In other words, a woman who dances for money is not a professional but only a social failure; rather than selling her performance, she is selling her honor.

At this point I felt I was on shaky ground, since I had little practice in the discourse of 'honor' to which Egyptians resort when they want to

37

dance is not tangible

condemn or praise. I was not certain what phrases like 'sell one's honor' really meant, other than being indications of what discourse the community valued or disliked. I did perceive the contradiction, however, between the value placed on women's dancing (in general?) and the low evaluation of women's *commercial* dancing. Obviously dancing was considered something so important that it should be taught to every girl, yet is was also something so dangerous to personal and family reputation that 'honorable' girls should not be permitted to dance in certain—commercial—contexts. I could also see that the argument about dance being 'an art' was weak in this context because it ignored the common distinction between artistic efforts that yield tangible, material, and hence marketable products (embroidery, clothing, carpets, ceramics, sculpture, books of poetry, paintings) and artistic efforts that produced only ephemeral goods (songs, dances, and dramatic entertainment). To be an 'artist' *(fannan)* in urban Egypt one had to produce material goods; female dancers and singers (and, to a lesser extent, male comedians, musicians, singers, and unpublished poets) did little more than display themselves and hence were categorized as morally questionable. Although a female sculptor would definitely be described as an 'artist,' a female dancer would laughingly be referred to as an *artiste* (a woman who was paid to dance in front of men only).[4]

It occurred to me after further reflection that these distinctions (paid/unpaid; material artwork/intangible display; artist/*artiste*) are not made in all social contexts. I knew that women do have 'honorable' opportunities to demonstrate their skill as dancers in Egypt. In fact, women's paid performances always stand in contrast to the unpaid performances that they are often called upon to give: ritual performances.

Unpaid Ritual Performances in Arab Societies
It is well known that rural Egyptian women dance without pay during weddings[5] and other rites of passage (such as the Egyptian *subuᶜ*).[6] These unpaid performances are regarded as honorable expressions of 'joy' *(farah)*.[7] Furthermore, judgments about ritual dancing do not sharply distinguish ephemeral physical display from material art, since the hand-embroidered clothing that a dancer wears to a wedding is an inseparable part of her performance. This is not only true of Egypt. Wherever a dancer makes her costume rather than purchasing it—for example, in central and southern Palestine during the 1930s—she makes the dance into a simultaneous display of movement and an exhibition of her skill as a seamstress. Thus a Palestinian woman's traditional costume always included a *thawb al-talᶜa*, 'going-out dress,' which was lavishly ornamented and worn while its owner danced and sang during wedding processions.[8] In a ritual context, the notion that a woman performer was merely exhibiting her body for money was unthinkable or, if not

completely unthinkable, unmentionable. Social norms protected ritual performers from censure. ≃ ₑₓₚ Rₑ ₛₛᵢ ₙg diꜱappRơVaĩ

If this is true, then judgments about professional performances and performers in Egypt are made in a wider context that includes unpaid performances. The contrast between the two forms an informal, non-textual (i.e., non-Qur'anic) basis for moral evaluation. When van Nieuwkerk's informants rated female nightclub dancers as (morally) 'very bad' and female folk dancers as 'reasonably good,'[9] they were not making these judgments in isolation but were implicitly comparing paid performers with ritual performers at weddings and other ceremonies. These unpaid performers, I suggest, would be rated 'very good' on van Nieuwkerk's moral scale.

This leads us to ask: why are women's ritual performances so well insulated from public disapproval? What do women's performances in ritual accomplish and why are they so highly valued? Answering these questions will help us understand why women's performances are so frequently criticized and yet regarded as indispensable parts of social and cultural life.

Decades ago, it would have been easier to study women's unpaid ritual performances in Cairo—for example, by analyzing weddings. During the 1930s paid women dancers performed at sex-segregated parties for the women who were invited to all weddings. The mothers of the bride and groom danced along with these ᶜ*awalim* (hired female dancers) to express their 'joy.' A handkerchief was then spread on the lap of the bride, where female guests would place tips for the hired dancers.[10] Without doubt, these actions had symbolic significance. By placing coins on the spread handkerchief, I would argue, the women guests expressed their hopes that the bride would be fertile and so dispelled any suspicion that they envied the bride. This would put the bride, who was entering this community of women as a stranger, at ease. They also helped the groom's family (who were responsible for providing this entertainment) pay for the dancers. By dancing simultaneously, the two mothers were expressing their solidarity and mutuality as new in-laws, hoping that their relationship would continue to be free of discord. Their 'spontaneous,' unpaid dancing contrasted with the paid dancing, which consequently represented one of the gifts to the bride (and her family) that had been paid for by the groom's family. The presence of paid dancers underscored the expressive, symbolic character of the unpaid dancing done by the two mothers-in-law.

Thus, I would argue, women's dancing at Cairene weddings helped to recategorize the bride as a member of the groom's mother's community and drew attention to the new relationship of affinity between the groom's mother and the bride's mother. Unpaid dancing was a form of ritual work, not merely entertainment, while the paid dancing was

considered part of the series of presentations that created the relation of affinity between the groom's family and the bride's family. As ritual work, it was highly valued and was considered an essential part of the wedding.

By the 1940s, however, the sexes were not so strictly separated during wedding parties, which meant that men were able to watch every female dancer. Unwilling to dance in front of these male audiences, the female relatives of the bride and groom no longer performed and often only the hired dancers were left.[11] In Cairo, then, paid performances have displaced the unpaid performances formerly presented at weddings by the mothers of the bride and groom. What we have now is a contrast between paid performer and audience that pervades the wedding and appears during two separate stages in the ritual. During the first stage, the paid performer entertains the audience. Her dance is a gift, paid for by the groom's party and the audience. Later, once the groom and bride have been recategorized as a couple (often having danced together as a couple themselves) the audience 'pays for' their previous entertainment by dancing 'spontaneously' for the newly married couple. In this way they can repay a momentary debt and also celebrate the marital union.

If this analysis is correct, modern Egyptian weddings present the dancer's performance as a commodity, not as ritual work. Only the audience's 'spontaneous' dancing is free of the stigma of commodification. But this is not the case in all Arab societies. One can obtain a clearer picture of unpaid women's dancing—and of the value system that accompanies it—by studying other Arab societies where there are no paid performers. The society I have chosen is that of the Rashayda Arabs of northeastern Sudan.

Dance in the Political Economy of the Rashayda

Until recently most Rashayda were nomadic pastoralists and combined livestock breeding with subsistence agriculture to obtain the necessities of life. Although commerce has always had a place in their economy,[12] at the time of my field work among the Rashayda (1978–1980) most men and women were deeply involved in household production and received no wages for their labor. Commercial transactions and wage labor had comparatively little importance for their social organization. Women's work (and men's work) was evaluated in terms of its importance for each household's economy. In the following discussion I will speak about the Rashayda in the 'ethnographic present,' using present-tense verbs for describing a situation that may well have changed since 1980. I will argue that women's dancing (and men's dancing) was also considered a valuable (although unpaid) form of work; it was ritual work that contributed to the reproduction of society and the ongoing classification and reclassification of people.

Women's production is important for the Rashayda's economy. Certainly no household can sustain itself without the complementary contributions of women and men. Women are responsible for providing and maintaining shelter, processing food, and child care, while men take responsibility for livestock breeding and agricultural production.[13] In 1975 wage labor in the Gulf states became available for Rashidi men,[14] but although this had some impact on household economies it has not reduced the value of women's unpaid labor for the household. When we examine women's unpaid ritual performances, then, we should situate them in the context of women's unpaid but highly valued labor.

Like women's production, women's ritual work is important. Among the Rashayda, women's ritual activities consist of: formal presentations of coffee and tea to guests; yearly purifications of their tents with incense; formal exchanges of greetings during the two main Islamic holidays *(ᶜId al-Adha* and *ᶜId al-Fitr); and dancing during weddings. I will concentrate on wedding dances here, because they represent the most elaborate ritual form and because they come closest to our Western concept of 'performance.'

The Ritual Context of Women's Performance: Weddings

To understand the goals and meanings of women's dancing among the Rashayda it is important to establish its immediate context. Women dance only during weddings; thus weddings to a large extent determine the meaning of dance. Although it can also be argued that women's dancing is also perceived more subjectively, through a web of free symbolic associations, it is almost impossible to trace such associations rigorously without first placing women's dancing in its ritual setting. Hence I will begin my analysis with a general description of Rashidi weddings.

The First Day of the Wedding: Shelter and Protection
Among the Rashayda a wedding lasts for seven days. Since it is customary for married couples to reside uxorilocally (with the bride's parents) for the first year of their marriage, weddings are held in the camp where the bride and her parents live. During the first day the groom and his parents arrive and are welcomed by the bride's family. The bride herself does not greet him but leaves her parent's tent before he even arrives. She is said to be *mithashshida* ('shy, reluctant, bashful') and unwilling to see the groom. She conceals herself in the neighboring tents of a relative and stays there in the company of her girl friends for the next twenty-four hours. The groom and his family normally appear in the afternoon, bringing with them the livestock, flour, and other supplies needed for feeding the guests who will be attending the wedding on the following day. The bride's family slaughters one of the goats that the

groom has brought immediately, however. They offer the meat to the groom's family and to some of the nearest residents in the bride's camp.

The most important activity during this day is the raising of the 'wedding tent.' All of the women in the bride's camp come to stretch out a length of tent cloth and set up a temporary shelter where the groom will sleep. They decorate it with ostrich feathers and a mirror (devices that are believed to protect the groom from the envious eyes of strangers). Then one of the groom's male friends who happens to be living in the bride's camp approaches and fires a few shots in the air from a pistol or rifle that he has borrowed for the occasion. Thus the women of the camp protect the 'wedding tent' and its inhabitant, the groom, from envy, while the men also make a symbolic gesture of protection by firing shots over it.[15]

Setting up a wedding tent is a crucial step because it separates the groom from his family of origin. Because he has his own shelter, he is henceforth considered one of the residents of the camp. His parents, on the other hand, are categorized as guests of the bride's parents, and as such may neither work nor act as independent moral agents. They sit passively in the bride's parents' tent, enjoying the conversation and constantly being offered food and drink. The groom, in contrast, is preparing to take on a more active role by helping the residents of the bride's camp prepare to receive wedding guests.

By the end of the first day of the wedding the groom's natal household has now completely dissolved. The bride, also, has been detached from her natal household and is awaiting the next step in the wedding. What remains to be done is to unite the bride and groom as members of a new household, assign that household a place in the social universe of the camp, and demonstrate that the mutual exchange of services and goods that is normative for husbands and wives has been started by the groom and bride.

These exchanges cannot begin, however, until an appropriate space for them has been created and both bride and groom have been assigned their places in this space. In Rashidi thought, all legitimate exchanges of sexual services and domestic labor between husbands and wives take place inside tents. A wife cooks for her husband inside the tent; a husband delivers the tent poles and tent pegs that he makes for her inside the tent and stands guard outside the tent in times of armed conflict, ready to protect the people inside if necessary. So to transform the groom and bride into a married couple, the wedding ritual must not only join them to form a household but must also place them inside a house.

I would argue that this is what is accomplished by the ritual work that is done during the next six days of the wedding. Support for this interpretation can be found in one of the names given to the wedding ritual: *bina' al-bayt* ('constructing the house'). When a man invites his friends to his wedding, for example, he does not say that he is going to

'marry' *(yitzawwaj min)* a particular girl on a particular day; instead, he says he is 'going to build on her' *(yabni ᶜalaha)*.[16] As Abu-Lughod points out, this expression "simultaneously suggests the establishment of a household and the building of a lineage." Abu-Lughod also argues, however, that it "deflects attention from the significance of marriage as that which joins a man and woman and stresses its significance as . . . [something] which . . . contributes to the growth of kin groups."[17] This interpretation is possible but overlooks the dependency of the groom on the bride that the expression implies. Without a bride, no man can establish an independent shelter of his own and has no legitimate moral space within which he can act. Among the Rashayda, tents are literally owned by women, which means that a man must depend on either his mother or his wife for shelter. Only marriage, and consequently weddings, can provide a man with a moral and physical space in which he is no longer under the direct authority of his parents. No wonder, then, that the ritual work of weddings is so important.

The work is done in stages. After being given a separate shelter in the bride's family's camp, the groom is slowly transformed into a resident of that camp. Next, during the wedding dance, he is compared to all of the other men present and all men (including the groom) are ranked according to their achievements as men. The performance also ranks married women and singles out the most beautiful dancers and seamstresses. Although the bride does not dance herself, she is implicitly compared to the best dancers, who represent the ideal wife. After being measured against the standards of the dancers, the bride and groom are now viewed as equals who can be matched with each other. The match takes place on the second night of the wedding, when the bride is formally introduced to the groom and is brought to her new home. The following steps in the wedding merely specify in idealized terms the exchanges of goods and services that are expected to take place between the new husband and wife and which should make them dependent on each other. Women's unpaid performances in the wedding thus constitute an indispensable part of the ritual and contribute to its general goal: to unite a man and a woman in matrimony.

To support this analysis I will provide a detailed description of the second day of the wedding. Since my description is also an interpretation (as all descriptions of ritual must be), it includes short arguments about how best to understand the particular symbolic acts that constitute the wedding. I will conclude with a few more remarks about the difference between paid and unpaid women's performances.

The Second Morning of the Wedding: Community and Rank
The groom gets up at dawn the next morning, on the second day of the wedding. He helps the other camp residents to slaughter and butcher a

camel (or, if the bride's family is poor, a few sheep) so that there will be meat to eat during the celebration. After this he helps the men of the bride's camp stew the meat in large pots and make coffee and tea. The groom's participation in this work demonstrates his equality and solidarity with the other men of the bride's camp.

When the first guests arrive the groom joins some of the other young men from the bride's camp who are preparing themselves for a camel race. Each of them finds a fast racing camel and leads it away from the camp toward a prearranged meeting place in the desert where the race will begin. After about an hour's march they reach the starting line, turn their mounts around, and race back to the camp.

By this time a great many guests will have arrived and will be drinking coffee and tea. One of them will keep watch for the racers, and when he sees them coming he alerts the entire camp. All of the men rush out to watch, and the women stand in front of their tents giving 'joy-cries' *(zagharit)* to encourage the racers. Although the groom *must* join the racers he is not supposed to actually win the race; he holds back, *mithashshid.* The fastest three racers are awarded cash prizes after they cross the finish line. Usually the bride's father awards these prizes. The winners enjoy the praise and esteem of the onlookers but do not race for the money. After receiving their awards they turn them over to the groom as wedding presents for him. One of the reasons, then, why the groom is not permitted to win the race is that he cannot pass on his award to himself. He participates because he is trying to act in concert with the other residents of the bride's camp, not because he wants to earn esteem or money.

During the next phase in the wedding—the serving of meat and a special cooked porridge *(raghida)*—the separation of the groom from his parents and his assimilation to the bride's camp is also marked. He and the other camp residents serve the guests (including his parents) first, before having anything to eat themselves. He eats later, with the other camp residents, not with the guests. He is careful to prepare a separate dish of food for the bride and her unmarried female friends, who do not approach the 'wedding tent' but only partake in the meal from a distance. He tells a small child to bring them tea, coffee, meat, and porridge. Once the meal is over and the men residing in the bride's camp have washed the dishes, everyone relaxes and prepares to chat or nap during the noontime heat. The groom's assimilation into the category 'residents *(mahalliya)* of the bride's camp' is made apparent at this point by the way in which he is granted a place to sleep. Most of the male guests who have come from other camps eat and sleep in the 'wedding tent,' that is, the tent that had been erected on the previous day for the groom. Female

guests eat and sleep in the bride's parents' tent, where the bride's mother has served them food. Camp residents, in contrast, leave the site of the ritual and return to their families' tents to take a nap. One of the young men residing in the camp always invites the groom, informally, to accompany him. Thus the groom's mother stays in the bride's mother's tent as a guest, the groom's father stays in the 'wedding tent' with the other male guests, and the groom himself naps in the tent of another camp resident.

The First Performance:
Men Dance with Swords and Are Ranked as Swordsmen and Poets
After the men of the bride's camp and their male guests have woken from their noontime nap, they get up and assemble for dancing (*li°b*, literally, 'play'). They walk over to the wedding tent and form two parallel lines in front of it. The men in one line face the men in the line opposite them. Little boys, who are too young to play with swords, and unmarried girls of all ages (who may not sing or dance during daylight hours) stand to one side, watching.

The man in the center of one of the lines starts to recite poetry, which is composed in a meter called *az-zaribi (al-zaribi)*.[18] Often the poet recalls heroic deeds or reflects on the difficulties of life. When men in nearby tents hear the singing they come to join in, and slowly the two lines are drawn farther apart until there is a wide space for dancing between them. After the singing has been going on for some minutes, some of the young men present display their physical dexterity by performing a sword dance, which is also called *az-zaribi*.

Each performer takes his turn, entering the dancing area, facing one of the lines of men, and unsheathing his sword. Grasping it by the hilt tightly, he holds it in front of him at arm's length and swings the blade to the left and to the right in wide, flashing arcs. While rapidly flipping the heavy sword he jumps backwards and forwards, approaching and retreating from his audience, in time to their singing.

If he is truly skillful, the line of singers allows him a great deal of time for performing. They continue to sing, marking the beat by clapping and leaping, all at one time, into the air. The booming of their feet against the hard clay ground can be heard throughout the camp. If the sword dancer is not successful, however, at least one of the two lines of men stops singing. Lacking accompaniment, he must retire from the arena and yield his place to another performer. Both the groom and the young men of the bride's camp take turns at this. Their swordplay suggests that the groom and the other camp residents are ready and able to protect the bride.

The Second Performance:
Men Sing, Women Dance, and Both Are Ranked as Potential Spouses
The very next event of the wedding, during which women dance,
constitutes a dialogue between men and women about the aesthetic and
erotic complementarity of the sexes. The men exhibit a representation of
the ideal husband and the women present their version of the ideal wife.
The best husbands and the best wives face each other collectively and
exchange gifts and other signs of appreciation. This sets the stage for the
more individual meeting of the bride and groom and is a prelude to the
marriage's consummation.

When the women in the women's tent hear the men start to sing and
dance, they adorn themselves *(yitazachchinin)*[19] for the next stage in the
dance. They apply *kuhil* (a powdered eye liner) to their eyelids and put
special rings with long silver bangles on their fingers. If they have any
extra silver necklaces or jewelry they put these on also, so that the metal
will make a pleasant jingling sound as they dance.

They also take out their married women's ritual veils *(baragi^c,* coll.
sing. *burga^c)*, which they have brought with them for the wedding, and
slip them on over their masks. The ritual veil is secured at the back of the
head by a strap and in the front by a safety pin, which is fastened to the
heavy piece of richly embroidered red silk *(khirga)* that a woman lays
over her head when dancing. When a woman wears a *burga^c*, then, her
head, face and shoulders are completely covered with decorated cloth
except for her eyes. Even the eyes, which are visible through the two
square eyeholes of the *burga^c*, are not undecorated, since they are lined
with *kuhil*. The shape of the woman's body is completely obscured,
while the intricate decorative patterns she has sewn onto her clothing are
displayed to their best advantage *(Plate 2.1)*.

Their change of costume complete, the women leave their tent and
approach the dance ground. When the first cluster of married women
arrives at the wedding tent the swordsman leaves the arena and makes
room for them. The two parallel lines of singing men move closer
together and everyone else crowds around them to watch the dancing
women.

The 'man in the middle' of one line sings out his composition, which
may be new or old and which often describes the women in oblique but
flattering language. Raising his right hand high to attract the attention of
the other singers, he shouts out one stanza and its refrain. One poet I
heard likened a dancer to "a dark rain cloud that drops its moisture" *(hiya
chamā mizintin mustaḥilla)*. As we will see, this was a reference to the
black costume of the dancer and the perfume she splashes on her
audience.

Other poetic descriptions of dancing women can be even more oblique.
One poem, for example, was:

badā muṭrigin wagt-i shāni bi dhillah
yibill il-baḥar wa-l-baḥar mā yibillah.

A rod that is used to beat [time with music] appeared,
and when it cast its shadow across me,
it moistened the sea but the sea did not moisten it.

According to informants, the 'rod' is the dancing woman, tall and
slim, who dances in time with the songs the men sing.

Each poet tries out his composition on the crowd. The men in the
opposite line listen, and if they like it they repeat the refrain. The poet
then has the right to repeat his composition and everyone within earshot
has another chance to hear it and memorize it. Creativity in describing
dancing women, and celebrating women's dancing, is rewarded; the poet
acquires a good reputation. A successful composition will be taken up
and repeated many times, with one line of men singing the opening
stanza and the second line taking up the rhymed refrain.

Many poets are given their turns to perform. When a man wishes to
present one of his compositions, he must persuade the others who are
next to him to let him move to the center of the line and shout it out. He
asks for silence from the opposite line by raising his right hand high and
then recites his poetry. For a brief time, this 'man in the middle' is
'made senior' by the singers standing opposite him. They judge his
composition and, if it pleases them, repeat it. In the context of song and
dance, the distinction between senior and junior men, which is so
important in the normal life of the community—and is also evident
during the wedding meal, since senior men are served before junior
men—is ignored. Senior men take their places in line alongside younger
men, and their skill in butchering, pastoral tasks, or trade counts for
nothing. Only the expert poets and dancers are given the spotlight, and
these are often young, unmarried men.

The role of audience approval is succinctly portrayed by one such
wedding verse, which I recorded.

tamaththīl yā rāᶜy il-yamīn aṭ-ṭawīla
mā zāl al-ᶜarab lamma hū ḥāḍirīnah

Recite [for them], you of the long right arm;
The people did not stop [singing] for as long as
they attended it [i.e., your poetry].

The crowd's immediate rejection of weak poetry, even when it is
composed by otherwise respected men, is described in another verse,
which pokes fun at a conceited man who thinks that his high rank in
Rashidi society should entitle him to inflict his wretched poetry on the
wedding celebrants:

ᶜalām il-ᶜarab yadgalūnī ᶜaḍāda
wa anā mi[n] ir-rubūᶜ il-kubār imḥasūbī?

Why should these people shoulder me to one side [of the row]
[When] I am considered one of the most respected people?

My argument is that singing and dancing during weddings provide an
occasion for ranking the men who are present in a way that is quite
different from the way in which men are usually evaluated. Ordinarily
men earn the respect of their community by being able scouts during
pastoral migrations, by acting as shrewd tacticians during armed conflict,
by skillful negotiation when conflicts are resolved, and by careful
husbandry of their herds to accumulate livestock and capital. Such
technical, political, and economic rankings guide people when they search
for possible patrons or leaders. This is the case, for instance, when the
Rashayda select leaders for their dry-season camps. When the dry season
approaches, the various nomadic households curtail their pastoral
migrations and gather around a well or other reliable source of drinking
water. They informally select one man as the 'senior man of the camp'
(chibīr al-farīg) who will represent the camp to outsiders and who will
take responsibility for organizing access to the well water. They choose to
camp near a senior man because they want to have an effective leader as
their neighbor.

The people at a wedding, on the other hand, are looking for the man
who can best entertain them with his witty songs and who has the most
manly appearance as he dances. To put it another way, dancing and
singing singles out the 'most available' man, from the women's point of
view. He is the most desirable husband and is selected by the community
of men. They present him to the unmarried girls, who stand outside the
circle of men, watching, and to the married women who have entered the
dancing ground.

Exchanges between Women Dancers
and Men Dancers during the Performance
No man addresses any particular woman directly as he sings and no
woman speaks at all. Rather, each woman raises her silver-laden hands
and claps them together lightly, in time with the singing. While the other
three or four women are turning slowly about, dancing, a fifth woman
takes out a bottle of perfume and walks past the lines of men, splashing
their white turbans and hands with it liberally. The men hold their hands
out to receive it and apply any excess perfume to their beards and faces.

One of the men may show his appreciation for this by unsheathing his
sword and handing it to one of the dancers. She takes it in both hands
delicately, holding it by the hilt and the blade, and rests it against her

forehead: Turning to face one row of men, she salutes them by hopping toward them as she dances, and they reply by jumping still higher. Clapping in unison every time their feet hit the earth, they sing out their verses of praise. In this way the community of men and the community of married women exchange gestures of esteem.

The manner in which the dancers interact during the dancing expresses the complementarity of the sexes. This complementarity is evident in many different aspects of the performance. For example, when swords are displayed men and women handle them differently. A man swings the heavy sword rapidly using only one hand to demonstrate the 'strength of his forearm *(guwwat dhiracah)*,' while a woman displays the sword without moving it, so that its gleaming blade reinforces the metallic whiteness of her holiday costume. The dancing woman's holiday finery consists of silver bracelets, silver rings, and the shining *burgac* with its rows of mother-of-pearl buttons and silvery beadwork. An especially well decorated costume is described approvingly by the Rashayda as being 'white' *(abyad)*. A gleaming sword fits into this shining display only if it is held against it and kept stationary. In short, each dancer uses a sword in a sex-specific manner.

A number of things are exchanged by men and women during this performance. Men loan their swords to dancing women and women refresh men by splashing them with perfume. The members of each sex give what it is culturally defined as appropriate for them to give. Thus the exchange of swords for perfume that takes place during the dancing appears to be consistent with the more general norms of exchange between men and women.

To illustrate gender roles in intra-household exchanges, let us examine domestic work. When male guests arrive at a Rashidi home, the senior woman of the household serves them liquid refreshment (water, tea, and coffee). Women are also responsible for keeping the water skins used by the household in good repair. Some women are even given names that refer to water; one woman I knew, for example, was named Matar ('rain'). Women are not, on the other hand, expected to keep or use weapons; this is a man's responsibility. Although women who use weapons to defend themselves and their families earn widespread respect—as is evident from the stories that circulate about courageous women who shot dangerous hyenas, and so on—there is also a general recognition that women rarely do so. This can be seen from a common expression of skepticism; when a Rashidi man hears a narrative that he does not believe, he says, "*banat wishhan*" ('virgin girls armed with swords').

At the same time, men compose poetry for women and women dance for men. This exchange of gestures, like the exchange of swords for perfume, replicates the Rashayda's division of the civilized arts between the sexes. Once again, this sex-linked division is not simply a matter of

assigning one activity to men and another to women. Both men and women can be excellent poets and both men and women dance during this stage of the wedding. It is less a question of what men and women do than what they give to each other.

Both men and women among the Rashayda appreciate fine poetry and have many occasions to hear it. A woman who can memorize and recite many fine odes *(gasayid)* earns the esteem of her family and neighbors; there is nothing to prevent her from learning them.[20] However, a woman has no opportunity to compose extemporaneous poetry in mixed company or present it during large gatherings (such as weddings). Women sing or recite only when in the presence of close friends or the members of their households. Men, on the other hand, are not just allowed to develop poetic expertise; they are encouraged and even required to do so. A young man who wishes to enhance his reputation must try his hand at poetry during weddings. Only men take part in the competition and judging that goes on during weddings. For this reason a man's poetry may be heard and repeated by a great many more people than a woman's compositions. It is not that the Rashayda make better poets out of men than out of women; the point is, rather, that men's poems are designed to circulate, while a women's poetry tends to be recited to and learned by only a small circle of intimates.[21]

The fact that Rashidi women's dancing takes place while men are also dancing distinguishes it from the performances of folkloric or nightclub dancers. The men at a Rashidi wedding are not simply there to watch; they also dance, which means that they also have ritual work to do. The comparability of men's and women's dances further insulates Rashidi women's performances from the charge that they are sales of honor for money.

Among the Rashayda, dancing, in itself, is neither feminine nor masculine. The actual movements of men and women during *al-licb* are quite similar; both leap into the air in time to the music. Yet dancing men do not and may not provide anything like the dazzling spectacle that is presented by women. Women's dancing is art *(fann)*; men's dancing is at most musical and has only a minor visual component. This point is best brought out by a consideration of another aspect of dancing: the award of prizes to the best women dancers.

Awarding Prizes to Women Dancers

After some minutes of strenuous exertion the first women to enter the dancing ground are exhausted and some of them pause to breathe. This pause gives the men an opportunity to enter the arena while the women are resting. If he so chooses, one of the men approaches and, using a safety pin, fastens a wad of ten-pound notes to the right side of a woman's *burgac*. This is not a gift; it is a prize *(al-sagala)* that the woman

has earned by dint of her excellence as a dancer and a seamstress. But the award is purely symbolic and has no monetary value for the woman who receives it. Although she is pleased to be singled out, she does not keep the money but passes it on later to the groom as a wedding gift. Gratified that she has been selected as an example of an ideal woman and wife, she leaves the arena and makes room for others to take their turns.

By awarding the *sagala* to a woman, the man who attaches money to her veil silently declares her to be the most skillful dancer present and also shows that he thinks she is the seamstress with the most attractive clothing. Sometimes the other men are not satisfied with his choice and so one of them may present a second woman with a similar prize. Alternatively, a man who wants to give *sagala* but does not wish to dispute the aesthetic judgment that has been made waits until a completely new group of dancers has entered the circle. Then he singles out a different exemplary woman.

The name of this prize—*al-sagala*—is the same as the name of the prize that is awarded to the men who win a camel race. I have argued elsewhere[22] that the prize is given this name in order to emphasize the agency of a morally upright woman. She is in control of her emotions and her body and can 'tame' them just as a man can 'tame' domesticated animals such as camels.[23] The goal of my analysis here, however, is different; rather than trying to explain why this prize is verbally equated to the prize given to camel racers, I want to know why the prize is given at all and why it is given at this particular stage in the wedding.

My interpretation is as follows. On the second day of the wedding, the normal residential organization of the camp, in which the camp senior is distinguished from marginal camp residents, has disappeared. Instead, two unrelated communities (women and men) have been created. The bride has been separated from her natal household and incorporated into the local community of women, while the groom has been taken from his natal household and included in the community of men. Next, men and women are brought together by virtue of their desirability as marriage partners. Their most attractive cultural and physical characteristics are highlighted. As the performers stand face to face, the best dancers (women) are matched with the best poets (men).

Conclusion

My analysis of women's performance in this economically peripheral society, in which the subsistence economy has not yet been completely penetrated by commodity production and wage labor, demonstrates that women's performance can be very highly valued when it aids in the reproduction of the social order and contributes to the work accomplished by ritual. The extent to which women are unpaid ritual dancers in other Middle Eastern societies may well determine the evaluation of their

performance in these societies, also. As subsistence production is displaced by commodity production, women's performance tends to become progessively devalued, for a number of reasons. First, commercialization tends to transform men into a passive audience, even at weddings, and divorces men's ritual work from women's ritual work. Thus the men increasingly take on the role of consumers while women become 'entertainers.' Complementarity between the sexes is undermined. Second, commercialization separates women's dance performances from their other skills (e.g., embroidery, sewing, and clothing design) since their costumes are no longer handmade. Thus the dance becomes an almost unidimensional display of the body.

Under these circumstances it is not surprising to hear criticisms of women's performance. Women's dancing becomes a commodity, a lens which collects and intensifies a multitude of tensions between rich and poor, 'respectable' and 'dishonorable,' 'high' and 'low.' I would argue, then, that today's debates in the Middle East about women's dancing are not only concerned with 'women' per se. They are also grounded in the increasing economic and political stratification of the region and represent a reaction to the commercialization of ritual and cultural life. Where inequality between rich and poor, and men and women, has increased markedly, it is difficult to avoid the conclusion that paid performances are in fact becoming demeaning. In this respect the Islamic movements are right. If they propose, however, that the only solution to this problem is to prohibit women dancers entirely,[24] they run the risk of antagonizing the majority of Egyptians. Women's dancing is still strongly associated with joy, vitality, and fertility in Egypt; most Egyptians do not want to do away with it completely. What, then, can the reformers do?

Their options seem to be: (1) acquire enough political power to impose an absolute ban on all women's dancing, paid or unpaid, in all contexts. This extreme solution would be practically unenforceable, however. Furthermore, even in the unlikely event that an Islamic movement could actually seize power in Egypt, by trying to enforce such a ban it could provoke a hidden resentment that would undermine its popularity and legitimacy.

A second option would be (2) to eliminate all women's dancing (paid and unpaid) from the weddings of the movement's members and make 'purified' Islamic weddings into examples for the general public. In other words, they could restrict themselves to this form of 'educational' work rather than attempting to coerce the less ideological majority. This more moderate approach, however, would result in an impoverished ritual life for the reformers themselves, which they might find depressing and which would probably not attract the admiration of ordinary Egyptians. What is worse, a ban on paid women's dancing in weddings would ironically reinforce the excessive commercialization of this practice, since

professional dancers would have no places in which to work other than bars and nightclubs.

A more realistic option might be (3) to try to keep paid and unpaid dance forms during weddings but restructure them, in the name of Islam and national authenticity, to recover the ritual work that Egyptian women dancers used to provide during the 1930s and that Rashidi women dancers still carry out at the present time. This third solution would be complex, however. It is no longer possible to return to the sex-segregated wedding parties of the 1920s because Egyptian women no longer observe seclusion. Women do not wear 'Islamic dress' because they want to confine themselves to the home. Rather, they adopt more modest clothing styles because this allows them to penetrate domains and spaces that were traditionally dominated by men.[25] Although the reformists could sponsor two completely separate wedding parties, one for men and another for women, and permit women's dancing only in the context of the women's party, this antiquarian solution would not address the fact that the sexes are no longer segregated in the workplace. Secluding women dancers during wedding celebrations would not return working women to their homes during working hours; the image portrayed by the wedding would be only a shallow pretense. What is needed, rather, is a ritual form that does not categorize women dancers as mere 'entertainers' and that restores the real symbolic value of women's dancing.

No doubt many Egyptians are struggling to reformulate tradition so that the energy and joy of women's dancing will not be sacrificed for the sake of modesty. In order to resist commodification they will have to come up with creative and effective solutions. One resource that they can use in this struggle is ritual tradition. No one can question the authenticity and value of women's traditional dancing at weddings and other occasions, and the majority of the people still recall such performances fondly. Some dancers, drawing on this tradition, may succeed in reclassifiying dancing as 'authentic popular folklore' *(turath sha^cbi asil)* that does not necessarily conflict with Islamic values. Perhaps we will witness the invention of new dance forms and costumes (e.g., veiled dancers in Cairo?) that manage to reconcile 'joy' with dignity.

Notes

1 The long vowels in Rashidi and Cairene Arabic are unmarked in accordance with the publisher's transliteration system, except in the transcriptions of lyrics. Similarly, differences between emphatic and non-emphatic consonants in Arabic are not marked, nor is the difference between the voiceless pharyngeal /h/ and the voiceless laryngeal /h/ of Arabic. I would like to express my gratitude to the Social Science Research Council and the Fulbright-Hayes Commission for supporting my research among the Rashayda from 1978 to 1980.

2 Karin van Nieuwkerk *"A Trade Like Any Other": Female Singers and Dancers in Egypt* (Austin: University of Texas Press, 1995, and Cairo: The American University in Cairo Press, 1996), 7.
3 A. Blok, "Infamous Occupations," in T. Vuyk, ed., *Essays on Structural Change: The L. H. Morgan Symposium* (Leiden: ICA Publications, 1985), 34.
4 van Nieuwkerk, *"A Trade Like Any Other,"* 53, 108–110.
5 Hani Fakhouri, *Kafr el-Elow: Continuity and Change in an Egyptian Community*, 2nd edition (Prospect Heights, Illinois: Waveland Press, 1987), 66–69.
6 Fadwa El Guindi, *El Sebou': Egyptian Birth Ritual* (an ethnographic film), Los Angeles, El Nil Research, 1987.
7 van Nieuwkerk, *"A Trade Like Any Other,"* 1–2.
8 Shelagh Weir, *Palestinian Costume* (Austin: University of Texas Press, 1989), 74–76, 245, 267–269.
9 van Nieuwkerk, *"A Trade Like Any Other,"* 189–190.
10 Ibid., 55.
11 Ibid.
12 William C. Young, "From Many, One: The Social Construction of the Rashayida Tribe in Eastern Sudan," *Northeast African Studies* 4, no. 11 (1998).
13 William C. Young, *The Rashaayda Bedouin: Arab Pastoralists of Eastern Sudan* (Fort Worth, Texas: Harcourt Brace College Publishers, 1996), 33–54.
14 William C. Young, "The Effect of Labor Migration on Relations of Exchange and Subordination among the Rashayida Bedouin of Sudan," *Research in Economic Anthropology* 9, 1987.
15 I should point out that informants do not stress the protective elements included in these ritual acts. Rather, they focus on their expressive aspects. Both raising the tent and firing shots over it are said to be expressions of 'joy' *(farah)*. The women utter 'joy-cries' *(zagharit)* when they raise the tent. The men smile and brandish their pistols dramatically when they fire them, watching the other celebrants jump in surprise at the sharp reports of their firearms as they go off. I have no doubt that these weddings are, indeed, joyous, but regarding such acts as simple expressions of joy does not help us explain why they take place exactly when they do. Why not fire the shots on the second day of the wedding? Because, I would argue, the shots are protective and complement the women's protective acts (e.g., placing a mirror over the front of the tent).
16 One of the distinctive features of Rashidi Arabic is the tendency to lower a long front vowel such as -ay when it preceeds an open syllable, thus transforming it into long -aa. My own transcription of this phrase would read *yabnii ᶜalaahaa*. Readers who doubt the accuracy of such a transcription should be reassured; it is correct.
17 Lila Abu-Lughod, *Veiled Sentiments: Honor and Poetry in a Bedouin Society* (Berkeley: University of California Press, 1986), 150.
18 This name for this meter is arcane, but may suggest flowing or gurgling water, *ma zariba*.

19 Another distinctive characteristic of Rashidi Arabic is the affrication of the consonants /k/ and /g/, which frequently occurs in contiguity with high front vowels. I have transcribed affricated /k/ as 'ch' here but have made no attempt to transcribe the affricated /g/ in the words that follow, such as *baragiᶜ*.

20 Also illustrated by Abu-Lughod, *Veiled Sentiments*, 171–175.

21 Ibid, 178–185, as a comparison.

22 William C. Young, "The Body Tamed: Tying and Tattooing among the Rashaayda Bedouin," in Nicole Sault, ed., *Many Mirrors: Body Image and Social Relations* (New Brunswick, NJ: Rutgers University Press, 1994), 68–73.

23 Peggy Reeves Sanday, *Female Power and Male Dominance* (Cambridge: Cambridge University Press, 1981), 44.

24 As the examples given in Walter Armbrust, *Mass Culture and Modernism in Egypt* (London: Cambridge University Press, 1996).

25 Fadwa El Guindi, "Veiling Infitah with Muslim Ethic: Egypt's Contemporary Islamic Movement," *Social Problems* 28: 4 (1981); Andrea Rugh, *Reveal and Conceal: Dress in Contemporary Egypt* (Syracuse, New York: Syracuse University Press, 1986); Sherifa Zuhur, *Revealing Reveiling: Islamist Gender Ideology in Contemporary Egypt* (Albany: State University of New York Press, 1992).

3

FOLK MUSIC AND DANCE
IN THE ARABIAN GULF AND SAUDI ARABIA

Kay Hardy Campbell

Folk music and folk dance in Saudi Arabia and its neighboring Gulf
states are characterized by monophonic musical structures, the
predominance of the voice in music and sung poetry, highly syncopated
rhythms, strongly emotional lyrical content, and repetitive group dance
movements. Particularly striking in the folk music and dance of the Gulf
is the participatory role of all in attendance at such performances in their
traditional settings, such as tribal encampments, and the salons of private
homes. The line between audience and performer fades, as all take part in
what can be described as a collective performance experience.[1] Regional
writers refer to these traditions, particularly those involving complex
dance and song performances, as al‑ab, games or sport, reflecting their
collective nature.

Drama and emotional power are among the key characteristics of Arabic
music and dance in general. This power transports the audience and
performers to a state of musical ecstasy *(tarab)*, which the audience
expresses by shouting verbal appreciation at certain times in the
performance. This contrasts with Western classical musical traditions in
which the audience waits until the final measure of a piece before reacting
with polite applause and only an occasional shout of 'Bravo!' The
dramatic expressive power of Arabic music and dance also obtains in the
Gulf. These arts have the same capacity to express and give audio-vocal
and physical form to emotion in an outdoor oasis party in Hofuf as in a
celebrated concert hall in Cairo.

Both men and women participate in folk music and folk dance
traditions, though in modern Saudi Arabia they usually do so separately.
Performances allow the participants and audiences to express emotions,

frivolity, a spirit of play, and sometimes total abandon, in a public forum acceptable even in the most religiously conservative societies of the Gulf. They are a cultural escape valve, acceptable as long as all who participate do so within cultural limits.

This chapter attempts to analyze the way folk music and dance in the Gulf, and Saudi Arabia in particular, are performed today, with a focus on the music and dance of Saudi women. Saudi women's music and dance traditions are chosen for particular attention for two reasons. First, they are rarely discussed in the West. Second, Saudi women's performance arts are the most socially and culturally sensitive genres in the region due to Saudi society's strenuous efforts to maintain the privacy of its women. Their music and dance traditions serve as an interesting example of the way a modern, conservative Gulf society practices its traditional performance arts. Finally, the chapter discusses how the modern state, as well as modern recording and video technology, have had a profound effect on these traditions, serving both to preserve and change them.

Materials for this chapter were gathered over eight years while residing in the Gulf region. Access to weddings and women's parties is not easily obtained, and the author was therefore grateful for the opportunity to explore the topic of women's music and dance. The author has produced two collections of songs from Saudi Arabia, some of which serve as examples for discussion.[2]

The Origin of Musical Genres in the Region
The interplay of cultures in the Arabian peninsula, in its combination of both historic and contemporary isolationism and cosmopolitanism, has given rise to a strong folk music and folk dance culture. The region's traditions can be divided into several basic genres, representing the subcultures from which they originally sprang: the music of the Bedouin, of city dwellers, of women, and of pearl divers and seafarers. The pearling and seafaring tradition exhibits strong influences from Africa and countries to the East, in both instrumentation and folk dance costumes.

Each of these genres has many folk dances and songs associated with it, tied to the towns or tribes where they are performed. The Banu Dawasir, a tribe from the *wadi* of the same name extending southwest from Riyadh, perform a song and dance style known as *al-dawsari*, but there are many variations of this within the tribe. Each region, sometimes each village, produces special songs and dances. *Al-majrur al-taifi*, a famous men's song/dance in which the participants dance and twirl wearing a characteristic circular-skirted thob, is a tradition of Saudi Arabia's mountain city of Taif. Another song and dance style, *al-yanbuwiya*, hails from Yanbu on the Red Sea. This tradition features as its primary instrument the *simsimiya* or *tambura* (*tunbur* in classical Arabic), a six-stringed lyre-like instrument also found in East Africa,

Egypt, and elsewhere in the Gulf. Other traditions span many areas, such as *al-ᶜarda*, a men's sword dance and song poetry genre. While some have characterized this as a Najdi tradition, variations can be seen throughout Saudi Arabia and the Gulf states. In southwestern Arabia it is sometimes performed with rifles to a fast 4/4 rhythm, whereas in Riyadh it is danced and sung to a stately 3/4 meter.

General Environment for Song and Dance in the Gulf

While the popular music of the Gulf is gaining a larger pan-Arab and international audience through satellite broadcasts of music videos (and video clips) produced in the Gulf, the folk music and dance traditions of the Gulf are little known outside their own regions. One can speculate that city dwellers in the largest Arab capitals find the traditions too steeped in the premodern era. In addition, few recordings of the folk music reach beyond their performers' national borders, a result of the highly localized and segmented music recording and sales structure in the Middle East as a whole. Finally, and perhaps most significantly, the large number of traditions and the complex variations of these traditions make it difficult to present the subject of Gulf folk music to the outside world. Given the complexity of the topic, it may be years before enough material for a comprehensive survey has been gathered to map out the details of these traditions in their historical and geographic contexts.

While waiting for an encyclopedic collection of the folk music and dance of the Gulf, one can make some basic observances about them and their social settings. Saudi and Gulf folk song and dance performances occur in both formal and informal venues. In the nineteenth century the formal occasions for song and dance centered on family rites of passage such as weddings, circumcisions, and the birth of children, as well as religious holidays such as *ᶜId al-Fitr* after Ramadan. Informal performances took place anywhere families gathered; at home, at tribal encampments, or in the case of pearl divers, at sea. In addition to traditional occasions, people of the Gulf today sing and dance to mark such diverse times of national celebration as school graduations, a national soccer victory, the return of King Khalid of Saudi Arabia from heart surgery abroad, or the end of the Gulf War in Kuwait. In addition, television and radio have provided a forum for formal performances. In nearly all the Gulf countries the makers of long-running television shows on local folklore travel among the towns and tribes recording the local singers, poets, and dancers for national broadcast, thus cataloguing older traditions which may be dying out due to urbanization.

Poetic composition using song, clapping, and dance is a major component of the Bedouin folk arts. While not all folk music and dance traditions of the tribes involve original poetry, most have sung verse at their core. Tribal folklore is complex and variations of these poetry

generating traditions are dizzying in number. In the Hijaz region of Saudi Arabia alone, these arts include *al-qasid, al-majalisi*, and *al-ᶜarda*. As Steven Caton found in his research on Yemeni tribal poetry, there is a distinction in the minds of tribesmen between *sung poetry* and *song* in general.[3] Tribesmen consider the playing of musical instruments (i.e. making music) inappropriate for tribal members. This is despite the fact that to an outside observer, everyone involved in a poetry contest is actually singing and dancing. Since tribesmen do not traditionally play instruments, song and rhythm are their musical mainstay. Others of lesser social status play instruments if they are used at all. An exception to the Bedouin disdain for musical instruments is solo singing performed to the accompaniment of *al-rababa*, a one stringed violin-like instrument.

The *Majlis al-Tarab*

In the cities and towns, musical instruments were traditionally more common, though secondary literature about the early years of the modern Saudi state refers to a banning of all musical instruments for a time.[4] Informal folk music and dance performances traditionally took place (and are still held) in the large rectangular *diwan* (salon) of a well-to-do family's home. Some refer to this setting as a *majlis al-tarab*, a salon of entertainment. In such a session, the musicians and audience sit in a traditional formation *(Figure 1)*.

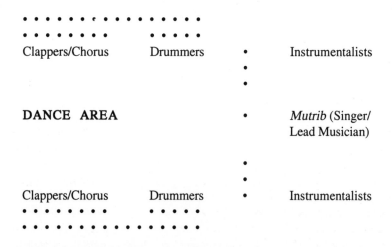

Figure 1. Seating arrangement for the majlis al-tarab

In a typical performance, the featured musician, usually a singer and *ᶜud* player, sits at the center of one of the narrow ends of the *diwan*. If the ensemble is large enough to include them, string and wind instrumentalists take their places on either side of the lead musician. The

percussionists play an array of drums in various pitches and sizes, from the deep double-headed *zir* to the high pitched *tabl*, a miniature *darabukka* held under the left arm. The drummers sit in a line perpendicular to the musicians. Beyond them are the singers and clappers. A larger performance might include a second line of singers and clappers behind the drummers. A second line of singers sits across from the drummers. The resulting U-shaped seating arrangement includes the entire audience and orchestra, and everyone becomes part of the show as a musician, singer, clapper, or dancer.

Once the music starts, the singers and clappers join in. The rhythmic clapping, known as *tasfiq* in the Gulf, is a resonant hollow clap performed during the musical refrains in syncopated rhythms. A lead clapper will start and stop clapping with exaggerated movements at the appropriate moments, such as at the beginning and end of the musical refrain (*taslim*). The clappers sometimes sway from side to side, sit up on their heels, add small shoulder movements, and sing the vocal refrain. In a men's salon performance, it is from among the clappers that the men will get up to dance any number of traditional steps matching the music. In this setting participants perform a wide variety of songs and dances, including the traditional *khaliji* song cycle known as *al-sawt*. The important thing to note here is that everyone present participates; the audience becomes part of the performance.

In the Gulf countries outside Saudi Arabia where men and women still sing and dance together, women will sing and clap as part of the chorus. They will also occasionally dance solo or in pairs in the center of the room, wearing the traditional *thob nashal*, a loose floor-length embroidered caftan.

The Social Relevance of Music and Dance

The folk music and folk dance traditions of Saudi women deserve special focus, as they encapsulate the issues surrounding the performing arts in a region where a conservative society collides with older traditions of non-segregated celebration in music and dance. In modern Saudi Arabia, women's lives are primarily spent outside the public realm (defining 'public' as areas in society where men and women outside the family might mix). Since modern Saudi society enforces the predominant separation of women and men outside the family, and vigilantly watches the reputations and privacy of its women, it would seem the last country where one would find a strong women's music and dance culture. Yet these arts are flourishing, partly because women are able to practice their music and dance without compromising their reputations. Saudi society allows them to do this, as long as it is accomplished within clearly defined limits, i.e., as long as it remains invisible to the province of men outside the family.

Saudi women's folk music and dance can be seen in the salons of well-to-do women, who have their own *majlis al-tarab* to entertain guests or to celebrate family rites of passage without compromising their reputations in public. The women's schools, universities, and secondary schools put on formal variety shows that give the students a chance to learn performing arts. Finally, the traditional women's wedding party, the *haflat al-zaffaf*, is the most common and most traditional venue for Saudi women musicians and dancers to perform. Saudi women musicians play there for women-only audiences who sing along, clap, and perform their folk dances in spirited celebrations lasting long into the night.

The Wedding Party

In Saudi Arabia the *haflat al-zaffaf* take place in a variety of settings, including the high-walled flat roofs of houses, function rooms in posh hotels, and in outdoor 'wedding gardens' (literally outdoor function areas), walled-in gardens where hundreds of women guests sit out in the open night air unveiled.

The bride's family hires the musicians, who are usually women from the lower classes, including the descendants of servants. Presiding at the head of these groups is a lead songstress, *mutriba*. She brings with her an entourage of a chorus, drummers, players of the *tar* (frame drum), and sometimes a violinist or two. Recently, electronic keyboards especially designed for the microtones of Arabic music have also become popular instruments in these ensembles. Often the *mutriba* plays the *ʿud*. These bands usually perform on a small stage with open space in front of them for the women in the audience to dance.

At the wedding parties attended by the writer, the performance style of these musical groups set the tone of the entire event. The musicians came onto the stage with little or no applause, slowly set up their equipment, tuned instruments, and tested microphones. After a cup of tea and a few minutes to tighten the drum skins by slowly tapping them over a charcoal brazier *(mabkhara)* the music began with a vocal improvisation *(mawwal)*. Then the chorus broke into the first song. Each song lasted between ten and fifteen minutes. Between each number the group would stop to retune, tighten the drum skins, and take a few sips of tea. As the musicians got warmed up and as more party-goers arrived, the atmosphere became more charged with excitement. The musicians and audience members grew more enthusiastic, particularly as the time for the procession of the bride and groom approached. More popular songs crept into the program, and the audience responded more immediately to the music.

Once the music began, the young girls and teenagers got up to perform the traditional dances of the Peninsula, wearing the long embroidered and sequined *thob nashal*. They danced solo or in pairs, alternating between

mirroring and ignoring the movements of their partners. Their movements were centered in the shoulders and head. They also performed the characteristic swinging of their hair in circles, from side to side, and even in a figure eight pattern. The women in the audience clapped and sang along. At big city wedding parties there is often a clearer separation of the audience from the performers due to the size of the audience, which can number in the hundreds. Even in such circumstances it is acceptable and expected that friends and family of the couple will dance.

While these are highly social occasions in which all are formally dressed, the music and dance gradually transform many of these gatherings into boisterous parties replete with *zagharit*, whistling, clapping, and dancing. Some wedding parties are clearly more exciting than others. This appears to be a function of many factors, including the family's budget (reflected in the skill of the musicians), the liberality of the bride's and groom's families, and the lateness of the hour.

At some parties the attendees will reach a frenzied excitement, and many young women dance with abandon. Other parties are more subdued with just a few girls or very young children getting up to dance. Some wedding parties include the impromptu performance by audience members of an Egyptian-style dance, *raqs sharqi*. The parties last for several hours, until the bride and groom arrive to make an appearance before the women of the family. After they present themselves, all the women retire to a large feast. Traditionally, the musicians would follow the bridal couple to continue performing outside the bridal chamber. When the party is over, all go quietly home re-wrapped in their cloaks and veils, to return to their everyday existence.

Regional differences, such as among the Shiᶜa of the Eastern Province, produce variations of this party tradition. In addition to *haflat al-zaffaf*, *lailat al-hanna* (henna night) involves entertaining the bride and her friends with live music while the bride's hands and feet are decorated with henna. Traditionally the women of the family put on a song and dance party to entertain the bride as she sits for hours waiting for the delicate designs to dry.

Emotional Discourse and Women's Music

In addition to the dancing, the lyrics of the songs performed at the parties are charged with ideas and emotions one would never expect to hear expressed in public. Many of the songs performed by the folk bands at weddings are not originally Saudi songs at all. They include the latest popular songs from all over the Arab world, from as far as Tunisia. They intersperse these with their favorite traditional folk songs. But the choice of song, and the lyrics of those songs and the audiences' reactions are of interest. Love songs, those expressing strong emotions never verbalized by women in public, are sung loudly and boisterously by all. And

everyone knows the words. The following is an excerpt of lyrics from a song performed by popular female Saudi singer, ᶜItab. The full text of the song is transliterated and translated in the footnotes.[5]

He left without saying good-bye,	*Sāfarū mā waddᶜū,*
He left me and went.	*Sayyabūnī wa rāḥū*
He left me to go far away,	*Sayyabūnī li-nawā,*
And I'm burning from his wounds	*Bankāwī bājirāḥū.*
When I was with him I was happy.	*Bainahum baina marāḥu.*
After he left me,	*aᶜadī ma sābūnī,*
He left me desiring him.	*Sāyyabūnī wa sabāḥū.*
I have met my match.	*ᶜIndī min laᶜamūnī.*

While powerful emotional disclosure is typical of all genres of Arabic music and poetry, it is worth noting that it is also expressed in song by women in traditional Saudi society. Lila Abu Lughod's interpretation of the acceptability of self-expression through poetry's formulaic structure among Egypt's Bedouin, and Steven Caton's work on Yemeni tribal folk poetry are both of relevance in analyzing the folk music and dance of the Gulf. Women's poetry among the Egyptian Bedouin allows the poets and listeners to communicate strong emotion within an honorable forum.[6] The Yemeni poetry traditions studied by Caton, such as *al-bala* and *al-zamil*, give participants a forum for public self-expression with many subtleties and social implications.[7] Using their models, one could interpret Saudi women's folk music and dance as a means to express otherwise unspoken emotion. Could it be that the *haflat al-zaffaf* setting allows participants an acceptable forum to not only enjoy the abandon of song and dance, but to play out and express sentiments not otherwise acceptable? This deserves closer observation and study and has further possible implications for the intersection of gender and performance.

The fact that women of the traditional Gulf countries take part in this practice of structured public self-expression at all deserves attention, particularly since it has been left relatively unstudied. Secondary literature in English about women in the Gulf and Saudi Arabia usually focuses on non-musical aspects of women's lives. Weddings are treated in their anthropological and sociological contexts, as in Soraya Altorki's discussion of marriage strategies,[8] or Unni Wikan's description of Omani weddings and the roles of family members in such a union.[9] The literature mentions that there is music and dance, but does not focus on it as a subject of study.

Clearly then, more work on the subject is needed, with regard both to women of Saudi Arabia and her Gulf neighbors.

Folk Arts and Gender, Past and Present

How have Saudi women's folk arts changed in the last decades? The increasing central authority of the state, the country's concomitant increased social uniformity, and modern technology have brought many changes to the way Saudi women sing and dance, and to the way they learn these arts.

There is descriptive evidence of mixed men's and women's folk music and dance traditions among the Hijaz Bedouin tribes occurring in the recent past. While it appears these are no longer extant, it cannot be ruled out that some tribes may still practice them discreetly. Two folk dances from the Hijaz known as *al-hashi* and *shabba al-nar* featured solo dances by young girls holding a stick as they danced (bare-faced and bare-headed) in front of men of their tribe. In one tradition, a young man might dance with the solo dancer. But if the man got too close, she would hit him hard with the stick, sometimes chasing him from the dance area.[10]

Hijazi folklorist ᶜAtiq bin Ghaith al-Biladi wrote that in his youth women would sometimes participate in the chorus of his tribe's rendition of a sung poetry contest, *al-qasid.* To do so, the woman would ask her *mahram* (a brother, father, or husband) to stand at the end of the chorus/dance line. She would then stand next to him on the end. Other women wishing to join in would stand next to her. Thus the women could participate without standing next to an 'off-limits' man. Al-Biladi wrote of the decline of this mixing of men and women, "This tradition has disappeared today since we have persuaded women that it is not their place and is not suitable for them . . ."[11]

With the growth of the modern Saudi state in the 1920s and 1930s, religious authorities took a dim view of singing and music. Ameen Rihani, who lived in Riyadh in the 1920s and wrote about his experiences there, reported that singing and musical instruments were banned in Najd, along with smoking, due to objections to these practices by the religious conservatives.[12] Al-Biladi also mentioned that for a time musical instruments and song were also banned in the Hijaz, though he does not mention exact dates.[13] Fortunately, several hadith supporting the singing of women in celebration of weddings are known. These hadith may have prevented the *haflat al-zaffaf* from being totally banned in the kingdom even during the strict early years.[14] The government's lifting of the ban allowed music and dance to be performed at weddings and times of certain religious celebrations.[15] However, the original banning of music and enactment of stricter sex segregation appears to have diminished (if not eliminated entirely) the mixed Saudi tribal folk music and folk dance traditions.

Today folk music and dance are allowed in their proper place, i.e., at celebrations of weddings, religious holidays, and national events. In fact the Saudi government, like its Gulf neighbors, has become a generous

supporter of a revival of the folk arts, including folk music and folk dance. In every Gulf country, state agencies support the study and preservation of folkloric traditions. These agencies, such as Saudi Arabia's Society for Culture and the Arts, sponsor musical training and performances of drama, music, and poetry recitals. In Saudi Arabia, the annual folk-life festival at Janadiriya near Riyadh has become a regional cultural colossus, featuring folk poetry recitals, national camel races, and folk dance performances, and drawing large audiences. Women present their folk arts on special days when only women visitors may attend.

With the exception of wedding party music and dance, a conservative attitude toward folk music and dance is still rigidly in place regarding Saudi women, with some interesting results. While women's performance arts may be absent from official public events, or limited to female attendees, women may nonetheless be actively engaged in performance endeavors on their own. The women's universities, secondary schools and women's charitable groups are venues for folk art performances to celebrate graduations, or just to put on a show. The most prominent women in Saudi society attend these parties, including the upper ranks of royalty, which in effect puts the women's royal seal of approval on them, and protects them from criticism by conservatives. These well-to-do women sponsor their own parties, where music is played and dances are performed. The wedding party tradition is thriving. And as long as these parties remain in the Saudi women's realm, they are acceptable.

Economic and social change have brought some aspects of the women's folk music and dance out into the open, testing the limits of the conservatives. In 1978 an article appeared in the English-language daily newspaper the *Saudi Gazette* describing the graduation variety show put on at the *Dar al-Hanan* girls school in Jeddah. It described in detail several of the dance numbers, and interviewed Saudi girls in the dance show, giving their names. Pictures of some of them were published with the article, where they appeared unveiled and with their hair uncovered. It is said that the newspaper was severely criticized for this reportage.[16] This response showed that the photographs of the girls and the mention of their names in association with music and dance offended the religious authorities and most probably the women's families.

In contrast, the author published two feature articles in the two years that followed in *The Arab News,* describing women's wedding parties. One included an interview with a popular Saudi singer, Sarah Uthman. There was no negative reaction from the authorities, since the article gave only the name of the singer, who was not from a well-known Saudi family. It also did not include photos of Saudi women. Describing the dancing, the music, and the party was not offensive. Apparently it was exposing the names of the unmarried young women without their families' permission that was taboo.[17]

A lively music recording market has developed in response to demand for tapes of the music at the women's wedding parties. Sound studios make professional recordings of the parties, then sell them. The tapes are sold in the name of the singer, sometimes listing the family name of the wedding where she sang. Selling the tapes of the latest wedding party is acceptable, because only the name of the singer is on the tape. This is allowed since the women in attendance are not named, and all who are there are anonymous, despite the lively clapping, whistling, *zagharid*, and yelling heard clearly on the recording.

It should be noted that in the more socially liberal Gulf states such as Kuwait and the United Arab Emirates, women are allowed to participate in the state supported arts activities. They can study music at the institutes, and perform with the national folkloric troupes all over the world, something that is not allowed in Saudi Arabia. Women's folk groups are featured on the region's folklore television shows, including lengthy interviews with the lead singers. Although they do not appear in public concerts in the kingdom, Saudi women musicians travel abroad to perform in mixed company, and make full-orchestrated recordings in Cairo or Kuwait. This too is acceptable, since they are not from the kingdom's conservative families.

Advances in recording and video technology have served to keep the Saudi women's folk music and dance traditions alive, despite the social pressures inside Saudi Arabia. Cassette tapes of the wedding parties are played at home, giving even the poorest women access to the latest women's folk music, whenever they want to hear it. Since the latest performances of the popular wedding singers can be heard all over the country, at the whim of the listener, the women actually now have more access to their music than before. The writer has observed impromptu folk dance parties at homes of people from differing social strata, where a cassette is played so the women can sing along and dance. Aspiring performers can listen to the latest wedding party tapes and learn the songs performed by imitation. They may also watch women's folk music groups on television broadcasts from the Emirates or Bahrain that can be seen in the kingdom.

Thus despite the strict social customs of the kingdom and the religious authorities' dim view of women's performance arts, Saudi women's folk music and dance survives. Within the limits of acceptable venues, the wedding parties, graduation shows, and homes of the well-to-do, all can sing and dance without fear of a reputation being sullied by publicity. Skilled performers can develop their talents and perhaps travel to neighboring countries to gain fame outside the Saudi women's network. Finally, the more liberal social practices of neighboring Gulf countries result in a more public viewing of women's folklore, available to scholars and aspiring performers from either gender and any country.

While the governments of Saudi Arabia and its neighboring Gulf countries have fostered the recording and cataloguing of folkloric performance arts, their popularity at the 'street' level, as well as modern recording technology, have allowed them to remain vibrant forms of acceptable public emotional expression and group play. In Saudi Arabia, even the absence of state support and media exposure has not been able to dampen the vitality of women's folk music and dance. The patronage of Saudi women at the highest levels of society, the acceptability of the wedding party tradition, and modern recording and video technology have made the survival of Saudi women's folk arts possible. These factors have actually fostered their enduring popularity and have been crucial in keeping the women's music and dance traditions alive, even under the kingdom's social conditions of the late twentieth century.

Notes

1 Ali Jihad Racy. "The Interconnection of Elements in Folk Arts: Implications for Research," *al-Ma'thurat al-sha^cbiya*, vol. 1, no. 2 (April 1986).

2 *Samra: Songs from Saudi Arabia* (audiocassette). Kay Hardy Campbell, 1985; *Samra 2: More Songs from Saudi Arabia* (audiocassette) Kay Hardy Campbell, 1986.

3 Steven Caton, *Peaks of Yemen I Summon* (Berkeley: University of California, 1990) 56.

4 Ameen Rihani, *Ibn Sa^coud of Arabia* (Boston: Houghton Mifflin 1928) 130, 211–12.

5 These lyrics are from a recording by Saudi singer ^cItab and are transliterated to approximate the singer's dialect.

He left without saying good-bye,	*Sāfarū mā wadd^cū,*
He left me and went.	*Sayyabūnī wa rāḥū.*
He left me to go far away,	*Sayyabūnī li-nawā,*
And I'm burning from his wounds.	*Bankāwī bājirāḥū.*
When I was with him I was happy.	*Bainahum baina marāḥu.*
After he left me,	*Ba^cadī mā sābūnī,*
He left me desiring him.	*Sāyyabūnī wa sabāḥū.*
I have met my match.	*Indī min la^camūnī.*
The knocking came later,	*Id-daga yīgī ba^cadahum,*
When I was alone at night.	*Kulli waḥdī bi-l-lailah.*
The one who came to me from him,	*Willi jā minnāhum,*
Brought me a letter and a solution.	*Jā bi-risālah wa ḥailah.*
He brought a letter, which I read	*Jā bi-risālah igritahā,*
and understood.	*Wa infaham ar-risaha.*
I found its sentiment	*In-nabaṭ algaitāhā*
Sweet, like its intention.	*Ḥilwa zayy ma^canāhā.*

Tell him, "If I could come,	*Gulluh law agdir 'ajī*
I'd come to him at night.	*Kunt 'aji-lu il-lailah,*
But I'm afraid for myself,	*Bass ana khāyyifa ᶜalay,*
From the eyes of the family."	*Min ᶜuyūn il-ᶜā'ila.*
"Peace," I write, "Peace"	*As-salām aktub salām,*
To my dear beloved.	*Li-l-ḥabīb al-ghāli.*
Tell him I sleep	*Khabbiru innī manām,*
On a chaste bed.	*ᶜAla wisādi iḥlāli.*

6 Lila Abu Lughod, *Veiled Sentiments: Honor and Poetry in a Bedouin Society.* (Berkeley and Los Angeles: University of California, 1986), 248–55.

7 Caton, *Peaks of Yemen,* 56–62.

8 Soraya Altorki, *Women in Saudi Arabia* (New York: Columbia University, 1986), 123–147.

9 Unni Wikan, *Behind the Veil in Arabia.* (Chicago: University of Chicago, 1986), 16–26.

10 ᶜAtif bin Ghaith al-Biladi, *al-Adab al-shaᶜabi fī-l-Hijaz* (Damascus: Maktabat Dar al-Bayan, 1977), 234.

11 Ibid., 230.

12 Rihani, *Ibn Saᶜud,* 130, 212–213.

13 al-Biladi, *al-Adab,* 210.

14 Three hadiths, as follows, would seem to support the Prophet Muhammad's sanctioning of women's festival singing.
1. "The Prophet said, 'Announce this wedding! Play the *ghirbal* concerning it.'" Ibn Majah, *Sunan Ibn Maja* (Cairo: ᶜIsa al-Babi al-Halabi, 1952), vol. 4, 611.
2. "The Prophet was passing through part of the city and happened upon a group of women playing the tambourine and singing. . . . He answered them, 'God knows I'm fond of all of you . . .'" Ibid., 612.
3. "Ibn ᶜAbd Rabbihi related, 'The Prophet went to ᶜA'ishah and asked her, "Did you send the girl to her husband?" "Yes," she answered. "And did you send with her someone who sings?" "No," she answered. "Didn't you know that the Ansar (Supporters) are a people who are fond of love poetry? You should have sent one who would sing . . ."'" Karam al-Bustani, *al-Nisa' al-ᶜarabiyat* (Beirut: Dar Sadir, 1964) 75.

15 Biladi, *al-Adab,* 210-211.

16 Janice Brunson, "Dancing Sixsome Are The Party Highlight," *Saudi Gazette* (May 25, 1978), 5.

17 Kay Hardy Campbell, "Arabian Wedding Nights," *Arab News* (August 1, 1979) and "Why Sarah Uthman Wants to Expand Beyond Wedding Party Audiences," *Arab News* (August 4, 1980).

Zaffat al-arusa: procession of bride.

4

A PROCESSION THROUGH TIME
THE *ZAFFAT AL-^cARUSA* IN THREE VIEWS

Carolee Kent and Marjorie Franken

A *zaffat al-^carusa*, the procession of the bride, is a major ritual in a series *Bride is* of events preceding a Middle Eastern wedding. There are many local and *formally* regional variations, and this chapter will discuss two contemporary styles *presented* and the historical version that gave rise to both the later versions. The *to guests.* data consist of observations, interviews, and video recordings of wedding processions made between 1991 and 1994 in Cairo, Egypt, involving attendance at approximately 100 weddings.

The basic form of a *zaffat al-^carusa* is simple but subject to many elaborations. The bride, surrounded by her family and friends, is formally presented to the assembled wedding guests. Musicians, followed by young girls, in turn followed by the bridal party, process through an open space, often a hotel lobby and into the main party area, where the bride and groom sit on a decorated platform to be admired by all during the feasting and entertainment that is to come. A superior *zaffa* involves dancers as well as musicians.

Modern *zaffat* function as public proclamations of the legal union and familial approval of a marriage. Entertainment of the spectators, and noise that calls attention to the wedding ceremony and to the bride herself, are the principle features of *zaffa* processions. Originally, and on a practical level, the *zaffa* processions functioned to escort the bride from her home through the public streets, and to the home of the groom, where the marriage was consummated. There are *zaffat* for occasions other than weddings, and even other *zaffat* within the wedding process, that can continue over several days. We will focus in this chapter on *zaffat al-^carusa*, the *zaffa* of the bride.

71

Zaffat of the Past

According to historical sources, *zaffa* wedding processions in Cairo were, until the twentieth century, and still are in perhaps fifty percent of Cairo weddings, outdoor affairs staged in the public streets near the bride or groom's residence. Edward Lane spent several years in Egypt beginning in 1833 and has left us one of the most-quoted sources on the private lives of Cairenes of his time. He describes several styles of *zaffat al-carusa*, and indicates which social class followed each particular tradition. For a middle-class bride in Cairo, a *zaffa* procession included these participants: at the front, leading and announcing the event, came musicians playing drums and 'hautboys' (oboes, meaning the *mizmar*) and singing popular songs. After the musicians came a group of married women, friends and relatives of the bride, wearing the customary black veils of modest street wear. Following them came a group of young girls, also friends and relatives of the bride, distinguished by white veils. Finally the bride herself appeared; she and two female relatives, all veiled, walked under a canopy carried by four men. At the end of the procession were more drummers and musicians. This description (and a sketch of it) contains the minimum number of participants necessary, although other entertainers could be added. Of these the most popular were sword fighters, stick fighters, magicians, strong men, and so forth.[1]

Variations included the following. Brides of 'great families' rode on donkeys and brides in villages rode on camels. Poor families, either urban or rural, who could not afford paid entertainers provided the music with their own singing.[2] In each type of *zaffa* described here we see three functional aspects: 1) noise calls attention to the persons and the occasion, 2) the bride is guarded and conveyed by her two closest female companions in the public announcement of her marriage and physical transfer of residence, and 3) she, the focal point, is framed by a canopy, or by riding an animal, and by the procession itself.

Modern Zaffat

mostly same w/ a few additions

Moving forward one hundred years we can see how bridal processions changed. We can literally see, because Egyptian movies of the 1930s, 40s, and 50s (and even today) often include wedding scenes. The principal participants described and sketched by Lane are still there—musicians, married female relatives, young girls, and the bride—but there are some new features as well. Now the groom is sometimes shown walking with the bride through the streets, the young girls walk in two parallel lines and carry tall candles, the married women walk in a group behind the bride, and there is a belly-dancer directly in front of the bride and groom. Sometimes the dancer is surrounded by female musicians.

Caution is advised, of course, in taking movie weddings as completely accurate portrayals of real Cairo weddings. According to Roy Armes,

Lizbeth Malkmus, and others, Egyptian movies were heavily influenced by Hollywood productions. Egypt's reputation as the 'Hollywood of the Middle East' is more than analogy in some cases. Still, the use of a belly-dancer in wedding processions of the twentieth century is confirmed by many other sources.[3]

This form of Cairene *zaffat al-ᶜarusa* draws attention to new symbolic features. The central symbolism of the married women and the virgins still holds as Lane described them, with the bride as the transitional figure in this ritual of transformation. Her changing status from virgin bride to honorable wife and future mother is set in even sharper relief by the dancing female figure who immediately precedes her in the *zaffa*. The contrast derives from the social values ordaining that a dancer is everything a good woman should not be: free, independent, earning her own living, openly friendly to men, even flirtatious and seductive, and available to men on her own terms.[4] She is, to use Mary Douglas's terms, the element of pollution in the transforming ritual of virgin to adult woman.[5] According to Douglas a bit of filth, the unspeakable, a polluting element is necessary in the most powerful of human rituals in order to demonstrate their transforming power and intimacy in human affairs. A belly-dancer beside a bride demonstrates the power for evil (sexual chaos) inherent in women, even as their control and maintenance by men is the bedrock of the social order.[6]

A new variation in Cairene weddings became increasingly popular in the 1970s. The earlier version of the *zaffat al-ᶜarusa* fell into disfavor with upper- and middle-class Cairenes who thought it vulgar and old-fashioned. In the new variation, the wedding parties and festivities took place inside a large hotel, utilizing lobbies, staircases, ballrooms, and other large public areas. The inclusion of the *zaffa* in weddings in tourist hotels came to be seen as a way to display conspicuous consumption. In the 1980s the *zaffa* became part of the hotel wedding.

In this 'hotel *zaffa*' the procession usually goes from the lobby into a ballroom where the *farah* (main entertainment) and feasting take place. The bride and groom are seated for several hours in prominent places, to observe and be observed. This form of *zaffa* escorts guests through the hotel and is completely divorced from its former function, the residential transfer of the bride. Five-star tourist hotels are preferred and among these hotels there is ranking according to the size, location, and relative luxury of the hotel. The older *zaffa* format was never deleted from the street celebrations of weddings among less wealthy Cairenes.

Another contemporary version of the wedding *zaffa* is found in the United States. The hotel *zaffa* is very popular among Arab-Americans. Similarities to the modern Egyptian *zaffat al-ᶜarusa* are noteworthy. Because Egypt produced far more films than any other Arabic-speaking country, those movies became standard fare in theaters all over the

colloquial: informal. Relates to conversation.

Middle East. People from Morocco to Iraq became familiar with Egyptian colloquial Arabic and cultural conventions. The *zaffa* wedding procession with a belly-dancer, years later, on another continent, became a new sophisticated style for Arab-Americans to emulate. The use of belly-dancers in Arab-American weddings crosses all lines of religion and ethnicity and has become a firm old tradition in a new land.[7] The hotel is a convenient venue in American cities, where, just as in modern Cairo, the residential transfer of the bride is no longer an intra-neighborhood operation.

Male Dancers and Public Women

In the 1960s still another innovation in wedding processions was introduced in Egypt, called the *firqat zaffa* (*zaffa* troupe). This entertainment features not only a female belly-dancer, but also a group of young men, averaging twelve to twenty dancers. They are dressed in Western clothing, play Egyptian drums and sometimes a variety of Western instruments as well, such as the saxophone, trombone, or trumpet, and perform a marching drill while singing popular Egyptian songs. In addition, one or more *mizmar* players dressed in traditional Sa'idi galabiyas (floor-length robes associated with Upper Egypt) are included.

This company of handsome young dancing men appears first, in two parallel rows, leading the procession. They are followed by the young virgins carrying candles and finally the female dancer, with the bride and groom directly behind her. The happy couple are surrounded by family members, and some of them, both male and female, may dance briefly at intervals in front of the bride and groom. The procession concludes as before, with guests and bridal parties entering a ballroom for food and more entertainment.

The *firqat zaffa* is primarily a hotel *zaffa*, but when it is performed out of doors, in public streets as in Lane's day, the female dancer's position is left unfilled because of possible objections or even disruptions by conservative spectators.[8] If the female dancer is omitted in a hotel *zaffa*, this is understood to be an economy measure, as the young male dancers work for about a tenth of the female dancer's fee. If money is no object, other entertainers may follow the *firqa*, such as folkloric dancers.

The sequence of *zaffa* styles and traditions described here offers some intriguing contrasts and invite analysis. The variations in these *zaffa* processions—Cairo then and now, compared to the Arab-American versions—are not random choices among entertainment options, we suggest, but are important indicators of social change. Westernization and modernization are evident, but closer analysis also reveals fundamental changes in the role of women and the economic realities of contemporary marriages. As society sees itself on display in weddings, the *zaffa* has

proved to be a flexible ritual that responds to cultural change. Weddings are an eternal institution, but the social values that are demonstrated in them can and do change over generations.[9]

In particular, the role of the female dancer raises questions. Lane's descriptions include no female dancers in the *zaffat al-ᶜarusa* itself, but public dancing girls whom he calls *Ghazeeyeh* (pl. *Ghawazee*) were sometimes hired to dance in front of the groom's house on other days during the wedding period. Village weddings might include dancing by village women and even the bride herself, but again not in the procession itself, where women are said to have sung but not danced.[10] One hundred years later, a female dancer plays a major role in the *zaffa*. She has become the most visually arresting part of the 'frame' around the bride and the groom, and performs the crucial function of defining the focal point of the procession. Gone are the canopy, the donkey, and the camel. The young girls still precede the bride, but directly in front of the bride is the belly-dancer. Dancers in movies are shown wearing glittering costumes that are sophisticated, flashy, and seductive all at once. The dancer also plays *sagat (brass finger cymbals)*, attracting more attention with their clamor. Finally, in the latest *zaffa* innovation, the female dancer shares the framing role with a kaleidoscope of smart, athletic young men marching in and out of formation. In the *farah*, the enclosed entertainment that follows the *zaffa*, both the *firqa* (the troupe) and the female dancer may perform again for the seated guests. Again the most prestigious wedding is the one with the most famous and greatest number of performers.

So what can we make of all this? Over a period of one hundred and fifty years the focus and central entertainment of wedding processions has changed from street entertainers to female dancers. When the belly-dancer was added in the twentieth century, the meaning and function of the *zaffa* shifted from the utilitarian to the symbolic. The public announcement and transporting of the bride are now assisted by modern conveniences, and the public appearance of middle-class women has been common since 1920. The latest innovation, combinations of young men and female dancers, has shifted the central symbolic focus away from female sexuality. No doubt a great many factors influence these popular displays of family wealth and joy, such as general levels of prosperity in Egypt and shifts between conservatism and liberal attitudes. But the factor we wish to examine more closely is the role of women themselves, as entertainers and as wives, in particular how their images, roles, and especially self-images have changed over time.

Changing Images of Women

Among Egyptian women, no alteration of status and role has been more dramatic than that of the ᶜ*awalim*. The ᶜ*almehs* (pl. ᶜ*awalim*) are described

by Lane. The name translates literally as 'learned women,' that is women
educated in the arts of singing, sometimes in playing an instrument, and
in poetry and music composition and performance. In the 1830s, ^c*awalim*
were "often hired on the occasion of a fete . . . of a person of wealth. . . .
They are often very highly paid [and there are] some who are not
altogether unworthy of the appellation of 'learned females,' having some
literary accomplishments."[11] Prior to the 1830s an ^c*almeh* was a respected
person, and was invited into harems among respectable women. When
male householders and guests wished to listen, her honor was protected
and modesty preserved by *mashrabiya* or window coverings of wooden
lattice work from which she could sing over a courtyard of listening men.

^c*Awalim* did participate in weddings in the Cairo of Lane's day, but
only in the singer role. They might have attended various private parties
of the bride, such as at the *hamam* (bath house) or the *laylat al-hanna*, a
henna application party held the night before the *zaffat al-^carusa.*[12]

The respect commanded by the ^c*awalim* is in stark contrast to the
attitude Lane records toward public dancing girls. These women,
Ghazeeyeh *(ghaziya/ghawazi)*, of mysterious origins, Lane calls the "most
abandoned of the courtesans of Egypt." These public dancing girls, "who
exhibit in the streets with unveiled faces, are very seldom admitted into a
hareem; but . . . often perform in front of a house, or in the court; though
by many persons even this is not deemed strictly proper."[13] They "are not
unfrequently hired to entertain a party of men in the houses of some
rake," where "performances are yet more lascivious" than on the street,
their costumes abbreviated and "semi transparent." Much drinking
accompanies the dancing, and "the scenes which ensue cannot be
described."[14]

Ghawazi also had a part to play at weddings, and were hired to dance in
front of the house for various parties the groom sponsored, and often in
the morning after the *dakhla* (consummation).

Lane was present in Cairo during events that both confused and
lowered the status (and remuneration) of all women entertainers, both
respected singers and suspect dancers. The origin of the confusion seems
to be a decree of 1834 by Muhammad ^cAli banning all prostitutes from
Cairo. Some public dancing girls, judging by Lane's description, seem to
have been prostitutes. But Lane also says that "there are also many
[^cawalim] of an inferior class, who sometimes dance in a hareem; hence
travelers [read Europeans] have often misapplied the name 'alma' meaning
'al'meh to the common dancing girls."[15]

Judith Tucker provides further insights on the change of status and
confusion the ^c*awalim* suffered in the 1830s. In the following extract, she
is speaking not of respected educated ^c*awalim*, but of the other types of
public women:

The line between public dancers and prostitutes proper cannot be drawn with any precision. . . . Women who plied the trades of public entertainment and prostitution inhabited a world where the bonds of family and custom were loosened. . . . This world remains veiled in obscurity, for the stigma attached to such activities militated against official recognition of these women in the court records or elsewhere. . . . [Still] most observers agreed that at least some of the dancers were prostitutes as well, although others seem to function as the awalim of the poor, performing songs and dances in the popular quarters.[16]

The ban of June 1834 on prostitution in Cairo also included public dancers of all levels of skill and respectability. Tucker proposes a link between the anti-prostitution campaign and the subsequent loss of status by ᶜ*awalim.* "A blanket ban on female entertainers may also have helped to blur distinctions between women with accomplished entertainment skills and those pushed into plain prostitution by reverses of fortune."[17] One official of an *iltizam* (a form of land ownership in which tax collection normally included a commission for the owner of the *iltizam,* the *multazim/a* of the time) practiced a form of extortion by listing respectable women as prostitutes and only removed their names from his official tax rolls if enormous bribes were paid. Wealthy ᶜ*awalim* might well have been victims and their reputations ruined by this practice. The descriptions left by European travelers indicate that "some of the women exiled from Cairo to Upper Egypt were clearly performers of considerable talent and training."[18] Kuchuk Hanem was a famous example described by Flaubert.[19] Tucker continues:

At least some of the 'women of learning' were thus classed with the public dancers of the popular quarters and exiled, a development which had repercussions on the status of the occupation as a whole. The inability of later travelers to distinguish the awalim from public dancers and prostitutes may reflect a similar lack of distinction by the State with a resulting dip in status and material standing for the awalim.[20]

Dancers and Brides: Changing Status and Occupation

Today the ᶜ*awalim* are still part of the public entertainment professions in Cairo. They are part of the quasi-guild system of entertainers[21] who use Muhammad ᶜAli Street as a headquarters and gathering place, not unlike a union hall for hiring. ᶜ*Awalim* still perform at wedding entertainments and as hired dancers for other occasions. They can serve as agents and teachers for other dancers. Their status however remains low, and their role is limited to the lowest common denominator of performance— lower-class weddings and saints' days festivals.[22]

Over 100 years later, a female dancer in the hotel *zaffa* is called the *calima*, while if she performs on stage she is called *raqasa* (dancer). The role in the wedding *zaffa* is specifically labeled with the name of this type of female performer. In early Egyptian movies these *cawalim* seemed to have regained the wealth, popularity, and skills of the singer-dancers of old, but to have lost the respect they had commanded before 1834. Many of these Egyptian movies with wedding scenes show not only the central symbolism of the dancer, but their cheapened personal status as well. Often the plot of the movie centers on the dancer, an old girlfriend of the groom, who has now chosen a young girl as his bride, instead of a stigmatized public performer.

If the lives and roles of the *cawalim*, among the least respected of women in modern Egypt, are changing, what about other women? Several female Egyptian scholars have commented on the enormous changes that Egypt and women there have experienced in the twentieth century. For example, Leila Ahmed writes that the 1952 revolution was especially important for women's status and role as it endorsed egalitarian and feminist ideals. Egyptian women responded in the thirty years following the revolution with an era of "dynamic feminism."[23] Women became more educated and were employed outside the home as never before. In 1962, women employed outside the home were mostly rural agricultural workers. By 1982 educated women had entered professional, technical, and scientific fields and held twenty-six percent of those jobs in Egypt.[24]

Modern brides and families who prefer *firqat zaffa* for their wedding processions are from the upper middle classes and are surely among those Egyptian women who are attempting to create their own images and ideologies. Modern upper middle-class brides have been educated far beyond the levels attained by their mothers and grandmothers. These are the women who may take the professional and technical jobs, whose income will be vital to the maintenance of their families' middle-class status.[25]

The symbolism of the wedding procession now includes modernism, cosmopolitan, sporty clothing, and middle-class consumerism in the form of young men in snappy drills wearing Western clothing. The traditional values symbolized in the early twentieth century *zaffat al-carusa* images of the virgin bride juxtaposed beside the independent seductive belly-dancer do not symbolize the central meaning of the modern wedding.

Change and Meaning

How did the belly-dancer fall from being a central figure to a lesser figure, or to being omitted altogether from upper middle-class wedding rituals? What do the changes signify in terms of the category of 'dance' in Egyptian classifications? What is different about the *firqat zaffa* which is

elements of zaffat: public presentation of bride, noise to draw attention to union, entertainment to show wealth.

so popular today? What can be said about dance as a category in Egyptian minds?

First, men are included as dancers and may be the only hired dancers to participate in the event. Second, their costumes are modern Western dress—the 'city dress' of modern Cairo. Third, there are many more dancers included in the procession: several men and/or folkloric dancers of both genders. Last but not least, female sexuality in terms of a rigid distinction between 'good' and 'evil,' between the family-based and the independent, between the controlled and the free woman, is down-played or omitted altogether.

What do all types of *zaffat* over this 150 year period seem to have in common? The persistent elements are 1) the public presentation of the bride, framing her in public view, 2) the presence of music, noise, and spectacle to announce the rite of passage to the public, and 3) conspicuous consumption in hiring expensive entertainers—the honor due to wealth. The final and most enduring symbol is youth itself, with its connotations of strength, fertility, and hope and confidence for the future.

persistent elements of zaffat

To interpret these contrasts and consistencies we offer the following analysis. Middle class brides in Cairo today have something in common with their Western sisters. In addition to their traditional duties as wives—to bring fertility and honor to their marriages—they now have an added responsibility. They bring in an income through employment outside the home. Advances in female education have led to opportunities that no middle-class family in the fragile Egyptian economy can forego. The *firqat zaffa* reflects that new responsibility for a middle-class bride; she will help her family in the modern consumer culture of Cairo.

In the Arab-American version of the *zaffa*, we suggest that immigration is the context that explains the symbolism involved, rather than the new sexual identity of the bride. It is the playing out of the old traditions, the reiteration of Middle Eastern values and customs surrounding virgin brides, gender segregation, and the ideology of sexual danger, that recreates a feeling of tradition and continuity. At a rite of passage families want to reaffirm their roots and values in order to regenerate the community. The belly-dancer is a polluting element in Arab-American weddings, but an authenticating one as well. *Rite: ceremony / ritual*

Finally, what does all this tell us about dance as Egyptians would categorize it? We see that it is not an 'art' in the Western sense at all. It is a skill, a means of making a living, "a trade like any other" in the words of van Nieuwkerk's informants. Dancing has never had the respect and honored position that music, poetry, Qur'an chanting, calligraphy, architecture, and so forth have had.

If dance is not an art, then we suggest that in Egypt, it is a commodity. Some people will dance in public for hire, accepting the stigma of the profession as well as the profit. Some people will buy it on

dance not seen as art

clearly in sight

commodity: useful / valuable thing

occasions when they wish to celebrate, entertain friends, announce important events, show off their wealth. As a commodity, dance is a fitting symbol of the bride's new economic role as she appears in her *zaffat al-ᶜarusa.*

Notes

1 Edward William Lane. *Manners and Customs of the Modern Egyptians* (London: Ward Lock and Co., 1890. Reprint of the 3rd edition of 1842), 152–58.
2 Ibid., 157.
3 Karin van Nieuwkerk, *"A Trade Like Any Other": Female Singers and Dancers in Egypt* (Austin: University of Texas, 1995, and Cairo: The American University in Cairo Press, 1996).
4 Fatima Mernissi, *Beyond the Veil: Male-Female Dynamics in a Muslim Society* (Bloomington: Indiana, 1987) 41.
5 Mary Douglas, *Purity and Danger: An Analysis of the Concepts of Pollution and Taboo* (London & New York: Routledge, 1966), 165.
6 Fatna Sabbah, *Women in the Muslim Unconscious* (New York: Pergamon Press, 1984).
7 Carolee Kent. "Arab-American 'Zaffat al-ᶜArusah' in the Los Angeles Area," *UCLA Journal of Dance Ethnology,* 13 (1989).
8 van Nieuwkerk, *"A Trade Like Any Other."*
9 Simon R. Charsley, *Wedding Cakes and Cultural History* (London: Routledge, 1992).
10 Lane, *Manners and Customs*, 158.
11 Ibid., 325–6.
12 Ibid., 151.
13 Ibid., 173.
14 Ibid., 348.
15 Ibid., 326.
16 Judith Tucker, *Women in Nineteenth Century Egypt* (London: Cambridge University, 1985) 151.
17 Ibid.
18 Ibid., 152.
19 Cited in van Nieuwkerk, "A Trade Like Any Other," 35.
20 Tucker, *Women in Nineteenth Century Egypt,* 152.
21 Gabriel Baer, *Egyptian Guilds in Modern Times* (Jerusalem: The Israel Oriental Society, 1964), 35–37.
22 van Nieuwkerk, "A Trade Like Any Other."
23 Leila Ahmed, *Women and Gender in Islam: Historical Roots of a Modern Debate* (New Haven and London: Yale, 1991), 214.
24 Ibid., 210–11.
25 Ibid., 214.

5

ASMAHAN:
ARAB MUSICAL PERFORMANCE AND
MUSICIANSHIP UNDER THE MYTH

Sherifa Zuhur

Asmahan, born Amal al-Atrash, was one of the great Middle Eastern performers on stage and screen in the late 1930s and early 1940s *(Plate 5.1)*. Druze in origin, her father, Fahd (ibn Farhan ibn Ibrahim ibn Ibrahim) al-Atrash came from the Suwayda branch of the large al-Atrash clan (known collectively as the Turshan) of the Jabal Druze in southern Syria.[1] He had been educated in Istanbul, married twice, and fathered two children before marrying Amal's mother. Fahd served the Ottoman government in Beirut and then in Dimarji, Anatolia, just before Amal's birth, and was eventually appointed a judge in Suwayda. Amal's mother, ʿAlia al-Mundhir, was from Hasbaya; the Syrian and Lebanese Druze often marry each other. She was unusual only in the following: she and a brother, Khalil, were musically talented and self-trained; she sang at family gatherings, and played the ʿud (the Arabic lute). She was reputedly one of the first women to drive an automobile in Beirut.

With Faysal's defeat and the imposition of the French mandate, the family returned to the Jabal. ʿAlia fled from the area with her children after French attacks following the Adham Khanjar incident and Sultan al-Atrash's reprisals, traveling to Damascus, then Beirut, and finally, in order to escape the French altogether, to Haifa and by train to Egypt.

Of ʿAlia's three children who lived to adulthood, two, Amal and Farid, became entertainers, an occupation unacceptable for Amal, but slightly less suspect for Farid in the eyes of their Syrian relatives. ʿAlia's straitened circumstances in Cairo led her to take in laundry, sew, sing at private parties, and even record. Her musical connections resulted in Farid and Amal's professional musical training and absorption of musical aesthetics.

Amal acquired her stage name, Asmahan, from composer/musician Da'ud Husni, one of her early mentors.[2] She was presented at the Opera in a concert setting, recorded on the Columbia label, sang in Mary Mansur's salon, and received a film offer in the period 1931–32. Her older brother and her Syrian Druze relatives considered a musical and cinematic career for the girl to be disgraceful, and suggested that a cousin, cAli Mustafa, might marry her. Her cousin, Hasan al-Atrash of the cEra branch of the Turshan, then declared his interest in her hand. Hasan, who had acquired a reputation through fighting in the Syrian revolution of 1925, led in the Jabal by Sultan al-Atrash, married nine times in all—twice to Asmahan. She relocated to the Jabal and her subseqent short life illustrated a constant tension between her conservative family and her personal commitment to an artistic career. She contracted at least four marriages (two to her cousin, Hasan) and attracted numerous rumors concerning her offstage behavior and involvement with French, British, and German agents during the war. She died along with her personal secretary and friend in a car accident on July 14, 1944, en route to her favored vacation retreat at Ra's al-Barr. She was dressed in yellow silk, and had a French novel in her hands.[3] Rumors fed her personal myth posthumously; it appeared suspicious to many of her fans that her chauffeur jumped out of the car just before impact.

Her personal history and mystique may live on, but her musical output is in some danger of being forgotten, for many young Middle Easterners possess few emotional or musical links with the musical styles of the late 1930s and early 1940s. Also, the history of performing artists remained the domain of journalists for some years in the Arab world. The media's influence over artistic public relations and a particular style of criticism shaped the portrayal of various artists in subsequent work. One early and influential biography of Asmahan omits detailed discussion of her songs and recordings, describing only two performances, her debut at the Opera, and an incident in which she purportedly sang while fleeing the French in Syria on the 'Road of Death.'[4] The other important biography also records two singing 'occasions,' while focusing on Asmahan as a woman, and a figure of fame and speculation.[5] More recent considerations of Asmahan in book form[6] and in articles in popular journals focus on her alleged acts of espionage, and her early and tragic death, rather than on her musical/cinematic career.

Other articles or contributions about Asmahan have been written from musicological perspectives. These chiefly consider her musical import in relation to various compositions. However, cAli Jihad Racy has discussed her musical significance in light of the transformations in musical style ·in the material she performed.[7]

Was Asmahan the mouthpiece of the genius of composers, including her brother Farid? Was she the vessel of oral art rather than art itself?[8]

This common implication is part of the general dilemma of female singers and performers in patriarchal societies. Karin van Nieuwkerk confirms the argument that society accords women entertainers lower prestige than men, because performance confirms their display of female bodies.[9] Secondly, it is true that Asmahan sang the compositions of others. Composers, however, were not an elite subgroup of musicians at this time, but were often instrumentalists, and were overwhelmingly male, with the exception of Bahija Hafiz. Even Hafiz's efforts at composition were rejected during the 1930s by her male colleagues in the Ma ͨ ahad al-Musiqa (the Conservatory) in Cairo,[10] the same institute that fostered and encouraged Farid al-Atrash's career.

There is a tendency in music history to discuss 'composed works' as a superior class of music, and thus to emphasize the role of the composer and the composition far more than the performers of any given work. Chroniclers of music history in the Middle East were not immune to this emphasis, particularly as music instructors attempted to systematize the teaching and learning of Arab music, and to control 'undisciplined' interpretation and improvisation.

Asmahan's own family de-emphasized Asmahan's musical significance, at least in that era, for reasons of honor. They reclaimed her status by conceiving of Asmahan as inseparable from (and chaperoned by) her brother Farid. Farid's compositions were important to Asmahan's career, but she also performed the work of many others. And her brother was unable to 'chaperone' or control her behavior after her resumption of her musical career in Egypt in 1939. It was instead Asmahan's musicianship and performance quality which made her one of a select group of great voices in modern Arabic music.

The Arabic-speaking public linked Asmahan and other singers with the compositions they sang so closely that their interpretations were immediately and indelibly associated with these songs. This was not solely due to mystique, fame, or, in Asmahan's case, infamy. It is true that Asmahan challenged fraternal control and the traditional mores of her own broader family, and that she excited the public by abandoning her career to remarry her Syrian husband, Hasan al-Atrash. Hasan had acquired the title *amir*, an office invented by the French and given to a previous member of the clan (Salim). Journalists made much of Asmahan's supposed status as an *amira*—a princess.

Journalists also regaled the public with stories about her racy conduct in Cairo, Beirut, and Jerusalem. Just two weeks before her death she was involved in a shooting incident following a domestic argument with her third husband, Ahmad Salim, who was hospitalized as a result. She had however, already captured her public with her renditions of some forty-five songs (more sung in private settings), and with her cinematic presence.[11]

The general audience for Arabic music has equated Asmahan with 'Western influences,' at times confusing her life and modern appearance with her stunning musical production. In fact, a great many of her songs, and the largest proportion of her own actual singing, remain firmly within the classical Arab musical genre (*lawn tarab*, 'color of enchantment'), including compositions by musical innovators such as Muhammad al-Qasabji and Riyad al-Sunbati. Therefore, in a construction of performance imagery, Asmahan was able to create a transitional model for her public through the stylistic range of her repertoire and the expanded range of female behavior she represented to those of her era.

Centrality of the Text

Around the globe, but especially in the Arabo-Islamic regions, language invokes cultural authenticity and popular response. Elegant language has been a requisite of courtiers in the past and politicians in the present. The Middle East has displayed a pervasive scriptural emphasis in law and other areas of human discourse. The singer, like the soothsayer and poet/magician of the Arabian past, must operate at an even more elevated level in imparting a text.

Asmahan gained stature through sensitive and successful textual interpretation as well as musical delivery. Her musical success was partly based on her command of Arabic, her enunciation and emphasis of lyrics, and upon the successful emotional interpretation of various phrases—often those which implied a deep understanding of emotional states. Such sensitivity is not limited to Arab singers. The late Frank Sinatra was told early in his career that he could not sing "Stormy Weather." What, asked his coach, could such a young man know of life's dark days and "bum raps"?[12] It was however, through just such conveyance of emotional conditions that Sinatra, and Asmahan, and other Arab singers captivated their audiences.

Above and beyond the problem of conveying emotional knowledge and life experience, the singer of Arabic must also impart some feeling to descriptive phrases that may or may not have a clear emotional overtone. Singers grappled with this problem before and after Asmahan. As Umm Kulthum, the great Egyptian singer and both role model and rival for Asmahan, related, it was Shaykh Abu al-cIla, Umm Kulthum's 'discoverer' and principal teacher-coach, who taught her to understand lyrics,[13] for she found "I could no longer sing properly the words I could not understand. One night I had trouble with a line of the song, 'Praise to him who touched your cheek with jasmine and pomegranate blossoms and selected pearls for your teeth.' The word for 'pearl' stopped in my mouth for some reason and refused to come out properly . . ." She asked her father "Am I supposed to be happy or sad about that phrase? Shall I sing it as though I'm smiling or frowning?"[14] The 'pearls [teeth] of the

beloved' is a common allusion in classical Arabic, so her question actually concerned the lyricist's intent for both sound and meaning.

Lyrics included the *qasida* (a classical strophic poetic form), verses for the *monolug* (more modern song-poems for solo voice), the *ughniya* (literally 'song' and the most prevalent popular vocal composition from mid-century on), the *taqtuqa* (a strophic light song in colloquial Egyptian), the *diyalug* (duets), processionals, and so on. The themes Asmahan sang ranged from love poetry to panegyrics, as in the songs dedicated to the lineage of King Fu'ad in *Gharam wa intiqam* (Passion and Revenge, 1944), set in front of the Sphinx and the Pyramids, to verses involving historical and social commentary.

Many poets wrote lyrics for Asmahan's songs. She most regularly performed lyrics written by Ahmad Rami, Bairam al-Tunisi, Ahmad Shawqi, and Yusuf Badrus. Ahmad Rami and Ahmad Shawqi were noted for the neoclassical trend of their poetry; Shawqi, who had served in the court of Khedive ᶜAbbas and was fervently anti-British, was renowned for his literary work. While Shawqi was a mentor to composer Muhammad ᶜAbd al-Wahhab, Umm Kulthum wrote that Ahmad Rami taught her to appreciate poetry and other literary works that he would discuss with her.[15] In comparison to these lyricists, al-Tunisi was a composer and political satirist who relied upon more colloquial wordage and common (and therefore accessible) metaphors.[16]

Asmahan gained early musical expertise from Da'ud Husni, Madhat 'Assim, Farid Ghusn, Muhammad al-Qasabji, Muhammad ᶜAbd al-Wahhab, and many other musical performers who were family friends and musical acquaintances during her early career. She acquired a knowledge of the elite lifestyle, dress, and accoutrements after her return to Egypt and resumption of her career in the late 1930s, through contacts like Ahmad Hassanain Pasha (chamberlain and former tutor to King Farouk), the critic Muhammad al-Tabaᶜi, and Amina al-Barudi, a girl friend and partner-in-mischief.

Shawqi and Rami's verses and Asmahan's creative vocal technique forged a connection for her to the classical Arabic oral tradition of an elite and cultured milieu. Yet she retained other sources for her unique sound; her eastern Arab heritage, a special feeling for arranged folk melodies, and the vocal and sight-reading (solfeggio) capabilities necessary for *lawn gharbi* (the 'Western' sound typical of the romantic and experimental compositions of the late 1930s and early 1940s). Asmahan's vocal output displayed poetic trends and personal influences throughout her career.

Classification

Danielson suggests a periodization for the great singer Umm Kulthum that reflects the social climate of Egypt in the 1930s (romanticism), the 1940s (musical populism), the late 1940s (neoclassicism), and the 1950s

to 1970s (modernized work).[17] Nabil ᶜAzzam employs a different sort of periodization in his decade by decade analysis of Muhammad ᶜAbd al-Wahhab's output.[18]

In trying to place Asmahan's work in the context of her contemporaries, one must reject thematic periodization, except to note her multifaceted reflection of the development in various forms of Arabic music (*alwan,* or colors, including *lawn tarab, lawn baladi,* and *lawn gharbi*—"Arabic classical, folk-inspired, or modern music with Western influences"[19]) throughout her relatively short performing span.

Umm Kulthum reportedly began her populist period in 1941, Danielson writes, although the trend did not generally appear in literature, according to N. M. Badawi, until after World War II.[20] Personally I would date the elevation of the 'common man' in Egypt to the 1950s. But Asmahan was producing works that could be termed 'romantic,' 'populist,' 'neoclassical,' and 'modernist' all within 1941, and in her final performances and film appearance after her last return to Egypt. Her career eludes thematic classification due to her versatility and vocal development. The progress of her artistic development was interrupted by marriages and childbearing, and also because of her working relations with various composers (among them her brother). Yet, her vocal output and level of performance did not suffer.

Umm Kulthum's eventual shift away from the songs of Zakariya Ahmad (after Asmahan's death) was related to Ahmad's discontent with Umm Kulthum and the lawsuits he pursued against her for over a decade.[21] Al-Sharif also discusses tensions between composer al-Qasabji (as modernist/composer) and Umm Kulthum, due perhaps, although not entirely, to al-Qasabji's compositions for Asmahan. He suggests that although al-Qasabji did compose for other singers after Asmahan's death, the composer lost that sense of partnership found with Asmahan, a singer who could execute his more complicated musical ideas.[22] Al-Sunbati as well as al-Qasabji might also have continued writing for Asmahan, had she lived. A genuine competition emerged between the two great singers, Umm Kulthum and Asmahan, and involved other musical personalities. Yet Asmahan had the deepest admiration for Umm Kulthum since her early days in Cairo; she studied the older singer's recordings, and begged her, in one meeting, to sit Arab-style on the carpet and sing for her.[23]

Conveying Enchantment *(Tarab)*

One means of surveying Asmahan's contribution is to assess the 'classical' versus the 'Western' features of her performances. Then one may perceive Asmahan's successful combination and integration of these elements in her work.

Asmahan was able throughout her career to entrance audiences with her command of the classical elements in her repertoire. These included

stylistic elements of delivery, mastery of the *maqamat* (modal) system and incorporation of that mastery into improvisation, utilization of the poetic aspects of the Arabic language in order to create dynamism and emphasis, and musical and emotional communication with her audience. Not one, but all of these elements, in combination with the ability to play with musical themes, make up the quality of *tarab* (enchantment) potentially wielded by a superior performer. Individual performances differ, and some, imbued with a special chemistry between vocalists and instrumentalists, or with the audience, produce more *tarab* than others.

Today, a young Arab audience might not be able to identify the vocalist of "Hal Tayam al-Ban" as being Asmahan. Some might well confuse her with Umm Kulthum, due to both stylistic elements of the composition, and vocal aspects of its delivery. The orchestra plays in unison in this song with very little instrumental arrangement for the call and response sections. Instrumental ornamentation is also limited, introduced by the leading violinist as an additional eighth note linking phrases, and occasionally in *lawazim* (short fillers or interludes that often echo the main melody or respond to it) for the *qanun* (a zither with 144 strings that was an essential component of the early Arabic ensemble, the *takht*). The large orchestra follows the lead of Asmahan's rich and powerful voice, and lowers its volume only slightly during her delivery. She delivers the vocal line with intensity, conforming to the insistent rhythmic undertone of the composition. Written in a fairly rapid meter, she ornaments the line with its sliding notes effectively and quickly, despite the fairly long phrases—great breathing and vocal control prevail. There is nothing 'Western' per se about the piece, whether in tempo, range, or arrangement. The emotions and feeling Asmahan evokes are instead those of the inordinate power of her personality.

"Ayyuha al-Na'im" (O You, the Sleeper), a composition by Riyad al-Sunbati, is sung by Asmahan in the film *Gharam wa intiqam* (Passion and Revenge). In it, the heroine sings to her departed husband, apparently the victim of a murder by shooting.

Asmahan, leaning out onto her balcony, introduces the first line of the song accompanied only by violin and *ʿud* (lute), which follow the basic melodic outline, and the full orchestra plays just the last phrase of the line. It is a dramatic introduction of the special quality of her voice, one that cannot be replicated by singers unsure of tonality, or unused to the *mawwal* (improvisatory) form. She then lengthens the word *'ruhi,'* displaying a slow, controlled decrescendo trill, and quickly produces a punctuated *'amanu.'* She moves into another slow trill on one syllable of the words *'fi muhgati.'* The effect heightens the emotive quality of her presentation, with variation in each word—certain syllables pronounced effortlessly, others with aspiration. The next section of the song is a full octave higher. Uninhibited, due to her wide range, she continues adding

to the feeling of desolation and deep emotion, with the use of ornamentation, and without it, as in the long phrases at the end of the song.

Another song which represented the 'classical' color, or *lawn tarab*, in Asmahan's repertoire was "Laita li-l-Barraq," which marked a period when Asmahan's star was rising. She improvises on the single syllable *'Ah.'* The melody soon modulates to a related, but less prominent *maqam*, within the singer's phrase. A more sophisticated call and response sequence occurs with the line beginning *'qayadūnī,'* (followed by the instrumental response in rhythm), then *'wa ballidhūnī'* (and the an instrumental response of the same length). Throughout, the literary tone enhances the formal feeling of the song.

A Synthesis of Modernism and Classicism

Musical training is a more potent instrument than any other, because rhythm and harmony find their way into the inward places of the soul.

Plato, *The Republic*.[24]

Plato noted the spiritual effects of music, which may or may not naturally accompany virtuosic technique, but which are essential to *tarab* in the Arab musical aesthetic. Likewise Gibran Kahlil Gibran wrote "The soul of Music is of the Spirit, and her mind is of the Heart."[25] Training, ability, opportunity, emotional but also spiritual sensitivity aided the blending of modern and classical elements in Asmahan's work.

The literary tone, older instrumentation and classical quality are a dominant part of the song "Asqiniha bi Abi, Inta wa Ummi" (I Beg You in the Name of My Father and My Mother). This song preceded Asmahan's cinematic appearance in *Intisar al-shabab* (The Triumph of Youth, 1941) and demonstrated a practiced clarity, vocal agility, and unusual strength. It also established a reputation for the performer's serious delivery, and ability to convey emotional vulnerability—part of that gratifying 'other' musical goal Plato suggests.

A song entitled "Rijaᶜat Lak" (I Return to You) is a beautiful example of Asmahan's exacting work, keen intonation, and modernist phrasing. The song highlights her wide middle range. Unlike several of her recordings that include large and uneven choruses, here a male chorus of excellent voices enters in mid-song. Asmahan's voice dominates and forms a striking contrast. Her exciting improvisation responds to the violins, following a brief (and relatively unusual) interlude by the ᶜud.

Voice of the Elite or the People?

Asmahan sang a number of compositions whose melodies and lyrics were simpler and more closely related to folk themes, both Syrian and Egyptian. Her mother ᶜAlia and other family musical acquaintances presumably influenced the siblings Farid and Asmahan to learn the distinctive vocal improvisational forms of the Syro-Lebanese, which are

not easily replicated by Egyptian-trained singers. In addition many folk themes were composed by Farid, including "Idi bi Idak," (My Hand in Your Hand), "al-Muhamal al-Sharif," (The Carrier of the Holy Places) with its religious overtones, or "Ya Bad^ca al-Ward" (Oh Glory of the Rose), and she had earlier learned others (including Husni's compositions) and ^cAbd al-Wahhab's "Mahlaha ^cAisht al-Falah" (The Languor of the Peasant's Life). The use of popular themes was not confined to Asmahan's era; Sayyid Darwish had previously introduced popular themes, and other composers in and outside the musical theater had been incorporating them in various ways. Asmahan sang "Mahlaha ^cAisht al-Falah," in the film *Yum Sa^cid* (A Happy Day). She did not appear in the film, however, whether out of concern for her family's reaction, or as others have suggested, because her appearance did not match the 'Arab look' desired by the producers. The lyrics, melody, and singing style in this song underscore the rural flavor immediately with the syllables, *'yahi yahi yahi ya'* following the verse.

In retrospect, over his long career, Farid al-Atrash exhibited a special flair for composing or incorporating and elaborating on folk melodies in his work. This was a characteristic element of private performances in the eastern Arab world, perhaps more so than in Egypt. Farid was also known for adding virtuosic instrumental solos, and very novel compositions of various sorts. Both characteristics attracted audiences, simple or sophisticated. The al-Atrash siblings learned through the long years of entertaining that audience appeal was a prime factor, and could not take second seat to the musicians' predilection for virtuosic pieces, although passages of more complex music could certainly be introduced, and appreciated by an audience of *sammi^ca* (true listeners, aficionados).

Asmahan's recording of "al-Muhamal al-Sharif" informs past and present listeners that composers and performers recognized the legitimacy of religious songs, patterns, and lyrics in the first half of the twentieth century. The song, composed by Farid al-Atrash, builds on simple folk patterns yet wields the sturdiness of Asmahan's interpretation. It is sometimes known by the words of the first line, *"^calayk salat Allah wa salamuh.'* The melody rises very simply, but the use of *maqam* Bayyati, the sense of a religious processional, and the short, easy phrases of the refrain invite repetition.

Maqam Bayyati

^cA - - lay - k ṣa - lāt Al - - lah wa sa - lā - mūh

cAlayk ṣalāt Allah wa salāmūh [repeat] / *Shafacāt ya jadd al-Hassanayn.*
Dah al-maḥabbāt lākā rajacat ayāmuh / Hanīyah wa tumlatu bīhī al-cain.
Karāmat liluh ya qāsid Makkatin / Wa niyātuka bi-l-Kacabah taṭawwuf
Tabus lī turāb al-sikkata amānatan / Min mu'min malhūf.

May the generosity of God be upon you, his salute and his intercession, oh
 grandfather of the two Hassans.
These are the days of love returning. What an opportunity to see You.
Be generous toward him, oh you who face Mecca and intend to circle the
 Kaaba.
You kiss the ground of the path for me as a pledge of an inspired faith.

The soloist continues with the first line, then returns to the refrain in
an AAB AAB C pattern. Full notation is given in Appendix 1 on page
104.

We may imagine Asmahan leading a chanting community into the
spiritual center of the Islamic world.[26] The vocalist in Muslim society has
functions that provide more than 'pure' entertainment. It is a 'vocalist'
who calls believers to the pilgrimage, or to devotion (although not a
'singer'). A vocalist is the one who imbues deaths and weddings with the
Holy Words. In this song, a very apparent reference is made to a singer
who provides focus and meaning for mourners, and who centers her
community in oral remembrance. And this genre of song reminds us that
in the Middle East and the eastern Mediterranean (and elsewhere)
"Women's singing is not necessarily the sound of a carefree heart."[27]

A lighter approach, involving a different use of folk themes and
musical patterns, is found in the song "Ya Badca al-Ward," composed by
Farid al-Atrash to lyrics by Ismacil al-Hakim. This type of song with its
large chorus singing in unison, Asmahan's strong rhythmic emphasis,
and the way she introduces the expression *'ya laṭif'* ('oh, how lovely!') at
the end of the verse, engineers an automatic audience response. The verses
each recognize a different color, *'ya ahmar,'* ('o, you red one') *'ya akhdar,'*
(green one) *'ya abyad,'* (white one), a folk device also found in Egyptian
folk songs, and are increasingly difficult musical phrases, as in the
taqtuqa form. Asmahan's voice takes the place of an instrument,
improvising increasingly complex renditions of the song's melodic line.
In this song, such a contrast exists with the folk color *(lawn shacbi)* of
the chorus that listeners cannot but notice the earthiness of ordinary
voices (slightly nasal or sharp) as contrasted with Asmahan's more
mobile and mellifluous, or 'heavenly' voice.

With the Syrian inspired, "Ya Dairati" (Oh My Village), Asmahan
invokes her origins and teases the non-Syrian audiences with a taste of
the 'authentic' Arab East. The *qanun* introduces the *maqam*, and from the
very first notes of Asmahan's *mawwal* (improvisation) *'Oh, fo, fo-oh-oh-
oh . . .'* we are transported to another clime and musical sensibility. Her

subtle and beautiful introduction continues to respond to the *qanunji*'s improvisation for about a minute. The audience would immediately have known from the syllables, '*oh fo,*' and '*ya ba ya*' that the improvisation was not Egyptian, but *shami* (Levantine, or Damascene), even without the brief Syro-Lebanese *dabka* dance sequence provided in the film scene. Asmahan's style in this piece is however, more akin to the 'Arab' color of the Iraqi *mawawil* (of Nazim al-Ghazali, perhaps) or of the more contemporary Sabah Fakhri (Aleppine style), than it is to the Lebanese *zajal.* This quality is imparted by her emphasis on the elision of final syllables as in the long drawn out '*di - - r*' and the clear *t* of '*ya di - - a - ti,*' and the simple delivery with only a touch of ornament on the *^cal* and *lawm.* Asmahan transcends this controlled opening in the next line with her power, emphasis, and ascent into the dramatic soprano range. Could any singer sing the line ending '*ma narsakhak bi ^cuthman*' in today's oversimplified versions of poetic *mawawil?*

In the studio's decision to include this song, we may also surmise that audiences were not expected to appreciate too lengthy or provincial a rendition of *zajal,* for example, but a short selection might be included to 'flavor' the scene. This tendency to create somewhat stereotypical regional allusions within music (or dance) was a feature of music and film that seemed to gain momentum after Asmahan's death.

The Druze attribute the lyrics of "Ya Dairati" (or the formalization of the lyrics) to Asmahan's uncle Zayd al-Attrache, born in the village of al-Qrayya in 1905. To them, the song signals the sacrifices made facing various external oppressors (historically these included the Ottoman forces as well as the French). The aged Zayd was still alive when I rode back and forth to the Jabal Druze seeking Asmahan's shadows.[28] He would have been saddened to know that later music chroniclers simply labeled his words, which hark back to the Druze revolt and earlier Druze resistance to the Ottomans, as "anonymous Syrian poetry."[29]

Ya dairati mālik ^calayna lawm / Lā ta^ctibī lawmak ^cala man khān
Iḥna rawayna suyūfna min al-qawm / Mithla ar-riḍa ma narkhāsak bi ^cuthmān
(Asmahan's version: *mithla ^cazzum mā . . .*)

O my village, there is no shame for you. Don't blame your shame upon those who are treacherous. We pass down our swords from the tribe (or, We quench our swords' thirst [with the blood] of the tribe). Like the agreement, we do not cheapen you for the Ottomans.

Lā budd matmadhi layālī ash-shawm / Wa ta^cazz ghalma qiyādat sulṭān
Wa anna ma akhdhinā hiqqna al-mahdawm / Ya dairati ma naḥna lākā sukkān[30]

We must mount the steeds on the night of evil, and strengthen the heat of Sultan's leadership. I claim our trampled rights for us. O my village, we are your guiding force.

The parallel to the Jabal's place in the Syrian nationalist saga could only be Maysalun, or Dinshaway in Egypt, and in contemporary times the occupied territories, the West Bank and the Gaza Strip. Though some criticized entertainers for their supposed lack of patriotism, such songs served to refute their frivolous qualities, or identified them with particular nationalist positions. In light of Asmahan's mission to Syria in 1941[31] to contact the Druze prior to the Allied invasion, the song has personal and nationalist overtones.

A Transitional Genre

"Yalli Hawak Shaghal Bali" (Let Your Love Occupy My Mind) is an example of a song bridging the traditional *tarab* color and the modern, romantic *ughniya*. Composed by Farid al-Atrash, the piece conveys neither the *tarab* of the cultured elite households nor the *tarab* of the village folk processional, but holds *tarab* nonetheless. It opens with a brief *nay* (reed flute) solo and full orchestra responding with just two notes to establish the *maqam* (modal framework) for each of the *nay*'s outbursts. The *nay* was an important member of the traditional *takht* or ensemble. Incidentally, Asmahan was a fan of the great *nay* player, Salim ᶜAbd al-Hayy, reportedly rising and dancing in ecstasy to his improvisation at a private party. In the song, al-Atrash evidently wished to establish a traditional and spiritual mood with this instrument.

Asmahan twice intones the line '*Ya-ā lli hawāk shā-a ghil bā-a li,*' ('O love, hurry to me and occupy my mind') guiding the full orchestra in behind her. This refrain is rhythmic, traditional in sound and cadence— yet its tuneful ease makes one want to learn the song. The instrumental section hints at innovation, with the lead of the *qanun* sounding like a piano, and Asmahan carries into the next section with a sophisticated use of breathing and ornamentation, '*fī-i-i-i gharāmak, ana ya ʾma'asit,*' then, as only this singer could introduce it, the stronger, '*saḥā-abak . . . ,*' in this case an ornamental ending. Then the orchestra plays a more unusual phrase, first the violins with a response from the *qanun*, and then the voice takes up that phrase, singing '*ruḥī, wa (u) rūḥak,*' followed by the same ornament in triple-notes in the *lawazim* from the *qanun*. Asmahan's technique allows her to replicate the strings' descent with triplets and sliding—in '*ya fu'ā-a-a-a-di.*' The paralleling of technique—voice imitating strings, and strings duplicating previous vocal phrases is an important part of the texture of the traditional genres that is carried into the more modern ballad form.

The section beginning '*Ya waḥishni . . .*' is more powerful and modern in feeling, even though the composer reemploys a traditional shift to a minor-toned *maqam* here. Asmahan repeats the '*rūḥī wa (u) rūḥak . . .*' section which leads into a very difficult segment and then to a sustained section where she must sing a perfectly measured solfeggic exercise

around one tone and then the next: '*Ya rait, ya-a rait . . . ī-i-i-i, i-i-i-i-i.*'
That vocal power is especially impressive when she can invoke it even in
fairly rapid segments such as these, and because each note is given
definition and equal volume when she is dynamically emphasizing the
whole phrase.

As with other songs Asmahan debuted, this piece cannot be termed
Western, yet it is 'modernized' in very specific ways. It is rarely
performed due to its difficulty, and because audiences are no longer
familiar with Asmahan's entire repertoire.

Musical Innovation

Asmahan was gifted and worked hard at her craft, musically and in
dramatic focus. She also chose very interesting and challenging material
to work with. Some of the compositions Asmahan performed exhibit a
novel emphasis upon expression or depiction *(taᶜbir)* of emotion, story
line, and lyrical sequence, which the cinema genre required, as Jihad Racy
has pointed out.[32] This represents a new trend of linearity in composition
and in performance. That linearity was complemented by innovation in
the composition itself, and in new choices in instrumentation.

Racy discusses a composition employing 'linear variety,' "Layali al-
Uns fi Fiyanna" (Joyful Nights in Vienna). This song, composed by
Farid al-Atrash, opens Asmahan's musical review in the film *Gharam wa
intiqam.* The visual vehicle may distract the listener as it involves dance,
lyrical and musical allusions to a time and place of censureless culture (an
imagined Vienna in evening dress). However, in concentrating on the
structure of the song, Racy sees that an expressive effect is produced by
the use of many subsections in the song, as noted in "Yalli Hawak
Shaghil Bali." Here, however, the refrain repeats a "waltz meter and
minor tonality" while elsewhere innovations have been made in both
instrumentation and notation.[33] These affect the structure, the solo
improvisations of the ᶜud and the Hawaiian guitar, and the singer's
melodic relationship to the piece as a whole. New instruments, and the
way they are played, e.g., the guitar with bottleneck, or violins executing
the waltz theme *a la pizzicato,* add to the song's initial *lawn gharbi*
(Western color). As another study of Egyptian song notes, Asmahan
moves from violence to softness within this song.[34]

The star, Su'ad (Asmahan), sings at first in *lawn gharbi:*

Layālī al-uns fī Fīyannā / Nasīmihā min hawā' al-jannah
Nagham fī-l-jaw luh rannah / Samᶜaha aṭ-ṭīr bakā wa ghannā.

Nights of intimacy in Vienna, where the breeze holds the scent of paradise.
A melody in the air is echoed by the bird who cries and sings.

Then, with a *mawwal*-like verse she ascends to the sustained Sol, and then draws out the last syllables of each half-line with great control.

Ma 'bain ranīn al-kās / Wa ran-nat-il-alḥān - - [ornament]
Adī al-[q]awām mayās / Ya ᶜāṭif al-aghṣān - - [melisma]

Between the echo of the glasses and that of the musical melodies.
Here is a body slim as a branch.

She very deliberately ornaments *'al-aghṣān'* with sustained triplets and then modulates at the end of the phrase. The section continues:

Tamma al-naᶜīm l-ir-rūḥ wal-ᶜayn / Ma takhallī [q]albak yithanna
Adī al-ḥabā - - yib ᶜal-ginain / Eeh illī fāḍil ᶜal-gannah.

Sweetness continues into the spirit and the eye, filling your heart with
 enjoyment.
Here are the lovers, face to face. What could be missing from this paradise?

In this section the audience hears classical emphasis on the colloquial wordage; the *mim* of *'ma'* and the *lam* of *"ᶜal-ginain'* are extended, the *qaf*s are dropped. Musically, the phrase, *'adī al-ḥabayib'* brings us briefly into a *lawn baladi* (urban or rural Egyptian popular coloring) as occurs later in the song after the waltz refrain when she sings the extended section, *'wa amraḥ . . . wa ashrab,'* fittingly ('I exult, and I drink') and then *'afraḥ . . . aṭrab'* ('I make merry and I enchant through song'). Full notation is given in Appendix 2 on pages 105–107.

Asmahan also sang the song "Imta Hataᶜraf?" (When Will You Know [that I love you]?) in the film *Gharam wa intiqam*. This is a composition by Muhammad al-Qasabji with a text by Mamun al-Shanawi.[35] She breezes effortlessly through a refrain that is demanding due to its lengthy third phrase. The beauty of the song emerges particularly in her emphasis and hesitation when modulating in the verse from the main *maqam* to the auxiliary *maqam* during the phrase *'wi-n-nar bitirᶜa fī-ih'* and in darkening the tone of her voice. Then a little hesitation precedes the return to the verse.

wi-n-nar bi - tir-ᶜa fī- - - - - - - ih

Refrain

Imta hata^craf imtā? / Innī baḥabbak intā? [repeat]
Imta hata^craf, innī baḥabbak / Imtā, imtā, imtā? / Imtā hata^craf imtā, imtā
hata^craf?

When will you know, when? That I love you, when?
When will you know that I love you, when, when, when? When will you
know, when, when will you know?
[Repetitions not indicated in Arabic version at end of chapter.]

Verse

Banājī ṭifak wa-atmannā, ashūfak
La yum ^caṭafta ^calaya / Wa la inta sā'il fiyyā. [repeat]
Wa-la-'imtā [pause] *hataḥayyar bālī / Wi-tzawwid hammī-i-i.*
Yallī gharāmak fi khayāli [repeat] */ Wa fi rūḥī wa dammī*

I speak to your shadow, and I long to see you.
Not a single day passes in which you do not sorely test this sentiment; nor a
single day when you are not asking this question.
How long will my spirit remain distracted? How long will my anguish grow?
Oh hasten, bring your passion into my imagination, and into my soul and my
blood.

Refrain

Verse

Faḍilt-akhabi ḥubbak / Ḥubbak fi qalbi, ḥubbak [repeat]
Wa aṣabbaru wa-'awāsīh / Wi-n-nar bitir^ca fī-ih.
etc.

I choose to capture love in my heart
I force it to be patient, I console it, although fire consumes it.
etc.

This song is deceptive, in giving the impression of more than one
cultural 'color'—Arab, Egyptian, Syrian, classical, modern, and even
(slightly) rural as suggested by the film scene with Asmahan and folk
dancers costumed in silvery 'Assiut' net robes (which would not have
been worn in the *shami* locale the movie portrays). The instrumentation
in the early portion of the song includes the less familiar (at that time)
accordion and simple use of the strings. Yet the musical progressions
later in the song, even in its final modal modulation, are simultaneously
innovative and reminiscent of elements of earlier repertoire. For example
in the Ottoman and Arab/Ottoman *sama^ci* (10/8) section of the traditional

wasla, instrumentalists also *ritard* and hesitate before plunging back into the final repeat of the refrain *(taslim)*.

In *Gharam wa intiqam* the song is performed in an evening party in the eastern mountain resort where Gamal, the composer/violinist and Su'ad, the heroine/singer, are staying. It is through this song that the heroine signals her love for the violinist in a teasing, semi-serious manner—but in a public venue. A love song may be taken to indicate affection, or not. As the singer asks, "When will you know that I love you?" the comical doctor who has befriended the two (Bishara Wakim) tells the hero (and the audience), "She is singing to you." Audience recognition of this song continued, probably because the many repetitions of the refrain allowed them also to sing at least this portion of the song, and it has been performed by others, such as the Moroccan artist ᶜAisha Jalal. Full notation is given in Appendix 3 on pages 108–109. [36]

Innovation through Dramatic Effect

"Dakhalit Marra bi Ginaina" (She Entered Once in the Garden), composed by Madhat 'Assim, is a prime example of this genre developed by Asmahan. The funereal theme is emphasized in the *maqam*, Nahawand, the employment of Asmahan's lower range, and piano chords used almost like the kettledrums *(naqqarat)* of the Ottoman repertoire. As in most of Asmahan's songs, the listener is compelled by the power of the singer's voice, a power without strain and extraneous vocal sounds. Elsewhere, the use of the upper range of the piano lends the song an extremely interesting texture. Madhat 'Assim was a pianist, hence the special use of that instrument despite the technical difficulties imposed by the piano's half and whole rather than quarter tones. This composition is most significant in that it represents a vocal poem, with stanzas and sections that are unified through dramatic effect.

Al-Sunbati composed "Hadith ᶜAinain" (A Tale of Two Eyes) with Umm Kulthum in mind as vocalist. However, in rehearsal, it seems that she was not capable of performing the song as the composer had hoped, and al-Qasabji convinced al-Sunbati to 'give' the song over to Asmahan.[37] Beyond the songs demanding notation is the poetic aspect of its lyrical refrain:

Ya li-ᶜainak, wa ya li min tasābīḥ khayālī
Fīhumā dhikrī min al-ḥubb wa min suhād al-layālī

Oh, to your eyes, and to that which is the hymn of my imagination.
In them is the memory of love and sleepless nights.

The song's long introduction, a single-themed orchestral section preceding and following an *ᶜud* solo (played by Sunbati himself) was not well recorded, but was no doubt extremely daring in this period, when

the notion of a long serious composition was taking shape. Far more interesting than this repetitive, almost hypnotic segment with its bass 'um-pah-pah' (to this modern listener) were the middle sections where the theme modulates to another *maqam*, and subthemes are introduced in the singer's line. In several of these middle-section improvisatory sections, Asmahan's dark middle tones, phrasing, and the resonance and timing of her ornamentation are striking.

Probably because of the explicitly coloratura segments of "Taghrid al-Balabil," (Warbling of the Nightingales, also known as "Ya Tuyyur," The Birds) Asmahan was remembered as the oriental singer who 'introduced an operatic, or Western sound.'[38] In the same song, with which the singer was always associated, she also achieves a strong classical quality, derived both from the composition and her sustained dramatic delivery. In a final section, she performs nearly solfeggic exercises: rises, trills, cadenzas, and a climactic operatic high C. These musical phrases startled the Arab world, which claimed Asmahan's talent as evidence of a technical equivalent to European and American singers of the day.

Innovation through Technical Ability

Asmahan's position as one of the "seven great singers" of the century[39] rested on her ability to utilize both the vocal requisites of the traditional repertoire and more innovative compositions requiring a very exact tonal and dynamic delivery. Jihad Racy has discussed the requirements of an authentic artist—one composing or performing 'art' (*fann*) music as it developed in the twentieth century. An artist must possess a thorough knowledge of the (Arabic) musical system, but also be capable of creative interpretation, "innovation, and individuality."[40] Asmahan reached a pinnacle in the musical world because she employed that mixture of traditional musical characteristics evoking *tarab* (enchantment) and innovation. Among her contributions was that she was able to "inlay the fundamentals of European singing into Arab singing," says Racy, and created musically significant works.[41]

She had acquired both Eastern and Western aspects of musicality, while retaining the Eastern performer's ability to impress her/his own style, personality, and mood in each vocal performance. Musical modernization was not a simple imitative process; not for Asmahan and her composers. Rather, relatively brief phrases or segments of songs were transformed through experiments in form, instrumentation, and arrangement, as well as important 'borrowings' from Western formats. In the work of Muhammad ᶜAbd al-Wahhab, these 'borrowings' were more explicit (introducing themes from Beethoven, or Tchaikovsky's "Interlude for Tea and Coffee," in the ballet *The Nutcracker*). In some of the earlier pieces Asmahan performed, borrowing, or musical 'citation,' is also obvious, as in the first segment of "Nawait Adari," which is part of the ode to

Egypt's imperial rulers. Asmahan's very precise delivery—operatic in the sense of being extremely faithful to the composer's intent—created an impression of modernism for listeners, counterbalanced by her own vocal additions. It is not that she did not ornament—she did—but rhythm, phrasing, intonation, and dynamics were never sacrificed.

Thus, from her early breakthrough rendition of "Farraq Ma Bayna," which is a triumphant blending of the classical and the innovative, Asmahan's singing represented a new range of technique, lyricism, and interpretation. Al-Qasabji's composition features a strong dependence on very clear diction, and elegant phrasing, an interesting melodic progression, and less significant but nevertheless startling instrumental innovations like the stationary castanets, or the rhythmic background to the waltz section. Al-Sharif rightly stresses this song as a true musical achievement both for Asmahan and for al-Qasabji, a song which announced her importance as a singer.[42]

Innovation through an Alternative Medium

Asmahan was also more than the vehicle of her composer's creations because of her connection with her audience. That connection was sustained visually in the films that outlived her, in addition to her recordings. Cinematically, Asmahan demonstrated the concentration, the simplicity, and the pathos that also appear in her singing. On screen, she became a focus from the moment the camera conveys her image. A sophisticated or mature femininity is transmitted to the audience, and a sense of the real charm and emotional depth of her persona.

Although it is not within this chapter's scope to discuss Asmahan's cinematic performances in depth, we should note that the themes of Asmahan's two films also established her in the public mind as a modern figure, since they dealt with contemporary issues in Egyptian life: immigration, social and occupational mobility (*Intisar al-shabab*), widowhood, treachery, revenge, death, and the artistic temperament (*Gharam wa intiqam*). These themes appeared to mirror events in Asmahan's own life. Such associations helped forge a cinematic impact that went beyond the surface of these films into the artist's posthumous repute.

A combination of factors led to Asmahan's contributions to Arabic music. She was a grand figure, given her short life span, in an innovative process, the construction of *al-jadid*, modern Arabic music. Her importance rested on musical imagery, sound musicianship, superior performance techniques, cinematic demi-realism, and the less tangible imprinting of personal attributes into art.

Notes

1 Details of the family relationships, and political and other attitudes of Asmahan's immediate and extended family were obtained from personal

interviews with members of the Turshan, Suwayda, ᶜEra, and Qrayya, Syria, 1993, whom, along with other Druze and Syrian contacts, I thank profusely, especially Munir al-Attrache, Abdullah and Mimi al-Attrache, and Mansur al-Attrache. The late Fu'ad al-Atrash, Asmahan's brother, was also interviewed twice in Cairo in 1993. Acknowledgments are made to C.I.E.S. and the Fulbright Regional Program for the Middle East, North Africa, and South Asia, which supported my research as a Senior Research Scholar in 1993; to U.S.I.S. in Damascus, Samim al-Sharif, and all the other generous individuals and scholars who helped in various ways; to the Massachusetts Institute of Technology, and the American University in Cairo for internal grant funding; and to California State University of Sacramento for granting leaves of absence.

2 The biographic details of Asmahan and Farid's lives and careers are problematic. I offer my own deductions after some eleven years of puzzling through a maze of contradictions in Sherifa Zuhur, *Asmahan's Secrets: Woman, War, and Song* (Austin, Texas: Center for Middle Eastern Studies, University of Texas, forthcoming). For example, concerning the discovery of Asmahan's voice: Fumil Labib describes two incidents with Muhammad al-Qasabji, at the second of which Shaykh Mahmud Sabah was also present. See Labib, as told by Fu'ad al-Atrash, *Qissat Asmahan* (Beirut: 1962); Samim al-Sharif, *al-Ughniya al-ᶜarabiya* (Damascus: Wizarat al-Thaqafa wa-l-Irshad, 1981), 220, follows suit. However, Muhammad al-Tabaᶜi claims to have written down Asmahan's own account, which concerns Da'ud Husni, Muhammad al-Tabaᶜi, *Asmahan tarwi qissatha* (Beirut: al-Maktaba al-Tujari li-l-Tabaᶜa wa-l-Tawziᶜ wa-l-Nashr, 1961), 47–48, and see Mourad El-Koudsi, *The Karaite Jews of Egypt 1882–1986* (Lyons: New York: Wilprint Inc., 1987). Fahd Ballan, a singer whose early career was aided by Farid al-Atrash, reported that it was Madhat Assim rather than Da'ud Husni who discovered Amal's voice, whereas Munir al-Atrash, Asmahan's half-brother, confirmed the version about Da'ud Husni (personal interview with Fahd Ballan, Suwayda, 18 August 1993 and personal interview with Munir al-Atrash, 22 July 1993).

3 "Asmahan Wished to be Buried in Egypt," *Egyptian Gazette* 65:19, 241 (16 July, 1944), 5; or see Zuhur, *Asmahan's Secrets.*

4 Labib, *Qissat Asmahan.* Labib appears to have borrowed the phrase 'Road of Death' from al-Tabaᶜi's book to sensationalize an apparently fictitious escape from Vichy-loyal troops on 'the road to Palestine.' Asmahan did not travel in that direction at all in those critical days. Al-Tabaᶜi used the 'Road of Death' to refer to the road to Ra's al-Barr, where Asmahan had a premonition of death, and later died.

5 Muhammad al-Tabaᶜi, *Asmahan tarwi qissataha*, 2nd edition, Cairo: Ruz al-Yusuf, 1965 (1st edition listed above). The work was originally published as a series of magazine articles in *al-Akhir saᶜa.*

6 Saᶜid al-Jaza'iri, *Asmahan dhahiya al-istakhbarat* (London: Riad al-Rayyes, 1991); Saᶜid Abu ᶜAynayn, *Asmahan . . . Laᶜbat al-hubb wa-l-mukhabarat* (Cairo: Dar al-Akhbar al-Yawm, 1996).

7 Fiktur Sahhab, *al-Sabaᶜa al-kibar: al-Musiqa al-ᶜarabiya al-muᶜasira* (Beirut: Dar al-ᶜAlam li-l-Milayin, 1987); Samim al-Sharif, *al-Ughniya al-ᶜarabiya*

(Damascus: Wizarat al-Thaqafa wa-l-Irshad, 1981); Samim al-Sharif, *al-Sunbati: wa jil al-ᶜamalaqa* (Damascus: TlasDar, 1992, 2nd edition, 1993); and more briefly in Samim al-Sharif, *al-Musiqa fi Suriya: Aᶜlam wa tarikh* (Damascus: Wizarat al-Thaqafa wa-l-Irshad, 1991); and in Adham al-Jindi, *Aᶜlam al-adab wa-l-fann*, 2 vols. (Damascus: Matba'a Majala Sawt Suriya, 1954); ᶜAli Jihad Racy, "Musical Aesthetics in Present Day Cairo," *Ethnomusicology*, vol. 26, no. 3 (September 1982), 391, 398–399.

8 Sherifa Zuhur, "An Arabic Mata Hari: Fact and Legend," University of Akron, Akron, Ohio, 28 November 1995, and "History versus Mystery: What Gender Meant for Asmahan (Amal al-Atrash)," presented to the Symposium on Gender and Discourse, Beer Sheva, Ben Gurion University of the Negev, 6–7 January 1996.

9 Yet she also found that the *shaᶜb* (the popular classes) were more understanding of entertainers' display of sexuality as a necessary aspect of their trade. Karen van Nieuwkerk, "'A Trade like Any Other': Female Singers and Dancers in Egypt* (Austin, Texas: University of Texas Press, 1995 and Cairo: The American University in Cairo Press, 1996). Others have already noted the relationship of sexuality and performance, but see that strictures are applied differently to women according to age, class, and their specific historical relationship to music. L. Jafran Jones, "A Sociohistorical Perspective on Tunisian Women as Professional Musicians," and Carol Robertson, "Power and Gender in the Musical Experiences of Women," both in Ellen Koskoff, ed., *Women and Music in Cross-Cultural Perspective* (Urbana and Chicago: University of Illinois Press, 1989).

10 Sarah Graham-Browne, *Images of Women: The Portrayal of Women in Photography of the Middle East* (New York: Columbia University Press, 1988), 187–188, based on an interview with Bahija Hafiz by Saiza Nabarawi published in *L'Egyptiènne* (issue number and date not cited).

11 In *Intisar al-shabab* (The Triumph of Youth, 1941) with her brother Farid al-Atrash as co-star, and *Gharam wa intiqam* (Passion and Revenge, 1944) with Yusuf Wahbi.

12 "The Sinatra Story," directed by Tina Sinatra for television.

13 Virginia Danielson, *The Voice of Egypt: Umm Kulthum, Arabic Song, and Egyptian Society in the Twentieth Century* (Chicago: University of Chicago Press, 1997, and Cairo: the American University in Cairo Press, 1997), 33–34 and 56–57.

14 "Umm Kulthum: Famed Egyptian Singer," in Elizabeth Fernea and Basima Q. Bezirgan, eds., *Middle Eastern Muslim Women Speak* (Austin, Texas: University of Texas Press, 1977), 150, translated from Umm Kulthum as told to Muhammad ᶜAwad, *Umm Kulthum allati la yaᶜrifuha ahad* (Cairo: Akhbar al-Yawm, 1969).

15 Ibid., 151.

16 Marilyn Booth, *Bayram al-Tunisi's Egypt: Social Criticism and Narrative Strategies*. (Oxford: Ithaca Press, 1990); also see Virginia Danielson, "Shaping Tradition in Arabic Song: The Career and Repertory of Umm Kulthum," Ph.D. Dissertation, University of Illinois, 1991, 166; Danielson, *The Voice of Egypt*, 102–103.

17 Danielson, "Shaping Tradition," 140–212.

18 Nabil Azzam, "Muhammad ᶜAbd al-Wahhab in Modern Egyptian Music," Ph.D. Dissertation, University of California, Los Angeles, 1990.
19 Ali Jihad Racy, "Musical Aesthetics in Present Day Cairo," *Ethnomusicology* 26:3, September 1982.
20 M. Badawi, *A Critical Introduction to Modern Arabic Poetry* (Cambridge: Cambridge University Press, 1975).
21 Danielson, "Shaping Tradition," 178.
22 Samim al-Sharif, *al-Ughniya al-ᶜarabiya* (Damascus: Wizarat al-Thaqafa wa-l-Irshad, 1981).
23 Labib, *Qissat Asmahan*, 70–72; personal interviews with al-Attrache family members; and al-ᶜAynayn, *Asmahan lubat al-hubb*, 13.
24 Translation by Benjamin Jowett, Oxford University Press, 401. D.
25 Gibran Kahlil Gibran, *On Music*, translated by A. R. Ferris, Boston (1905).
26 Asmahan's Druze identity is not problematic to her, for the Druze perceive themselves as Muslim. To listeners, this is an example of a unified aspect of Islamic culture, whatever the sect.
27 Susan Auerbach, "From Singing to Lamenting: Women's Musical Role in a Greek Village," in Koskoff, ed., *Women and Music,* 41.
28 Zayd was not the only 'folk' poet in the family. There was also Sayyah al-Attrache, the son of Salamah, who also wrote and improvised on existing *zajal.*
29 Marwan Ghattas labels these lyrics "anonymous Syrian poetry," in "Asmahan: Sawt ghadirna bakiran . . . wa yabqi fi asmaᶜna," *Fann,* no. 180 (16 July 1992), 59.
30 Other versions of the song exist, but this one appears in Adham al-Jundi, "Zayd al-Atrash," in *Aᶜlam al-adab wa-l-fann*, vols. 1 and 2 (Damascus: Matbaᶜa Majala Sawt Suriya, 1954), 300.
31 See Zuhur, *Asmahan's Secrets.*
32 Racy, "Musical Aesthetics," 398–399.
33 Ibid.
34 Mustafa Fathy Ibrahim and Armand Pignol, *L'Extase et le transitor: Aperçus sur la chanson égyptiènne contemporaine de grande audience* (Cairo: Centre d'Études et de Documentation Économique Juridique et Sociale, 1987), 35.
35 Ibrahim and Pignol mistakenly identify the song as Farid's composition, as did some of my own interviewees, *L'Extase*, 33.
36 The notation in Appendices 2 and 3 is by Farida Nazarian and the lyrics are close to this version. The discussion in this chapter is, however, based on Asmahan's audio rendition. The notation does not indicate the musical or textual emphases, nor the orchestral arrangement, which was traditionally set in rehearsal. The melodic line provides a basis for the vocalist, but also some of the *lawazim* (orchestral responses) and instrumental 'filler' notes.
37 Samim al-Sharif, *al-Sunbati wa jil al-ᶜamalaqa* (Damascus: 2nd edition, Tlasdar, 1993), 111–112. Personal interview with Samim al-Sharif, October 1993; and in al-Sharif, *al-Ughniya al-ᶜarabiya* (Damascus: Wizarat al-Thaqafa wa-l-Irshad, 1981).
38 In numerous interviews regarding the period (rather than Asmahan's own life) I would inquire if respondents recalled Asmahan, and those with the least exposure to the music of the period would respond in this way.

39 As indicated by Fiktur Sahhab's inclusion of Asmahan in his work, *al-Sabᶜa al-kibar: al-Musiqa al-ᶜarabiya al-muᶜasira* (Beirut: Dar al-ᶜAlam li-l-Milayin, 1987).

40 Ali Jihad Racy, "Musical Aesthetics in Present Day Cairo," *Ethnomusicology,* vol. 26, no. 3 (September 1982), 391.

41 Ilyas Sahhab, *Difaᶜan ᶜan al-ughniya al-ᶜarabiya* (Beirut: al-Mu'asasa al-ᶜArabiya li-l-Nashr, 1980), 69, cited by Racy, "Musical Aesthetics," 393.

42 Samim al-Sharif, *al-Ughniya al-ᶜarabiya.*

Appendix 1: "al-Muhamal al-Sharif"
(Also known as "ᶜAlayk Salat Allah wa Salamuh")

Appendix 2: "Layali al-Uns fi Fiyanna"



نسيمها من هوا الجنة ليـالي الانس في فينا

نغم في الجو له رنه سمها الطير بكى وغنى





- ٣ - - ١ -

ورنة الالحان	ما بين رنين الكاس	
يا عاطف الاغصان	ادى القوام مياس	
ما تخلي قلبك بتهنا	نم النسيم الروح والمين	
ايه اللي فاضل عالجنة	ادى الجباب عالجبين	
دى فينا روضة من الجنة	منع شبابك في فينا	
سمها الطير بكى وغنى	نغم في الجو له رنه	





- ٢ -





تنسى مماها الكون كله	ساعة هنا لو تصفالك
من النسيم ده غير ظله	ايه اللي راح يبقيلك
ولطيف جاري مع الاحلام	خيال ساري مع الاوهام
تفوت من غير ما تهنا	وله نصبر على الايام
نسيمها من هوا الجنة	دى ليلة القرب في فينا
سمها الطير بكى وغنى	نغم في الجو له رنه





- ٣ -

امرح واشرب	وافرح واطرب
ابث قلبـــك	ببـــح ويطـــير
في الدنيا دى	بلقى له عمــير
يهنا بجمه ويسعد وياه	و يهني شباب القلب مماه
دى ليلة الانس في فينا	نسيمها من هوا الجنة
نغم في الجو له رنه	سمها الطير بكى وغنى



Appendix 3: "Imta Hatᶜaraf"

امتى حا تعرف

اللازمة.

امتى حا تعرف امتى انى بحبك انت

امتى حا تعرف امتى

- ٣ -

قربك	والتمنـى	أحبـك	خليتني
وارحمنى فيه برضاك	اسعدني يوم بلقـاك		
واشرح لك حى	لا يكون فؤادك مش خالي		
اقا لك ببيــنى	تدوق غرامى اللى شرحته		
. . . .	باللى غرامك . .		
	امتى حا تعرف . .		

- ١ -

بنـاجي طيفـك	والتمنـى اشوفك
لا يوم عطفت علىّ	ولا انت سائل فىّ
ولامتى حا تحير بالي	وتزود همـــى
باللى غرامك في خيالي	وفي روحي ودمي
امتى حا تعرف

- ٢ -

فضات أخـــي	حبك في قلبي
وأصبره وأواسيه	والنـار بترعى فىّ
وانبرح لك حى	وخفت اورلك على حالي
وتعذب قلـــبي	لا يكون فؤادك مش خالي
. . . .	باللى غرامك في . .
. . . .	امتى حا تعرف . .

6

PERFORMANCE, POLITICAL IDENTITY, AND MEMORY
UMM KULTHUM AND GAMAL ᶜABD AL-NASIR

Virginia Danielson

What relationships exist between expressive culture and political issues? Is it possible that one of the least representational forms of expression, that is music, can bear political meanings? Under what circumstances are entertainers also political figures? Certainly we can all recognize political songs as such when they have explicit lyrics: in the Middle East, Shaykh Imam's songs about Nixon and Adli Fakhri's protest songs are surely certainly political. The Lebanese singer Fayruz offers another kind of example, as she clearly represents support for Lebanese and Palestinian national causes to her listeners but with less pointedly critical texts than Shaykh Imam's. Then there are such artists as Zakariya Ahmad, a composer whose musical style, behavior, and personal associations place him among advocates for the Egyptian working classes, but whose occasional songs, theater pieces, and love songs make few explicit references to their various causes.[1] Altogether, one senses more subtle connections of music to politics than exist simply in explicit texts.[2]

This essay explores relationships of musical performance to political issues using one of the more obvious examples of a musician implicated in politics, Umm Kulthum. Working from her repertory and performances, it examines her political relationships and impact. The sources of information include periodical literature from Cairo during her lifetime, and interviews and conversations with many Egyptians conducted since 1980. My work in general focuses not only on the careers of performers and stars but also—in fact, primarily—on the listeners and their reception and uses of music. Viewing in the highly mediated world of Egypt, I want to know how listeners use performances as much as what happens in the original performances themselves. For a performer as

concerned about her audience as Umm Kulthum and one with such a long and continuous history of performance, I want to ask what motivated an initial performance and then what were the results of responses to the performance? What did audiences conclude about themselves by believing, ignoring, perpetuating, or using these musical performances for their own purposes?

With a career that spanned decades in a place that experienced colonial domination, two world wars, and two revolutions, Umm Kulthum clearly moved in a highly politicized environment. Late in her life she became closely associated with President Gamal ᶜAbd al-Nasir, arguably one of the most charismatic political leaders of the century and certainly a premier nonaligned activist. It is with his government that Umm Kulthum, from a political point of view, has become most closely linked.

This connection may be gaining strength in the 1990s. A recent book touts the "very special relationship" between Umm Kulthum and ᶜAbd al-Nasir.[3] Describing the former president in 1996, film maker Mahfuz ᶜAbd al-Rahman said he was "a man of the utmost simplicity and modesty" for whom "the pleasures of life consisted of olives and cheese, going to the cinema, listening to Umm Kulthum."[4] "Umm Kulthum was an important weapon for him," people still say. "He used her voice to attract attention to his radio broadcasts." In the 1990s, a leftist intellectual friend remarked, "her voice reminds us of the Nasir years—a time for which we are very nostalgic now, even though we didn't much like it when we lived it." Indeed, the late Saᶜd al-Din Wahba, an official of the Egyptian Ministry of Culture who, as a journalist, had been imprisoned by ᶜAbd al-Nasir's government in the 1960s, recorded his strong sense of the positive values advanced by the two figures in Michal Goldman's documentary film about Umm Kulthum. Retelling an oft-related story about ᶜAbd al-Nasir's intervention to prevent Umm Kulthum from being banned by Egyptian radio, he linked aspects of their personalities and values:

> Nasir himself had to deal with this crisis. He didn't yet know her personally. He just used to listen to her, like any other Egyptian. Of course, there were many similarities between them. Feeling for the weak and the poor was present in both of them. Nationalism was present in both of them. Feeling for Egypt was present in both of them.[5]

"Does Umm Kulthum evoke memories of Nasir?" I asked a merchant friend in Cairo. "Of course!" he replied, "Did that only just occur to you now?"

On the other hand, a retired teacher and music aficionado told me, "No. Umm Kulthum sang for Fu'ad, Faruq, ᶜAbd al-Nasir, and Sadat. She

transcended politics." "The Revolutionary Council banned her from radio because she was a singer for Faruq," another said. "Art is one thing, politics another," a book dealer told me. "There's no connection."

Is there a reality amid these conflicting readings? Is there a history and a truth? Can we account simply for the apparently conflicting narratives that emerge from sentiments and memories in the 1990s? In what sense was Umm Kulthum a political figure? Coupling historical sources, that is documents that are contemporary with the events, with later memories, we can begin to see the political role of a singer in a complex society and in politically charged times.

First and foremost, the documents surrounding Umm Kulthum's life allow us to see her primary ambition as musical performance.[6] She wanted to become an accomplished, wealthy, and famous singer, and she worked toward this aim for most of her life. This process moved her toward the center of political circles in Cairo (and later in other Arab cities) simply because elite families were the main private patrons of performance, served on the board of directors of Egyptian Radio, invested in film and theater, and at the same time contributed to the economic and political leadership of the country. Umm Kulthum and most other successful entertainers moved among these families. In her case, her closest personal friends in the 1920s and 1930s supported the relatively conservative Liberal Constitutionalist party; however, she sang at more populist Wafdist events as well. This sort of moving around typified the careers of many of Umm Kulthum's colleagues in musical performance. She acted as a professional performer, not as anyone's voice crying in the wilderness or anywhere else.

The Political Voice

Notwithstanding her primary goals as a professional performer, Umm Kulthum did indeed develop a political voice, primarily in the 1940s. Her most important tools were neoclassical *qasa'id* written by the anti-British poet laureate of early twentieth-century Egypt, Ahmad Shawqi, set to music by the talented young composer Riyad al-Sunbati. In the wake of Miles Lampson's ultimatum to King Faruq in 1942 to appoint a pro-British prime minister or be deposed, audiences roared their approval of such lines as 'Demands are not met by wishing; the world can only be taken by struggle' *(Wa ma nila al-matalibu bi-l-tamanni wa lakin tu'khadha al-dunya ghilaban).*[7]

Confronted with the corruption of their own government and what was seen as the perfidy of the wealthy, lines such as 'You [Muhammad, the Prophet] gave justice to the poor in front of the rich' took on special meaning.[8] Umm Kulthum also repeatedly sang "The University Song," in support of student demonstrations against the British occupation and performed a newly commissioned work in support of the establishment of

the Arab League. "Her concerts," a journalist reported, "resembled political demonstrations in which she ignited nationalist feeling."[9] These local sentiments reached into reports on the political situation sent from the American Embassy in Cairo to the State Department in Washington:

> In a charged political atmosphere Um Kulsoum, 'Nightingale of Egypt,' opened her winter season [in 1951] of monthly concerts before a packed house of perhaps 2,500 persons in Cairo's Radio Cinema the night of December 6. As customary, the entire program, which was four hours in length, was broadcast by the Egyptian State Broadcasting Company, which is said to reach over much of the Arab world and is listened to as far south as the Sudan. Miss Kulsoum donated the sum of three thousand Egyptian pounds, which she regularly receives for her concerts, to the Society for the Care of Orphans. . . . The program was especially slanted for the 'situation.' . . . The climax came when, after reviewing the long history and greatness of Egypt, the poet asked, 'In view of this culture, are we in need of protection?' and shortly thereafter when the verse declared, 'The situation is critical, everyone must stand prepared to fight.' These lines 'brought down the House.' The theater crowd cheered wildly.[10]

Despite her wariness of scrutiny by the press, in the 1940s Umm Kulthum began to voice her own opinions more publicly than ever before. Her most dramatic effort in this regard was certainly her entertainment of the Egyptian troops who fought at al-Faluja. On top of the strife in their own society, the escalating violence in Palestine troubled many Egyptians, and the defeat at al-Faluja epitomized many problems: loss at the hands of Zionists despite a courageous defense by Egyptian officers who had been left with faulty munitions owing to a corrupt arms deal by their own government. The minister of war asked Umm Kulthum not to draw attention to al-Faluja by her very public invitation of all who fought there to a reception in her home. Her reply was unequivocal:

> I have made my invitation. If you would like to come, you are welcome. If not, it is your choice. As for the others, I have invited them in order to express my appreciation as a citizen of Egypt for their struggle and sacrifice in the Sinai. My sentiments have not changed and my invitation stands.[11]

The new public persona that Umm Kulthum developed in the 1940s was not, in fact, at odds with her personal goals. The sentiments she expressed and the positions she advocated were so commonly felt as to be 'normal' for the time and place, and were held by Egyptians of otherwise disparate classes, politics, and interests. As Muhammad Odah told Michal Goldman, "there were Wafdists, there were Communists, there

were Socialists, there were Muslim Brothers, but everybody thought a revolution must come. This system cannot survive."[12] Her political voice was hardly radical, and probably only distinctive in its great artistry.

Revolution must come ← all agreed

Umm Kulthum and Gamal ᶜAbd al-Nasir

The Free Officers were among the defenders of al-Faluja and this reception may have been Umm Kulthum's first meeting with Gamal ᶜAbd al-Nasir. Like the Dinshawai incident of 1906, the siege of al-Faluja remained in the public memory for a long time. ᶜAbd al-Nasir wrote that it affected the course of his own thinking dramatically.[13] He was among the leaders of the Egyptian Revolution that finally occurred in 1952, a bloodless coup that brought with it tremendous optimism in Egypt. Most Egyptians welcomed the new government with hopefulness and relief. Charles Issawi described the atmosphere in late 1952:

> Perhaps more important than all these specific measures [promised by the new government] are the new feelings of self-respect, hopefulness, and unity which have emerged in Egypt. A few *çi-devant* pashas and wealthy men look back with nostalgia on the *douceur de vivre* of the ancien régime, but the overwhelming majority of the country, including the middle class, has rallied to the new government.[14]

Umm Kulthum was no exception. Hearing of the revolution at her summer retreat in Ra's al-Barr, she immediately returned to Cairo and commissioned the poet Ahmad Rami and composer al-Sunbati to write an appropriate national song. The result, "Misr Allati fi Khatiri wa fi Dami" (Egypt, Which Is in My Mind and My Blood) premiered shortly thereafter. It is in this decade that the roots of the relationship between the internationally famous singer and the charismatic leader lie.

new society

Umm Kulthum commissioned more songs to sing in support of the new government;[15] as did virtually every other singer, producing a decade full of occasional, often not very memorable, pieces about the Suez Canal, the High Dam, the 'new society,' and ᶜAbd al-Nasir himself. Singers initially took this step partly out of the conviction widely shared in the society that the new government was a good thing for most people and partly because the government controlled broadcasting, which was the most important medium for most musicians. All of them needed to stay on the right side of the broadcasting authorities.

broadcast most important medium

This milieu yielded the now often-told story that authorities in radio banned Umm Kulthum because she 'had sung for the king' (Faruq) and that ᶜAbd al-Nasir himself overturned the ban, saying one or more of the following:

"The sun also rose for the king; are we going to ban that too?"

"Have you gone crazy?"

"Do you want the people to turn against us?"

This popular story is not quite true. The parties that sought to invoke such a ban were members of the Musicians' Union who opposed Umm Kulthum's continued presidency of the group. This faction had enough power to frighten Umm Kulthum, who sought the intervention of friends to protect her status. A number of people now claim to have solved the problem, among them Shafiq Abu ᶜAwf, then the liaison between the Revolutionary Council and the Musicians' Union, who said he settled the matter personally with Salah Salim, ᶜAbd al-Nasir, and ᶜAbd al-Hakim ᶜAmr.[16]

ᶜAbd al-Nasir, for his part, immediately began to strengthen Egyptian Radio, to add to its broadcasting power and to take steps to assure the continuation of popular entertainment over the radio and the influx of new performers from other parts of the Arab world.[17] This effort, of course, extended the reach of performers throughout the Middle East and augmented their audiences.

But to cast Umm Kulthum as 'Nasir's weapon' is to simplify in the extreme.[18] In the first place, competing entities had tried with varying degrees of success to 'use' voices during the Second World War: the Italian Radio Bari and the BBC Arabic Service were two that repeatedly tried to use local performers so as to increase audiences for their political messages. The process was a familiar one to audiences, certainly within Egypt.

Secondly, Egyptian Radio was probably the primary medium for performance in the Arab world: what singer would have declined to perform over its airwaves? The relationship of Umm Kulthum to Egyptian Radio at the time must be viewed as normal. She had, however, become wildly popular and had acquired considerable authority in broadcasting, which resulted in frequent programs of her performances. She explicitly supported ᶜAbd al-Nasir's government; broadcasting her songs served both their interests (see Umm Kulthum's Songs of Patriotic Import at end of this chapter). Hence she was perceived as a 'weapon.'

Umm Kulthum continued to speak about art in the new society, promoting her own views of 'good music,' and supporting the new government. She talked, for example, about her commitment to Arabic and Egyptian models and aesthetics:

We must respect our artistic selves. . . . Take, for instance, the Indians. They show great respect for themselves in art and life. Wherever they are, they insist on wearing their own clothes, and in their art they are intent on asserting their own independent personality, and, due to this, their music is considered one of the best and most successful forms of music in the entire world. This is the way to success for us in music.[19]
Music must express our Eastern spirit. . . . Those who study European music learn it as one would learn a foreign language. Of course it is

useful. But it would be silly to expect that this European language become our language.[20]

She, along with others, demanded and got funding for a state ensemble to perform Arab music and put local music on the cognitive map of the new Ministry of Culture. She, and other musicians, served on awards committees and study groups in the ministry.

cAbd al-Nasir, however, spent more money and effort on classical European arts than on Arab music, greatly expanding state facilities for the study of music and ballet and initiating exchange programs that sent talented young performers such as the ballerina Magda Saleh to the Soviet Union. His relationship with the performers of Arab music—at least in his official capacity as head of state—was often rocky. Umm Kulthum was hardly 'his voice' in this realm as she argued with him more than she agreed with him, threatened to resign from her positions on committees, and occasionally, but not predictably, won her points.

Nevertheless, cAbd al-Nasir had a keen feel for public sentiments. He know who the popular stars were and courted them, not only Umm Kulthum but also the young singer cAbd al-Halim Hafiz and the composer Muhammad cAbd al-Wahhab. He entertained them socially, just as Umm Kulthum invited him and his close associates to dine at her home. It was certainly cAbd al-Nasir's initiative that prompted the long-awaited but artistically difficult collaboration between cAbd al-Wahhab and Umm Kulthum in 1964. "Although she did not at first intend this," Nicmat Ahmad Fu'ad told me, "President cAbd al-Nasir gained much from his association with her. He always liked her and he took the opportunity to befriend her."[21]

In other aspects of behavior, Umm Kulthum and cAbd al-Nasir shared a number of personal traits. Both began as relatively austere Egyptians who entered the public arena with some difficulty. Both were ambitious and detail-oriented.[22]

Yet the public images of Umm Kulthum and cAbd al-Nasir did not depend on each other. Umm Kulthum appeared with him only at the most obvious occasions: when she was the recipient of a state award, or when she was the featured entertainer at a national holiday celebration, often held at the Officers' Club. Similarly, cAbd al-Nasir was rarely photographed with entertainers of any sort. He attended Umm Kulthum's concerts and was sometimes photographed there. But his public image was constructed with images from major construction projects, land reclamation projects, or contacts with Egyptian peasants and workers.[23]

At the time of the defeat in 1967, Umm Kulthum's concern with public affairs was viewed by her critics as nil and her politics as the politics of self-interest. Her long performances, in the view of Egyptian Leftists in particular, produced useless feelings of self-satisfaction among

her listeners and promoted uncritical acceptance of an 'Arab' status quo, where, in the view of these critics, past practice could well be submitted to scrutiny. She was, in a rather exaggerated view, one of the 'reasons' for the defeat. Occasionally, she was compared unfavorably to Fayruz, whose more explicit support of local political initiatives in her songs and plays, and her apparent lack of connection with wealthy elites, were considered by Leftists especially to be more 'politically correct.'

Motivated by patriotism and also in an effort to combat these perceptions, Umm Kulthum launched the biggest political effort of her life, her concerts for Egypt. Between 1967 and 1971, she traveled in Egypt, to ten Muslim countries, and to Paris to do benefit concerts to replenish the Egyptian treasury, sorely depleted by the war. "She sang of love," newspaper headlines proclaimed, "and collected 76,000 Egyptian pounds for war."[24] By 1971, she had donated about two million dollars, much of it in gold and hard currency, to the Egyptian government. Her travels, aided by a diplomatic passport, resembled state visits; she met local leaders and toured important sites. While these trips lodged her as a 'political' figure in the eyes of international press agencies, they did next to nothing to ameliorate critical perspectives on her. She died in 1975 as a great artist—indeed, even to her critics, the singer of the century—but hardly a political activist. This view of her persisted in Egypt certainly for five, possibly ten years after her death.

Performance and Memory

What, if anything, has changed now? First and most obviously, relieved of the Nasserist government's constant presence, its decisions, and their effects, a number of Egyptians—most notably those who were affected positively by ᶜAbd al-Nasir's redistribution of property (usually the middle and lower classes)—feel nostalgia for the Nasir era. But nostalgia for what exactly? A number of Egyptians who spoke with me about this were in fact imprisoned in the 1960s by ᶜAbd al-Nasir. What is it that they remember in the 1990s?

Beginning from what we might view as the 'facts' of the matter, we can probably acknowledge that ᶜAbd al-Nasir and Umm Kulthum were each, in their own ways, highly visible public figures. Their separate visibilities were carefully constructed; indeed they both 'performed' public personae, repeatedly and deliberately projecting 'people' that seem, in retrospect, to be simplified versions of themselves. Both developed remarkable affect in verbal art, hers sung poetry and his oratory. "She does not simply sing the Rubaᶜiyat of ᶜUmar Khayyam, she infuses it with meaning," an Egyptian violinist told me. "Listen to ᶜAbd al-Nasir's speech nationalizing the Suez Canal," another musician said. "You will feel you are afraid of nothing."[25]

Both made effective use of colloquial Egyptian dialect, Umm Kulthum in the clever *zajal* (colloquial poetry) of Bayram al-Tunisi and ᶜAbd al-Nasir by allowing colloquialisms in his speeches on formal occasions, which would commonly have depended exclusively on the more formal literary Arabic. Using local Egyptian language, they both spoke over the radio and to newspaper and magazine reporters about who they were and what they thought was important. The perception that they held attitudes in common—expressed earlier by Saᶜad al-Din Wahba—is now widely shared and was probably generated by their separate verbal performances. Whatever each of them in fact *did*, they tended to talk about themselves and about Egypt in similar ways.

Early in her career, journalists noted that, unlike most female performers, Umm Kulthum did not pretend to emanate from the upper classes. "My childhood was not different from most *abnaa' baladi* [children of the 'people,' i.e., 'real' Egyptians of the popular classes], " she would say. "My father was a shaykh. My mother was a good woman who lived simply and loved God." "We were poor. We hadn't an extra penny." Describing her identity, she gave voice to characteristics and associations many Egyptians would like to believe are true:

> They [*fallahin*, peasants] are simple people . . . but they have hearts of gold. They were my first audience. Whatever success I have realized goes back to them. They are the real masters of this country because they are the source of goodness, generosity, and love in it. . . . The country is the foundation and source of the city. If you live in the city, you live in exile, but in the village you live with your relatives and friends.[26]

She evoked this identity constantly in the last fifteen years of her life. Claiming, in an interview, that her chief entertainments were reading and taking walks, she happened to mention that she liked to walk in the rain. The interviewer responded that people who like to walk in the rain were usually very sensitive and attempted to draw her into a discussion using the language of creativity and sensitivity that was in vogue at the time. Umm Kulthum stopped this by interjecting simply "*il-matar khiir*" ('rain is good' in colloquial Egyptian), a common expression used by farmers about Egypt's infrequent rains. Following this exchange, the interviewer continued to ask her about nature, asking what sort of scenes she liked. Responding to her answer, he exclaimed, "But that's a picture of a village!" "Well, we are *fallahin*, or didn't you know that?" she replied.[27] She described those she admired in similar terms. About singer Muhammad ᶜAbd al-Mutallib she said:

He is a son of the country, a real man *[ibn al-balad* and *jada^c].* He has tones and cadences that are Egyptian 'folk,' typical of the strong Egyptian male who, in his voice, makes you laugh or makes you happy because he is a strong man in a time when this quality is vanishing. *Awlad al-balad* are becoming ashamed to be *awlad al-balad.* . . . I have observed that television has depicted them to us as thieves and hashish-smokers instead of the brave and heroic figures [they really are].[28]

There were obvious similarities in the ways Umm Kulthum and ^cAbd al-Nasir spoke. "The *fallahin* are myself," said Umm Kulthum. "They are my youth. They are my life. They are the broad foundation from which I emanated."[29] Compare this with ^cAbd al-Nasir's words:

I am proud that I am one of the people of [the village of] Bani Murr. I am increasingly proud that I was raised by a poor family. My origins are peasant. . . . These two qualities have defined me from my youth until this day as the leader of the July Revolution.[30]

Umm Kulthum and ^cAbd al-Nasir spoke colloquially and compellingly, drawing attention to the value of life on the land, the legendary 'goodness' of the Egyptian peasant, and the salience of values believed to emanate from the Egyptian community of believers, whether Muslim or Christian. Although few personal or family photographs were published of either figure, both allowed themselves to be photographed praying. The implied message was that goodness was inherent in the Egyptian people, that local values (which were largely unspecified in this discourse, but included faith)—not foreign innovations—constituted the truly important essence for living and social development, and that the salient figures in Egypt were its farmers and its workers, not its bankers, its merchants, or its landlords. This was a language unknown to any previous Egyptian leader in anyone's memory at the time. It was rarely the language of international stars of radio, television, and cinema. Umm Kulthum was not unique in her attitudes; but, in the 1950s and 1960s, she was more highly visible than any other performer in the Middle East and she used her position to articulate this particular public identity.

To grasp their combined impact, an American might imagine combing the value systems remembered from John Kennedy's inaugural speech and, perhaps, Loretta Lynn's "Coal Miner's Daughter." We recognize identifiable, strong, but not very specific value systems articulated in both. However, American society and history does not really join these two statements in a single unity, nor is it easy to think of occasions when such a link is made. However, for Umm Kulthum and ^cAbd al-Nasir, this connection occurred, formed a large part of what is

remembered by many, and found its way into the contemporary words of Sacd al-Din Wahba and others. The underlying belief, it seems, is that a vision of a good society was shared not only by these two people but by many others as well. Nostalgia for this shared vision implies that it has since been lost. The sturdy public personae of Umm Kulthum and cAbd al-Nasir resulted not simply from actual deeds but also from their performances, which were constructed from the habitus of each and also deliberately made by choosing sounds, images, and behaviors each considered appropriate to a dignified and persuasive public figure. Finally, and critically, the 'performances' of listeners in the 1990s appropriate sound and image to their own purposes, constructing and projecting their own attitudes. By moving sound and image through time and space, listeners use performance to situate themselves socially and politically and thus enact political and social identities of their own. The process of remembering in this way draws the singer, the song, and the sound into the political world, where neither singer nor song may be expressly political. Thus we see, in one instance, one intersection of music and politics in this century.

Notes

1 Among the exceptions is "Hatgannin ya Rait ya Ikhwanna Maruhtish Lundun wa la Baris."
2 Good work on this subject outside the Arab world has been done by Veit Erlmann, for instance his *Nightsong: Power, Performance and Practice in South Africa* (Chicago: University of Chicago Press, 1996), and Tom Turino, *Moving Away from Silence: Music of the Peruvian Altiplano and the Experience of Urban Migration* (Chicago: University of Chicago Press, 1993).
3 Hanafi al-Mahallawi, *cAbd al-Nasir wa Umm Kulthum: calaqa khassa jiddan* (Cairo: Markaz al-Qada li-l-Kitab wa-l-Nashr, 1992).
4 In Joel Gordon, "Cairo 96/Nasser 56: Reimaging Egypt's Lost Community," paper presented at the Colloquium on the Politics of Culture in Arab Societies in an Era of Globalization, Princeton University, May 9–11, 1997, 5.
5 *Umm Kulthum: A Voice like Egypt.* Documentary filmed, produced and directed by Michal Goldman, 1996.
6 Information about the course of Umm Kulthum's career that supports this point appears in Virginia Danielson, *The Voice of Egypt: Umm Kulthum, Arabic Song, and Egyptian Society in the Twentieth Century* (Chicago: University of Chicago Press, 1997, and Cairo: The American University in Cairo Press, 1997).
7 From "Salu Qalbi."
8 From "Wulid al-Huda," also by Shawqi.
9 Muhammad al-Sayyid Shusha, *Umm Kulthum: Hayat Naghm* (Cairo: Maktabat Ruz al-Yusuf, 1976), 59
10 Jefferson Caffery, "Report on Um Kulsoum, Favorite Egyptian Singer," Foreign Service Despatch No. 1329 from Cairo to the Department of State,

Washington, D.C., December 7, 1951. I am grateful to Robert Vitalis for sending me copies of materials relevant to Umm Kulthum that he located in the course of his own research. Reading this material is both informative and amusing, as it features a number of odd interpretations, mistranslations and misinformation, such as Despatch No. 99 of July 11, 1953, which makes the astounding claim that Umm Kulthum's "métier is simple folk songs which have wide appeal to Arabs everywhere." This missive was written to report on Egyptian press coverage of the singer's trip to the U.S. for treatment of her thyroid problem, a goodwill gesture from the American government to the new government of Egypt.

11 Anwar Za^cluk, "Qissat awwal liqa' bayna ^cAbd al-Nasir wa Umm Kulthum," *Sabah al-khayr* (29 January 1976); Sherif Abaza in *Umm Kulthum: al-Naghm al-khalid* (Alexandria: Hayat al-Funun wa-l-Adab wa-l-^cUlum al-Ijtima^ciya bi-l-Iskandiriya, 1976), 43. As Issawi wrote, "The Palestine war proved to be disastrous, and the disappointing performance of the Egyptian army was only partly redeemed by such gallant acts as the defense of Faluja." Charles Issawi, *Egypt at Mid-Century* (London: Oxford University Press, 1954), 263.

12 *Umm Kulthum: A Voice like Egypt.*

13 Gamal Abdul Nasser, *Egypt's Liberation: The Philosophy of the Revolution* (Washington, D.C.: Public Affairs Press, 1955), 21–24. Also noted in Anthony Nutting, *Nasser* (London: Constable, 1972), 28.

14 Issawi, *Egypt at Mid-Century*, 272.

15 One of them, "Wallahi zaman, ya silahi," was adopted as the Egyptian national anthem.

16 "al-Mawt bi-dun alam," in *al-Idha^ca wa-l-tilifizyun* (5 February 1983), 48; for notices of various disputes within the union involving Umm Kulthum see *Ruz al-Yusuf* Nos. 1245 and 1250 (21 April and 26 May 1952), pp. 33 and 32 respectively; Anwar Za^cluk, "Qissat awwal liqa' bayna ^cAbd al-Nasir wa Umm Kulthum," *Sabah al-khayr* (29 January 1976); Mahmud Kamil, *Muhammad al-Qasabji* (Cairo: al-Hay'a al-Misriya al-^cAmma li-l-Kitab, 1971), 80.

17 Douglas Boyd's *Broadcasting in the Arab World: A Survey of Radio and Television in the Middle East* (Philadelphia: Temple University Press, 1982) and his *Egyptian Radio: Tool of Political and National Development* (Lexington, Kentucky: Assocation for Education in Journalism, 1977) offer a good history of the medium.

18 The idea of Umm Kulthum as 'Nasir's weapon' may be more common outside Egypt than within the country.

19 Raja' al-Naqqash, "Liqa' ma^ca Umm Kulthum," *al-Kawakib*, 1965. Reproduced in *Lughz Umm Kulthum* (Cairo: Dar al-Hilal, 1978), 48–49.

20 Quoted in Zaki Mustafa, *Umm Kulthum: Ma^cbad al-hubb* (Cairo: Dar al-Taba^ca al-Haditha, 1975), 63–64

21 Personal communication from Ni^cmat Ahmad Fu'ad, 12 May 1982; also personal communications from Umm Kulthum's husband, Hasan al-Hifnawi, 22 August 1982.

22 Compare aspects of Umm Kulthum's life with Nasir's as in Nutting, *Nasser.*

23 See for instance *al-Musawwar* 12 March 1965, devoted to ^cAbd al-Nasir.

24 *Akhbar al-yawm*, 19 June 1967.

25 A number of ᶜAbd al-Nasir's important speeches have been marketed in Egypt more or less continuously over the past thirty years, first on long-playing records and then on cassettes.

26 "Umm Kulthum tatahaddath ila *al-Taᶜawwun,*" *al-Taᶜawwun,* 9 February 1969.

27 "al-Hadith al-akhir ᶜan al-fann," Sawt al-Qahira cassette tape SC76015.

28 Quoted in "Hal tushawwah tasjilat Umm Kulthum?" *Uktubir,* 5 February 1978, 73. *Jadaᶜ* denotes a strong and competent man.

29 Mahmud ᶜAwad. *Umm Kulthum allati la yaᶜrifuha ahad* (Cairo: Mu'assasat Akhbar al-Yawm, 1971), 72; "Umm Kulthum tatahaddath ila *al-Taᶜawwun.*"

30 "Ibn al-Shaᶜb," *al-Musawwar,* no. 2109 (12 March 1965), 6.

Umm Kulthum's Songs of Patriotic Import, 1951–1973

(Title, composer, poet, approximate year of first performance)

"Misr Tatahaddathu ᶜan Nafsiha"	Riyad al-Sunbati	Ahmad Rami	1951
"Misr Allati fi Khatiri wa fi Dami"	Riyad al-Sunbati	Ahmad Rami	1952
"Ya Jamal, ya Mithal al-Wataniya"	Riyad al-Sunbati	Bayram al-Tunisi	1954
"Nashid al-Jala'"	Muhammad al-Muji	Ahmad Rami	1954
"Bi-Abi wa Ruhi"	Riyad al-Sunbati	Ahmad Shawqi	1954
"Wallahi Zaman, ya Silahi"	Kamal al-Tawil	Salah Jahin	1956
"al-Sabah al-Jadid"	Riyad al-Sunbati	Mahmud Hasan Ismaᶜil	1956
"Ya Jamal, ya Mithal al-Wataniya" *(2nd version)*	Riyad al-Sunbati	Bayram al-Tunisi	1956
"Allah maᶜak"	Riyad al-Sunbati	Salah Jahin	1956
"al-Fajr al-Jadid"	Riyad al-Sunbati	Muhammad al-Mahi	1956
"Sawt al-Salam"	Riyad al-Sunbati	Bayram al-Tunisi	1956
"Inna Fida'yun"	Baligh Hamdi	ᶜAbd al-Fattah Mustafa	1957
"Mihlak, ya Misri"	Muhammad al-Muji	Salah Jahin	1957
"Batal al-Salam"	Riyad al-Sunbati	Bayram al-Tunisi	1958
"Baᶜd al-Sabr ma Tal"	Riyad al-Sunbati	ᶜAbd al-Fattah Mustafa	1958
"Mansura ya Thawra"	Riyad al-Sunbati	ᶜAbd al-Fattah Mustafa	1958

"Ya Rabba al-Fiha'"	Riyad al-Sunbati	Mahmud Hasan Isma'il	1959
"Ughniyat al-Jaysh"	Riyad al-Sunbati	Tahir Abu Pasha	1959
"Qissat al-Sadd"	Riyad al-Sunbati	'Aziz Abaza	1960
"Thuwar"	Riyad al-Sunbati	'Abd al-Fattah Mustafa	1961
"Bi-l-Salam wa bi-l-Majd"	Riyad al-Sunbati	Bayram al-Tunisi	1963
"al-Za'im wa-l-Thawra"	Riyad al-Sunbati	'Abd al-Fattah Mustafa	1963
"Ya Sawt Biladina"	Muhammad al-Muji	'Abd al-Fattah Mustafa	1964
"'Ala Bab Misr"	Muhammad 'Abd al-Wahhab	Kamal al-Shinawi	1964
"Ya Salam 'ala al-Umma"	Muhammad al-Muji	'Abd al-Fattah Mustafa	1965
"Tahwil al-Nil"	Riyad al-Sunbati	'Abd al-Wahhab Muhammad	1965
"Ya Hubbina al-Kabir"	Riyad al-Sunbati	'Abd al-Fattah Mustafa	1967
"Habib al-Sha'b"	Riyad al-Sunbati	Salih Judah	1967
"Haqq Biladina"	Riyad al-Sunbati	'Abd al-Wahhab Muhammad	1967
"Tuf wa Shuf"	Riyad al-Sunbati	'Abd al-Fattah Mustafa	1967
"Tariq wahid"	Muhammad 'Abd al-Wahhab	Nizar Qabbani	1969
"Misr"	Riyad al-Sunbati	Ibrahim Naji	1970
"Walidna Jamal 'Abd al-Nasir"	Riyad al-Sunbati	Nizar Qabbani	1970
"Baghdadu, ya Qal'a" *(For Iraq)*	Riyad al-Sunbati	Mahmud Hasan Isma'il	1958
"Sha'b al-Iraq" *(For Iraq)*	–	–	1958
"Ard al-Judud" *(For Kuwait)*	Riyad al-Sunbati	Ahmad al-Adawani	1966
"Ya Darna, ya Dar" *(For Kuwait)*	Riyad al-Sunbati	Ahmad al-Adawani	[4]1968

7

WESTERN CLASSICAL MUSIC
IN UMM KULTHUM'S COUNTRY

Selim Sednaoui

Western classical music is as much a part of the contemporary Egyptian scene as Western pop, rock-and-roll, or popular Arabic music with its Western crossover elements. In each musical form the influence of the West is undeniable. The performance of and interest in Western classical music is a result of the continuing interaction of Western and Middle Eastern cultural influences in Egypt. One may indeed contest the 'ownership' of Western classical music, as is the case with the spread of representational techniques in art, also discussed in this volume, which at one time were also considered 'Western.' Today, Egyptian performers and composers of Western classical music are a part of the global fabric of this art form.

Since some readers may nonetheless doubt the presence or relevance of Western classical music in the Middle East, it is worth pointing out the influence of the Middle East and Middle Eastern themes on Western music. This has been discussed by Edward Said, Yehudi Menuhin, and Gerhard Baumann.[1] Said's interest in the colonial enterprise informs his comments concerning musical 'borrowings,' which lead us to explore an alternative direction, that is, how classical music may exist in the Middle East and be influenced by its Middle Eastern environment and practitioners. The intent of this article is to briefly describe the background and some aspects of the contemporary classical musical scene in Egypt, and to set out some thoughts for future analysis and criticism.

The history of Western classical music in Egypt may conveniently be divided into two periods: before and after the 1952 revolution.

1798–1952

The opening of Egypt to Western influence is often traced back to Napoleon Bonaparte's military expedition to the country in 1798. Along with his soldiers, Bonaparte brought a sizable team of French intellectuals, scientists, politicians, and economists, who, despite only a brief presence in Egypt (1798–1801), had an important influence upon the country's development in the nineteenth and twentieth centuries.

Later on, Western penetration (cultural and political) was greatly facilitated by Khedive Ismail, who ruled Egypt from 1863 to 1879 and vowed to make his country 'a part of Europe.' He encouraged foreigners to invest and work in Egypt. It was during his reign that the Suez Canal was opened, in 1869, thus setting Egypt at the crossroads of Europe, Africa, and Asia.

From that time until the 1952 revolution, foreign communities (mainly English, French, Italian, and Greek) prospered in Egypt, bringing along their cultural traditions and preferences. It is significant that the common languages of these communities, and of Westernized upper-class Egyptians, were French and English, not Arabic. Foreign schools (religious or secular), foreign-language newspapers and radio programs, and screenings of American and European films are but a few examples of the Western cultural presence during this period. However, access to this culture was mainly restricted to the above mentioned groups, the large majority of Egyptians being only marginally affected.

Western Classical Music

Western classical music traveled to Egypt along with other forms of culture. A milestone in this respect was the opening of the Cairo Opera House in 1869, coinciding with that of the Suez Canal. The Opera House was built in the southern part of the Ezbekiya Gardens not far from Abdin Palace. Verdi's opera *Aida*, with its 'Egyptian' plot, was scheduled to have its premiere on this occasion, but as it turned out Verdi was unable to finish it in time, and *Rigoletto* was performed instead.

There followed a continuous stream of Italian opera companies performing in Egypt, including, in the twentieth century, world class singers such as Lily Pons, Beniamino Gigli, Maria Caniglia, Tito Gobbi, and Gino Bechi. The cosmopolitan, elite society of Cairo and Alexandria also attended concerts by top foreign instrumentalists such as Artur Rubinstein, Pablo Casals, Alfred Cortot, and Wilhelm Kempff. Before the Israeli–Arab conflict of 1948, the Palestine Orchestra (composed entirely of Jewish musicians) came to perform in Egypt under the baton of Arturo Toscanini. So did the Vienna and Berlin Philharmonic orchestras under W. Furtwängler and C. Krauss. Cairo's main concert hall in prerevolutionary days was the Ewart Memorial Hall at the American University in Cairo.

The teaching of Western classical music was mainly offered by Italian, Armenian, and Jewish musicians, who founded a few private conservatories attended by pupils from the foreign communities and the Egyptian upper class.[2] This instruction was limited mostly to the piano and the violin, with very little training in musical theory or composition, the main aim being to produce good amateur musicians, rather than to offer a strict professional training. Most Egyptian composers of the first generation, with whom I will deal below, started their musical apprenticeship with these foreign musicians.

1952 to the Present
With the 1952 Revolution led by Gamal ᶜAbd al-Nasser, a nationalistic trend swept through Egypt and altered not only the political, but also the cultural scene. This trend was reinforced by the 1956 attack on the Canal Zone by Britain, France, and Israel (the Suez War) in retaliation for Nasser's nationalization of the Suez Canal.

Foreign communities gradually left Egypt, and the Western cultural presence shrank accordingly. This exodus took with it the resident foreign musicians. In these years, one might well have feared for the future of Western classical music in Egypt. Fortunately, nationalistic fervor did not turn against this form of art, but on the contrary was a positive factor in its development. Credit for this achievement is mainly to be given to the 'enlightened' and music-loving minister of culture, Sarwat Okacha. Instead of 'importing' foreign talent, the motto of these years was to develop local talent. Consequently this period was important for contemporary performers and composers and for students of music in Egypt. Among the most notable successes in the field of classical music, generated initially in the Nasser period, one must mention the following institutions.

The Cairo Conservatory
Founded and built in 1959 by architect/composer Abu Bakr Khairat, who headed the institution until his death in 1963, the Cairo Conservatory set out from the very beginning to give students a thorough knowledge of Egyptian folkloric music and of Arabic music as well as the traditional Western musical disciplines of theory, composition, conducting, instrumental playing, voice, music education, and musicology. Thus, the philosophy of the Conservatory aimed to bridge the gap between the two cultures and provide future musicians with a solid base in both fields of music. For example, the Conservatory offers courses in modal harmony and counterpoint as applied to classical Arabic music.

The staff includes forty music teachers, Egyptian and foreign (mainly from Eastern Europe), and thirty-nine assistant instructors. The number of students now reaches seven hundred. These students are largely from the

middle class, although there are also some enrolled from the lower classes and the elite. In addition to music, English and French are taught.[3] Gifted students are granted scholarships to study abroad.

Practical musical activities are an important part of the students' training. The following activities have been supported over the years.[4]

A *Children's Choir* was founded in 1973, consisting of sixty pupils from the Conservatory's preparatory school, who perform Egyptian folk songs in a polyphonic style as well as foreign songs.

A *Children's String Orchestra* was founded in 1979 and included twenty-five performers.

The *Young People's Choir* was a group of fifteen students from the piano, voice, and composition sections. They accompanied the Egyptian Opera Company in its performances and participated in concerts by the Conservatory Orchestra, particularly on important national holidays.

The *Conservatory Orchestra* was founded in 1974 and was made up of students from the higher levels. This orchestra attained a professional standard and has performed works of Egyptian and Western composers in Egypt and abroad.

The Cairo Symphony Orchestra

Founded in 1956, the Cairo Symphony Orchestra began its activities under the baton of Franz Litschauer from the Vienna Opera Orchestra. He was followed by the Yugoslavian conductor, Zika Dravkovich, and then by Egyptian conductors Ahmed Ebeid, Youssef el-Sissi, and Ahmed El Saedi. Of the 101 members of the orchestra forty-seven are Egyptian and fifty-four are Eastern European. The presence of musicians from Eastern Europe owes something to the history of the Nasser period, but more perhaps to the recent dissolution of the Soviet Union. The distribution by instrumental sections suggests some differences in training and experience available to young musicians *(See Figure 1)*.

	Egyptian	Foreign	Total
Strings	16	39	55
Wind	26	13	39
Harp	1	1	2
Percussion	4	1	5
Total	47	54	101

Figure 1. Instrumental Sections of the Cairo Symphony Orchestra in 1997

The symphony orchestra offers weekly concerts, featuring both Egyptian and foreign soloists. Programs include the standard Western

repertoire, plus occasional works by Egyptian composers. The 1997/8 season, for instance, included five concerts described as being "inspired by Oriental mythology, or an Oriental music idiom," and several that feature French compositions in honor of the bicentenary of the Egyptian–French relationship (dating from Napoleon's initial expedition).[5] The Oriental 'inspirations' include music by Prokofiev, Nanes, Rimsky-Korsakov, Adel Afifi, Saint-Saens, Tchaikovsky, Rageh Daoud, Ahmed El Saedi, Debussy, Strauss, Takemitsu, and Rachmaninov; the French music consists of Ravel, Dukas, and (again) Debussy.

The orchestra has performed under the direction of renowned guest conductors including Charles Munch, Carlo Zecchi, Yehudi Menuhin, and Genady Rozhdestvensky. Among the soloists who have performed with the Cairo Symphony Orchestra are cellists André Navarra and Mistislav Rostropovitch, pianists Rudolf Buchbinder, Abdel Rahman el-Basha, Victoria Postnikova, and Jorg Demus, and violinist Salvatore Accardo.

The Cairo Symphony Orchestra has recently embarked on a series of CD recordings of Egyptian music and works of the standard repertoire (such as Beethoven's Fifth Symphony).

In spite of all these positive activities, symphony attendance is rather low. Perhaps this is related to the general lack of musical education, and inconsistent program information. The ticket prices vary from five to fifty Egyptian pounds, too expensive for most Egyptians.

The symphony orchestra appears on television on an irregular basis. During Ramadan, fewer performances are scheduled, although other cultural events (Arabic music and storytelling, for example) take place in that month. The Arabic press rarely covers Western classical music performances, with the exception of large, gala events, such as *Aida* performed in Luxor, but they are regularly reviewed in Egypt's foreign-language newspapers *al-Ahram Weekly*, *al-Ahram Hebdo*, and *Le Progrès Egyptien*.

The Cairo Opera House

In 1971, the historic Cairo Opera House was destroyed by a fire. A garage building was put up in its place. Cairo remained without an opera house until 1988, when the Japanese government offered Egypt a new home for opera and other performances, which was built on the exhibition grounds on the island of Gezira. The new building is a beautiful blend of Islamic and modern architecture and forms part of a complex that also includes the Museum of Contemporary Art, a music library, a talent development center for music and ballet, a theater with a small gallery, and a planetarium.

The new Opera House uses state-of-the-art equipment for sound and stage. Performances take place on an almost daily basis, and include

opera, symphony concerts, ballet, chamber music, choral works, and
Arabic music. A smaller hall is devoted to recitals and chamber music, as
well as film screenings and panel discussions. In 1995 a new Opera
Orchestra was founded, whose role is to accompany opera and ballet
performances in order to allow the Cairo Symphony to devote itself to
symphonic works.

Audiences at 'the Opera,' as it is known, consist mainly of affluent
Egyptians and Western residents. Ticket prices, although cheap by
European and American standards, are still beyond the reach of most
Egyptians. Efforts are now being made to offer reduced prices to students
and senior citizens. The Opera is also extending its activities to schools,
universities, sports clubs, and so on, as well as making efforts to reach
audiences outside Cairo, in the provinces. The 1997/98 opera season
includes *Thaïs*, *Aida*, *Barber of Seville*, *La Bohème*, and *Anas al-
Wogood*, composed by Aziz El-Shawan and discussed briefly below, and
several operettas including *The Merry Widow*.

A recent addition to the classical music scene in Egypt is the
Akhenaton Chamber Opera Company, linked to the Akhenaton Chamber
Orchestra (see below), the first privately formed operatic organization in
Egypt. Its main goal is to present works in Arabic and English to a new
generation of music lovers in venues that will be more casual than the
Cairo Opera House, which gives some the impression of catering only to
a select portion of society.

An obstacle to attracting wider audiences to Western classical music
events in Egypt is the barrier between the local, Arabic and Western
cultures. This barrier may only be overcome by encouraging music
appreciation through the educational system, and the audio-visual media.
Thus far, insufficient and uncoordinated efforts have been made toward
this aim.

One way to broaden the appeal of opera may be to present it in Arabic
as well as in foreign languages. Arabic-language versions of Mozart's
Marriage of Figaro and *Don Giovanni* have recently been produced and
recorded onto compact disc by the Cairo Opera Company. The idea of
producing European operas in Arabic has both supporters and adversaries,
and would require a separate discussion. Nonetheless, it seems to the
author that any means of bringing this art form closer to an Arabic-
speaking audience is commendable.

Other Ensembles and Venues

The Symphony and Opera Orchestras are not the only groups that perform
Western classical music in Cairo; there are also a number of smaller
ensembles. The two most stable are the Akhenaton Chamber Orchestra,
founded and conducted by composer Cherif Mohieddine and made up
almost exclusively of Egyptian musicians, and the Amadeus Orchestra,

founded by violinist Samir Khoury and employing both Egyptian and European musicians from the ranks of the Cairo Symphony. This year the Sinfonietta has been established, predominantly a wind ensemble, and a special string ensemble, the Chamber Orchestra. These two groups also draw from the members of the Cairo Symphony.

The foreign cultural centers—including the American, British, French, Italian, German, Austrian, Dutch, Spanish, and Paraguyan—are an important part of Western musical life in Egypt. They invite artists from their respective countries to perform in Egypt. These concerts are usually organized in cooperation with the Cairo Opera, or with the American University in Cairo, where performances are still given in the Ewart Memorial Hall (and sometimes in the main garden area). Audiences are a mixture of Egyptians and expatriates.

Most concerts given in Cairo by international artists are repeated in Alexandria, usually on the following night. The Cairo Symphony also performs in the provinces, as well as at the national universities.

Since 1989, an annual summer festival has been held at the open air theater of the Cairo Citadel, with various kinds of music being performed (classical, jazz, Arabic, folk) to a popular audience. No entrance fees are charged, but the wind can interfere with acoustics at this site. At the other end of the social spectrum, it has become fashionable to mount extremely expensive classical music concerts-cum-dinners at five-star hotels.

Opera also takes place outside the Opera House. Performances of Verdi's *Aida* have been regularly booked for some years at famous Egyptian sites such as the Giza Pyramids and the temples of Luxor. Operatic performances at Luxor—for example a gala performance of *Aida* at the temple of Queen Hatshepsut in the fall of 1997—are also expensive for local audiences. The ambience of these sites nevertheless casts an historical allure that may add to opera's mystique or pageantry.

Egyptian Performers
Egyptian performers of Western classical music, both singers and instrumentalists, have often studied at the Cairo Conservatory for their basic musical training. Many have then completed further studies in the West. Most of them are competent in their chosen field, but they generally fail to attain an international level of performance or recognition. This assessment may seem harsh, but it reflects the realities of the musical scene in Egypt today. Performers may not reach their full potential due to the small size of the Egyptian musical 'market,' which in turn reflects the lack of competition. Without the challenges to be faced abroad, the performers seem satisfied with their status as 'the best in Egypt.' A few talented performers have either emigrated permanently from Egypt, or spend most of their time abroad pursuing international careers.

Two examples of internationally successful Egyptian performers who also maintain a local base are pianist Ramzi Yassa and bass-baritone Reda al-Wakil. There are many other talented performers, but the careers of these two artists are briefly described here in order to illustrate the caliber necessary to expand a musical career beyond Egypt's borders.

Ramzi Yassa

Born in 1948, Ramzi Yassa studied piano at the Cairo Conservatory and then at the Moscow Conservatory. He obtained a scholarship for study at the École Normale de Paris, where he now teaches.

He won the First Prize at the 1977 Santander (Spain) Piano Competition, as well as the First Prize for performance of Spanish music. Yassa has given numerous recitals in Europe and Japan and has performed with such conductors as Yehudi Menuhin, Zubin Mehta, and Charles Groves. He has recorded music by Beethoven, Chopin, Tchaikovsky, and Prokofiev on CD.

Reda al-Wakil

Al-Wakil was born in 1960 and graduated from the Cairo Conservatory in 1984. He also studied singing in France, England, and Spain, and studied with the renowned soprano, Irmgard Seefried.

In March 1994 he obtained the Diplôme Supérieure de Concertiste avec Félicitations du Jury at the École Normale in Paris. In April of the same year, he won First Prize in the Placido Domingo Competition at the Paris Bastille Opera. Then in September, al-Wakil won the First Prize in the International Singing Competition at Toulouse, France, as well as the Audience Prize for that event. He was among fifteen bassos from various countries represented at that event.

Since then, Reda al-Wakil has received engagements to sing at the Bastille Opera and in other French opera houses, and has also sung in England, Spain, Italy, Yugoslavia, Bulgaria, and Poland, in addition to his appearances at the Cairo Opera.

He has recorded the roles of Don Alfonso, Count Almaviva, and Don Giovanni with the Polish Radio orchestra in the first Arabic-language version of Mozart's operas.

Classical Composition in Egypt

The status of Egyptian composers of classical music is a complex issue that requires some in-depth analysis.[6] First, one must agree upon the definition of an 'Egyptian classical composer,' as the term 'classical' could also refer to traditional Arab music. We define the term here to mean an Egyptian composer who has had training in Western compositional techniques (harmony, counterpoint, orchestration, etc.) and uses them to compose music that could be (but may not be) inspired by

Egyptian and/or Arabic traditional music. We will consider the case, which is the most frequent, of the composer who attempts to blend Western and Arabic music. Various obstacles appear in the composer's path, arising from basic differences between the two types of music.

Western music
- Harmonic, polyphonic (The melody involves more than one note at a time, or more than one line of notes, i.e., chords).
- Diatonic and chromatic modes.
- Instruments ranging from solo to large symphony orchestras.

Arabic music
- Monophonic.
- Arabic modes *(maqamat)*, which have a large variety of intervals, including the quarter tone and the famous augmented second used by Hollywood film composers when they hope to evoke a Middle Eastern setting.
- Mainly solos and small ensembles. Some use of larger orchestras in Arab capitals.

The problems involved in adapting the features of either musical form are inherent in the various experiments of modern Egyptian composers. To mention just one issue of orchestration, certain notes of the Arab *maqamat* may not be played by all Western instruments. Western instruments have been adapted, including the piano,[7] organ, and accordion; however, these 'quarter-tone' versions have mainly been employed in modern Arabic music, rather than in the classical music under discussion here.[8]

Further, and on another level, there seem to be two schools of thought regarding the combination of 'nationalistic' and 'classical' elements in music. One school, exemplified by Eastern European composers of the second half of the nineteenth century, and by the likes of Kodaly and Bartok in our century, advocates the use of folk songs, dance tunes, and so on, to give a local tinge to the music. The other school is best represented by the Russian composer and pianist Sergei Rachmaninov's opinion that since he himself was Russian, and his whole environment Russian, his music too would of necessity be Russian, with no need for folk elements to make it sound so.

How have Egyptian composers attempted to resolve these opposing tensions and elements? Each composer has coped in their own individual manner. As this chapter is not meant as a comprehensive review of all classical musical production, coverage of some other talented Egyptian composers remains to be written. Here we will briefly consider some of the best known composers

Abu Bakr Khairat

The founder of the Cairo Conservatory, Abu Bakr Khairat chose to combine folk elements with a nineteenth-century style of classical music composition. However, his music sounds more like a juxtaposition of different styles than a true combination of the two. In his *Folk Symphony*, for example, one hears a passage that could have been written by Beethoven, abruptly followed by an Egyptian folk melody. In general, his music is pleasant to the ear, with a sweet sentimentality that in fact gives it more of an Oriental flavor than his artificial injections of folk music.

Gamal Abdel Rahim

On a more sophisticated level, we find Gamal Abdel Rahim (1924–1988), who acquired advanced compositional technique during his studies in Germany with H. Genzmer, a pupil of Hindemith. His melodies make use of the modal scales and microtonal intervals characteristic of Arabic music, and the rhythms are often lively and asymmetrical, as in many forms of Middle Eastern music. He also makes good use of his contrapuntal skills, especially in his piano pieces, and choral works. Samha al-Kholi summarized Abdel Rahim's musical principles as follows:

1) The replacement of the Western major/minor system with traditional Arab and Egyptian folk *maqamat* or modes.
2) The revival and extensive use of irregular (5, 7. 9 [i.e. 5/4, 7/8, 9/8], etc.), complex rhythmic patterns of the traditional [Egyptian Arab] heritage together with variable meters. Abdel Rahim also uses a wide range of both Western and local folkloric percussion instruments.
3) The introduction of a linear model [of] polyphony as the natural extension of Eastern monodic melodism and the use of new contrapuntal/harmonic rules, based upon, and derived from the typical intervals of the modal system used in and around Egypt.[9]

Aziz El-Shawan

Aziz El-Shawan (1916–1993) studied in Moscow with Aram Khachaturian, whose influence is apparent in El-Shawan's music through the colorful orchestration and use of the melodic line. He has employed motifs and titles concerning ancient Egypt and Egypt's Arab past. He has written a ballet score, *Isis and Osiris*, and *Dances* based on traditional music from the Sultanate of Oman, as well as four symphonies. He has also composed a piano concerto that sounds like an Oriental Rachmaninov, with a 'cadenza' that imitates the Arabic *qanun*, a large zither. He has also written the first Egyptian opera, *Anas al-Wogood*, which had its premiere in 1995, thirty years after its composition. The opera is based on a legend from the *One Thousand and One Nights*.[10]

The New Generation

The new generation of composers such as Rageh Daoud, Mona Ghoneim, Ahmed El Saedi, and Cherif Mohieddine, tend to move away from the earlier group that employed 'folk' adaptations. Instead they have attempted to develop a style of their own, often influenced by the twentieth-century Viennese School, as many of them studied music in Austria.

Conclusion

The best prospect for a viable solution to the East/West conflict in Egyptian classical music would be the advent of an Egyptian composer of the stature of a Bartok, a De Falla, or a Gershwin. All we can do is to create the most favorable environment for such an event to occur. It should be added that even such improvements may not guarantee the advent of such a figure. America, for example, has a fantastic musical environment, yet has not produced a composer of truly great stature in some years. There is still some mystery as to when, where, and why genius emerges.

The picture of Western classical music in Egypt is a mixed portrait, with some favorable elements. Others aspects are still underdeveloped. It would be interesting and appropriate to compare this musical scene with that in other non-Western countries such as India, or Japan. We see that Yo-yo Ma, the Chinese cellist, conductors Seiji Ozawa and Zubin Mehta, and scores of other non-Western performers reside in the West because the performance and recording opportunities are more plentiful and more prestigious. So we may hypothesize that a 'talent drain' also affects the classical music scene in Egypt as in other non-Western countries, except where emigration is restricted. In some respects this situation unfortunately strengthens the perception that Western classical music is the property, or heritage, of the West alone.

However, the other side of the coin is that Western classical music has an increasingly multicultural presence in the West. Egyptian performers there are an element of the 'multiculturalism' that characterizes Western classical music in the twentieth century. Egyptian composers, performers, and instructors of classical music fulfill the same function—enriching cultural life—in their own country and are voices asserting that classical music belongs to the world at large.

Notes

1 "Where Corals Lie . . . Menuhin and Said: The Debt to Other Musics," panel presentation with Yehudi Menuhin, Edward Said, Gerhard Baumann, on audiocassette, ICA video 565, London, 20 July 1990.

2 Among the best known of these was the Tiegerman Conservatory, founded by the Polish-born pianist Ignaz Tiegerman.

3 Personal communication from Aisha Hamdi, professor of the piano at the Conservatory.
4 *Prism* 24 (Cairo: Ministry of Culture, July–September, 1989).
5 Cairo Symphony Orchestra Season Programme, 1997/1998, Ministry of Culture, Egypt.
6 The following written sources may interest the reader. Zain Nassar, "Itijahat fi-l-musiqa al-Misriya al-muᶜasira," *al-Fann al-muᶜasir* (Winter 1986); Farial al-Shimi, "Mu'alifat al-piano ᶜind ruwwad al-ta'lif al-musiqi al-mutatawwur fi Misr," *al-Fann al-muᶜasir*, issues 1 and 2 (1988); Aziz El-Shawan, *al-Musiqa ta'bir naghmi wa mantiq* (Cairo: General Book Organization, 1986); Sarah Louis, "La musique occidentale a du mal à percer au pays d'Oum Koulsom," *Le Progrès Egyptien* (29 September 1997).
7 The invention of the quarter-tone piano is accredited to Abdallah Shaheen of Lebanon.
8 Editor's Note: The *maqamat* may also be manipulated in the composition, thereby avoiding the quarter tones for certain instruments, or assigning them to other instrumental voices. Or, more often in the cases described in this section, the composer may simply suggest a *maqam* with the introduction of a few musical bars, and then blend the new theme back into a Western scale through the main melody or harmony.
9 Samha al-Kholi, "Gamal Abdel Rahim's Approach to Intercultural Music," in *Festschrift for Gamal Abdel Rahim* (Cairo: Binational Fulbright Commission, 1993), 72.
10 Aziz El-Shawan, *al-Musiqa taᶜbir naghmi wa mantiq.*

institutionalize: to cause a custom, practice, or law to become accepted and used by many people (to establish... and used by

8

THE MUSIC OF ARAB AMERICANS
AESTHETICS AND PERFORMANCE IN A NEW LAND[1]

Anne K. Rasmussen

Before the turn of the twentieth century and during its first two decades, when Arabs began to immigrate to America in significant numbers, Arab music was performed there on an informal basis. Later, by 1940 and up until the early 1970s, performances by a select group of respected musicians became the axis for a musical system that encompassed several dimensions. First, institutionalized performance events became important social gatherings where community relations and religious affiliations were solidified. Second, these events were primary vehicles for philanthropic fund raising. Third, they were environments where traditional musical and cultural values and practices were nurtured and protected. Fourth, this musical system also encouraged creative innovation by the musicians on social and musical levels. Some of these *demise* innovations gathered a great deal of momentum and, ironically, eventually led to the demise of many of the concepts and practices *dying* fundamental to the musical system that had been created.

How did this system develop, subsist, and subsequently deteriorate? Here I investigate both the experience of musicians and community members during music events and the decisions and actions of influential individuals, in order to account for the production, reproduction, and eventual degeneration of a dynamic and formative era in Arab American musical life.[2] I am particularly interested in the way musicians of this middle period (c. 1930–1970), affectionately referred to as 'old-timers,' and their contemporaries represented themselves to me as *the* artists of their community in their musical and social prime; that is to say at a time when *their* musical taste and artistic sensibilities became those of the community.

immigrate "in"
emigrate "exit"

This work represents a revision of earlier research and field work that was published in 1989. It is a revision that benefits from several more years of ethnographic research among community members, much of which is reflected in my doctoral dissertation (1991) and subsequent publications on contemporary Arab American musical life. Many of the musicians and community members who speak in these pages are no longer alive. During the late 1980s, when I began my ethnographic work among Arab Americans, these older musicians painted for me a picture of Arab American life that was 'complete,' with a beginning, a middle, and an end. My subsequent research and field work during the 1990s revealed a picture much less grim. The musical life of Arab Americans is in fact a continuously evolving set of individuals, practices, and institutions that is a thriving part of the contemporary American multicultural soundscape as well as an important voice in Arab music as a diaspora phenomenon.[3]

A sketch of this formative era of the Arab American music scene, the focus of this chapter, provides not only crucial insight into the history of a particular community, but also offers a useful processual model of musical action, practice, and change that may resonate within other American communities and that may well again be set into motion among Arab Americans themselves. The 'middle period' musical system that the 'old-timers' evolved did not last more than a generation or two. Many of the musicians they trained on the stage went on to create the eclectic nightclub scene of the 1960s through the 1980s. These nightclub musicians, many of them American-born, in turn saw the significance of their musical work shrink with the arrival of thousands of post-1965 immigrants, who enriched Arab American musical life and brought to it the immediacy of a directly transplanted spoken language and an up-to-date and 'authentic' musical repertoire 'straight from the homeland.' Compounded with the conflicting musical aesthetics and procedures of successive generations and the broader history of Arab American immigration are issues of community economics, world politics, and technological advances in communications and transportation. Such social factors figure prominently in the life of this and perhaps any musical subculture.

A Historical Overview of Arab American Musical Life

From the late nineteenth century up until the end of World War I, there was a small but steady immigration to the United States by predominantly Christian Arabs from 'Greater Syria,' the region comprising contemporary Syria, Lebanon, Jordan, and Israel (then Palestine). However, mixed in as they were with the approximately 27 million primarily European immigrants who inflated the populations of the eastern industrial cities of the United States, Arab Americans hardly constituted a visible ethnic group. Two major obstacles prevented many

emigRate : leave youR country to Reside somewhere else
immigRate: is to enteR and Reside in new country.

potential immigrants from augmenting the relatively small Arab community in the 'New World':

> As the major European powers squared off against one another, most of the Continent and the Mediterranean Sea basin became inhospitable to normal civilian travel, especially by ship, which was the only way of reaching America at the time. It was not until the end of 1919 that immigration began to assume its prewar dimensions. The United States, however, was no longer eager to receive millions of immigrants. A wave of anti-foreign prejudice swept over the 'non-alien' population and led to the enactment of the country's first restrictive immigration law in 1921.[4]

Those who did emigrate from the Ottoman province of Greater Syria left their homeland for economic and social opportunities in the New World, to escape military conscription, or because of perceived religious and social oppression by the Muslim Ottoman regime or local forces. Whatever the cause for their departure, once they arrived in America, Syrian immigrants are said to have adapted to their new environment rather successfully. By 1914, there were at least 110,000 Arabs from Greater Syria living in the United States.[5] The first communities they established were and still are situated in the northeastern United States and in Detroit, Michigan, the sites of my field work.[6] I divide their musical life into four periods: the 'early years,' the 'middle period,' 'the nightclub scene,' and 'contemporary times.' I have dealt with the nightclub scene and contemporary Arab American musical life in a number of publications.[7] The work that follows here focuses on the evolution of the middle-period musical system and the ways in which, in the eyes of its progenitors, factors that led to its success led also to its demise.

During the early years, when many Arab immigrants worked in mills and factories, or as peddlers, music events were limited to informal gatherings, functional events such as births or weddings, and listening to both imported and domestically produced 78 r.p.m. recordings of Arab music.[8] Most immigrants either worked long days or peddled dry goods, garments, and linens imported from the Middle East along the peddling routes they established from "Maine to Texas and New York to California."[9] They had neither the time nor the social and artistic infrastructure for the music making events that were to become paramount in later years. Furthermore, many immigrants never planned to stay in America; they expected to return home to their families in Syria with their newly acquired wealth. Establishing a permanent American-Syrian community complete with leisure and philanthropic activities was not a priority.

informal gatherings

SyRians planned to RetuRn back to SyRia.

Arab music was sponsored informally in non-professional settings, performed by amateurs who might have an ᶜ*ud* (lute) or *darbakka* (drum) from back home. It might simply take the form of group singing, clapping, and dancing. While many immigrants of the early twentieth century came from Greater Syria, there is an important distinction to be made between those who came from the villages of Mount Lebanon, where group singing, sung folk poetry, and folk dancing prevailed, and those from Aleppo, Damascus, and Beirut, where an urban tradition involving vocalists accompanied by a small ensemble of instrumentalists prevailed. Folk song genres like ᶜ*ataba* and *mijana* or *zajal,* all forms of improvised folk poetry, were performed by and for the 'Lebanese' while the 'urban Syrians' enjoyed a musical repertoire including vocal *qasa'id* (sing. *qasida*) and *muwashshahat* (sing. *muwashshah*), and instrumental *basharif* (sing. *bashraf*) from the classical Ottoman/Arab repertoire preserved and disseminated to some extent on 78 r.p.m. recordings. This distinction between the urban and the rural has been articulated to me by young and old community members and is one that has evidently contributed enormously to their musical taste and contextual aesthetics throughout the twentieth century.

Between the 1930s and the early 1970s, as the population stabilized after the first wave of immigration lightened, live music performances became the focus of two new types of events in the Arab American community: the *hafla* (pl. *haflat*), a formal music party, and the *mahrajan* (pl. *mahrajanat),* a three-day outdoor event involving hundreds, sometimes thousands of participants. During this era of Arab American musical life, an era I have called the 'middle period,' various influential musicians established a musical style and repertoire they describe as 'authentic,' and 'strictly Arabic.' The patterns of interaction between musicians and audience members solidified into an institutionalized code of contextual aesthetics. While they were supported enthusiastically by church groups and social organizations, community members unanimously testify that it was the musicians themselves who activated the evolution of these exciting new American performance events.

Middle-period musical activity was eventually undermined by the nightclub scene that emerged in the late 1960s. This scene was characterized by polyethnic interaction among Arabs, Turks, Greeks, and Armenians, who shared and combined their musical traditions. The urban nightclub was a commercially motivated venture that strove to entertain the general American public. In contrast to the events of the middle period, when a high premium was placed on the musical program, solo belly dancing and group Oriental-style and folk dancing were the most important components of nightclub performances. Although this shift of emphasis that occurred some twenty-five years ago was significant, performances in both nightclubs and at *haflat* in fact revolved, and still

today largely revolve, around socializing, eating, drinking, dancing, making merry, and making money.

In 1965, immigration quotas were finally lifted, thus parting the seas for new immigrants from all over the Arab word. The influx of new immigrants and musicians along with the influence of the civil rights movement, which legitimized the expression of ethnic identity and cultural diversity, contributed to the resurrection of a more purely Arab nightclub repertoire.[10] As new immigrants permeated established Arab American communities, some traditional cultural practices were – *Re invented* reintroduced or reinforced. This population has not, however, effected a return to tradition in musical style or musical values. At most music events today, social interaction prevails over musical appreciation and dancing is clearly as important as listening.

The contemporary Arab American music scene reflects the disappearance not only of the repertoire and styles of the middle period, but also of the contextual aesthetics, namely the rapport between artist and audience that was integral to the vitality of the middle-period music scene. While several factors contributed to the decay of the middle-period musical values and practices, I suggest that the seeds of decomposition were unintentionally sown by conscientious artists and appreciative audiences during the dynamic performance events of the middle period.

The Rise of Professionalism, 1930–1970

Starting in the 1930s, audience demand for the services of recognized musicians in the community increased and a number of amateur musicians began to form a class of professionals. Musicians became increasingly in demand and, little by little, performance events became larger and more frequent. This proliferation was due to the growing stability of the Arab American community, as well as to a patronage system created by their churches. The Ottoman Turks who ruled Greater Syria for four centuries until the end of World War I had inhibited political coalitions, the dominance among Levantine populations of any one religious group, or the identification with specific cultural symbols and patterns of expression on a broad scale. Elements of pluralism, therefore, in terms of religion, social position, and region existed, but were not translated into distinct cultural expressions in the turn-of-the-century Levant due to the factionalizing process that accompanied Ottoman rule. Potential immigrants from Greater Syria, in fact, were more likely to identify with kin groups, village communities, economic or social position, and, importantly, with a religious tradition, than with any national or regional image. The overwhelming majority of Syrian immigrants to the United States were Christian (although cohesive Syrian Jewish communities settled primarily in New York and New Jersey). According to Philip Hitti, the most important source of Syrian identity

was the church: "A Syrian is born to his religion just as an American is born to his nationality. In fact, his church takes the place of the state for him . . . the Syrians are loyal to their church because of the national aspect of its character, and it therefore forms an integral part of the constitution of their community wherever they may be."[11]

The churches that were established—and in Rhode Island alone, where the Arab population by 1910 numbered around 1,300, there were Maronite, Melkite, and Orthodox parishes —organized a plethora of social and artistic activities to benefit kin and comrades and, as a result, acted as agents of cultural preservation and promotion.[12] These occasions included the *hafla* and *mahrajan* described below.

The *Hafla*

The *hafla* developed as a cross between the *sahra* (an evening house party involving live music), and the formal concert. The Deckey family, originally from Aleppo, have been music promoters in the Blackstone Valley area of Rhode Island for at least two generations. Blanche and Georgiana Deckey described their father's approach to music patronage:

> Our father was president of the Aleppian Aid Society; our mother was also involved, that's how we got into it. Years ago here, when Arabic music was introduced to the people it was in an auditorium . . . the concept of having people sit around tables with food available, was something that my father tried and it worked so well.[13]

Virginia Solomon, wife of the celebrated violinist Philip Solomon, recalled, "The Deckey family love Arabic music and when they used to have an affair, they used to have it auditorium style. People would go and just listen and it would be like a concert. But [they] said, 'Why do that? Why not make it more like a *hafle* [Syro-Lebanese colloquial Arabic] where we have tables, where we can serve drinks and have food and hire our musicians and have a good time and get into the folk dancing and all that?' That was how it started here in Rhode Island." [14]

Haflat then crystallized as formal events held in the evening, in a church or social hall, where musicians entertained from a stage and during which families at reserved tables enjoyed Arab music, *mazza* (a variety of snacks and appetizers), and alcoholic beverages.

It is important to emphasize the fiscal and philanthropic enterprise embodied by this new musical context. According to the members of the charter Arab communities in New England, church parishes generated social organizations (such as the Aleppian Aid Society) that were preoccupied with raising money for both their own communities and good causes in the homeland. Immigration scholars Naff, Hitti, and Kayal and Kayal—who overlook *haflat* as the lucrative vehicle for fund raising that

they were—all attest to the tendency among Arab Americans to create social organizations based on sectarian and village ties. Hitti refers to this tendency as "societitis."[15] Kayal and Kayal indicate that Syrians were not only raising money for less fortunate parish members and to "bury the friendless dead," but that Syrians actually sent home more money per capita than any other immigrant group in America.[16]

Also largely neglected by immigration scholars mentioned above is the 'woman power' behind these social institutions and consequently in the planning and execution of sociocultural events like the *hafla*. The Syrian Ladies Aid Society of Boston, for example was an interdenominational women's organization founded by members of Saint George's Orthodox Church in 1917. The purpose of the organization, according to Evelyn Shakir, a native ethnographer and participant in the Society, was to raise funds for kin and countrymen who were suffering from poverty, starvation, and social oppression. "When I was growing up, it seemed to me that, in my house at least, the Syrian Ladies' Aid Society of Boston ranked in importance somewhere ahead of the church and only slightly behind the family itself." [17]

The society's minutes tell us that it hosted *sahrat* (musical 'evenings') every week as well as monthly dinners, annual plays, picnics, and *haflat* where musicians from Boston and New York staged a more formal program .[18] One member of the society recalled, "We were so nervous, we were afraid some men might come, bring bottles, listen to music, and get drunk. And if they did, what could we do about it? And people would say 'A ladies' club! And they have such goings on? No, we were worried. But all went very well, very well. We made a lot of money." [19]

The Music at Haflat

The musicians who performed and recorded a transplanted and transforming repertoire of folk, art, and popular music describe themselves as "only a handful."[20] Because they were few, each of these musical pioneers was powerful; the aesthetic tastes and musical background of this group, now called 'old-timers,' was fundamental to the evolution of the music scene during this middle period.

Russell Bunai (né Riskallah), who died in his nineties, spent most of his life in the same Boston neighborhood to which he immigrated as a teenager from Damascus, Syria. He and his wife, Rose, described his transition to professionalism. "All the Arabic-speaking people, they got after me, they knew I knew music, naturally, so I started to sing. This was during the Depression, things were bad, and they said 'Why should you do it for nothing, we would like to hire you, [you should] do it as a profession.'" [21]

Reflecting an urban Syrian 'musical world view,' Bunai described the music he performed as 'classical music' from the Syrian/Egyptian

tradition; he told me he "never bothered with the Lebanese way of singing." [22]

Bunai, unlike many earlier immigrants and their children, spoke and read classical Arabic. He stressed the importance of good diction as well as the meaning of the poetry of the songs. Distinguishing himself from younger generations of musicians, he declared that he had never played in a nightclub and has always promulgated values of honesty, respect, integrity, and hard work. Bunai is representative of the Syrians who derive their musical identity from such cities as Aleppo, Beirut, and Damascus and, by association, Cairo, Egypt, the city that became the dominant commercial, cultural, and media center of the Arab world in the early twentieth century.

In comparison to their compatriots from Mount Lebanon, urban Syrians enjoyed a varied and what they considered sophisticated musical repertoire consistent with that of the secular urban music contexts of the Arab world.[23] The vocal music reflected both the ubiquity of Quranic or liturgical chant in Muslim, Jewish, and Christian religious contexts as well as the Arabic literary and poetic tradition. The singing style featured highly ornamented manipulation of the melodic modes *(maqamat)* and the musical rendition of various poetic forms. These included the *qasida,* classical Arabic poetry characterized by vocal delivery without rhythmic accompaniment and liberal amounts of improvisation; the *muwashshah,* a strophic song written in a mixture of classical and colloquial Arabic and often set to complicated irregular meters; the *dawr,* an Egyptian vocal genre with precomposed and improvised sections during which a chorus follows a solo vocalist; and *layali* and *mawwal,* vocal improvisation (with or without rhythmic accompaniment), beginning with a few repeated words (*ya layli, ya ᶜayni,* literally 'oh my night, oh my eye'), and then followed by sung poetry, usually in colloquial language.

Singers were accompanied by a *takht* (the word indicates both an instrumental ensemble and the platform upon which the musicians performed). As an ensemble, the *takht* featured instruments of complementary timbres: the ᶜ*ud,* a pear-shaped, round-bellied, plucked lute; the *qanun,* a trapezoidal zither; the *kamanja,* originally an upright bowed lute, later replaced by the Western violin; the *riqq,* a heavy fish-skinned tambourine; and the *nay,* a reed flute.[24] In the American *takht,* the rhythmic role of the *riqq* was often played, for both practical and aesthetic reasons, by the *darbakka,* an hourglass-shaped ceramic one-headed drum (also called *tabla* or *darabukka*). Solo instrumental improvisations (*taqasim*) were indispensable to middle-period performances as were composed instrumental genres such as the *dulab* (a short prelude), and the *bashraf,* a classical Ottoman form (*peshrev* in Turkish).

This 'authentic Arabic music,' often referred to by Arab American 'old-timers' as the 'heavy stuff,' was presented for an audience of appreciative

and serious *sammiᶜa*, listeners, usually male music connoisseurs. Russell Bunai and his contemporaries, many of whom learned their craft in the United States, balanced this essentially Syrian/Egyptian 'classical' repertoire with lighter strophic songs *(taqatiq)* in colloquial dialect, folk songs, and music for dancing. Musicians explain that the 'light music' was included for the enjoyment of American-born children and women who, many assumed, were not as appreciative of the classical poetic forms and traditional musical artistry.[25]

All the musicians I interviewed described the most musically satisfying moments as those that occurred after the completion of the formal program. At this time the people who really enjoyed music, the *sammiᶜa*, would remain to request their favorite pieces. The musicians, who by then were warmed up and musically energized by the evening's performance, were primed for demanding musical renditions and creative improvisation. With an audience of attentive and appreciative *sammiᶜa*, they had the artistic license to perform their preferred repertoire, the 'heavy stuff.' Anton Abdel Ahad, a middle-period singer, composer, and ᶜ*ud* player, remembers:

> In my day, the emphasis was on the singer. Say I perform for two or three hundred people: we use the light [music] and intermingle some of the heavier stuff during the course of the evening (the classical and semi-classical music of ᶜAbd al-Wahhab, or Farid al-Atrash, for example). Then, when it comes close to quitting time, there will be about fifty remaining who want to hear the real heavy stuff. They make a half moon around the stage and they'd be hitting me with one request after another. "Please don't stop," [the audience would say] "now we enjoy it, the others are gone." So now I enjoy it because I can do what I like to do.[26]

Hesitant to accept payment as a musician, which some felt implied a questionable status, Russell Bunai resisted a shift to professionalism for several years. When he began to perform publicly, his role as a patron was as important as his performance as a musician. Integral to the planning of *haflat,* Bunai asserted aesthetic authority in booking and rehearsing musicians as well as in the choice and order of the music to be performed. He planned and printed programs for the evening's entertainment, which consisted of one or more *waslat* (s. *wasla*), a suite of instrumental and vocal pieces based in one mode with precomposed and improvised sections.[27]

Other middle-period musicians and many of the communities' social leaders were also integral to the planning and promotion of music events. For example, Bunai and his fellow musicians were associated with the famous immigrant society, al-Rabita al-Qalamiya, the 'League of the

Pen,' a group of Arab poets, artists, authors, and journalists led by Kahlil Gibran and based in Boston and New York. Members of this group included: Nassib Aridah, who edited the newspaper *Al-Fanoon* (The Arts), writer Elia Abu Mahdi, who founded the magazine *As-Sameer* (The Entertainer), and Sabri Andrea who hosted an Arabic radio show. These literati were among the social leaders who patronized and participated in the growing music scene.

During the middle period, Bunai, Abdel Ahad, and fellow pioneers traveled frequently. They performed almost every weekend in the New York area and in communities that extended from Montreal, Canada, through New England, New York, New Jersey, Pennsylvania, the Carolinas, and west to Detroit. Many young musicians launched their careers on this *hafla* and *mahrajan* circuit (*mahrajanat*, 'festivals,' are dealt with below). Together the musicians above negotiated contracts, organized events, determined dress codes, and endorsed respectable behavior on the road to such an extent that even women artists were known to tour and perform with them.

At performance events, the conduct of the audience was dependent upon the demeanor of the musicians, their regulation and juxtaposition of the musical genres they performed, and the example set by responsive *sammiᶜa*, the true music connoisseurs. The success and prevalence of the 'high-quality *hafla*' during the middle period was due not only to the integrity of the performing musicians but also to the social nature of the event and the honorable causes they served. In addition to their serious music the musicians always included a few *taqatiq* (popular songs) and dance pieces. However, the musical ensemble, or *takht,* sat on a stage directly abutting on the tables and chairs of the audience; any dancing occurred during prescribed times and, because there was no dance floor, only in the back of the room.

The *Mahrajan*

The *mahrajan* was an extended outing lasting two or three days where music was played both in the afternoon and evening. Originally, *mahrajanat* were church picnics where musicians would play, women would dance, and the old folks would tell stories to the young. Platforms for the musicians were constructed out of whatever was available. Russell Bunai remembers being perched on top of a tonic box or wooden crate for early *mahrajan* performances. Later, real stages were built with some sort of roof to protect the musicians from the sun. Concurrently, musicians opted for a more summery yet professional look, donning white tuxedos and shoes for the summer festivities.

Eventually the *mahrajan* grew into a three-day affair sponsored by a church or a larger organization such as the Lebanese League of Progress, the *Lebanese American Journal (LAJ),* or *al-Hoda,* another newspaper.

The festive *mahrajan* was especially popular with children and young adults. Because of the length of the event and its open-air context, the musical program was varied and consisted of lighter, popular tunes and music for dancing. Virginia Solomon, who always traveled with her husband Philip, a highly respected violinist, remembers:

There was a group of businessmen in New York who organized a three-day *mahrajan* in Trenton, New Jersey over Labor Day. People came from all over, it was fantastic. Eventually the *LAJ* and *al-Hoda* sponsored the outings and they became a little more sophisticated in their approach. They held it at the Narragansett racetrack, they used to have big floodlights, a huge stage, you would see miles of tables of people there, with their families, their children . . . they'd buy food, or bring food . . . and drinking and dancing and listening to the music and just having one hell of a time and they always used to have the best musicians. Always![28]

Like the *hafla*, the purpose of the *mahrajan* was philanthropic fund raising; the *mahrajan*, however, was also a society affair where networking, matchmaking, eating, and dancing were as important as the live music.

Music at the Mahrajan
While an explicit aim of the *mahrajanat* was social, their impetus remained charitable and the entertainment, musical. Performances took place during the afternoon and evening, and featured alternating groups of musicians for the larger festivals. The length of the event and its open-air context led to a more varied musical program of 'lighter,' popular music. Albert Rashid, who helped plan the musical programs, recalls inviting both professional and amateur musicians. "You're not supposed to have sophisticated music," he said, "you're supposed to have gay, lively [music] and dancing."[29]

In addition to the programmed musical activity, many people remember getting together and playing and singing among themselves. "The *mahrajan* was something everybody looked forward to, even the younger generation," said Virginia Solomon. Jimmy Tayoun remembered, "All of us would be in one suite, two rooms, we'd throw parties and everybody would come over to the hotel from the *mahrajan* grounds at night and we'd have the *'ud* and the *darbakka* and we would all sing until like three, four, five in the morning."[30]

The *mahrajan* then was a family affair that had a special appeal for younger people, most of whom had been born in the United States. There is no question that, in addition to coming to *mahrajanat* for the music, young folks came to socialize. Kayal and Kayal, who cite statistics that

indicate that young people were in the vast majority at these events, contend that "ethnic in-group marriage" was an explicit goal of the three-day festivals. These authors also note that while "most of the people there genuinely enjoy the Arabic entertainment, it also appears that the young are more limited and very selective about the type of Arabic music they respond to."[31] American-born second generation community members had little tolerance for the 'heavy stuff,' preferring to dance. Musicians' testimony echoes this observation. Although many of the same musicians performed at both *haflat* and *mahrajanat*, their performances for each context were different in content and purpose. The prevalence of young audiences and their enthusiasm for light, popular tunes and dance music affected artistic choices and the performance process at Arab American music festivals.

Evidently the *maharajanat* became too large and too much of a financial gamble for those who planned and promoted them; the last large-scale *mahrajanat* of this type were held in the mid-1970s.[32] Albert Rashid, who served as master of ceremonies for the annual Lebanese American National Mahrajan from 1947 to 1958, believed "its bigness killed it."[33] He explained that the same people planned and organized these huge ethnic festivals every year, and that no one was prepared to take over that responsibility from them. Hanan, a highly respected singer of Brooklyn, New York, in recalling the decline of the *mahrajan*, explained that no one replaced the committed individuals who planned and produced the big festivals: "They used to have *mahrajanat*, a long time ago, not any more. They used to get two or three churches together . . . and the old-timers were pleased, there's a lot of money in it for the churches. [But] its a lot of work because the old-time ladies' societies in the church, they always take care of the food. They [the old ladies] used to sit all day long in the hot sun, preparing food in the heat and making shish kebab. The old people, they can't do it anymore."[34]

Jimmy Tayoun, founder of the *Lebanese American Journal,* used his mailing list of ten thousand people to publicize the *mahrajanat* he sponsored during the 1960s. Advertisements for the numerous musicians and personalities who were to appear at the events were published in the *LAJ* and Tayoun offered reduced hotel rates and maps for out-of-town guests. Eventually the *mahrajanat* sponsored by Tayoun and the *LAJ* attracted a variety of people of Middle Eastern heritage. Its popularity eventually waned and became a community memory.

Greeks, Armenians, Assyrians . . . it got to the point where I had as many as ten thousand people. But then I got hit with the Six-Day war [the Arab–Israeli war of 1967]. It was like a ghost town. I lost ten thousand bucks. And the next summer I said, "Well things look better now." [It was] 104 degrees! . . . three or four thousand people in the

motels around the pools, and I'm at the grounds by myself hoping somebody'd buy an admission ticket. So I got killed with that.[35]

The Nightclub Scene, 1960s–1980s

Russell Bunai, along with a number of other 'old-timers,' never made the transition from the church function to the club date; they never worked in nightclubs. Furthermore, they dissociate the Arab community from the evolution of the nightclub. They claim that foreign nightclubs are not an Arab phenomenon but that they originated in the Armenian, Turkish, and Greek communities. On the other hand, up and coming Arab American musicians of the 1960s and 70s, who originally shared the stage with middle-period old-timers, thrived in this exciting environment, which, according to Eddie 'the Sheik' Kochak, emerged during the 1960s in the Greek restaurants along Eighth Avenue in New York City. The nightclub music created during the 1960s and 1970s was adventurous, creative, polyethnic, electronic, and commercial. The music reflected interaction both with other immigrant groups and with American society and music culture as a whole.

Many of the characteristic features of nightclub music—including the driving rhythms that accompany group *dabka* and solo belly dancing as well as the use of Western instruments such as the saxophone, electric guitar, trap set drums, and flute—can be traced to the collaboration between Muhammad al-Bakkar and Eddie 'the Sheik' Kochak. Al-Bakkar, an Egyptian film star, who became the 'Elvis Presley' of the Arab American music scene, capitalized on the tastes of younger American-born audiences for whom Arabic poetry and song texts were insignificant and who "just wanted to dance and have a good time."[36]

The nightclub was an environment for dance, both for the paying public as well as for the paid 'belly dancer.' Different genres of dance may be performed to Arab music. The 'Oriental' style, or belly dancing, is traditionally performed by a woman alone, although today (and in nightclubs) couples may dance together in this style. The Oriental style is characterized by curvaceous movements of the hips and torso, with hands held at shoulder level or higher. It is an improvisatory dance that can be subtle and delicate, bouncy and rambunctious, or erotic, voluptuous, and licentious. *Dabka* dancing, another genre, is a group line dance traditionally performed by men, characterized by squared shoulders, hands held tight with arms touching, and much percussive stamping and stepping. The *dabka* was a rural tradition of immigrants from Mount Lebanon and surrounding areas. Eventually *dabka* dancing became a common activity for both Syrians and Lebanese, especially the children.[37]

Creators of the nightclub music of the 1960s say they respect 'authentic Arabic music'; indeed many of them heard the music while growing up. The music of this generation, however, was tempered to create a product

that was palatable and yet intriguing for mixed audiences. Improvisation, "which can be boring," and Arab intonation, "which has too many indigestive tones for the modern ear," were tightly controlled.[38]

In addition to weekly live performances in urban clubs and eateries the nightclub era also witnessed a surge in the production of LP records of music for belly dancing. On these albums the original composers of traditional tunes were rarely recognized. Song titles were often anglicized ("Camel Hop"), exoticized ("Dance of Contessa"), bastardized ("Chifti," derived from the name of the Turkish rhythmic pattern *çifti telli*) or omitted altogether.[39] Such linguistic alterations were made to accommodate non–Arabic-speaking audiences. Names of rhythmic patterns, tempo indications, and time signatures often replaced the names of songs as exemplified in one recording of the popular tune "Ah ya Zayn" retitled "Medium 2/4." Marketing was aimed at an expanding group of professional and amateur belly dancers who used the recordings for teaching, practice, and performance.

The musicians of the nightclub scene and their audiences included many second- and third-generation Americans of Arab heritage. Their lack of familiarity with the Arabic language, and vocal music in general, comprises the third level of a three-tiered process of language loss—from classical Arabic, to colloquial or vernacular dialects, to the negation of the Arabic language altogether. While progressive loss of language may be an expected result of immigration, the language issue for Arab American music is complicated by the classical/colloquial dichotomy in the Arab world. While no one speaks classical Arabic as an everyday language, it is always used for public speeches and lectures, media broadcasts, in newspapers and published literature, and for some musical genres. Even in non-classical texts, the rules of pronunciation and articulation and the poetic formulas of the classical Arabic language are important components of vocal music compositions and improvisation. Middle-period musicians, some of whom sang classical Arabic lyrics they could not actually understand, nevertheless recognize the loss of classical Arabic language and poetry as a catalyst for the loss of authentic Arabic music.

The complete disregard for Arabic titles and composers' names as well as their control of improvisation and intonation reflect the nightclub musicians' perception of the 'period ear,' the aesthetic sensibility and musical taste of the general public.[40] Nightclub musicians wanted to be in step with the trends of the times. Their motivation was perhaps commercial more than communal, and they strove to gain audience and professional stability on a much broader level than did the musicians of the middle period. They did not want to intimidate either their American-born 'relatives' or the polyethnic American public with an unfamiliar tuning system, long boring improvisations and instrumental numbers, and

odd-sounding foreign titles. The values and techniques of musical compromise and innovation served to wipe out many of the contextual aesthetics of the middle-period *hafla*, namely an older repertoire rooted musically in the *maqam* system and textually in the Arabic language, and non-commercially motivated performance events held by and for communities wherein artist–audience relationships were thought to be based in appreciation and respect.

A Matrix of Periods and Processes
In conceptually organizing the path of change for this protean music system, we might envision a matrix of these four periods—the 'early years,' the 'middle period,' the 'nightclub scene,' and 'contemporary times'—intersected by at least three processes: marginal preservation, transplantation, and innovative assimilation, all of which are rooted in the musically fertile middle period. These processes were set in motion by the ideas and accomplishments of cultural leaders such as those described in this article. While most of the choices and actions of middle-period musicians were voluntary, some of them are defined here as proactive and others as reactive. For example, musicians' instigation of new events for music making and their introduction of new musical styles may be described as proactive; these actions set precedents for other musicians and eventually became accepted trends. On the other hand, musicians' perceptions of the tastes and expectations of their audiences resulted in reactive compensation.

Due to the prevalence of Syrian *sammiᶜa*, the importance of imported 78 r.p.m. recordings of Egyptian/Syrian classical music, and the musical performances and recordings of Arab American performing artists, a 'traditional' and 'authentic' music style was preserved in the United States among middle-period musicians and audiences.[41] Traditional vocal and instrumental genres continued to be performed in the New World years after their popularity had diminished in the old country. This marginal preservation is specifically exemplified by singers' recordings of the *dawr* from the late 1940s through the 1960s, the *qasida*, and the *muwashshah*, genres no longer disseminated on 78 r.p.m. recordings from Cairo after the 1930s. Preserving 'authentic' Arabic music was consistent with an implicit common code of contextual aesthetics that musicians and patrons proactively instilled in the performance events of the middle period.

Direct transplantation of the newest tunes from the old country was (and still is) a continuous process. During the first half of the century, musicians would travel to New York to get the 'samples,' the newly imported hits from home. They would borrow the records, learn them, perform them on the *hafla* and *mahrajan* circuit as well as on the Arabic radio shows in New York, Boston, and Rhode Island, and popularize the

music to the delight of audiences and record importers. Musicians' choices were more or less dictated by the modern trends of Cairo, especially film songs and *taqatiq*, both of which used colloquial Arabic.

"I always did sing classical Arabic, but because of the young American-born children, I took care of my program," Bunai explained. "I picked the cutest songs to please them."[42] His wife Rose continued:

> Well in those days, they would listen, you could hear a pin drop when Russell sang. Those that really knew the language liked the classical songs. They would sit and say "aaaahh," you know how they go. But the youngsters that were brought up in this country, who didn't know the language, they didn't want "ya layli" [vocal improvisation]. What they wanted was the folk song. When he played the tambourine and sang a song they could dance to they loved it! Whenever he would sing it [folk music] they'd go nuts.[43]

The comments of music patron, producer, and 'old-timer' Albert Rashid, whose family is still one of the largest importers of Arabic music, videos, and printed material, also reflect the tension between the performance aesthetics of 'authentic' music, and the commercial potential of the popular. "I liked *haflat* where *sammi^ca* listened and enjoyed it . . . no drinks, no eats. When you have a setup with tables and drinking and hollering and dancing, that to me was not music, just a good time."[44] In spite of his traditionalist attitude, Rashid, always attentive and reactive to the changing tastes of his American audience, clearly felt that recordings of Egyptian classical music were inaccessible to the Levantine families in the United States. Due to *his* perception of the 'period ear,' he imported scores of film songs and light music in colloquial dialect—music he thought would sell.

Finally, innovative assimilation, which may be described as both proactive and reactive, may be heard on the recordings of Anton Abdel Ahad, a middle-period singer, composer, and ^c*ud* player. In addition to transplanting all of the hits of the popular Egyptian composer ^cAbd al-Wahhab,[45] Abdel Ahad set Arabic words to Italian and American popular music and composed humorous songs about the shortage of housing and of ladies' nylon stockings, subjects that were relevant to his audiences during the Depression. Innovative assimilation was, of course, central to the musical methodology of nightclub artists.

My interviews and experience of the contemporary music scene of the 1990s confirms that the dynamic energy of the *hafla* has not been lost. During the middle period, however, that dynamic energy resulted from the solidarity of the community, who joined together in order to raise money for a good cause, and from the interaction between the musicians and their audiences. The musicians, who performed a varied repertoire of

'authentic' and lighter music and improvised in a traditional idiom, played for the listening connoisseurs and their families who in turn responded with verbal compliments and encouragement.

As in the old days, it is the choice and order of music styles that determines the response and social conduct of audiences. Today's musicians are prepared with a battery of the latest hits from home as well as the technological advances in performance ensembles that demand the volume of a sound system, synthesizers, and drum sets. Audience response takes the form of almost continuous group *dabka* and Oriental-style couple dancing. Older musicians, however, complain that unlike the old days, they can no longer assert aesthetic authority in their choice of a musical program. *Haflat* have lost their audiences of true *sammiᶜa,* the members of the audience who were crucial for the musical leaders of the past. Those who still enjoy the 'heavy stuff' listen to or perform this music only on recordings, in a concert setting, or at a private *sahra* or house party. Older musicians themselves have lamented their lack of leadership, saying that they have no control over the audience. "Business is business. You give the people what they want [and] all they want is *dabka.*"[46] Virginia Solomon is overwhelmed by the social process occurring at Rhode Island *haflat:*

When we used to go to a *hafla* you would listen to the musicians and the singer, and during the intermission you would do the *dabka* or have solo dancing [Oriental or belly dancing]. Now the music plays up on the stage and before you know it here come the couples and they're dancing Arabic disco. It's amazing you know, we just sit back and watch it. [Before] if you ever got up to dance while a singer was singing not a dance number but a classical number, wow! You were committing . . . it was awful. You couldn't just get up and dance, you waited until they had the special dance music. Now it is entirely different.[47]

This type of social behavior is for the most part tolerated, indeed expected, and even appreciated by musicians who, like their audiences, judge the success of the event by the amount of fun had by all. Musical appreciation and sophistication, as conceived by the 'old-timers' of the middle period, have taken a back seat to social interaction. While some professional musicians complain about their ignorant audiences, few of them can really tackle the 'heavy stuff' or play more than a quick cliché *taqasim*; they are both victims and advocates of the patterns of mediocrity that are by-products of the good intentions and rational decisions of creative artists, appreciative audiences, and supportive patrons of the middle period.

Conclusion

The *hafla* and *mahrajan* were events of an era of Arab American musical life in which musical and social values and contextual aesthetics werè tested, defined, and combined. Musicians and patrons based their actions upon their own creative ideas as well as on the social needs and artistic expectations of the community. Their moves to institute reserved tables, *mazza* drinks, and a little popular music for the young folks came in response to short-term goals and concerns. Taken collectively, however, their actions had the long-range effects of 1) destroying a reputable patronage system in favor of commercialism and capitalism, 2) replacing an 'authentic, strictly Arabic' musical repertoire and performance tradition with a simpler and more heterogeneous musical fare, and 3) transferring the social role of the musician from that of an authoritative specialist to that of a professional servant.

I have attempted here to describe an ongoing historical process by examining the relationship between the middle-period musical system and the individual actors who created that system. An understanding of contemporary trends and future developments may be possible using this focus on performance events as dynamic structures where residual and emergent cultural forms are tested and rearranged. I close with a thought from the French philosopher, Michel Foucault: "People know what they do, they frequently know why they do what they do, but what they don't know is what what they do does."[48]

Notes

1 This article is based on field work and research originally conducted during 1986–89 and published in the *Pacific Review of Ethnomusicology*, vol. 5, 1989. I am grateful for their permission to publish this revised version of that article. The work appearing in this volume benefits from additional field work and interpretation, reflected in my dissertation (Anne K. Rasmussen, "Individuality and Social Change in the Music of Arab Americans," Ph.D. dissertation, Department of Music, University of California, Los Angeles, 1991) and drawing on continuing field work in various Arab communities, especially those in Massachusetts, Rhode Island, Pennsylvania, Detroit, and New York. Among the many community members whose comments are incorporated in the article, I am especially grateful to Anton and Mary Abdel Ahad, Russel and Rose Bunai, Warren David, Georgiana Deckey, Albert Rashid, and Virginia Solomon. I also wish to thank Jihad Racy and my colleagues Virginia Danielson, Scott Marcus, and Jane Sugarman for their invaluable perspectives and Sherifa Zuhur for her interest and patience.

2 Ortner describes an emerging theoretical orientation which she calls 'practice,' 'action,' or 'praxis.' The analysis of my data on Arab American musical life follows a similar dialectical approach in my consideration of the reciprocal effects of people's decisions and actions upon a musical system and the effects of that system on its participants. Sherry B. Ortner, "Theory in Anthropology

since the Sixties," *Comparative Studies of Society and History,* 26:1 (1984), 126–166.

3 Anne K. Rasmussen, "The Music of Arab Detroit: A Musical Mecca in the Midwest," in Anne K. Rasmussen and Kip Lornell, eds., *Musics of Multicultural America* (New York: Schirmer Books, 1997).

4 Eric J. Hoogland, ed., *Crossing the Waters: Arabic-Speaking Immigrants to the United States before 1940* (Washington, D.C., and London: Smithsonian, 1987), 1. [Editor's note: This law affected Arab immigrants, but there were earlier restrictions on other categories of immigrants—Chinese women, for example.]

5 Ibid.

6 For information on early Arab immigration to the United States see Philip Hitti, *Syrians in America* (New York: George Doran, 1924); Philip M. Kayal and Joseph M. Kayal, *The Syrian–Lebanese in America: A Study in Religion and Assimilation* (Boston: Twayne, 1975); Alixa Naff, *Becoming American: The Early Arab Immigrant Experience* (Carbondale: Southern Illinois University Press, 1985); and Alixa Naff, "Arabs in America: An Historical Overview" in *Arabs in the New World: Studies on Arab American Communities,* Sameer Y. Abraham and Nabeel Abraham, eds. (Detroit: Wayne State University, Center for Urban Studies, 1983). For studies that include information on both early immigration and the recent and continuing wave of Arab immigration see Abraham and Abraham, eds., *Arabs in the New World* and Hoogland, ed., *Crossing the Waters*.

7 Rasmussen, "Individuality and Social Change"; Anne K. Rasmussen, "'An Evening in the Orient': The Middle Eastern Nightclub in America," in *Asian Music* 23:3 (Spring/Summer, 1992); Anne K. Rasmussen, "Theory and Practice at the 'Arabic org': Digital Technology in Contemporary Arab Music Performance," *Popular Music* 15:3 (1996); Rasmussen, "The Music of Arab Detroit."

8 All of my informants discuss the importance of listening to imported and domestic 78 r.p.m. recordings of Arab music. Anton Abdel Ahad (who, as a child, was responsible for cranking the Victrola record player) recalls his father paid up to eight dollars for imported 78 r.p.m. recordings from the old country. A collection of music recorded by Arab American artists on 78 r.p.m. between 1915 and 1950 has been released on Rounder Records, October 1997. See Anne K. Rasmussen, *The Music of Arab Americans: A Retrospective Collection,* compact disc with documentary booklet (Rounder Records, 1997) for reissued recordings by Bunai, Abdel Ahad, Solomon, Hanan and several other Arab American musicians.

9 Alixa Naff, *Becoming American*, 16.

10 Naff has suggested that peddling, the primary occupation of the first Arab immigrants, hastened their acculturation by encouraging them to travel widely, learn English, and, consequently, adopt American values (Naff, "Arabs in America," 117). Like many ethnic groups, Arab immigrants pursued the 'American Dream' and gradually detached themselves from their heritage and cultural traditions. The ideological wheels that were set in motion by the civil rights movement deemphasized the popular notion of America as a melting pot; cultural diversity became tolerated, even fashionable. As a result, many

third- and fourth-generation Arab Americans began to reassert or rediscover their heritage; Abraham and Abraham, eds., *Arabs in the New World,* 3. Most recently, the influence of new immigrants from the Arab world and their struggle for political power and human rights have further reinforced the revitalization of ethnic identity in America.

11 Hitti, *Syrians in America,* 34.

12 Marlene Koury Smith, "The Arabic Speaking Communities in Rhode Island: A Survey of the Syrian and Lebanese Communities in Rhode Island," in Joan H. Rollins, ed., *Hidden Minorities: The Persistence of Ethnicity in American Life* (Washington D.C.: University Press of America, 1981), 149.

13 Personal interview with Georgiana and Blanche Deckey, Providence, Rhode Island, 17 June 1988.

14 Personal interview with Virginia Solomon, East Providence, Rhode Island, 23 July 1987.

15 Hitti, *Syrians in America,* 87, 90.

16 Kayal and Kayal, *The Syrian-Lebanese in America,* 89–111.

17 Evelyn Shakir, "Good Works, Good Times: The Syrian Ladies Aid Society of Boston 1917–1932," in Hooglund, ed., *Crossing the Waters* , 133.

18 Ibid., 137.

19 Ibid., 139.

20 Personal interview with Anton Abdel Ahad, West Roxbury, Massachusetts, 20 July 1987.

21 Personal interview with Russell and Rose Bunai, Cambridge, Massachussets, 21 July 1987.

22 Ibid.

23 ᶜAli Jihad Racy, "Music in Nineteenth-Century Egypt: An Historical Sketch," *Selected Reports in Ethnomusicology* 4 (1983); ᶜAli Jihad Racy, "The Record Industry and Egyptian Traditional Music: 1904–1932," *Ethnomusicology* 20:1 (1976).

24 ᶜAli Jihad Racy, "Sound and Society: The Takht Music of Early Twentieth-Century Cairo," *Selected Reports in Ethnomusicology* 7, 1988. During the first few decades of the twentieth century there were few *nay* players in the United States (I have yet to discover a domestically produced 78 r.p.m. recording with *nay).*

25 Musical genres and repertoire do not always fall into such clear-cut categories as classical or popular. Most Arab American musicians do make a clear distinction between what they call 'light music'—music for dancing, folk songs, or simple strophic *taqatiq*—and the 'heavy stuff,' which refers to more complicated instrumental pieces incorporating improvisation that requires the exposition and manipulation of the Arab modes.

26 Personal interview with Anton Abdel Ahad, 1987.

27 ᶜAli Jihad Racy, "The *Waslah*: A Compound-Form Principle in Egyptian Music," *Arab Studies Quarterly* 5:4, 1983.

28 Personal interview with Virginia Solomon, East Providence, Rhode Island 23 July 1987.

29 Personal interview with Albert Rashid, Brooklyn, New York, 31 July 1987.

30 Interview with Jimmy Tayoun by Dwight Reynolds, 1985.

31 Kayal and Kayal. *The Syrian-Lebanese in America,* 195.

32 *Mahrajanat* still occur in various Arab American communities. Their structure and spirit, however, differ radically from those held in the past. During the course of my field work, I attended small afternoon or weekend *mahrajanat* sponsored by churches in tightly knit Arab communities in New England. In contrast to these community events, the *Mahrajan al-ᶜalam al-ᶜarabiya,* or Arab World Festival, is a city-sponsored festival that has been held annually for the past eighteen years in Detroit, Michigan. This three-day festival draws a general audience of several thousand, the majority of whom are Arabs from the diverse communities of Detroit. The festival is ecumenical in- its presentation of professional and amateur groups representing every nationality, religion, and community from the surrounding area.

33 Personal interview with Albert Rashid, 1987.

34 Personal interview with Hanan Harouni, Brooklyn, New York, 1 August 1987.

35 Interview with Jimmy Tayoun by Dwight Reynolds, 1985.

36 Personal interview with Mary Abdel Ahad, West Roxbury, Massachusetts, 20 July 1987. This statement was reiterated by Jalil Azzouz (29 June 1988), Anton Abdel Ahad (16 June 1988), and Virginia Solomon (23 July 1987), among others.

37 Kayal and Kayal, *The Syrian-Lebanese in America.* Although there are several regional and national styles of *dabka* dancing and many different step patterns that may alternate, most groups perform a simple repetitive pattern of four to seven steps as established by the leader of the line.

38 Eddie 'the Sheik' Kochak explained to me that Americans have little patience with the long improvisations characteristic of traditional Arab music. He feels that general audiences do not enjoy the "weird sounding" quarter tones that appear in some Arab modes (Personal interview with Eddie Kochak, Los Angeles, California, 8 November 1986). Freddy Elias, another important musical innovator of the nightclub era, has repeatedly described these quarter tones as "indigestive tones," which, he fears, will give American audiences "migraine headaches " (Personal interview with Fred Elias, Cambridge, Massachusetts, 2 July 1987).

39 "Camel Hop" is from the album *Ya Habibi* by Eddie 'the Sheik' Kochak, Hakki Obadia, and their Amerabic Orchestra (Audio Fidelity AFS 583). "Dance of Contessa" was composed by nightclub musician Freddy Elias and may be heard on his album *Arabic Moods for Dance, Vol. 2* (Intrasonic Records IS 2003).

40 Michael Baxandall organizes his study of visual aesthetics, *Painting and Experience in Fifteenth-Century Italy* (Oxford and New York: Oxford University Press, 1972), around the notion of 'the period eye.' I find an analogous term, 'the period ear,' quite useful here, for I try to discover what the community palate or sense of musical aesthetics was during different historical periods and in various communities.

41 The interaction between Arab American musicians and such visiting artists from the Near East as Zakki Murrad, Sami al-Shawwa, and Muhammad al-ᶜAqqad also contributed to the prevalence of an 'authentic' repertoire.

42 Personal interview with Russell Bunai, 1987.

43 Personal interview with Rose Bunai, 1987.

44 Personal interview with Albert Rashid, 1987.

45 Egyptian singer, film actor, and composer Muhammad ᶜAbd al-Wahhab is considered the most important male artist in the Arab world during the twentieth century. His innovations set a precedent for the modernization of Arab music in terms of style, instrumentation, and form. His music was especially popular from the 1940s to the 1970s.
46 Personal interview with Kerim Badr, Detroit, Michigan, 24 June 1988.
47 Personal interview with Virginia Solomon, 1987.
48 Personal communication cited in Hubert Dreyfus and Paul Rabinow, *Michel Foucault: Beyond Structuralism and Hermeneutics* (Chicago: University of Chicago Press, 1982), 187.

9

BEYOND THE PERFORMANCE

Simon Shaheen

Interview by Sherifa Zuhur[1]

Simon Shaheen was born on February 1, 1954 in Tarshiha, a village of 2,500 persons, close to the Lebanese border and the city of Haifa. A Palestinian who grew up and was educated within the state of Israel, he now resides in Brooklyn, New York. Shaheen is considered a virtuoso performer on the Arabic violin, and the ᶜud.[2] His recordings include Taqasim: Improvisation in Arabic Music, The Music of Abdel Wahhab, Turath, Hallucination Engine, *and* Sultaneh. *His music can be heard in the films* Malcolm X *and* The Sheltering Sky, *and in the stage plays* Majnun Laila *and* Collateral Damage. *He was asked in this interview to define his perceptions of the musician's role, and his own relationship to music.*

* * *

How influential was your father, Hikmat Shaheen [a performer, conductor, and teacher of Arabic music], in your decision to pursue Arabic music as a career?

He never forced me; we did not believe in doing this in our family. But to grow up in this kind of environment—well, you live music every day [Simon's brothers, Najib and William play the ᶜud, his sister Laura sang professionally, Najib is also an ᶜud-maker; all understand the entertainment industry and frequently perform together]. It was my own decision. I remember that when I finished high school, before university—because this is when you really have to make a decision if you want to pursue a career in music—I was talented in math, and chemistry and physics, and I had to make this big decision. I could

157

also have gone to medical school, or become a lawyer. It was very difficult, and very confusing. I lived through a year of confusion, trying to decide what is the value of music, do I want to keep it up, to pursue it, or not? Finally, I just tried to pay attention to what I like; I love music, so I went after it.

The small village of Tarshiha produced your musical family, and the Tarshiha Ensemble, a relatively large musical group of musicians, chorus, and vocal soloists; can you explain why such a place would encourage music?

Yes, it's a small place, and the Ensemble (which Shaheen performs with in international settings) has forty members. And there are more [musicians in Tarshiha]; there is competition to get into the Ensemble.

When you were growing up, did Tarshiha have this musical character, or interest in music?

Yes, it did. Tarshiha was always active musically. It was basically [due to] my father, he's the one who established this momentum. He was deeply involved in music education. He directed two ensembles, one in Haifa and one in Tarshiha. The Tarshiha ensemble was called the Arabic Music Ensemble. At Haifa, he established the Arabic conservatory, which offered instruction in Arabic music for the first time. Music education was his forte. Without him, the music education front would have been a disaster [in the area].

Also this idea of preserving Palestinian folk music, he did a lot of work in this vein. Because after [the defeat of] 1948, he was alone— most of the musicians and poets left, writers, thinkers, most of them left Palestine. And the one who came back and then remained there was my father. He felt a great responsibility in carrying on this project.

Did he want you to have an education in Western classical music? Was he himself educated in Western classical music?

No, he only knew Arabic music. It was my decision to study Western music. But he agreed with whatever I wanted to study. I was seven years old when I started at the conservatory. I studied the violin on an on-and-off basis until I was eighteen. I would say that altogether this was about five or six years of instruction. And then I continued at the Academy of Music [at the Hebrew University in Jerusalem]. I studied violin, harmony, counterpoint, literature, history, all these topics. I started to teach in those years, and to play concerts. Concerts were not the fashion there.

Did people play music in each other's homes and at parties?

Oh yes. In each other's homes, and the regular party circuit like weddings and so on. But no concerts. The Arab population did not

understand the concept of 'concert.' So I started to tour. I played in Jerusalem, in Jaffa, in Haifa, in the North, Galilee, even in villages. This was between 1974 and 1980. At that time I decided to leave and travel to the United States.

Why?
[A laugh.] Well, for education. My sisters and brother were there, so it was easy for me to obtain the green card and citizenship. I went [emigrated] because I knew I wanted to pursue a career in music.

Had you completed a bachelor's degree?
Yes, at the Hebrew University in Jerusalem; the Academy of Music is there.

Where did you study in the United States?
I went straight to the Manhattan School of Music. I took violin and composition. I studied music education and courses in musicology at Columbia. [While he studied, he worked in nightclubs, not for a very lengthy time, and in the Arabic party and festival circuit, in order to support himself. Legitimate concert venues were his goal].

While I was studying, I met so many agents, heads of institutes who pushed me to give concerts. So I started in New York, and little by little I started to work out of the area, in Boston, in Washington. The most important aspect of this period for me was that I wanted to deal with Arabic music, the artistic side of Arabic music. On the other hand, I met all these great musicians in New York; we did some great fusion [performances and recordings that combine Arabic music with other musical forms]. I started to deal with new elements in my own music, in my own composition and performances.

Do you consider your music to be world music?
I don't know what to call it. Probably it is the collision of so many great artists in one place and the effect of being exposed to so many different kinds of music. Whether I like it or not, I heard the finest Indian music, and whether I like it or not, I heard the greatest Persian music in New York. You are there—it hits you in the face.

The fusion elements are exciting in your new compositions. Is there a difference between these two compositions and your other work, like "Sama'i Kurd Shaheen?" Was that composition closer to the tradition of Arab classical music?
Right. Yes, but [in the newer compositions] I depended very heavily on the maqamat [the modal structure], on Arabic rhythms, and I included improvisational sections. So I included the key elements from

Arabic music. But the question is the composition itself—it is how
you weave in the melody, and establish all these counterpoint voices
around it—which is not a harmony. You know? The violins have a
theme, and I am playing some broken chords in the form of a melody,
the flute has another line, and the cello has another line. [In the
performance of his compositions staged at the Arab Music Festival in
Cairo, 1997.] You did not hear the cello used as it usually is in
Egyptian compositions, either played pizzicato, or in unison with the
violins; no, you hear a distinct cello part in this piece. You could hear
that we had three percussionists, the *darbakka*, the congas, and the
tambourine, right? Each was doing something different—you didn't
hear them play the same rhythm at the same time. The rhythm is
established so that each is playing his own part, but they coincide at
certain points. So these are some of the ideas found in my
compositions. And there is a certain amount of virtuosity required,
which we don't hear that often in the Arab world.

*You disseminate Arab music beyond an Arab audience. Why do you
engage in these efforts?*
Yes, I do, in performance and in music education. This becomes a
natural instinct, an element. One has to think about how to convey this
music, this art, to a non-Arab audience, whether an American or a
European audience, or even in Japan. When I came to the United States
in the 1980s, the Arabic music scene was a disaster. The only one who
was dealing with the situation was Jihad Racy in California [professor
of ethnomusicology at the University of California, Los Angeles].
Arabic music was viewed as cabaret music, and people composed
whatever they imagined to be Arabic music; whatever suited the
[nightclub] business.

 I began giving lectures, and lecture-demonstrations, master classes,
and private lessons. We established a large ensemble, and then the
Brooklyn and New York City Mahrajan [an annual music and dance
extravaganza] and a summer music retreat in Massachusetts. So
Americans did have a chance to be exposed to Arabic music in its true
form. In other words, we play the traditional repertoire.

Do you play folk music?
No, not much. We [The Near Eastern Ensemble] play some tasteful
popular music, such as the songs of Asmahan or Leila Murad. [The
ensemble also features suites of traditional folk melodies arranged by
Shaheen, as for example a "Medley of Palestinian Folk Melodies."] I
combine in our programs very traditional repertoire such as
muwashshahat, adwar, and *taqasim,* with more popular music that is
still interesting and attractive to the Western ear.

Do you accept the division between 'al-qadim' and 'al-gadid?' These are the terms used by musicologists and laypersons in Egypt to describe the break between the old and the new genres of Arabic music.
No. For example, I wrote a *samaᶜi* [in 1991] that is in a traditional form, and so such divisions have nothing to do with time.

Tell me about your Arab audience, in the United States and abroad.
When I first began playing [in concert format] in the United States, our Arab audience consisted of only 5 to 10 percent, and today they make up about 50 percent of our audience. On the other hand, Arabic institutes and organizations invite me to perform for all-Arab audiences as well.

Those who know me and come to my concerts are musically inclined and understand what they hear. But there is also a huge segment of the Arab population in the United States who know nothing about music. They cannot differentiate between genres, or styles. They do not comprehend the meaning of 'traditional,' or 'classical,' 'popular' or 'folkloric.' When they listen to a pop song, they think this is all there is to Arabic music.

As for my Palestinian audience—in the United States, they are always part of a larger Arab audience, unless I've been invited to perform at a specifically Palestinian event.

And here in the Middle East; were you happy with your performance at the Opera House yesterday? I thought you were.
No, I was responding in a sarcastic way. [The volume of the amplification had been turned down during the entire performance, so he, as soloist, and the Tarshiha Ensemble were forced to play as loudly as possible. The volume was restored immediately after the Palestinian ensemble left the stage.] Of course when we performed in Haifa, there was a completely different atmosphere.

What is your plan to broaden the scope of Arab musical activities?
I started to consider establishing an Institute for Arab Arts several years ago, and to search for funding. It will be basically a conservatory for teaching music on two levels, to children, and to adults. For the children, we really have in mind the Arab population, to make sure they commit themselves and their children to conservatory training. It would be a home for the Near Eastern Music Ensemble, which I am now expanding. We want to hold monthly performances, or recitals, and host guest poets, or guest visual artists. There is no institute to arrange [for] or absorb any visiting artists who come to visit the country, unless they have some sort of academic sponsorship.

Why is it necessary to train musicians?
The reality is that there are five million Arabs in the United States. Why should we simply import and regurgitate imported art? The opportunities are different, and spark new ways of thinking that should create new music, new art, new poetry. Think about the Pen group [al-Qalamiya, see Rasmussen in Chapter 8], Kahlil Gibran, and Elia Abu Mahdi—they changed the course of Arabic poetry and literature—and they lived in the United States, they didn't live here in the Middle East!

What happens to your identity when you are removed from the region?
The educated Arab feels an enhanced Arab identity, and deals with the issue by emphasizing what is traditional, what is classical, and by trying to preserve the past. But if we want to develop our art, and enter an experimental phase, well then, the environment in the United States allows it. I do not think that in the Middle East I have actually seen very many attempts to experiment, or to develop really new artistic ideas. It's important to go beyond an elite audience, and make an attempt to educate the public about music—is this happening in the Middle East?

You left Israel, but visit. What is the situation for Arabic music there?
There is no creativity—musicians do not compose music that has a powerful identity. Only recently in the last four or five years have some attempts been made to perform traditional Arabic music to the best of their ability. The Tarshiha Ensemble is one of these efforts.

On the other hand, folk music is still the most powerful element—along with poetry, in the villages—like the *zajal*. But as far as 'art music' is concerned, there are good musicians, who basically imitate other good musicians they have heard in the Arab world, but I do not think they are creative.

Now there is the Radio Orchestra *(Firqat dar al-ida'a al-isra'iliya)*, which was established by the Israeli government for the performance of 'oriental' music. They set the aesthetics for this sort of music. Most of their productions and recordings were performed by Jewish musicians who came from Cairo, Damascus, or Baghdad. They gathered there and established the orchestra, and are all Jewish. They are not bad musicians, I'm not saying that. But their work and their compositions set the caliber for Arab musicians, who began to imitate their style. Their compositions have no identity. They just dump in melody and words which have no meaning. Politically, you understand, they cannot choose lyrics with any important meaning. So they have to use bland or meaningless poetry. So my idea when I first started to perform was to focus on live performances, a sort of alternative to radio

music. I have returned and performed in this way on three different visits back.

Is the Tarshiha Ensemble a new, or a revived group?
The Tarshiha Ensemble is a sort of continuation of the ensemble my father started. There was a hiatus for the old group, because my father was concentrating on his activities in Haifa, and he could not keep up both. So in 1987 or 1988, a group of young men and women in Tarshiha had a meeting and decided to revive the ensemble. Some of the older members began, and little by little the younger generation has replaced the older generation. They make no money [from the Ensemble], they all have other jobs, they are professionals.

Why is music acceptable in this relatively small village setting?
In Tarshiha, music is accepted on a social level. Parents will not, however, encourage their children to pursue music as a career. They want them to study medicine, or law, and keep music on the side.

What are you working toward—what is your goal?
I'll tell you what. Creativity is the bottom line, isn't it. I want to compose, and I want to be creative. My problem is that I have had to establish a career, actually manage myself and others, be a music educator, deal with boundaries between my audience and myself, and try to defend myself as well from the media which can, as you know, be very destructive. We [Arabs] are not part of the mainstream—we have to use our own *ta^ca*, our own energy, and commitment, otherwise one is easily dismissed.

Now, I have some other people who can help with management and coordination, so hopefully I will have more time to compose. I know that what I compose, or think of composing today, will not come tommorrow.

I am performing without practice, which I need. I used to practice a lot, yes, now it's only an hour or so before performances. It took me years with the Ensemble to help them read [music]; they are great musicians, they are fantastic, but I have to work so hard with them to have them reach their capacity.

Is Arabic music losing its spontaneity while it is being improved technically?
It depends how you define spontaneity. If you are talking about the art of *taqasim*, it is still present—it will never disappear. And considering yesterday's performance—the [Shaheen's] violin improvisation was very Arabic. I was performing *passagios*, double stops, all these technical additions, but I chose that *maqam*, Nawa Athar, because it's a

very deep *maqam*. Unless people lose their skill at *taqasim*, Arabic music will keep its spontaneity.

The standardization of playing, projecting, working on pronunciation, this is all occurring, but it is not enough. If you compare Umm Kulthum's ensemble, and a band today—well they [the modern ensemble] may be technically correct, but it is the difference between heaven and hell.

The old bands really played the *maqam* to its full capacity in terms of the intervals within the *maqam*. This is a very important point. The pitches are not identical in one piece as compared to another. The *qanun* should have eleven or thirteen *ᶜuraba* [the small pieces which may be flipped over to press against the string, altering the note by a microtone] or none, because the older style, which depended on pressing the string itself, had been replaced with one having the eleven or the thirteen *ᶜuraba*. Muhammad Abdu Salih, you know, the *qanun* player who performed with Umm Kulthum, he was the champion of the eleven or the thirteen [*ᶜuraba*] and used the correct intervals. This doesn't exist anymore [in the Middle East]. Now, they only have four *ᶜuraba* [so one cannot play the smaller intervals]. And with the keyboards and guitar—well, the Arabic 'ear' in the street has adapted to the new 'pop' sound and cannot distinguish the sensitive intervals and pitches—they have no taste for it anymore. It doesn't make any difference to them. When I listen to my old 78 r.p.m. recordings, the most beautiful element for me is to listen to a singer and hear these micro-intervals—they could enchant you, or kill you.

Notes

1 Personal interview with Simon Shaheen, 8 November 1997, Cairo, Egypt. Questions and information are also based on previous communications dating back to 1982.

2 Also see Kay Campbell, "A Heritage Without Boundaries," *Aramco World* 47, no. 3 (May–June 1996) for information and discography.

10

GENDER AND POLITICS IN CONTEMPORARY ART
ARAB WOMEN EMPOWER THE IMAGE

Salwa Mikdadi Nashashibi

While the US taxpayer continues to debate freedom of expression in the arts and the future of the National Endowment for the Arts, American artists are looking back at the aftermath of public outrage at the Mapplethorpe, Serrano, and Harold Washington exhibitions and trying to come to terms with their role in society. Their art is becoming less marginalized and less commodified as they reclaim its social and political reality and make its content more accessible to interpretation by the public. Carol Becker argues that the majority of artists were working in an isolation defined by the absence of a continuous discourse with a world beyond that of the artistic community. Those who tried to use popular imagery—appropriating figures or characters from advertisements or cartoons already part of the mainstream—were not taken seriously by the public; their work was ridiculed. Some used a visual language that depended upon 'hidden signifiers' seldom understood by their audience, while others used less subtle imagery, alienating viewers with overtly sensational messages.[1]

Contemporary art in the Arab world, though relatively young, is facing a similar predicament. Modern art, with its inherently Western idioms, is still marginalized in Arab cultures, its audience limited to the educated elite and the wealthy. Its content is considered incomprehensible and obscure, and too 'Western' for the general public. Introduced to the Arab world by the colonialists, modern art education based on Western techniques and styles has been the cornerstone of art curriculums in almost all the Arab universities. With a few exceptions, Islamic art is studied from a historical rather than an analytical perspective, and little attention is given to new trends in art that are forging a cultural

authenticity derived from the Islamic/Arabic heritage, and its relationship to pre-Islamic art, or its contributions to international aesthetics. Art historian Afif Bahnassi blames the educational systems in the Arab world that have neglected cultural studies and have only recently started translating available texts on Arabic and Islamic art. He also attributes the public's disregard for modern art not so much to their ignorance, but to its apparent lack of cultural ties to their heritage. Bahnassi asserts that the only way to resolve the 'authenticity' of a culture is to create works that are unique in their aesthetic foundations, rejecting all foreign elements, and relying on the personal and cultural to merge in new ways that would begin to redefine the elements that make a culture 'work.'[2]

With little research on this subject, many artists are experimenting and working independently of each other, trying to resolve issues of 'authenticity' and modernity. Salwa Choucair and Wasma'a Chorbachi are two Arab women artists who have tackled these issues. A review of their experiences is summarized in the section 'Crisis of Identity' below. These artists have chosen to work within a social and political context; they represent a growing number of *socially conscious* artists.

What are their issues of concern? Who is their audience? Who are the gatekeepers of this political art form? What kind of visual language is used? Have they succeeded in initiating a dialogue? For several years these artists have been testing and questioning the political boundaries of the arts without the luxury of government subsidies. Who are their patrons? Do they face censorship? How is their work interpreted by a Western audience? While this paper does not present a full picture of women's contributions in the arts, it does try to draw attention to a growing number of artists who are confronting these questions. The following pages are intended to shed light on some of these questions by looking at the works of several artists who have devoted some years to specific political or social issues.

Historically, Arab women artists have played an active role in the development of current artistic movements of the Arab world. Before the introduction of contemporary art forms, many Arab women excelled in the art of weaving, embroidery, and pottery. Works of art in themselves, traditional crafts influenced contemporary artists working in Western idioms with oil paints and watercolor. Throughout the period of decline in Islamic art between the sixteenth and the mid-nineteenth century, Arab women artists' role in the early development of contemporary art is relevant to the appreciation of the arts within the community.

Studio Art and the Modern Middle East
Egypt
Arab artists today are heirs to a legacy of more than thirty centuries of artistic endeavor; their studio art tradition, however, is fairly young.

Easel painting, for example, was introduced to the Arab world during Napoleon's Egyptian expedition in 1798. In the 1890s women from the Egyptian aristocracy were taught painting and drawing by private European tutors. Among the women artists of this early period was the leading feminist Huda Sha°rawi.

In 1908, the first institute for the arts to offer classes in Western styles and techniques opened in Egypt. The school accepted artists from villages and towns, offering free education to all talented students. In the 1920s the Egyptian parliament guaranteed freedom of expression for artists and bestowed official protection on the arts.[3] By then art education was accessible to all sectors of the population. Art was introduced into the curriculum at girls' and boys' schools, and in 1939, in the newly opened Higher Institute of Fine Arts for Female Teachers, which became coeducational in 1947.[4]

In the 1930s, a national Egyptian movement in the arts representing the struggle against colonialism was established, with women artists participating as active members. Incorporating nationalist ideals in their work, they drew on pharaonic symbols and depictions of peasant life using Western techniques and styles. Surrealism was another important influence in the work of Egyptian artists, irrespective of gender. In 1952, Egyptian artists celebrated the revolution and their independence with a renewal of the national movement, replacing pharaonic with Arab imagery. Art with scenes of victory, folk traditions, and festive celebrations in country settings became popular. Political poster art and other propaganda art was produced and became known as the 'art of the people.' Women artists, however, were not part of this movement, their work continuing to center on human compassion, conditions of women, and human relationships, as exemplified in the works of Gazbia Sirry and Tahia Halim. Their work during this period was both personal and political.

The artist Inji Efflatoun (1924–1989), a feminist and social activist, portrayed laborers and the poor. Brought up in an upper middle-class Egyptian home, and educated in French parochial schools, Efflatoun studied Arabic as a second language. It was her art teacher, Kamel al-Tilmisani, who introduced her to the life of the Egyptian peasants and their struggle for human rights. She advocated restructuring what she saw as the master–slave relationship between landowners and peasants to alleviate poverty among the peasant class; she was also committed to feminist rights and represented Egypt at several international women's conferences abroad. Her early surrealistic phase ended in 1946 with her complete absorption in feminist, political, and social work. She began to search for the personality of the Egyptians and the special character of their surrounding environment. In 1960, the government passed a decree authorizing the detention of women for political activities and Efflatoun

was imprisoned for four years because of her political beliefs. She later described (and painted the site of) her incarceration as a victory: "Imprisoning women for their political ideas was an irrefutable admission of their political power and a public proof of their equality with men."[5]

Her paintings of wretched faces of young girls, fellow women prisoners, and laborers are reminiscent of the personalities depicted in Alice Neel's work. Efflatoun's work The Cell (1965, Plate 10.1) portrays life in prison with its cramped conditions; ironically she received a first prize from the Ministry of Culture for her early work in landscape painting while she was in prison. Presently a museum dedicated to Efflatoun is being built in Cairo.

Effat Nagui, who passed away two years ago, also devoted a lifetime to the arts. In 1994 a museum was opened in Alexandria to house Nagui's extensive art work, spanning over sixty years. Because this and the Efflatoun museums are government institutions, they will allow the general public to view previously inaccessible art done by women.

After a period of popularity in the sixties and early seventies, political art, with its overly graphic representation, gave way to more subtle abstract art, with symbols taken from local culture. Later, calligraphy combined with abstract art became—and still is—among the most commercially viable art forms.

Today, several private galleries operate in Egypt, while the government offers a limited subsidized art program for young people. Artists have access to a number of government-run galleries that are open to the public with a free or minimal admission fee. Of the large number of graduates from art academies, few can afford to work as full-time professional artists; consequently, most graduates take teaching positions or work in design or graphic arts.

Lebanon

Around the turn of the twentieth century, young Lebanese artists who had traveled to France returned home to give private lessons in drawing and painting. Most of their students, including the females, were from the elite. It is of interest that at a time when families refused to permit their daughters to pursue higher education in the 'male-dominated' professions such as law and medicine, they allowed them to attend predominantly male art classes. Art was considered a 'safe' occupation for women. These classes included the study of the male nude. While women in Europe attended private schools for women in the arts, art academies in Egypt and Lebanon were open to both men and women. In 1931, four women artists participated in the first group exhibition in Beirut. When the Academy of Fine Arts (l'Académie des Beaux Arts)[6] was opened in Beirut in 1937, a large number of women joined the Academy and art education became accessible to all.

Helen Khal attributes the high visibility of Lebanese women compared to men in modern art to a patronizing attitude in a patriarchal society where men do not feel threatened 'artistically' and as a result provide women with protection and special consideration in the world of art.[7]

By 1960 Beirut, with its freedom of expression and openness to Western thought, had become the cultural center of the Arab world. Its rich and vibrant artistic atmosphere allowed artists to experiment and develop a close relationship with leading writers and poets. Many artists left Lebanon during the civil war, but they still considered themselves as residents of Beirut. They now return every year and many have already had one or more successful solo exhibitions. Today galleries are flourishing, with over a hundred galleries that exhibit contemporary art in Lebanon.

Iraq

In Iraq, painting was introduced at the turn of the century by a group of officers who had received their art education in Istanbul. During British rule and until 1932, there was little progress in art. However, one woman artist received a government scholarship to study art in England in 1930. In 1940–41 the Institute of Fine Arts and the first art society were established; all the teachers were Iraqis.

After World War II, Polish officers and artists introduced the latest European art styles. This led to the expansion of local art trends and artists began expressing a more individualistic style, one greatly influenced by one of the leading Iraqi artists of the period, Jawad Selim, who encouraged Iraqi artists to draw from their local heritage, using symbols and motifs from Babylonian, Assyrian, and Islamic art.[8]

After a series of military coups, the subsequent military dictatorships ended a period of rich artistic endeavors. Following the 1968 revolution, the government initiated an intensive program of art development: it acquired a large number of pieces by Iraqi artists, thus expanding the holdings of the National Museum; it provided unprecedented opportunities for artists to study abroad; it established annual exhibitions that brought artists from several Arab and foreign countries; and it supported several art publications and research in the field. This continued until the onset of the Gulf War; thereafter, and to this day, in the face of food shortages and medical crisis, art has ceased to be a priority.

Algeria

In 1930, France celebrated the 100th anniversary of its colonial rule—and virtual annexation—of Algeria by opening a Museum of Fine Arts to house the large collection of Orientalist paintings by French and European artists living in Algeria. Romantic imagery of Bedouins and

reclining nudes in harems were common themes. Schools of fine art opened in the 1920s; their methods of instruction were in line with the Orientalists' style. Algerians were forced to learn French, while teaching of the Arabic language was prohibited in government schools. The arts, and culture in general, as well as language, were affected. In the 1930s, the first national movement in the arts was established to counter the imposed style. One of its major leaders was Mohammed Racim. An Islamic figurative style was combined with Arabic calligraphy and a three-dimensional perspective. Aside from the self-taught artist Baya Mahieddine, there were few women artists prior to independence in 1962.

Artists joined the liberation struggle and new movements in the arts were born. Berber designs and Arabic calligraphy appeared in abstract formation. Another movement depicted the political problems of Algeria in a bold expressionistic style. After 1962, artists in exile returned home and these two schools continued to flourish. Many Algerian artists today, however, are back in exile for fear of persecution. Recently, several artists, art critics, and the director of the art department at the School of Fine Arts were executed by Islamist extremists who consider art a by-product of Western influence and therefore a cause of decadence.

Palestine

In Palestine, the British mandate stressed training for civil service jobs and did not support or encourage modern art. Artists studied in Europe at their own expense or with scholarships from local missions. Fatima Muhib, a Palestinian, was the first woman artist to receive her masters in fine arts, in 1942. Other women artists from this period were hindered by the unsettled political atmosphere and the threat of war and displacement. Yet traditional crafts of wood carving, weaving, embroidery, glass blowing, mosaic and mother-of-pearl became more advanced. The war of 1948 caused the leading artists Ismail Shammout and his wife Tamam al-Akhal to commit their lives to national art. Shammout and al-Akhal continue to work on the subject of Palestinian rights, human suffering under occupation, and the *intifada*, as well as other themes relating to Palestinian history and identity.

The wars of 1948 and 1967, the outbreak of the Lebanese civil war in 1975, the Israeli invasion of Lebanon in 1982, and the massacre of Palestinian refugees prompted Palestinian and other Arab artists to dedicate works to these tragedies. For Palestinians living in exile and those under occupation, art forms bearing messages of resistance and self-determination have become a means of declaring their national identity. Palestinian embroidery has achieved a similar status in Palestinian culture. An art form passed down through generations, its distinctive patterns and designs could be identified as the heritage of towns and villages that have long been destroyed, or overrun by Israeli settlements.

Colonialism, wars, universities established by foreign missions, the cinema, and more recently the mass media have all affected the cultural models and values of the Middle East. In countries such as Syria, their impact has been resisted, due largely to political factors. In Lebanon the new models and values have been embraced and absorbed, becoming nearly indigenous, especially in urban areas. This defines the process of 'modernization.' Although similar conditions prevailed in other Arab countries, this review is limited to the countries in which the selected artists resided.

Women and Visual Arts in the Arab World

The majority of Arab women artists work independently and do not belong to a feminist art movement. They are well represented in national and regional Arab annual exhibitions, their solo exhibitions receive ample coverage in newspapers and magazines, and most of them are members of local or regional art unions or societies.

Their roles in these societies vary from one Arab country to another, but in almost all the Arab countries women are leaders in art education and outnumber their male colleagues as deans or directors of art departments at Arab universities. In nearly every Arab country women direct over half the museums and galleries (both government and commercial). In the last two decades Jordan has witnessed remarkable achievements by women in the arts. Jordan's only national gallery was founded and continues to survive because of the efforts of Princess Wijdan cAli, who has devoted the last twenty-five years to expanding the collection and to promoting the contemporary artists of Jordan. The gallery is one of the few venues for international exhibitions in Jordan; it also houses the largest collection of contemporary Islamic art in the world.

The Jordanian institution *Darat al-Funun,* also the brain child of a woman—artist and lawyer Suha Shoman—is funded by the Arab Bank as part of a comprehensive cultural program. It is centrally located in the heart of the old city, accessible to the public and to artists, and features a weekly lecture series on art and literature, making it the most popular cultural center in Amman.[9] Women also own and manage over 90 percent of the commercial galleries in the city. The fact that Arab women hold such highly visible and responsible positions in the arts has encouraged many young women artists to exhibit and take on challenging projects.

In the last fifteen years I have conducted interviews with Arab women artists and art professionals living in or outside the Arab world, visited museums and galleries, and attended cultural programs and seminars organized by these institutions. In addition, between 1987 and 1993, I did research in preparation for the traveling exhibition, "Forces of Change: Women Artists of the Arab World."[10] Seventy women artists

living in fifteen Arab countries or in either Europe or the United States participated in this exhibition.

The artists contacted for this exhibition were initially reluctant to join an all-female exhibition. Eighty-five percent of the artists who later participated in "Forces of Change" felt that such an exhibition might send the wrong message in regard to the status of women artists in the Arab world. Yet they were determined to seize the opportunity and to empower the *image* that would counter the misconceptions created over the last two hundred years through the Western monopoly on the representation of the Arab woman in the world media. They made a conscious decision to use their art work as a tool to convey their own message, a personal message, yet also a message of change.

American audiences were puzzled because the exhibition explored many contradictions, and disturbed their categorized imagery of Arabs; one of the exhibition visitors exclaimed, "I'm surprised they would let them do that."[11] Here 'them' refers to Arab women and 'that' refers to modern Western art. This statement confirms the prevalent stereotype of Arab women in bondage trying to escape and be freed by the West, and reinforces the notion that modernism is the exclusive domain of the West. This view of Arab art as static and bound to traditions is still common among curators in the United States. Comments about the exhibition included the criticism that the art work was 'too modern or not Arabic enough,' i.e., not sufficiently Arab to be placed in an ethnographic setting, and too modern to be considered unique when set alongside similar work by modern Western artists, as if the Arab art had been simply assimilated into a Western standard.

Current Events and Artistic Themes

In order to assess the artistic work presented in such an exhibition, it is important to understand both the conditions that influenced the development of the art in the region and the current forces that affect the content of the work.

The introduction of modern art to Saudi Arabia is relatively recent—in the mid-sixties—as compared to Egypt, where the first art institution was established in 1908. Art education in the Arabian Peninsula was begun by Egyptian teachers. Women artists in Saudi Arabia are active in art societies and hold frequent exhibitions. They also participate in local and international group shows. The varying histories of art development bear meaning to an informed viewer.

Other regional nuances and recent circumstances are relevant. For example, in the 1980s, during the *intifada,* Palestinian artists living under Israeli occupation were not permitted by the Israelis to use the colors of the Palestinian flag in their art work; that is, the state attempted to constrain their creative expression.

Fearing persecution by the extremists, Algerian artists fled their country; some took refuge in Europe and the United States. Such moves have a lasting impact on art work. Rabia Sukkaria, a Lebanese artist who remained in Beirut during a time of turmoil braved the fire at the Green Line dividing the city of Beirut to set up an installation of yellow ribbons, working for many hours under the astonished gaze of the Syrian and Lebanese factions, wrapping hundreds of feet of yellow ribbons around the charred remains of trees. The artist's intention was to honor those who died crossing the Green Line trying to reach their relatives on the other side. Unfortunately, her installation, a symbol of a peace that seemed like a mirage at the time, was torn down by the soldiers.

Another artist, Seta Manoukian, taught art to the children of the Lebanese civil war. Confined to crowded rooms in shelters in central Beirut, the artist carried on for three years, supplying her own art material. She published two books of the children's works.

After the Gulf War, an Iraqi artist, unable to travel with her Iraqi passport, tore up its pages and incorporated the remaining shreds of stamps and visas into her painting by superimposing them with images of passageways and doors that seemed to lead nowhere. Her work emphasizes a disturbing reality in the Arab world—the borders, passports, and visas that haunt every Arab planning to travel in the region.

Before the Gulf War Iraqi artists enjoyed great popularity, and their work was highly prized by local and regional collectors. Now they can no longer work in Baghdad. As a consequence, they periodically travel to Jordan to work for a few months to produce figurative art work that sells. This has resulted in a drastic change in the style of many Iraqi artists.

Issues of concern explored by women artists living at home or abroad focus on similar themes; however, the artists' techniques differ. Artists with limited access to Western models seem less concerned with avant-garde styles and tend toward a pleasing aesthetic; their message is more subtle and could easily pass the censor in conservative countries like Saudi Arabia. Mixed media installations, computer imagery, and site installations are gaining popularity among young artists; such works have a limited audience, however, and in some cases their dependence on government support—as in Egypt, where art is highly institutionalized— restricts the artists' freedom. This and other conceptual art can be seen in university galleries, and occasionally in private galleries or even shopping centers. In a recent survey of works by seventy-five Arab women artists working in such media 95 percent were living abroad or had recently returned from studying in the United States or Europe.[12] Thus, a transnational dynamic is at work.

With the exception of those in the oil-rich countries, artists are struggling to make a living and maintain a career in the arts. The

Egyptian government employs the largest number of artists, providing
positions in the Ministry of Culture and in art education. All the high-
ranking positions are held by the most respected male artists. In art
education, many women artists have succeeded in maintaining an
economic base from which to work. Still, funding for the arts remains in
the hands of the male artists working as state functionaries. Liliane
Karnouk, an artist and professor of art in Cairo (now living in Canada),
described this exclusive male loyalty to the state as both a curse and a
blessing:

> As employees, they [the male artists] must please superiors responsible
> for their advancement and opportunities for better exposure, and as
> artists, adapt their creativity to the preferences of their superiors. On the
> other hand their involvement in the public sector allows for the direct
> participation of artists in matters of cultural policy, although this
> privilege is applicable only to those in high-ranking positions.
> Moreover, their political views, presuming they essentially coincide
> with the government's, can find expression outside their art.[13]

In a paradoxical manner, women artists working in education or as
professional artists have a greater freedom to work independently of these
limitations.

Gender Issues in the Art of Arab Women
In the 1960s, American women artists deliberately used needlework,
weaving, or fabrics and other 'female' objects in their work to express
pride in their work as women artists and to draw attention to the biases in
the presentation of women's art in textbooks, galleries, and museums
across America. For Arab women artists these same symbols were used as
a means of asserting cultural identity, and also to draw attention to
gender issues of concern to the artists.

Human rights abuses are on the rise in countries such as Algeria, where
women artists are abandoning lifetime careers in the arts to avoid
persecution by the Islamic militants. In Saudi Arabia women still risk
flogging and imprisonment for walking in the streets without being
'covered.' Art books depicting the nude are censored in Saudi Arabia, and
most students study art abroad. Women's behavior that does not comply
with the strict codes set by Eastern patriarchal society is considered a
curse from the West. Laura Nader wrote:

> Knowledge about the West has a strong bearing on the position of
> women, for it is through this knowledge that the grip on women is
> justified in many countries of the Middle East. Women are no longer
> treated as women but as 'potential westerners,' posing a severe identity

crisis. . . . Arab Muslim women resent Western models of aspiration as they encroach on their lives, and as they are used as justification of Moslem 'fundamentalism.'[14]

In the last ten years Leila Shawa, a Palestinian artist from Gaza, has consistently addressed sociopolitical issues dealing with gender inequalities. She grew up in a prominent liberal and wealthy upper middle-class family. Her parents gave her the freedom to work and study in Italy, and she returned to Beirut where she lived for many years. She currently divides her time between Gaza and London. In the seventies, Shawa embarked on an ambitious project, to build a cultural center in Gaza, and this at a time when the Israeli occupation restricted cultural or political meetings there. Despite these restrictions, Shawa succeeded in establishing the only cultural institution of its kind in Gaza.

After ten years of dedicated work, during which she gave up painting, the center was permitted to operate, albeit in a limited capacity due to intermittent closures imposed by the Israelis. It provided Gazans with their only opportunity to attend cultural events and see art exhibitions. Shawa attributes her independence and strong will to her parents, who never pressured her into an early marriage but encouraged her to pursue her career as an artist.

Shawa describes her artistic role:

As an artist, I criticize life in the Arab world—and in any country I live—through my paintings. I am outraged by the Arab women who submit to the manipulation of men. I do not believe women are the victims, on the contrary many choose this role, as a convenience.[15]

Shawa explored this issue in a series of works on prostitution. She followed that with other work on the rise of religious extremism that she witnesses in Gaza.

In *The Impossible Dream* (1990, *Plate 10.2*), Shawa uses bright colors skillfully and with different intensities. She portrays the women hiding behind heavy, dark veils, their eyes closed, dark ominous figures huddled in limited space as if pushing forward with a unanimous energy that contrasts with the vivid colors of the ice cream that melts beyond their grasp. "The ice cream," she says, "represents the West; it also represents what is hypocritical and repressive; this hypocrisy exists everywhere. The fundamental teachings of Islam have nothing of this extreme conservatism. . . . This is a political situation. I think that the Gulf War has resulted in this. . . . It created a feeling in the Arab world whereby you automatically reject whatever is Western, because you see a power that is trying to destroy you without even trying to understand what you are about; it is an estrangement from the West."[16]

The Politics of Imagery

In the last two hundred years, the West has disseminated a picture of Arab women as exotic, bondaged, romantic, distant, and mysterious. From the early nineteenth century to the latest Hollywood images of the 1990s, the West has been the purveyor of this image. Houria Niati questions these images as represented in Eugene Delacroix's *Women of Algiers* (1834)—a point of view that was perpetuated by the nineteenth-century Orientalists and by modernists such as Henri Matisse. In *No to Torture* (1982, *Plate 10.3*) Niati eliminates the romanticized surroundings found in earlier depictions of 'oriental' women, and presents her viewer with the naked truth of feminine reality. With heads encaged or obliterated by heavy strokes of black or red paint, her intensely colored nudes convey Niati's anger over the suffering of Algerians under French occupation and the continuing exploitation of women in the subsequent Algerian regimes. Growing up in Algeria during the revolution that ended French colonialism, Niati remembers being taken to prison at the age of twelve for writing anticolonial slogans on walls. This incident led Niati to confront Western Orientalism fifteen years later. Asked why she undertook this series Niati replied:

Women in Algeria were fighting and dying. They were tortured. Western notions of the Oriental imagined a fantasy world of women. Delacroix's women were half naked. The images that he had painted were used for many things.[17] Behind his paintings [the] suffering, torture, repression, unhappiness and even spiritual happiness was not pictured. In 1993, I did a series of works as a sequel to *No to Torture*. In it I dealt with my anger at the suffering of women.in present day Algeria. Women were national heroes in the battle for independence, and now they are denied their human rights by the new wave of religious extremism.[18]

Doris Bittar, a Lebanese artist living in the United States, responds to yet another form of alienation of the Arab/Islamic world, as depicted in Delacroix's painting *Jacob Wrestling with the Angels*. In that painting Jacob's men are 'abandoning' him. They are dressed in Arab garb, while Jacob is dressed in Western clothes and has a fairer complexion. Because the West has chosen to isolate Islam as an alien and aberrant religion rather than acknowledging its roots in the Judeo-Christian tradition, the depiction of Arabs in Delacroix's painting seems ominous and bigoted.

In *Watching Jacob* (1994, *Plate 10.4*), Bittar has taken the essential elements in Delacroix's work, and reconstructed them into a triptych in much the same way that Niati has constructed the five panels of *No to Torture*. The hulking image of the Arab, seen from behind with bare back, is in the center panel watching (perhaps enviously) Jacob and

Gabriel wrestle/embrace. The Arab acknowledges the scene and becomes part of it rather than being cut off and disinterested. Yet the Arab is still excluded because the emotional center of the piece is Jacob and Gabriel. It becomes the story of Ishmael, forever linked to his brethren and forever excluded. Bittar, who is a Maronite Christian married to a Jew, explains:

> This work was motivated by my own experience of being part of a Jewish culture and at the same time excluded. As does my position, the Arab's position embodies both love and exclusion. I have superimposed on the painting a verse from an Arabic poem, 'He who denies his face shall be renounced by all the birds of paradise.' The words could be a warning against a denial of history or identity . . . or the Jews' denial of their link to the Arabs.[19]

In Search of a Cultural Identity at Home and Abroad

Colonialism in the Arab world marked a pivotal phase of European influence on Arab art. It also initiated a tense dialogue between Eastern and Western ideologies. Today, this tension is reflected in the continuing struggle over the region's heritage, the perceived authenticity of its art, and the integrity of its artists. Among many Arab artists, living at home and abroad, who experienced an identity crisis are Wasma'a Chorbachi from Iraq and Salwa Rouda Choucair from Lebanon. They each came to terms with the authenticity of their art at different historical periods.

In the aftermath of the 1967 Arab–Israeli war, Chorbachi's work reflected the sociopolitical significance of the war, its violence, and human sacrifice. She later criticized her work:

> Stylistically there was nothing of the Arab or Muslim. The subject matter of my paintings expressed the Arabs' outrage by the war. But they could have been painted by anyone who was so outraged by the war. Trained as I was in Western schools of contemporary abstract art, influenced by the surrealistic and Italian schools, I realized that I was speaking with a foreign artistic language. At that time, most Arab artists considered the Western model modern and the most advanced form of art.[20]

Chorbachi resolved this crisis by returning to the study of Islamic art and for the next twenty years she studied the link between science and art in Islamic civilization. She learned that early Muslim scientists worked with architects and artists in solving design problems. To her, the Islamic patterns and abstract designs based on mathematical proportions were contemporary and challenging to modern art. Chorbachi lives in the United States and works exclusively in designing and decorating ceramic works, basing her patterns on Islamic calligraphy.

In 1944 Salwa Choucair was disturbed by the words of an art teacher at the American University of Beirut, who described Islamic art as inferior because it was not based on the human figure. Choucair set out to create an art that bridges the gap in understanding Islamic art. In her work she uses Muslim artists' emphasis on the form, the curve, and the straight line, as these are essential characteristics of arabesque design, defining a tradition involving mathematically calculated patterns.

Working in the same studio in Beirut since 1945, Choucair has experimented with a variety of media including paintings, handwoven textiles, glass and enamel, clay, metal, stone, and wood. Choucair, considered by many the first abstract artist of the Arab world, has continued to work uninterrupted by the world around her. She has never left Beirut. On several occasions I visited Choucair without an appointment; she explained: "There is no need to set up appointments; you can always find me in my atelier." Her *Dual Piece* (1968, *Plate 10.5*) is a sculpture made of units that fit together like pieces in a puzzle. This sculpture and many other works by Choucair are inspired by the mathematical structure of Islamic architecture and the strict forms of classical Arabic poetry. She describes her art as

> a form embracing the spirit of arabesque designs, gaining inspiration from Arabic poetry, which concentrates on the form. To understand my art one has to understand the philosophy of Islam, the Muslim artist wanted to explain the existence of God without the use of the image. He took the essence of the 'form'—to show divine unification, divine eternity, resignation to God's will. When I comprehended the essence of Islamic art, I discarded all figuration and began to use the curve and the straight line . . . to create a new style of art using the essence of our heritage.[21]

Other Arab women artists who live in exile while remaining conscious of their roots have found a new international language in large installations, computer art, and performance art. Their issues are both personal and universal. Liliane Karnouk, resident of Canada and Egypt, responds powerfully to global ecological concerns in a large mixed media installation that includes bark and fiber from Canadian and Egyptian trees. Karnouk expresses her outrage at the human and environmental destruction during the Gulf War, and the installation was conceived as a requiem for all that was lost in both worlds. The complex visual dialogue in *Black and Green* (1990) stems from the artist's strong need for reconciliation.

"It was the fate of our generation," she explains, "to swallow the world in one bite and to give birth to a new language expressing this indigestion."[22]

Art and War

Many Arab women artists were outraged by the wars in the Arab world, torn as they were from their country, living apart from their loved ones, watching the loss of family members, home, and childhood memories. In Balqees Fakhro's work *Birth* (1990, *Plate 10.6*), color constitutes the message. Influenced by the view from her home in Bahrain, Fakhro evokes memories of the raging fires that erupted in the oil fields of Kuwait during the Gulf War. The vibrant colors and simple brush strokes provide a powerful reminder of the devastations of war.

Ginane Makki Bacho moved between eighteen different houses during the civil war in Lebanon. Her home in Beirut was bombed so often she made sculpture out of its broken walls and empty bombshells. In *The Image of the Word . . . The Image of the Picture* (1985, *Plate 10.7*), Bacho tears out pages from a diary, which are superimposed on two identical images of a woman; in the background, a map of Beirut divided by a red line that veils part of the woman's face symbolizes the trail of blood that divided Beirut for almost two decades. Bacho weds word and image in this page from her artist's book. The woman remains the center of the image, a maze of streets crisscrossing her face; her gaze, removed from the viewer, is distant, creating a tension which draws the viewer to the background of the divided city.

Bacho explains her use of images of women as follows: "My work is the mirror of my personality, my fears, my dreams, my art stems from experiences as a daughter, a wife and mother . . . That is why I use the image of the woman in most of my work. Beirut used to be a pretty woman, it is now mutilated by the war." Several Arab women writers have used this metaphor of the woman representing the city torn by war amd destruction. In her novel on the civil war in Lebanon, *Sitt Marie Rose,* Etel Adnan[23] describes Beirut as a woman dehumanized and dismembered by the war. The parallels drawn by Bacho's image and Adnan's novel are evident in Adnan's description of Beirut:

> The city is an electromagnetic field into which everyone wants to plug himself. It is no longer a place of habitation but a being which resembles a runaway train. . . .Women stay at home more than ever. They consider war like an evening of scores between men.[24] . . . Beirut is humiliated.[25]. . . This city is like a great suffering being, too mad, too overcharged, broken now, gutted and raped like those girls raped by thirty or forty militia men, and are now mad and in asylums because their families, Mediterranean to the end, would rather hide than cure.[26]

Art and Image

At the symposium held in conjunction with the "Forces of Change" exhibition the meetings between the artists and leading Arab women writers, scientists, and politicians who came to celebrate this event

underscored the importance of the *image* in Arab society. Both artists and writers agreed that the power of the *image* and the *word* gave women artists a greater freedom of expression, for their art is a reflection of the realities of the region. Distinguished Arab women writers and painters have continued to be important contributors to literary and artistic production. In the last five years several books have appeared that focus on Arab women's contributions to literature. The Arab woman writer's message is more accessible to the public than the images that are restricted to art spaces; however, over the next decade, with increasing access to the electronic highway, Arab audiences will be able to view uncensored images. Two Saudi Arabian women already have their own Web pages. Clearly, sex segregation in Saudi Arabia has not hindered these women's participation in political and social discourse through the disseminiation of their literary work through this new medium.

The challenge that faces Arab men and women artists is in attracting a larger and more diverse audience to the spaces featuring their artistic productions. Opening nights of major art exhibitions draw essentially only the artistic community, the social elite, and the press. Although few people choose to visit art spaces on Thursdays and Fridays—the traditional weekend in Arab countries—there has been a considerable change in the public's attitude toward contemporary art, in part due to education· and information· provided in schools and through the media. Efforts to draw a larger audience succeed when other cultural activities, such as poetry readings or musical events, accompany the art exhibit. In addition, art critics and journalists review art exhibitions regularly; for example, Shawa's exhibition including a series of work on gender and political issues received ample coverage in the Jordanian press.

In the majority of Arab countries, overtly political art and art dealing with gender issues is ignored by conservative groups as long as it remains outside the public sphere and within the 'already corrupt circles,' i.e., the milieu of artists and intellectuals. Frequently, works of art with controversial themes may elude the governing powers, who fail to perceive the messages hidden in the art work. Another reason for the virtual absence of censorship of women artists' work may be that women artists have generally not joined forces in presenting their work as part of the feminist movement, nor as members of organized women artists' groups. Saddeka Arebi attributes the success of Saudi Arabian women writers' strategy of 'measured challenge and response' in undermining power to two conditions: "First, resistance, if too organized and apparent, may spark alarm and lead to increasing opposition. . . . Second, if resistance is too masked or hidden, it may be incorporated as a means by which the dominant discourse displays its tolerance for opposite views and [one] may confuse this tolerance with participation."[27]

Although contemporary Arab art has not reached the status of Arabic literature, questions that challenge current women's literature depict similar realities to those encountered by women artists. In answer to a question regarding the adequacy of the novel as a source for the study of society, Evelyn Accad stated that "[the] creative works are more appropriate than other works. . . . They allow us to enter into the imaginary and unconscious world of the author. In expressing his or her own individual vision, an author also suggests links to the collective imaginary. Through the imaginary, societies endlessly experiment with new forms of organization, communication, participation. . . . The imaginary is an exploration of what is possible."[28]

In art as in literature, women are taking the lead in initiating a political, social, and personal dialogue that evokes outrage or amusement. Their focus on humanity is both liberating and disturbing to virtually all of them. Their messages are a clear attempt to raise the consciousness of the audience; they are active participants in the processes of change in their respective cultures. Some have also taken on the specific responsibility of esablishing art spaces, making art work more accessible to the public.

Their art is witness to who we are. It may take several decades before future generations, themselves the product of a world of images, appreciate the role these Arab women artists have played in this century.

Notes

1 Carol Becker, *Social Responsibility and the Place of the Artist in Society* (Chicago: Lake View Press, 1990).

2 ᶜAfif Bahnasi, *al-Fann al-hadith fi-l-bilad al-ᶜarabiya* (Beirut: Dar al-Janub li-l-Nashr, 1980), 34–37.

3 Wijdan ᶜAli, "Modern Arab Art, an Overview," in Salwa Nashashibi, ed., *Forces of Change: Artists of the Arab World* (Lafayette, California: International Council for Women in the Arts, and Washington, D.C.: The National Museum of Women in the Arts, 1994), 74–75.

4 Ibid., 78.

5 Liliâne Karnouk, *Contemporary Egyptian Art* (Cairo: The American University in Cairo Press, 1995).

6 Founded by Alexis Boutros.

7 Helen Khal, *The Women Artists in Lebanon* (Beirut: Beirut University College, 1989), 21.

8 Wijdan ᶜAli, "Modern Arab Art," in Salwa Nashashibi, ed., *Forces of Change.*

9 Editor's Note: See Jocelyn Ajami, "Jordan's House of the Arts," *Aramco World* (July–August 1996).

10 Editor's Note: The exhibition tour included Washington, D.C., Atlanta, Georgia, Los Angeles, Concord, Calif., Chicago, Vancouver, and other cities. Works from the exhibition are discussed, alongside other historical and analytical contributions in Salwa Nashashibi, ed., *Forces of Change.*

11 Vicki Roland, "Torrents of Arabia: A New Wave of Arab Women's Art," Creative Loafing, in *Atlanta Weekly*, vol. 23, no. 43 (18 March 1995).

12 Personal interviews with the artists, 1993–1996.

13 Liliane Karnouk, *Contemporary Egyptian Art* (Cairo: The American University in Cairo Press, 1995), 12.

14 Laura Nader, "Orientalism, Occidentalism, and the Control of Women," *Cultural Dynamics* 2 (1989), 327.

15 Personal interview with the artist, 1994.

16 Personal interview with the artist, 1993.

17 Ibid., and cited in Salwa Nashashibi, Laura Nader, and Etel Adnan, "Arab Women Artists: Forces of Change," in Salwa Nashashibi, ed., *Forces of Change*, 30.

18 Personal interview with Houria Niati, July 1994.

19 Personal interview with the artist, 1995.

20 Wasma'a Chorbachi, "Arab Art Twenty Years Later," *Arab Studies Quarterly* 11, Nos. 2 and 3 (1989), 144.

21 Personal interview with the artist, 1993.

22 Personal interview with the artist, 1994.

23 Editor's Note: Etel Adnan is a novelist, poet, and artist who creates oils, ceramics, and tapestry. She has utilized drawings within her poetry, notably "Arab Apocalypse," and in her artist's books done in watercolor and ink, *Carried with the Sound* (1991), and *One Linden Tree, Then Another* (1975).

24 Etel Adnan, *Sitt Marie Rose* (Sausalito, Ca.: Post-Apollo Press, 1982, 1989), 13.

25 Ibid., 20.

26 Ibid., 21.

27 Saddeka Arebi, *Women and Words in Saudi Arabia: The Politics of Literary Discourse* (New York, Columbia University Press, 1994), 294–95.

28 Evelyn Accad, *Sexuality and War: Literary Masks of the Middle East* (New York, New York University Press, 1990), 4.

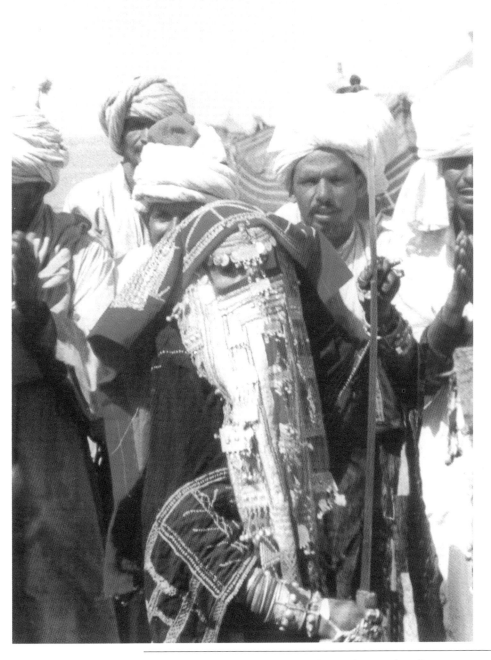

2.1. The Rashayda Bedouin. Photograph, William Young.

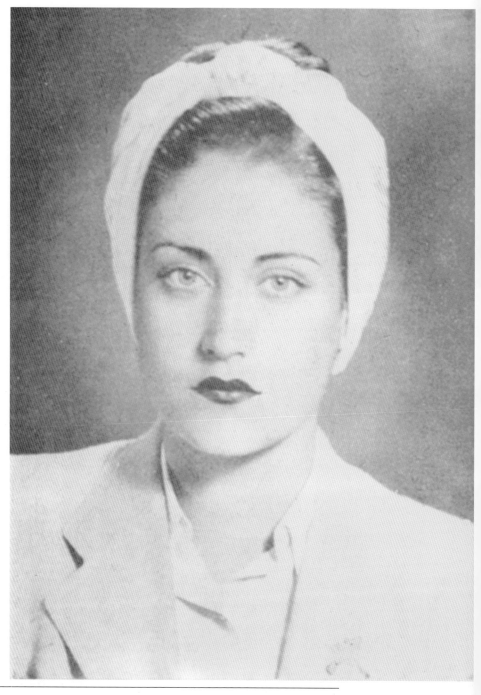

5.1. Asmahan, April 1941. Collection of Sherifa Zuhur.

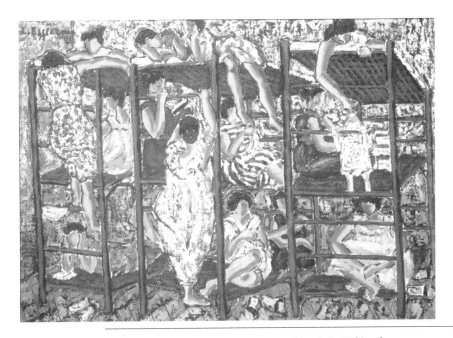

10.1. *Inji Efflatoun (Egypt)*, The Cell, *1964, oil on canvas, 65 x 50 cm. Collection Gulperie/Ismail Sabry Abdulla.*

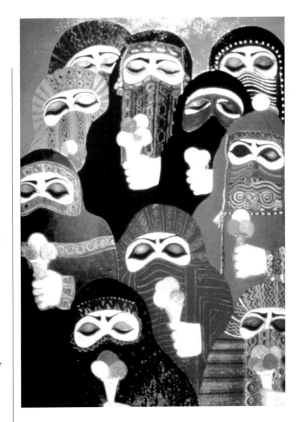

10.2. *Leila Shawa (Palestine),*
The Impossible Dream, 1990,
oil on canvas, 100 x 70 cm.
Collection of the National
Gallery of Jordan.

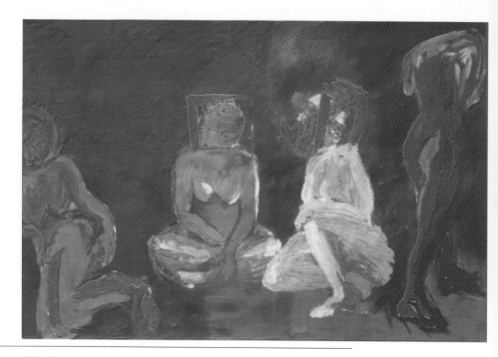

10.3. Houria Niati (Algeria), No to Torture, *1982, oil on canvas,*
182 x 275 cm. Artist's collection.

10.4. Doris Bittar (Lebanon), Watching Jacob, *1994, oil on canvas,*
92 x 274 cm. Artist's collection.

10.5. Salwa Rouda Choucair (Lebanon),
Dual Piece, 1968, wood,
50 x 35 x 33 cm. Artist's collection.

10.6. Balqees Fakhro (Bahrain), Birth, 1990, acrylic,
60 x 72 cm. Artist's collection.

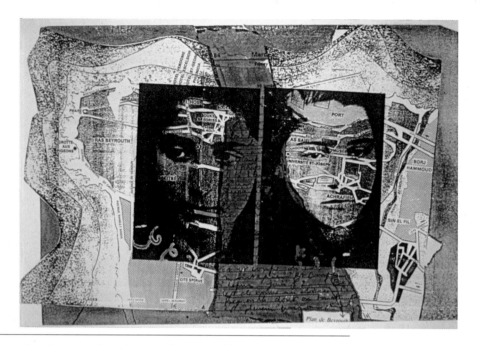

10.7. *Ginane Bacho (Lebanon),* The Image of the World . . . The Image of the Picture, *1985, mixed media. Artist's collection.*

11.1. *Chaïbia Talal, Village of Chtouka, 1982. 180 x 180 cm. Collection of l'Institut du Monde Arabe.*

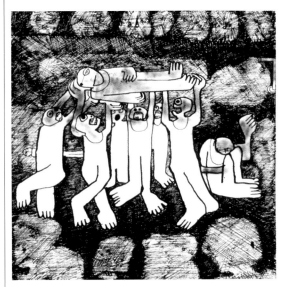

12.1. *Mohamed Omer Bushara (Sudan),
untitled, from the series of art and poetry
by Mohamed Omer Bushara and Sondra
Hale,* Seasons of Our Discontent, *1975. Ink
and burning on paper, 30 x 30 cm.
Collection of Sondra Hale.*

12.2. *Mohamed Omer Bushara (Sudan), untitled, 1993,
watercolor on paper, 56 x 41 cm. Collection of Sondra Hale.*

12.3. *Musa Khalifa (Sudan), untitled, 1972, oil on canvas,*
 54 x 49 cm. Collection of Sondra Hale.

12.4. *Musa Khalifa (Sudan), untitled, 1979, oil on canvas,*
 68 x 58 cm. Collection of Sondra Hale.

11

THE ARTIST'S VOICE

Chaïbia Talal

Translated from Arabic by Fatima Mernissi[1]

At fifteen I was widowed. I was illiterate.

They changed my birthdate so that the wedding could take place. I was thirteen. Then I had a son. My husband died in an accident. I was his seventh wife. I had to survive. I put my son in school. It cost me sixty rials. You see, I was illiterate. My son had to escape from that. I began working with wool, I bought it, washed it, spun it, and gave it to a friend who sold it for me. I could have married, of course, I had a lot of offers. But I was afraid it would be somebody who would ill-treat the child and I wanted to live in freedom.

You will find all of this in my painting.

Listen! Don't forget that I am a peasant . . . but that is not all. You must know the rest, otherwise you won't understand my success. You have to know that when I was little I used to do unusual things. I used to make flower crowns and wear them . . . no other girl did that . . . nobody ever did that in Chtouka [her village, *Plate 11.1*]. They treated me as crazy, I was crazy for red poppies and daisies. They found me strange, they said: you are queer, like a *Nasranya* [Christian, outsider].

You must understand, it's important, not being afraid to be different. Don't forget that at that time people were afraid of *Nsara* [Christians, i.e., the French, who were the occupiers]. They ran away as soon as the *Nsara* approached. I did not. I watched them when they came fishing at the seaside. At the seaside I liked to build houses with stones and shells. I gave them windows and doors. We lived in a tent. But me, I drew them, before I even saw them. I drew houses in the sand. My father took me one day to the city, I was six years old, I was fascinated by the beauty of the decorations on the walls . . . the clocks . . . everything you can hang

183

on a wall . . . I collected pieces of paper and I used to make birds and animals with this paper.

I was always fascinated by animals. Do you know how many turtles I have in this garden, right in the center of Casablanca? Five or six, who knows, nobody counts them anymore. I also love birds, very much. But it was not this love that disturbed people. It's the fact that I covered myself with flowers. My family tried to stop that. They hit me. I ran away. I vanished into haystacks. You do not know what it is to hide in a haystack when fresh rain falls down. You find all that in my painting.

How did I become an artist? You know, each of us has his way traced for him. Before I painted, different events decided my future; a meeting in a *zawiyya*, a feeling and a dream [a *zawiyya* is a religious lodge, or a refuge, often dedicated to a holy man or woman]. One day I visited the Moulay Bouchaib *zawiyya*. A holy man saw me and said, "You, you are *mbouhla* [from another planet], you will bring us *baraka* [luck]. Pray for us."

Then in the sanctuary, I enjoyed the beauty of the decorated columns and walls. Then a woman came to me . . . she was dressed in her *haik* [a white wrap that Moroccan women used to wear before they changed into the *djellaba*, which is a man's dress, a long robe; the change from the *haik* to the *djellaba* represents the same change as European women's change from dresses to trousers]. That woman was deaf and mute. She communicated through gestures, she drew on the wall. I understood what she said. She said I had a talent, that I would accomplish things, create.

I dreamed of a blue sky full of colors.

I dreamed, just there in the small room near the garden. I was home, the sky was blue, full of colors flashing in the wind like a storm. From the bedroom to the door, through all the garden, there were lighted candles. The door was open. Men in white came in. They brought me paintbrushes and canvas. There were many young men and two old men with long beards. They said to me, 'This is your breadwinner." What could an illiterate woman do for a living? What do you think? I was a maid, a house maid. I cleaned houses and floors. . . . I felt I had to do something. I told my sister about the dream, it had to happen. Two days later, I went to the *medina* [the city, or the shopping area of the city] and bought paint, the kind you use to paint doors, but that was not important.

My son Talal had a studio. I watched him painting. I always complained when he came home covered with paint. One day, he found *me* all covered with paint. He asked me what was I doing, I said I was painting. He told me to continue. One day, Pierre Gaudibert, the director of a modern art museum in Paris, came home with Cherkaoui, a Moroccan artist. They liked my painting. They asked me to show them the rest.

On 8 March 1984, we were invited to celebrate the Year of the Woman at the Ministry of Culture. I went but nobody paid any attention to me. The same year I was invited to France. One hundred and seven women from all over the world were invited as artists. They chose one of my paintings to make a poster. [That was for the exhibition organized in March 1984 by the municipal gallery of Vitry-sur-Seine about women's rights, with the subject: "A Woman's Role in Contemporary Art."]. It touched me very much. An artist like me needs that.

Educated women have to take care of us who did not have an education.

There must be a joint responsibility between women who were lucky enough to go to school and those who were not. An educated woman has to help the others, otherwise how can we change society? Morocco will not advance if those who have privileges forget the others. Every time I sell a picture I give to the poor people a part of my earnings. God sees everything, but I see that between women there is no joint responsibility. The educated don't pay attention to the illiterate. What are they doing for them? We have to share in order to progress. I loved it when an educated woman tried to teach me, tried to share something with me. I like to learn and when you have not been to school it is an obsession. When I was a little girl I leaned close to the radio, I wanted people to shut up when a teacher, a minister, a king was talking. At home nobody could be silent when somebody else was talking. I used to say, "Are you crazy? Don't you want to go beyond ignorance?"

The Muslim sisters are wrong.

I have always been a mystic. Even when very young, I used to pray. But I also wanted to be modern. I moved around, was curious about everything. I wanted to learn French to understand what life was about. I didn't stay in a corner like the Muslim sisters of today. Religion helps to organize life but must not be interpreted incorrectly. The other day, at the market, I met a Muslim sister; she couldn't breathe because her face was covered with so many scarves. I told her, "Do you want to create a new religion? Do you want to change the Prophet's message? He wanted education for Arab women. With the veil we are like donkeys. The French people occupied the country and the women didn't realize what happened. The veils and walls made them *hmarat* [donkeys]. Our mothers were maids for the French.

"Muhammad V [the grandfather of the present king] changed that. He gave us education and dignity and you Muslim sisters, you want to take us back to the dark age. Now that Moroccan women are doctors, lawyers, and we have begun to be proud of ourselves, you want to give us the *hijab* [Islamic dress]. It's not Muhammad who wanted that. He was angry when somebody humiliated a woman."

Notes

1 This text is from an interview with Fatima Mernissi conducted in Casablanca
in January of 1985. It was published as "My Life," in Margot Badran and
Miriam Cooke, eds., *Opening the Gates: A Century of Arab Feminist
Writing* (Bloomington and Indianapolis: Indiana University Press, 1990), and
is reproduced with the permission of Indiana University Press, Miriam
Cooke, Margot Badran, and Chaïbia Talal.

12

IMAGERY AND INVENTION:
SUDANESE AT HOME AND IN THE WORLD
CONVERSATIONS WITH MOHAMED OMER BUSHARA
AND MUSA KHALIFA

Sondra Hale

The Frame and the Subversion of the Frame

Our empty eyes can see more than they want us to . . .[1]
An artist is not outside history and culture, and yet most artists, intellectuals, and academics resist the notion that they/we are working within a cultural frame, that they/we have all internalized a hegemonic culture. Some argue that we have, at most, internalized a vernacular that is peculiarly our own—a community, ethnic, or national identity—one that nonetheless leaves space for us to process 'outside' influences. We might argue this in the face of some of the ideas of postcoloniality about the West permeating everything: "The West is everywhere, within the West and outside; in structure and in minds."[2] And isn't this vernacular itself a frame? When we are self-positioned in that localized culture, we might acknowledge outside influences, but what do we acknowledge is inside us when we travel outside, become intellectual nomads, exiled artists?

My experience of interviewing, interacting with, and collaborating with Sudanese artists and intellectuals for some thirty-six years, inside and outside Sudan, has made me recognize that people do not have to be one identity or the other, that the products of their artistic and intellectual endeavors do not have to be 'Sudanese' or 'not Sudanese' (as in 'Westernized' or some other term of colonial discourse that posits the possibility of 'losing one's native identity'). Rather, they can be both or assume many positions, sites, and identities at once, and that absence reveals as much as presence. Ultimately, I had to acknowledge that I had tried to impose a frame on their work and that my framing was a form of colonial discourse—the power to name and control.[3]

The dialectics of 'being Sudanese' (the vernacular [the local] and/or being 'of the world' [the universal]) permeated my 1972 interviews and conversations with Musa Khalifa, one of Sudan's leading modernist painters. He referred to being born in Sudan as "his unique chance."[4] He later scoffed at the title of the article carved from those first interviews, "Musa Khalifa of Sudan," remarking that he is "Musa Khalifa of Kawa" (his village of birth on the White Nile).[5] In these interviews that took place over more than two decades, I saw Musa Khalifa as 'moving in and out' of local and universal identities and goals, instead of being both or all at once. I saw contradictions in his 'universalist' and 'vernacular' claims: e.g., that he is seeking the unity of the common human elements. "We can give the world a local concept; we can build upon our historical foundations, but we have to be very open to breed with any other world view."[6] Or, "This world is now a unit. We take from all cultures; we touch all cultures ourselves."[7] He spoke of giving "Sudanese culture to the world,"[8] of "contributing to human culture."[9] And then he would localize his aesthetics to "a dot on a horizon":

> You can call the terrain [where he was born] pure savanna—Kawa Village—the White Nile—the open horizon, very few houses. You always see the village as a dot on the horizon. . . . When you are approaching the farm or departing from it, you can see the village in that way—a dot. A donkey walks at noon, forming a slow, gradual relationship with the village. . . . The reverse of this experience (rushing to be home, have a meal, [or] see one's other) might be the upward bolts . . . to show the shortest way—the straight line.[10]

Ibrahim el-Salahi, Sudan's best known painter, is elusive about identity, neither embracing nor shaking off the label 'Sudanese artist,' while casting a naked woman's body (a suggestion that she is not Sudanese?) above the skyline of Khartoum's mud dwellings, encasing Islamic and Sudanese folkloric motifs in a washed circle—modernist, universalist, localized and vernacular. When I tried to pin him down, frame him, he slipped out of the claims, insisting that he is all these things, or as Ahmed Shibrain, another leading artist, proclaimed, a "fusion of the two visions—East and West— . . . merg[ing] into a common aesthetic."[11]

Salih Abdou Mashamoun, a modernist painter, began with sweeping social realist strokes and universalistic references to the masses, but turned inward to a more vernacular nomenclature, reclaiming his Nubian identity and the village of Debeira in Wadi Halfa, now under water after the building of the High Dam at Aswan. Nonetheless, he saw no change in his work. To him, his work was an expression of human agony, whether the agony of the masses or the agony of one dislocated Nubian

villager. Whilst most of his motifs of the 1970s were of Nubian subjects
(e.g., Meroitic antiquities, Halfawin mysticism, or the unique house
decoration of the 1960s Nubian villages), his claims of universal subjects
marked his refusal to be categorized as a 'Sudanese artist.'[12]

The Context from Which
We Never Escape/from Which We Are Exiled

While seeming mundane, but in actuality describing an invention of both
colonial discourse and imperialist ventures, I can state that Sudan is the
largest country on the African continent and in the 'Middle East.' Or, it
can be said to be the first European-colonized 'sub-Saharan' country to
become independent (in 1956, from the British).

Anthropologists construct Sudan as one of the most heterogeneous
regions in the world: over 500 ethnic groups, 110 separate languages, a
panoply of social and political formations, and hundreds of religious
sects. Although the country is vast, the population is sparse—only some
estimated 30.1 million (much smaller Egypt has 63.1 million). Sudan is
one of the twenty-five poorest countries in the world, made poorer by
colonialism and neocolonialism. For example, the life expectancy at birth
is fifty-one; the per capita GDP is some $340 per annum; literacy is less
than 31 percent, much lower for women; and the towns and cities are now
surrounded by shantytowns.

Such poverty was not always the case. We can imagine a rich history of
powerful empires and Iron-Age civilizations when Europe was in the
'Dark Ages.' One such empire was Kush or Meroë, located in an area we
generally refer to today as Nubia. It is the best known, but there were
many kingdoms further south (e.g., the Funj kingdom of Sennar) and to
the west, not to mention the large and powerful kingships and
chieftainships of the Dinka, Nuer, and Shilluk in the south. Strong
nomadic/pastoral groups were prevalent in much of the north and south.

But changing material conditions, complex migrations, and
international and regional economic transformations brought on a series
of invasions and colonial incursions, ultimately resulting in
Ottoman/Egyptian and then Anglo-Egyptian domination. However, in the
nineteenth century Sudan experienced the rise of a local religious/political
figure, the Mahdi, who with his followers (the Ansar) brought a great
deal of the country under his control and drove out the British. Not to be
deterred from their economic conquests, the British 'reconquered' (surely
an invention from colonial discourse) Sudan with great military force in
1898, and ruled until 1956.

The legacy of colonialism is still with Sudan, the British having
turned the northern part of the country into a large, nearly exclusive,
cotton-growing plantation, up until now controlling cotton prices. The
British also 'developed' and ruled the northern and southern parts of the

country separately—dividing them for more effective rule—and keeping
the people separate from each other. That legacy is now Africa's longest
running civil war, between the south, said to be 'Christian' and 'Black
African,' and the north, said to be 'Arab' and 'Muslim.' These are
Western inventions to describe two highly heterogeneous regions that
were artificially separated.

The Nile and its adjoining riparian lands form the physical backbone of
Sudan and the center of its agricultural, economic, social, and political
life. Except for the narrow green strip along the Nile, the Sahara desert, if
beautiful, is harsh and daunting. To the east across the hills lie the Red
Sea coast and the higher reaches of Eritrea and Ethiopia. Far to the west,
Jebal Marra stands as a formidable, wetter, volcanic upland interrupting
the vast, seasonally dry plains that approach it from both east and west.
Scrub and semidesert dominate much of the country, although the south
is lusher, with its great swamps and tropical vegetation.

The capital, Khartoum, is the largest urban center in the country,
located at the junction of the Blue and White Niles. Khartoum has been
imagined as a more 'Europeanized' city, where the colonials dwelled and
where the current seat of government is located. Omdurman, across the
Nile, is constructed as a more 'indigenous' city, with a large bazaar at its
heart. Omdurman is also associated with the Mahdi and other religious
figures and is one of the politico-religious centers of the country. This
invention of the bifurcated main city served colonial interests.[13]

Nonexistent census figures on religion are used by Muslims to
construct the country as 70 percent Sunni Muslim, 20 percent indigenous
beliefs, and 5 percent Christian. Politics and religion, even when
invented separately to serve variable interests, are usually one and the
same. Politics are said to be dominated by religion, from before the rise
of the Mahdi and including the current government. Major Islamic
brotherhoods spawned powerful political parties and interest groups, and
they have rivaled each other for control of the patches of 'democratic,'
parliamentary periods since independence. The one exception, according
to the construction of the left, has been the Communist Party, once one
of the largest in Africa and the Middle East. But their golden years ended
in 1971, with an abortive left-led coup that resulted in the execution of
internationally prominent leaders, including Abdel Khalig Mahjoub,
secretary-general of the Sudanese Communist Party. This period is
burned into the imagination of progressive Sudanese, especially artists
and intellectuals on the left. Mainly the Sudanese have been ruled by
military governments. Twice these military regimes were overthrown by
nearly 'bloodless' civilian uprisings (in 1964 and 1985), but each time, it
is said, sectarianism spoiled the victory.[14] Then, in 1989, an
ultraconservative, Islamist military junta came to power, undergirded by
the National Islamic Front, a political offshoot of the Muslim

Brotherhood. Sudan is now an Islamic state, with *sharica* (Islamic law) in effect. All political parties, interest groups, unions, and professional associations are banned, as are most newspapers. The constitution was eliminated. Writers, artists, intellectuals, and academics went into massive exile. This is the story of Sudanese politics and the text for much Sudanese art in exile.

Culturally, northern Sudan is an exciting place where the beauty and complexity of the Arabic language turns everyone into a poet, and calligraphy reigns. Unlike the United States, people *like* poetry; it is for the people; they own their own language, occupy it, use it as a tool, a weapon, a solace, and as text for visual art. Visual art, too, thrived in the capital, especially at Khartoum Technical Institute (K.T.I.), now the College of Fine and Applied Art, where for decades dozens of modernist artists emerged, often combining traditional forms/motifs/techniques (e.g., calligraphy and designs) with new methods and images. Although initially rejected by the general public and officials as too 'Western,' these artists increasingly occupied important places in society, and some were given government jobs. Ibrahim el-Salahi was, for a brief period in the 1970s, the minister of information and culture. This was a period when the Department of Culture was established, and a number of young artists were employed—Mohamed Omer Bushara *(Plates 12.1 and 12.2)* and Musa Khalifa *(Plates 12.3 and 12.4)* among them. Now a large number of these artists and cultural figures are in exile, including Bushara and Khalifa.

Mohamed Omer Bushara: Imposing a Biographical Sketch

In the nearly twenty-seven years that I have known Bushara, I have related his life story in print many times. Usually, the same elements appear: Mohamed Omer Bushara is now in his late forties, a quiet, earnest, passionate, and committed man with a disarming manner. He received an honors degree in geography from the University of Khartoum in the 1970s. But he had been mapping a different universe—art. Not having the money to buy art supplies (what few were available in the austere country), he made art out of found objects. He read any art books he could lay his hands on and was impressed by Picasso, Matisse, and Klee. However, he did not need the influence of Europe; he had the example of the thriving 'Khartoum School,' with such fine artists as Ibrahim el-Salahi, M. H. A. Rabbah, Kamala Ibrahim Ishaq, Ahmed Shibrain, Hussein Shariffe, Hassan Bedawi, Hassan el-Hadi, Taj Ahmed, Musa Khalifa, Mohamed Omer Khalil, Amir I. M. Nour, Omer Kheiry, Salih Abdou Mashamoun, and many others.[15] Some were Bushara's indirect teachers; at the same time, they ignored him because he was not one of them. Finally his voluminous line drawings, and caricatured water washes began to attract the attention of his peers and others. In 1974 he

held his first solo show at the British Council in Khartoum—displaying crudely mounted and hung but wonderfully executed drawings that earned him first prize from the *African Arts* journal and a scholarship to the Slade School in London, his only formal art training (and where he produced the gripping political etchings that I refer to simply as the 'Slade Series,' 1976–77).[16]

Omdurman, the large city of his birth, a brown city along the Nile, gave him so many ideas and images. What he saw in Omdurman amongst the poets and dreamers, the market vendors, the taxi and lorry drivers, the camel caravan drivers and the boatbuilders, the goatherders and milksellers on donkeys, the sheiks and sayyids in their Mercedes, and the beggars in the sand, the politicians and religious dignitaries, the women in their white wrap-around *tobes* and the men in their flowing white *jallabiyas*, all moved him to produce the images that remained the icons of his work (even when they are shrouded abstractions). And what he has seen politically in the last few decades has caused him to produce images of soldiers eating the people, of cadavers embracing each other or hanging by hooks like slabs of meat in a butcher's shop—of "empty eyes that see more than they want us to." Are they the eyes of the malnourished, the blind, or the bored/indifferent? Perhaps they are eyes turned inward, waiting.

The metaphor of waiting is prominent in his art—the suggestion of a slow-moving, languishing-in-the-heat, inert population waiting to become galvanized into resistance and rebellion.

Bushara is waiting. He is living in political exile, unable to return to his beloved Sudan because people with his progressive politics who insist on expressing their views in some way (for Bushara, it is his art) are at risk now. So, Bushara, his wife, Fatma, and their three young sons live in a small city in Saudi Arabia. She teaches, he works at the university, only partially using his talents as a geographer, poet, art and literary critic, and journalist.

In his shows from the 1970s and into the 1980s, Bushara's political cartoons were heavily represented, some in series (e.g., "The Private Collection of Mr. X"), whereas others are included in the unpublished poetry/art manuscript "Seasons of Our Discontent"—tableaux of the legacy of colonialism, with its overblown and immobilizing bureaucracy, religious fatalism and inertia, political corruption, and brutality and oppression.[17]

In writing about his art and curating Bushara's shows, I always stressed the political protest nature of his art, constructing him as the alienated hero, the dissident in exile. It is problematic how much of his protest was really my own. As an outsider I felt politically muted. Bushara, in a sense, spoke for me.

The Political Art of Mohamed Omer Bushara

These thin black lines
cannot say how we feel:
grotesque figures[18]

The term 'political artist' is not viewed as an oxymoron in much of the Middle East and Africa. The artist is a purveyor and repository of the culture (and politics), not above or apart from the society. This does not mean that there are not attempts by dominant cultures to mold art in the image of the powerful. For Mohamed Omer Bushara and many Sudanese artists this has been a major problem.

In 1994 the Armory Center for the Arts (Pasadena, California) hosted the first West Coast showing of Bushara's work, a propitious time, because the show addressed so many misconceptions about Sudan, North Africa, and Afro-Arab culture, as well as the fact that dissident and exiled Sudanese artists and intellectuals on the left are, once again, being silenced—this time by a military Islamist regime.

North Americans do not think of art when they think of Sudan, and the reverse. Yet, for over forty years Sudan has been one of the most significant centers of modernist art in Africa. The fact that this center produced more than two dozen internationally known artists surprises many. One paradox is that so many Sudanese artists claim alienation from the very Sudanese environment that generated their art. In Bushara's early, and in his more recent work, this estrangement is generated by the low priority given to art, the lack of appreciation for abstractions that are not calligraphy, suspicion of the kinds of freedoms the artists demanded, such as a certain individualism in a society that expects social control by the family and community, and the relationship to a state that controls the media. Yet, the rich and varied social environment—heterogeneous social and economic forms and diverse histories of colonialism and resistance—generated complex artistic forms and themes.

However, in Bushara's late 1970's work (heavily represented in the Armory show) he increasingly invokes images of political alienation and oppression. Motifs change from internal exile to themes of political and military brutality (especially powerful in his three series of political cartoons in "Seasons of Our Discontent"). The art parallels recent political history—Sudan evolving from a society where 'nonviolent' overthrows of military regimes by civilians were still possible, to a politics where well-financed force, state-sanctioned torture, executions, and the curtailment of civil liberties rule Sudanese life. Whereas Bushara used to express sarcasm about the repetitive palace coups, "now games scar the people."[19] Politics has become deadly serious.

Bushara is the oldest son of a nonpolitical working-class family. He talks of a nonliterate father who nurtured creativity and free ideas, of his

university activism, of the impact of the 'Khartoum School' of modernist art that thrived in the 1960s and 1970s.

All the tools for his trade (dull, meaningless office work), Bushara turned into tools for art: wood or paper scraps, matches, pen and ink, food stuffs, only later finding some scraperboard, watercolors, and markers. He used 'found art'; it suited his notion that art is ordinary and belongs in the public domain. He does not pose as that emblem of 'high culture,' the elite modernist/masculinist/romantic genius. He would not even preserve his works and refused to exhibit, producing small-scale, usable and disposable works. Since the 1970s he has tried to undermine voyeurism and the eroticizing of the human figure. The naked male figure is as brutalized as the female.

Bushara has lived much of his life under colonial, militaristic, or autocratic regimes, Sudan having had only brief spasms of free artistic and intellectual activity. While he is in exile in Saudi Arabia, a Sudanese Islamist regime relegates art to the religious realm, and attempts to curb the 'excesses' of the modernist (conflated with 'Western') artists in order to abrogate Western culture. Ironically, much contemporary Sudanese art has been 'culture-specific' and critical of Western cultures.

Bushara's early, 'whimsical' caricatures are not whimsical at all. They are portraits of irony: thin black lines—grotesques, tableaux of black comedy, absurd and indifferent. By the late 1970s, with his lithographic training at London's Slade School (a perfect medium for an artist who did not want to produce 'originals,' but mass art), Bushara had developed a dominant theme—the stark black-and-white, prison-bound motif. He had also begun to step beyond his personal or even culture-specific alienation to produce art about human oppression in general.

By the 1990s Bushara had begun to venture out of his black-and-white prison cell, color no longer his jailer. Nonetheless, until the 1990s he had hardly moved beyond tint or burn; he had given but a nod to landscape or space. He began to offer us vivid color and the suggestion of terrain beyond the prison doors. In the colorful 1990s works he has begun his cartographic experiment and many other forms of experimentation.

Bushara and the Asmara Interviews: 1994 and 1996

When I began to construct his work as 'more abstract,' with the suggestion that it was less bound to the Sudanese experience, Bushara rebelled and began a subtle campaign of subversions. It is, perhaps, no accident that these reactions to my (re)invention of his body of work based on the size, color, and 'subject matter' of a few dozen pieces, took place in Asmara, Eritrea, by 1996 the site of the Sudanese opposition movement. Our exchanges were in a series of interviews in July 1996, the beginning of my current research on Sudanese artists and intellectuals in exile.

For me, it was what was missing in Bushara's art that most moved me to refer to his work as 'more abstract.' But when he challenged me on why I saw it as abstract when it was not at all abstract to him, I would comment that there were no figures, for example, referring to those familiar grotesques of the past. He would point to one of the large watercolor pieces and ask, "What is that?" There, before me, would loom up as if to strike me for my insolence and arrogance, several grotesques: agonized creatures, contorted and twisted in a dance of meaninglessness. But if I used the word 'meaninglessness,' Bushara would say, "They have meaning to me." If I referred to the 'formlessness' of the 'objects,' he would repeat, "To me they have forms." I would imply that the politics is gone from the acrylic with the large yellow 'Xs' standing prominently in the middle; then with only one of his frustrated glances, I would suddenly see their anger, their demanding crossing out of political repression. Or, Bushara may have led me to see it that way, knowing my insatiable yearning for dissidence.

My most common refrain was that he was leaving his Sudanese scenes and figures behind because he could no longer remember them. (Besides, I wanted him to remember *my* Sudan.) His years of exile from his homeland were irretrievable and only moments of nostalgia peeked through the large brush strokes. He retorted that I was confusing motifs with strategies, subjects with techniques. He had not changed his themes, only his experiments in varying techniques. The toolkit was different, not the politics. But I wondered about the invention of a culture only remembered as Sudanese: an exile culture. What was I remembering?

The Ascent of the Dragonfly
Conversations with Musa Khalifa

A dialogue with Musa Khalifa about his work is a dialogue with a dragonfly: with filmy wings he flies away swiftly. The flight of his verbal images are matched only by the flight of his visual images. We had our first formal discussion in Khartoum in 1972.[20] The theme of my interview was what I referred to in those years as 'the role of the Sudanese artist in society' (always trying to control the discourse: construct the artist as doing and being one thing). In that interview we had discussed the specific strands of Arab and African cultures that bind Musa Khalifa to this universe (see above). After he had spent three years of art studies in the United States (earning him an M.F.A. from the Otis Art Institute),[21] he and I returned to these topics. We had both just attended the opening of his Otis Institute exhibition of three-dimensional, textural and organic installations. These unframed, asymmetrical, frayed tapestries and tableaux, texts of earth, sand, and wool were sharp departures from his oils, although he insisted that this show was a logical progression. He was still elusive about the strands that bound him to any culture,

subverting my every attempt to categorize him, to frame him, to pin the dragonfly. I wanted to associate the brown earth-textured spheres and fibers with the cartographies of village life in Sudan; he refused. I wanted to say that the seven columns are the seven pillars of Islam. Sometimes Musa would indulge me my own romantic, nostalgic Sudan image making, but he would not engage in it himself. Below is the tape transcription from 1976, a commentary on his Otis installations. As we talked we looked at slides of the work and of some of his earlier works.

* * *

When I asked you to speak about this show, you told me that your works mark the thunder of your heart, and that verbal expression complicates things. But sometimes we can repeat "What the Thunder Said."[22] *That is the name of a section from one of my favorite poems, "The Waste Land," by T. S. Eliot. In fact, I will frame some of my comments about your work with some of Eliot's imagery (I have memorized portions of the work). When I think of Eliot's "The Waste Land," and also "The Hollow Men," it is as if it is the verbalization of your visuals. It seems as if Eliot had been in Sudan, or in the Sahara [Musa does not respond]. The range of your images [in the Otis show] cannot keep us in bounds; there is no frame and our mouths are dry. There is no water, only rock and the sandy road, a road winding through the mountains, mountains of rock without water. If there is no water, we could stop. Our sweat is dry and our feet are in the sand.*

I take you to a shrine where there lives a scream of grief, an evening, and shade seared by the hollow drumbeats, the dead morning, and the flat light.

[He completely subverts my frame of dry rock.]

[Not deterred.] If there were only water in that rock-dead mouth that cannot spit. One can neither stand nor lie, nor even hope for silence in those mountains. There is always that dry, sterile thunder without rain. There is not even solitude in your mountains, but brown sullen faces beseeching me from doors of mud-cracked houses. You show me rock without water and not dry grass moving. It is not the Nile. I would remember the Nile. Maybe it is a bird sounding from the dry and ancient baobab tree where a man drowned once, reaching for water. But there is no water, no birds. Only rock, silent, without people. Where are the people?

A blue bird is falling, burning. Before he collapses he becomes a peacock, circling in an orbit, locked in a monologue with immortality.

[He insists on inserting a colorful bird where I have said there is none.]

*Mountains hollow; men hollow—looming and locked together, filled
with rock, their mouths stuffed with dry pebbles. The voices of the water
were long ago desiccated and the rock spits straw, colorless, dry grass,
provoked only by the wind. Spiders feed on the broken joints of the
desert. "Shape without form, shade without color / paralyzed force,
gesture without motion . . ."23*

[*As if he has not heard me.*] Should I sing? Yes. If I will erupt the
rocks, burst my vocal chords, stop all sounds, shake the roots. Silence!
I will sing my song!

*There is sunlight on your clear seven columns. They sing in the wind
straight up.*

The seven will always come from behind the mountains, behind death,
over torture, carrying the dream.

*One is white; one does not know; one is brown earth; another one does
not know; still another does not know. I cannot see the others.*

We look, we see, we conceive different dimensions. We are confined to
write in the margin of the paper. Break out!

*Their angle eludes me, hides. And there you are, you, Musa, sit among
them on the ground. The earth is painted; it rises up slowly in large
welts. And there are pores in the earth, pores large enough to climb into
and be part of the earth. And you sit among them, not knowing quite,
not quite knowing. Here you have reshaped the earth in broken gourds
and broken calabashes, and in one million years the archaeologist will
say, "Ah, they drank their water from broken calabashes and broken
gourds. And the earth rose up and snatched them!"*

*Sometimes you run red. You run and you run, and the red runs until it
smashes into white! And then we see only fragments of the red—small
dots of red—splinters—tiny squares. Sometimes the red survives. Other
times it is all but swallowed by the tint.*

Red provokes; blue never stops; yellow whispers a rapacious whisper.
White is running toward action and never in. Should I cry? Never!

[*Insisting on staying within the confines of his show in front of us.*]

*White can be very dominant. White can be very oppressive. And in this
dream we know as blue, this dream you dream, blue dream, you, you
sometimes outline your blue dreams with red. It makes you remember
them, no longer latent blue dreams, but red dreams. Red outlined dreams.
Red outlined blue dreams, with white.*

That blue dream emerges when the white dream torments; that blue
dream dies immediately, craving the red dream, which is me.

*And once again white, and white, and white—the oppressor. Sometimes
you see white through the columns, maybe bars. They can watch the red
of our fervor through the prisons. We find ourselves in the corners of
cages.*

In the silence and range of time and space there is a smile that
surpasses all distances, answers before the call. It is simultaneously the
question and the answer, the shout and the silence.

*You paint on the edges; sometimes you paint only the edges. Do you
find yourself writing only on the margins of the paper? The space around
crowds the words, shoving them violently into straight lines. A military
mode of articulating tiny thoughts like pinpricks, paper dotted by
sharpened pencil tips—and at the end of each straight line is a belligerent
dot that says "Stop!" We stop. We are to the end.*

I am the intensity; from inside I move all things. My no is in my yes.
I surpass all distances while I am stopped, and laugh with hot tears
until my eyes bleed. Naked in the best costumes and jewelry am I.
Will you be?

[He has rejected my 'edges' (marginality), imagery, but I persevere.]

*We are on the very edges of everything we used to occupy, all the space
and time that our souls could spare. Now the time is shattered, flickering
in little glass pieces in the prisms of our eyes, cutting there around the
rims and fracturing each tiny vision. Now the space is mutilated and
cannot speak anymore.*

On the last pitch the shout dies when you stare at the laser; when the
body becomes the face, the face becomes the quivering nerves, the
sound becomes the light, silence, love is death.

*[I am conscious of margins, space, and confinement; he is totally
unconfined even by my 'rules' of dialogue.]*

*Space used to scream at us, and we would occupy it, cuddling it in our
motions until we all felt fulfilled. Space saturated; time tempered. Now
the margins of our hearts are all we can spare. And we have gone thin—
squeezed and pinched—pushed into submission by the very edges
themselves.*

When I collapsed I was standing, the wound was white even after the
leg was cut off.

[He returns to white, abandoning my earlier reference.]

You told me, "I want to dip into the sun and feel the burning." And as I
asked you academic questions, you said, "Yes, I feel the burning." I
asked, "Is there such a thing as the 'Khartoum School' of art?" "No," you
said, "unless you meant that we all feel the burning together."²⁴

The holy anxiety, the sharp strain, the exhausted anguish with no
shape—is to perish outside of time at the peak of immediacy, between
the coming privation and the before.

The breeding deserts, the sand, the sky, the earth, the palm trees, the cool
water of the Nile. Is that your meaning?²⁵

If only just the Nile would cease being cool. The time has come to
move, yell, revolt! Then the seeds will sprout and set forth towards the
light and never retreat into themselves again.

[He rejects the attempts on my part to position him in a 'school' or even
within a landscape which I am presenting as his.]

Who are you? [Always attempting to entice the artist to name himself.]

I feel I am between memory, time, rhythm, and outcome. In relation to
vocal and visual source I am within, on, or out of the natural and
environmental context—relevant or not relevant. By the strike of the
unfamiliar, the joy of the known, the challenge of the unknown, judge
creation and its relevance to preconceived references.

What do you do here?

Where is here? Art is the abstraction of life. I am here living an
abstraction. But I could be there living an abstraction. I can dream
either place. Because we undertake our freedom with responsibility, we
take the next step to know. It is the responsibility of the way, the goal,
the arrival and being—all choosing our coming world. It is a trial of
concept, a trial of the absurd as range and depth. Love and awareness of
time and place under contradictions—faces and changes. It is a trial
leading us no way and one way, to the idea of no exit—to be—as
acceptance and a shout. It takes a lot to carry the wound into the future.
I said to you once that our role is to call out to each person to feel the
sun in him. Paintings should burn with truths. We cannot escape our
Sudanese cultural origins, even if we wanted to. But a painter should
create fates of his own and rules for today. I am looking for a painting
that addresses itself to all problems. And I am insisting that people
address themselves to those problems. I said this in relation to a dream
for art, a dream in which the performer and the audience are one—
which would turn the performed work into pure existence—a synthesis
of time and space. Art does not relate to time or place as a preconceived

arrangement. There is a wholeness of elements, tying together the powers of existence. Art is, therefore, a way, a means, an end.

[He continues on the theme of exile and home; internalizing it.]

I was reborn in the village of America; the village taught me many things. In this rebirth I experienced the same suffering, the same pain— but the same joys. There is no difference. One is a reflection of the other. The wedding procession is exhausted from carrying the sunboat. When the glory of the party dimmed, I did not yet shout, "Give up the party; announce the funeral of the wedding!"

If art is the outcome of such loss, what did you lose? Is it there in your painting, in those dry objects, installed for voyeurs? Thirty-five years [in reference to his age at the time] and how many cultures? How many villages? How many White Niles? What is the unity of the common human element about which you speak? Where are Kawa [where he was born] and Mora [where his father was born]? You have the Blue and the White Niles mixed in your veins. Is that the unity of the common human element? "Between the idea and the act falls the shadow, for life is very long."[26]
I feel an invitation to unity through the development of consciousness in all its aspects—as an encounter and a precedent, attributing a function to all energies for the achievement of the ultimate. I feel an invitation forward to comprehensive continuity which being never approaches—with man in his communion and existence as a part of a whole which is not temporary. *[Again, in reference to his earlier work and to the Sudanese landscape.]* On the horizon there is a dot, perhaps not a belligerent dot that says "Stop!"

You cannot swallow the light, nor eat the blaze. For now you may neglect yesterday. But now never lasts until tomorrow. Never deny me the road again. Get your blaze; pour the laser on me. The brave one is back, carrying the wound of the past.

Is that what art is all about? Everything is now?
Now is the peak of time, the flaming moment. Now is when the drum whispers: extend the step. Death dies when the heart of the sun is the meeting point.

Being in America is now. And you transformed your canvas, washed it like the banks of the Nile, chose your colors from the natural hues, disheveled the burlap to meet the cracks and crevices and rocks, stones, and twigs. You soaked the burlap and filled it like the pores of the banks. And then you used the cool wet clay to cover your round universe and

draped that universe with the hangings of your heart. These tapestries of
your heart move oh so slowly, rushing so gently across your round, your
full, your earth-clay universe. Your brown eye is looking out, looking in.
I will be careful where I walk; these are the mountains of your moon,
your white mountains of the moon. And then the white mountains of the
moon address themselves to your canvas, to your sculpture that meets the
ground. You do not mutilate the space; you cuddle and nurture it. But
you do not fill it either. The emptiness, the wide emptiness is the margin
of your heart.

The codifications and the organization of the dream and the mythical
output, with the necessity for the relativity of experiment between two
absolutes, as a vehement, rational and sentimental response, to take a
situation with, within, or against things, a pioneering, a revelation, and
a tide. To specify a position amidst all the cosmic forces, as an attempt
to verify dream by reality; a transcendent wish fulfillment, a training of
mind and an arrival at . . .

* * *

In rereading that 1976 transcript today it seems so clear that Musa Khalifa
was resisting with all his heart being a subject of colonial discourse. I
had begun with "The Waste Land," an icon of Western alienation, and
tried to draw analogies with his life and work. Like Bushara, he refused
categorization or even having his work described. Frequently I fell into
the temptation to romanticize the subject (Sudan) and the artist (the
mystical poet/artist) in my attempt to position both of them within
colonial discourse: that Master touch. When I attempted to place the work
within a culturally specific category, Musa became "universal man" and
the reverse: "I am just a boy from the village . . ."

It was virtually, and still is, impossible to construct a biographical
framework for Musa Khalifa, nor is it possible to confine his art to a set
of canons. In 1976, when this interview took place, he was thirty-five
years old and was to return to Sudan in a few years. He was to live
through two more major political upheavals, sojourn in yet another
country for some time (Morocco), return to Khartoum, and then return to
his village when life in the metropolis got too dangerous for an
independent progressive with a stubbornness that was the only nonelusive
thing about him. I get news of him now and then. Is he still an artist? It
is hard to produce art among the dictators. It is time to take up arms, say
many of his comrades, but he is not a soldier. Still, if we can imagine
Musa, we know that he is producing something akin to the flight of the
dragonfly: energetic, peripatetic, beautiful.

*Do Cadavers That Embrace Feel the Mutual Death?* [27]

Bushara and Khalifa may not be soldiers, but they bear brushes, cleanse
with their canvases, do battle with the elements of their art and their own

psyches, and reinvent themselves again and again. Both of them have been busy building a culture unique to them in their exile, holding on and letting go. This is a time for grave tests for Sudanese artists and intellectuals at home and in the world.

Notes

1 From Sondra Hale (poetry) and Mohamed Omer Bushara (art), "Seasons of Our Discontent," unpublished manuscript, 1975, dedicated to the late Abdel Khalig Mahjoub, executed secretary-general of the Sudanese Communist Party. Portions of the manuscript were published in Sondra Hale (with Mohamed Omer Bushara) "Art and Dialectics: A Sudanese/American Experience," *Africa Today* 28, 2 (1981), 97–107. This poem was part of the title for Mohamed Omer Bushara's solo show at the Armory Center for the Arts in Pasadena, California, April 2–24, 1994, co-curated with Sabrina Motley.

2 Ashis Nandy, *The Intimate Enemy: Loss and Recovery of Self under Colonialism* (Oxford: Oxford University Press, 1983), xi.

3 After I left Khartoum in 1988, I was informed by a number of people that a series of articles on Sudanese art history had appeared in an Arabic-language newspaper. The author, an art historian at the College of Fine and Applied Art, and an Islamist, invented what he referred to as the 'Sondra Hale School of Art.' The purpose of the construction was to mock my collaboration with a number of Sudanese artists. As one might expect, these artists were accused of being influenced by 'Western art' and 'not being Sudanese.' (It did not help, of course, that in the Islamist's construction they were under the wing of a Western *woman*.) Ironically, the artist with whom I have worked most closely, Bushara, was spared the scathing critique. Other ironies are: (1) all of the Sudanese I worked with subverted my attempts to impose any categories on them, and (2) that, despite the poetic universalistic claims, most of the modernist Sudanese artists I talked with insisted on the culture-specific nature of their art.

4 Sondra Hale, "Musa Khalifa of Sudan," *African Arts* 6, 3 (1973), 14–19; quote is on p. 15. The article is based on interviews with the artist between 1971 and 1972, Khartoum, Sudan.

5 Personal conversation with Musa Khalifa, Los Angeles, 1975.

6 Hale, "Musa Khalifa of Sudan," 15.

7 Ibid., 16.

8 Ibid.

9 Ibid., 18.

10 Ibid., 19.

11 Denis Williams, "A Sudanese Calligraphy: A Contemporary Interpretation of Mohammedan Art," *Transition* 3, 9 (1963), 20. Sondra Hale, interview with Ibrahim el-Salahi, Khartoum, Sudan, 1961.

12 Sondra Hale and Mohamed Omer Bushara, "In Search of a Face: Salih Abdou Mashamoun—the Sun and the Eclipse," *Ufahamu* 6, 2 (1976), 82–105. Halfawin refers to people from the Nubian town of Wadi Halfa.

13 'Bifurcated' is an oversimplification. The invention is usually of 'Three Towns' at the confluence of the Blue and White Niles, including Khartoum North, constructed as an 'industrial city.'

14 Southern Sudanese, the primary victims of the long war between the 'North' (constructed as 'Arab') and the 'South' (constructed as 'Black African'), insist that there is nothing 'bloodless' about Sudan's politics.

15 I am constructing all of these artists as 'Khartoum School,' when in fact, a few were not trained in Khartoum and seldom worked or exhibited there. For a good summary of northern Sudanese modernist art, see "Desert Light: Sudan" in Jean Kennedy's *New Currents, Ancient Rivers: Contemporary African Artists in a Generation of Change* (Washington: Smithsonian, 1992), 108–122. For a summary of arts in general in postindependence Sudan, see Sondra Hale, "Arts in a Changing Society: Northern Sudan," *Ufahamu* 1, 1 (1970), 64–79.

16 Bushara's prizewinning pieces were published in "Competition 1974: Mohamed Omer Bushara," *African Arts* 8, 2 (1975), 8–11. Four years later his 'Slade Series' was published in "Bushara at the Slade," *African Arts* 12, 3 (1979), 36–41.

17 Sondra Hale (poetry) and Mohamed Omer Bushara (art), "Seasons of Discontent," 97–107.

18 Sondra Hale, from "Seasons of Our Discontent." This poem was published in *Africa Today*, ibid., 105. The use of 'we' suggests my own political identification with the struggle.

19 Ibid.

20 Hale, "Musa Khalifa of Sudan."

21 He later obtained a Ph.D. from the University of California, Los Angeles, in Education (through Art).

22 T. S. Eliot, "What the Thunder Said," Section V of *The Waste Land, The Complete Poems and Plays, 1909–1950* (New York: Harcourt, Brace and Company, 1952), 47–50. Throughout this section I have picked up phrases from this poem.

23 From T. S. Eliot, "The Hollow Men," ibid., 56.

24 I was paraphrasing the interview with Musa Khalifa published in Hale, "Musa Khalifa of Sudan," 19. The exact words were: "The painting I am dreaming of speaks to the universe, with universal words, seeking a self balance. . . . It should speak to every person's desire to dip into the sun, to feel the real flame, to feel the burning. . . . Our role is to call out to each person to feel the sun in him."

25 'The Breeding Desert' was an association of Sudanese poets who claimed that Sudan's artistic traditions came out of a combination of desert and jungle. Poets such as Mohamed Abdel Hai and Mohamed el-Mekki Ibrahim concerned themselves with the origins of Sudanese culture.

26 I purposely changed the lines. The correct lines are "Between the idea / And the reality / Between the motion / And the act / Falls the Shadow / For Thine is the Kingdom," T. S. Eliot, "The Hollow Men," *The Complete Poems and Plays*, 58.

27 This is a line from my poem, "The Return," *Africa Today* 28, 2 (1981), 100.

13

IMAGE AND EXPERIENCE
WHY CINEMA?

Farida Ben Lyazid

Translated from the French by Sherifa Zuhur

Why do we find the image in a conservative Islamic country where a tradition of imagery does not exist?

Why is there cinema in a country where there is no film production?

In the 1950s, Morocco received the Golden Palm award at the Cannes film festival for Orson Welles's Othello.

What do these questions and assertions mean? They are the jests of history! Morocco was a French protectorate and *Othello* was produced by the French in Morocco. Plenty of other, less well-known productions were filmed during this period. This was true of a whole series of films that we may categorize as 'colonial cinema.'

Many foreign productions were filmed in Morocco; we may recall the most important, *Lawrence of Arabia*, for which the country provided a fictional 'realistic' setting for certain scenes. *Casablanca* and *Morocco* were made on the Hollywood lots.

Some well-bred Moroccans were involved in film making, but theirs were isolated, individual efforts that were not long lived. Some were passionately attracted to the cinema, and wanted to pursue it along new lines. Some of them lost a great deal of money in the production process. Others gave up their dreams of a career in film making, and played various dead-end roles in other people's films. History recounts that Mohamed Ousfour nevertheless persisted to the bitter end. While very young, he had succeeded in getting himself onto the set of *Othello* as a lighting technician, and thereafter his passion for cinema never abated. He

205

tried to reshape the processes of cinema as part of an artisan's method. He made short films, which he showed in a garage in a lower-class area, and at the same time worked on a full-length production. Ahmed Bounani dedicated a very beautiful film to him, for it appeared that Mohamed Ousfour was no amateur, although certainly a film maker of the naive school.

Just as painting has its 'primitives,' so has the cinema. For a great deal of naivety and unconsciousness are necessary to construct a cinema among us. Thus it has been, among the pioneers, everywhere, throughout the history of cinema. These pioneers are often considered to be a little crazy, not really serious, tilting at windmills, chasing mythical beings. This has been the case for a long time here in Morocco.

Well then, how could it be that a girl from a good family who was considered beautiful—which means she could make a good match—why would an educated woman who could aim for important positions and climb the rungs of a career ladder launch herself instead onto a tortuous path which could ruin her?

I do not know. Perhaps it was because I discovered the cinema before knowing anything about life, even before knowing how to read or write.

In my childhood, Tangier was an international city. This was in the 1950s and the Second World War had already been forgotten. The various diplomatic entities competed in putting on a continuous series of festivities.

During these events one could go see the latest films from anywhere in the world, and my mother loved the movies. I do not remember exactly when it was that I went to the movies for the first time. I was too small to remember precisely, but I do remember the first films that made an impact on me.

I adored *Cinderella*. I was quite afraid when I saw *Quo Vadis*—I remember the scene where the lions ate the early Christians in the amphitheater. Cantinflas and Laurel and Hardy made me laugh loud, and I discovered romanticism with *Samson and Delila* and *Gone with the Wind*. Delila's treachery bowled me over and Scarlett's whims distressed me. I cultivated the 'blue rose' with Egyptian and Indian films whose magic entranced me. *El hijo de Nadie*, a Spanish melodrama, made me cry until there were no tears left, as did *Sans famille* a bit later.

My parents divorced in the end. My mother wanted to live a modern life, my father would not consent. We were eight children and we were to live with my father. He considered the cinema to be a booby trap. "I give you money [to watch the movies], and you'll speak like a floozy," he said. We got permission to go to the movies occasionally, but only so long as we didn't abuse our privilege.

I remember how one day an old religious man with a white beard came to see my father. He was astonished, and cross, to see me playing with a

doll. But my father defused the situation with an indulgent smile for a child's game. This was the first time I was confronted with the religious injunction against material representations of the human form. Since then the question has been regularly put to me, most often by our Muslims who have retained this Islamic precept, which Muslims the world wide continue to discuss. I am a believer, and a practicing Muslim, and I think that in some cases the image can be dangerous. We know that the image has a direct impact on the unconscious. We will return to this later.

As an adolescent, I constantly played hookey from my class at the lycée, so that I could go to the matinées. Alone, or with my girl friends, I went in secret.

It was at just this time that I discovered literature. I read endlessly, passionately. I was an orderly young girl, and my comings and goings were kept track of. I escaped during the hours of lectures by trying to write, but without much satisfaction, although I did accumulate some material which helped me much later.

In a hurry to live an adult life, I got married at the age of seventeen and left Tangier to go to Casablanca. I remember that one day a few months after my marriage, my husband refused to go with me to the movies. I could have gone alone, but he didn't want to let me do that either. I called my father, weeping over the telephone, and it was he who explained to my husband that I was young and he ought to grant me some pleasures like the cinema that I loved so much.

I had two little girls, but the joys of the hearth soon bored me. I went back into a private school to pass the baccalaureate; that was only granted to me after numerous interventions with my husband by family and friends. This goal did not seem to me incompatible with marriage, but that was not my husband's view, and we ended up separating. I was twenty-three years old and I decided to put it all on the line. My dormant, hidden dream to make films asserted itself as my destiny.

I abandoned all and, against everyone's advice, left for Paris to go to film school. Only one of my aunts, a woman of great character, one of the first to discard the veil, encouraged me. It was my journey through the desert, long, strenuous, and intense.

The years in Paris were very difficult and the most exhausting in my life. I had to work because I had no scholarship; I also had to amuse the children and do my coursework. For the last three years I worked in a bank, which served me well later when it came to setting up and managing productions. Once I completed my studies, I returned to Morocco. I wanted to create a Moroccan cinema. I had discovered by then that Morocco had no real film production and it would have to evolve its own if anyone was to make films.

My greatest experience was the production of *Une brèche dans le mur* (A Hole in the Wall), a full-length project by Jilal Ferhati, who had

previously made two interesting short films. To the great consternation of my parents, I sold my family jewels to finance this project, but the film made it to the Cannes festival, and was selected by 'La semaine de la critique.' From this film, I learned how the difficulties of the craft could drive me to distraction; but all things considered, the satisfaction at the end of the process had me totally hooked.

Since I was a producer of this film, I could track the different production stages closely, and grasped the appropriate technique for scriptwriting. I then adapted a novel I had written into a script—*Aisha*—and it was once again Ferhati who directed it, changing the title to *Reed Dolls*. I did not feel ready again for directing, so I was involved in the production of the film, which was also selected at Cannes as one of La Quinzaine des Réalisateurs (a coveted award).

Finally I propelled myself back into directing with *Une porte sur le ciel* (A Door to the Sky). Deeply inspired, I had written a very personal script, and I did not want to show it to anyone. It was time to start production. I had already directed a short reel in sixteen millimeter film for channel FR3 in Paris. But as for a documentary, a full-length feature to produce and direct, well that was another matter. My state of relative unconsciousness helped me once again to launch this adventure, with the support of Hassan Daldoul, my Tunisian co-producer. I had met him at Cannes, where he was attending on behalf of the film of Borham Alaouie, *Beyrouth la rencontre,* which he had produced. He is an individual who has done a great deal for what we call New Arab Cinema. *Une porte sur le ciel* was a fabulous experience. It was a film made on a shoestring budget, but that really did not matter much. I had the good fortune to travel with a crew of great solidarity, Moroccans, Tunisians, and French, all of whom believed in the project, as did the actors. I did the editing in Tunisia with Moufid Talati who later directed *Silences du palais.* Once again I was surrounded by sensitive, warm, intelligent, people. Tunisia became my second home. I traveled a great deal with this film, but it was not a commercial film, although it still exists and attracts interest. It continues to be shown at cultural festivals around the world. I have a distributor in the United States, where the film circulates around the American universities. I have also received very interesting work from students who have seen it. Since then, I have mostly written for others: for example, I wrote *Badis* for Monsieur Abderaham Tazi and the comedy *Á la recherche du mari de ma femme,* which was a great success in Morocco.

I love to write, and also to write for others. It is humbling to think of the screenwriter who allows me into that profession, or the technicians who remain unrecognized most of the time. I want my work to be known but I do not want to push myself as a product for sale. I like the simple life, and the blazing light of the cameras makes me ill at ease when it is

projected on me. Within each story that I write, I put a great deal of myself, of the emotions from which I obtain my culture. I love all cultures, and their sages especially. In their variations lies the wealth of humanity. It is the unfolding of all the possible human futures. And that is perhaps why I want to display my own culture and its subtleties. I want our children, whom the curvaceous film stars haunt, to draw their identity from it. I wish that the whole world could discover in it something other than stereotypes and preconceived ideas.

The centuries of culture are in the process of swinging into the MacDonald's culture, of liberated vulgarity and electronic music. In my films, I want to recapture forgotten melodies; I love using the women's songs that have traveled across the centuries through the oral tradition of learning.

I am often reproached for engaging in 'cultural' cinema. But this is exactly what I want to do! I don't want to go play in big sharks' pond. Our interests are not the same.

The image is the language of the epoch. It is a marvelous tool, which can be extremely dangerous. One must be vigilant. In my life I never sought to trick people. Why should I do so in my work? Why should I put myself in the position of selling them something unimportant, just because advertising pays well? It is a question of ethics. I do not mind amusing the public, causing them to dream and to reflect, but always respecting their dignity.

I do not think of encouraging those baser instincts that are in us all. Violence and perversion do not appear to me to be useful to the blossoming of the self. I moralize, yes. I make this demand on myself, and that's all there is to it.

14

VICTIMS OR ACTORS?
CENTERING WOMEN IN EGYPTIAN COMMERCIAL
FILM

Sherifa Zuhur

Change versus continuity is a constant theme in considerations of the image of Middle Eastern women, and in presentations of Egyptian society. It is a theme that reverberates in many areas of public and popular culture in Egypt. Cinema may reflect its makers' ideas of change or continuity, and is a prime arena for the exposition of social conflict. This is the case even when political views are not fully expressed. Gender themes or family dramas have provided much subject matter especially attuned to conflict, change, and continuity in Egyptian cinema and television for many decades now. This chapter investigates the expression of gendered material, and its gendered representation in popular, or commercial cinema in Egypt in the early 1980s.

Just as Hamid Naficy divides the cinematic production in Iran into 'populist' vs. 'quality' cinema, I differentiate two general categories of film produced in Egypt. The first may be classified as being popular (not always populist), commercial, and produced for internal or regional viewing. The second category has been referred to as 'art,' 'serious,' or 'quality' films, some of which may be prepared for export and submission to international competitions. In Egypt, there are hybrid productions, and directors, writers, and actors who have been involved in both categories, but their respective audiences are seen to be disparate groups. As Walter Armbrust observes in this volume, commercial film may be an expression of popular culture, but is not usually exported to, viewed, or appreciated by Americans, in contrast to certain 'art films' that make the circuit of university audiences. Implicit in his observation is that film 'tastes' exist, which are not international; there are issues of substance, style, and format in popular commercial Egyptian (and other

Middle Eastern) film that are not appreciated, understood, or tolerated by viewers of other cultures.

Commercial film is an interesting aspect of performed image, carefully planned, repairable (through editing), yet still a recording of each actor's nuanced additions to, or subtractions from, the script's intent. Not as aesthetically focused as non-commercial film, and more vulnerable to censorship, it has been less studied than other forms of popular culture.

Egyptian consumers of commercial film are thought to be lower in socioeconomic status than those of 'art' or hybrid films. The lowest and middle levels of the lower class cannot afford to attend the cinema. Televisions and VCRs have became a source of pride and status for the upper lower class and further up the social scale. The tone of commercial film is a mixture of voices intended to appeal to the *sha^cb*, but also to the middle classes; groups not always in accord over the ongoing changes in society.

Commercial films do travel out of Egypt, not to universities, but to Arab communities abroad. Arab Americans import, trade, and discuss commercial films, and the films serve to connect viewers with the *bilad* ('homeland'), their own nostalgia, and the *Weltanschauung* of their counterparts in the Middle East. A residence in the Arab-American community in the United States alerted me to the popularity of commercial films and the growing video copy business, during a period when there was much discussion about the use of film in teaching and textual analysis, in history as well as other disciplines. Commercial film may be opaque to outsiders, yet it contains vital information about a society in transition in Egypt and the visual texts it enjoys. These films have much in common with the Mexican *novellas*, also the source of laughter and incomprehension to the outside viewer. Transformations in the stories and characters of female protagonists may be even more relevant to our view of social change than gender comments in 'art' films, which are designed for an external and educated audience.

The films of concern in this chapter date from the late 1970s up to 1986, feature female protagonists and deal with various gender issues: adultery, polygamy, divorce, family manipulation, fertility, the loss of children, rape, and women's changing legal status. The author was not interested in quantifying the percentage of gender-related films in total production for these years, although scores of films on video were reviewed for this sampling, but rather establishing which commercial films were known by an Arab audience to involve gender issues, and what then may be deduced from these treatments.[1]

In Egypt, as elsewhere in the Middle East, both film genres, 'art' and 'commercial,' explore the tension between tradition and modernity, a theme also apparent in popular television series. In Syria for example, of two extremely popular *silsala*s (regular programs, or 'soaps'), one is set

in Egypt, where a village setting, complete with the village headman, the *cumda*, and the British authorities represents tradition, and the other takes place in Syria during the Mandate era. Gender mores are a prime example of the settings' veracity, as the characters, male and female, test their boundaries.

Commercial films set more clearly in the 'present' sometimes illustrate unlikely forms of gender discrimination, or those that are now rare; the films both historicize and contextualize gender issues, yet they play on stereotypes—some that have been criticized in Western films about the Middle East. Incidentally, this particular dilemma is illustrated in non-Arab as well as Arab cinema, for example in the 1972 Israeli film *I Love You Rosa*, directed by Moshe Mizrahi, which dealt with Judaic legal privileges allowing a boy 'first refusal' to marry his deceased brother's widow.

This section will focus on a select number of commercial films that were popular in Egypt when made, and then exported in video form to Arabs (Egyptian and non-Egyptian) overseas. The character development in these films shows that through the construction of a parallel film world, changes in gendered meanings or stereotypes gain a wider symbolic import. Screenwriters hold certain perceptions about an audience's gender attitudes. Simultaneously, the writers (and actors) shape and mold public attitudes.

The films selected center on gender issues via the adventures of female protagonists. My primary interest in these film-texts is as an observer of Egyptian society, for I believe that images of these female protagonists influence both male and female opinions of women and the changing relations of the sexes. The protagonists possess qualities familiar to their audiences, and offer parallels to powerful female characters in certain contemporary short stories or novels in Egypt. Certain scripts are in fact treatments of earlier written work. Yet they affect a greater number of viewers, many of whom have not (or cannot) read the original works.

Egyptians have been presented with an array of competing images of ideal lifestyles or character attributes, particularly since the mid-1970s when the Open Door economic policy *(infitah)* was initiated. This array is far more complex than a gradation of Westernized to less Westernized figures, involving as it does political and religious attitudes, career and family options, and shifts in economic power. Alongside the difficulties of reading social change, we find alternative methods for understanding aspects of popular culture. Should we consider each film a text, legible to 'insiders'—that is, viewers who have grown up on a diet composed of frequent helpings of commercial film, and illegible to 'outsiders'— opaque, as I wrote above? Or may different viewers interpret the polemical and emotionally charged discourse of popular film in various and equally accurate manners?

In examining commercial films produced in the 1980s, we see that gender in the context of these years plays a very important role in defining social boundaries. Changes and arguments over gender roles took place alongside socioeconomic shifts and ideological transformations in the country. The dream of Arab unity had tarnished with the quarrels between regimes, with the 1967 defeat, with Nasser's death, and subsequently with the Arab states' reaction to the Camp David treaty. The goals of Arab socialism were never ideally implemented, and perhaps unattainable in the face of Egypt's growing external debt.

Nevertheless, Arab socialist ideals had affected the arts. Sadat's expulsion of the Soviets and adoption of the Open Door economic policy signaled a major ideological shift as well as the gravy train for various groups who benefited from the new laws and joint ventures.[2] Grave discussions over the turn to the West marked academic and journalistic literature, but could not be represented as directly as certain effects of modernization and the *infitah* that were 'discussed' in cinema. Class differentiations of 'culture' as well as income (if not struggle) sharpened in comparison to decades past, and subsequent struggles over the degree of political openness of the regime involved critics of the left and Islamists. While some groups gained more income, property, and power, others were constricted by the lag in public sector salaries and inflation.

Working women became more numerous, visible, and suspect, divorces more common, but still to be avoided, if possible. Story writers and producers reflected these changes and a presumed public longing to contain them. Although writers, film makers, and producers expanded the range of action and reaction for female protagonists, culturally defined aspects of feminine identity prove to be the downfall of these heroines more often than not. We can read into the texts of these films an indictment of individual female weaknesses that launch the dramatic tension in the plots. These observations parallel those of Ghada Helmy, who noted in her analysis of films made from texts by Latifa al-Zayyat, Tewfik al-Hakim, and Yahia al-Taher Abdullah that "it is the acceptance and passivity of women that causes their entrapment in specific social roles."[3] Hence films simultaneously signaled female weakness, trepidation over social change, and the need to challenge aspects of gender ideology.

In 1979, President Sadat launched an important series of reforms to existing family law.[4] Women from a range of political backgrounds supported these reforms, but under pressure from Islamists and others, the government rescinded these legal changes, and subjected them to review and reformulation under proper legislative protocol. The 1979 reforms had involved important gains for women: better terms for divorce for women, including the granting of the family residence to a divorcée, extended custody of the children, an end to the cruel, outdated practice of

bait al-taᶜa ('house of obedience,' wherein a woman who sought divorce could be confined to her home, or even to a room in her home at the whim of her husband). Furthermore, under Sadat thirty seats in parliament had been set aside for women representatives, thus addressing the imbalance in political representation in the spirit of 'affirmative action.' When the guaranteed seats were withdrawn, female candidates continued to run for office, but statistics show that only 5 percent and under of elected officials are women.[5] More and more women obtained university degrees, but the overwhelming pressure to marry and have children, and gender discrimination in the workplace, constrict women's employment prospects. Islamist messages intended to encourage women to stay home have affected some, and influenced others, who adopted the *hijab* for various reasons in the 1980s. The 1980s witnessed both changes and setbacks (changes *and* continuity) for women and a greatly broadened forum for discussion of gender issues given the public debate over the reforms.

The films of the period reflect concerns over women's status and fears that too much change would throw society out of balance. Although some key reflections on gender issues had been introduced earlier in cinema in the Nasser period, incendiary challenges to the gender order were mainly contained in 'art' films, such as Youssef Chahine's *al-ᶜAsfur* (The Sparrow, 1974), in which the themes of corruption and political disaffection overshadow gender issues. In 'commercial' films the main concern was to address some issues of class oppression which could take a gendered form.

By the 1980s the increasing visibility of women in formerly 'male' professions and in the service sector could not be dismissed. The film industry realized that its screen heroines should therefore not reflect an Egypt of earlier decades. However, viewers are intended to understand that even these strengthened female figures face trials and tribulations that they have brought upon themselves by moving in conflict with society. The agency of the protagonists is ambivalent; fate still looms larger than the will of individuals. At their heart, these films provide texts about gendered options that are not very revolutionary, and that bolster misgivings about the changing structure of family and gender.

The growth and evolution of the commercial film industry in Egypt coincided with the growth and development of the middle classes and with class-oriented definitions of public and private entertainment. These definitions changed along with changes in technology. Hence, film showings that were once aimed at a mainly elite audience[6] have been produced more recently with a predominantly male and lower class and lower middle-class audience in mind, along with a female and male video market. In part, the gendered separation of cinema viewing results from social practices and beliefs that have historically asserted male dominance

over public space. This situation has crystallized due to social Islamization and the emergence of political Islamism in Egypt in the late 1970s and the 1980s.

Today, as in the 1980s, many elite viewers (especially women) would not care to attend downtown theaters. The construction of newer theaters in other neighborhoods has broadened cinema audiences, as has the introduction of home VCR viewing. Nonetheless, the presence of women as central characters in commercial films should not be attributed to these shifts in viewing patterns, nor are they a new 'women's genre' of film, like the 1940s 'weepies' in the United States. It is more appropriate to classify such films as female adventure stories, or as variants of romantic tragedies that may star male, just as often as female characters.

The film industry projects box-office returns on the estimated attraction of certain actors, elements of the plot, and taking the costs of production into consideration. In the last fifteen years, commercial film making has achieved technical and aesthetic sophistication and also exhibits the shift from public to private sector that has affected the entire economy since the 1970s.

Egyptian-produced cinema dates back to 1927, although the earliest feature films were commercial risks, and were both emulated and criticized.[7] In writing about early Egyptian cinema, Jacob Landau claimed that its failings stemmed from the audience's concern with the plot, and the insertion of musical entertainment in response to both illiteracy and theatrical tradition.[8] Yet, Egypt's successful cinema industry has proven to be a commercial success. Other observers and critics have characterized Egyptian films made before 1952 as being highly imitative of Western film. Among the criticisms leveled were the degree of melodrama, the inevitability of musical, or music and dance sequences, and that Egyptian films were too imitative of Western film.[9] These critiques may have been ethnocentric, or Eurocentric, and were at least insensitive to traditions of Egyptian/Arab theater and musical theater, natural relatives of the cinema industry. They were also part of a political agenda in the postrevolutionary period, seeking to devalue cultural products that were, as we would now say, politically incorrect.

Women were mainly portrayed in love stories in which their lives were shaken in the arms of the twisting fates. While heroines are pure at heart, society around them is often corrupt. Female characters usually demonstrated less complexity or development than their male counterparts; their roles were written and acted with heavy layers of sentimentality. Writers also emphasized traditional maternal virtues. Good and poor acting combined with the varied talents of directors and screenwriters.

Some women played important roles in the growth of the industry, as actresses and also as producers. Even some very early films, *Leila* (1927),

produced by ᶜAziza Amir, and *Zeinab* (1930), addressed dilemmas inherent in family life and the limitations on female independence.[10] Considering the era, with women newly emerging from previously expected seclusion, the introduction of such issues was significant and controversial. Other women producers included Amina Muhammad and Bahiga Hafiz, who also starred in one of her films, *Layla bint al-sahara* (Layla, Daughter of the Desert, 1937), although as Hafiz herself indicated, female involvement on or behind the silver screen was not considered very respectable.[11]

In the 1940s, a star system developed in the cinema industry. Romantic heroines were able to introduce questions about the struggles of women as individuals, but could not, for the most part, avoid their need for a hero-savior. Similarly, the role of interfering villains, or even society's interference with romantic love, might be challenged, but was only overcome with difficulty, as in *Intisar al-shabab* (Triumph of Youth, 1941) with Asmahan and Farid al-Atrash. Then, in Nasser's era, neo-realism ascended in cinema, along with an idealization of populism and the struggles of the lower classes, as is described at some length in this volume by Marjorie Franken (Chapter 17). Both commercial and more avant-garde films provided metaphors for class struggle, or occasionally for gendered conflict.

Complicated issues of gender, including sexual identity, were also featured in films. Garay Menicucci has recently described a variety of films that deal with gender crossovers and the presence of a non-heterosexual subculture, and which range from the comedic spoof of men or women in drag to considerations of their socially learned sex roles.[12]

With the Open Door economic policy *(infitah)*, new twists on the experiences of its primary beneficiaries, the nouveaux riches, were reflected in film. Star-crossed lovers from varying social backgrounds, or lovers affected by sudden changes in fortune appeared, as in films like *Intabihu ayyuha al-sada* (Watch Out, Sirs, 1980) featuring Hussain Fahmy and Mahmud Yasin. Here, a son of the elite who loses his girl to a newly wealthy garbageman cum drugdealer cum investor.[13] Another new script trend stemmed from the historical revisionism now allotted to the Nasser years. Some references to past political repression could be made, in film plots that also dealt with changing social values.

Leading ladies in commercial film might now depict elite or middle-class women struggling with a relative, husband, or colleagues less modern than themselves. Infidelity or spousal abuse might be encountered and was clearly wrong, yet the protagonist could never abandon her family responsibilities. Sometimes she championed the cause of a poor woman or child. A wide gap between this ideal woman and her viewers' values often evolved through the intervention of tragic events in the script. Fate frequently punished her for her independence, or

any assumption of male-like strength, or for moral laxity. That an elite heroine might occasionally triumph was congruent with the political atmosphere in the Sadat years.

Some films of the late 1970s and early 1980s began to address contemporary issues affecting women's economic and social status, including the effects of female and male labor migration, drug addiction, and violence. Films made references to the previously discussed personal status reforms and later to their amendments.[14] Other gendered situations affecting women continued in film despite various changes in law, such as the issue of forced marriages, and 'honor' killings, including murders of adulteresses, or other receptacles of family shame.

Many films dominated by female protagonists indicted contemporary situations and solutions, rather than castigating traditional mores. For example, in the film *Li-ᶜadam kifayat al-adilla* (Insufficient Clues, 1987), which features Nagla Fathi, it is the mega-city Cairo that represents the evils of modernity, invading the rural migrants' experience. The city, and the modern values it contains, infect her lying, cheating husband, the uncaring urban residents, and the callous, punitive bureaucracy that draws its lifeblood from the urban milieu. The traditional practice of polygamy is the obvious source of the lead character's problems, as is the Arab/Egyptian family's control over marriage. These practices affected both city and country dwellers: however, the heroine's life changes only after coming to the city.

Although polygamy is not widely practiced in Egypt now, the fact that it has not been legally abolished means that it could be a fair subject for film's social critique. In films of the 1980s, such historically based problems affect elite women as well as lower-class women. However, lower-class women in real life were less affected by seclusion, yet also lacked money, expertise, and the *wasta* ('connections') to overcome their familial dilemmas. In *Li-ᶜadam kifayat al-adilla*, it appears that the lower-class female protagonist is ultimately defeated by her inner *fallahi* ('peasant') qualities, including impatience and stubbornness, and by her ignorance of the bureaucratic maze. She identifies totally with her child who is taken from her. This loss obliterates her ability to function normally, and in her fury she murders her philandering husband. Here we see a transition from female victim to female avenger. It is not necessarily a healthy development, for the plot insinuates that it is the changing nation—an entity too vast to blame—that is really culpable for the individual's plight, but at least the injured mother who loses her child is cinematically permitted to react violently.

The lower-class woman, urban or *fallaha*, has been idealized in many films, commercial and non-commercial (such as Muhammad Khan's *Ahlam Hind wa Kamilia* (Hind and Kamilia's Dreams, 1988)). Commercial film makers seem to be concerned with producing a valid

cultural image of the peasant, or the *bint al-balad* (the lower-class urban woman), although actresses sometimes confound that image with their own mannerisms or speech. Typically, in the plots of commercial films, the lower-class woman lacks sophistication, critical ability, or experience, and these deficiencies bring on tragic complications. Sometimes the writers venture further, showing the cowardice or villainy of the heroine's family members, as in the revisionist film *Laylat al-qabd ᶜala Fatima* (The Night Fatima Was Seized, 1984). These male shortcomings appear to be rooted in their social background or individual characters, rather than in their gender, as the natural consequence of a society which builds the potential for female victimization from childhood onward.

Occasionally, female characters may be portrayed as devoutly religious women. In the past, such characters often provided comic relief, or were sometimes involved in exorcising troublesome spirits. In *al-Mar'a al-hadidiya* (The Iron Woman, 1987), the protagonist intends to kill her husband's four murderers, one by one. In one of her successful acts of revenge, she adopts Islamic dress to gain access to a wealthy and corrupt Islamic banker, who is one of the murderers. He offers her the contents of his well-stocked, secret office bar and tries to seduce her, before she kills him. This female character gains the ability to stalk her prey through her assumption of modest dress, which she discards when she goes to karate class and her weight-lifting sessions in between murderous acts of revenge.

Passivity versus motivated vengeance is not the only means to measure an expansion of dramatic possibilities for female characters. The range of female reactions to all sorts of crises and adversity has expanded in film. The viewer then gains a sense of possessing more choices (or that women possess more choices)—obtaining legal rights, battling against one's family—even if this is a vicarious experience. Simultaneously, the impact of sex-role expansion through cinematic images is dulled for the viewer if the heroines (and their adventures) are so unique that parallels to life may not be drawn. For example, some heroines become insane, and it is insanity, rather than social change, that allows them to commit previously unsanctionable acts. Viewers may also distance themselves from the heroines when the script contains too many unbelievable elements, a series of tragedies, for example.

In *al-Da'iᶜa* (The Lost One, 1986), starring Nadia al-Guindi, the heroine loses her children in court to her faithless husband. As a migrant worker she represents an important category in Middle Eastern economies, and the first part of the film focuses on her experiences in the Gulf, where she works in an unpleasant environment as a nurse and sends all her earnings home. While she endures the limitations and oppressive attentions of the hospital personnel, doctors, and local officials, her husband absconds with her remittances to finance a new marriage. The heroine represents all

the traditional values of self-sacrifice and hard work along with the modern hardships of immigrant labor, yet the court is unjust and unfair to her, granting custody to her perfidious ex-husband. She disintegrates, through despair to drug addiction. Her appearance alters, her smooth hairstyle becomes wildly curly and her make-up evaporates. After a disgusting man tries to seduce her, she steals his pistol and wallet and returns to shoot her husband, his wife, and his wife's mother. She has extracted her vengeance, but her sanity is gone. The film draws attention to practices which dehumanize or devalue women, but in this film as in others, the vicitimization of the protagonist causes her subsequent disintegration and self-destruction, lessening audience identification with her, rather than providing a story in which a woman is able to overcome abuse, infidelity, or legal discrimination.

In *The Iron Woman*, partially described above, Magda (the heroine) already has intelligence, physical strength, and resolve when she targets the murderers of her late husband. She successfully plots her acts of revenge. In one scene, she drives her red sports car around and around her terrified victim until he begs for mercy, and then drives him off a cliff. She gazes emotionless at his body, tossing the car keys into the sand. With the simple reversal of the male identification with car-as-weapon, and the continuous insertion of clips of Magda's muscle-pumping and karate *kiais* (ritualized cries included in traditional *katas*) in the gym, the audience understands that it must not admire this travesty of a contemporary black widow—she represents all the worst of female modernity.

When the police finally catch up with Magda as she is trying to murder the fourth man, in the hospital, they confront her with the knowledge that her husband Hassan was a criminal. She is not repentant, for she has become the Iron Woman, and a caricature, rather than a character.

Fatin Hamama, actress and producer (there is now even a Cairene movie theater named after her), played the roles of many strong and interesting women over her lengthy dramatic career. Franken (Chapter 17) has noted her identification with the 'long-suffering' quality of female protagonists, but Hamama has also, by virtue of her position in the field, been able to take on roles in which the heroine acts as well as submits.

In the film *Afwah wa aranib* (Mouths and Rabbits, 1977) Hamama is cast as Ni°mat, who lives in a small village with her sister's family. When her nephew steals a chicken, Ni°mat arranges his release with the *battawi* (the poultry-salesman). The *battawi* desires Ni°mat, and her brother-in-law agrees to marry her off. Ni°mat flees the village, but the brother-in-law marries her *in absentia* as her *wakil* (legal representative) to the *battawi*. Thus far, the plot calls into question the abuses of Islamic society, where such practices are legally forbidden, but occur nonetheless.

Ni°mat finds work picking grapes, but is badly treated. The owner, or bey (lord), of the agricultural estate installs her as a housekeeper after she

saves his life, and then falls in love with her, since she takes care of him so well. Despite his family's angry reactions to his alliance with a woman who is not his social equal, they marry. When she goes to visit her own family, she discovers that she is already 'married,' and her nephew decides to kill her to save the family honor. (As she is innocent of any intentional legal violation, very little fear or menace is packed into this scene, indeed the entire scenario is probably less likely than that of the Turkish film *Berdel* (1990, directed by Atif Yilmaz)). Nicmat escapes her nephew but is then confronted by the *battawi*, and finally saved by her loyal *bey* husband.

The film bridges the contemporary fissures between the social classes to predict social harmony in a rather unrealistic but charming manner. The traditional practices that violate the country girl's rights as a Muslim to assent to her own marriage are nullified by the protagonist's moral strength, and her highly traditional feminine appeal. Yet the seeds of conflict were injected by Nicmat herself when she left her family's home, for a woman working as a wage earner, alone, without family, is always morally suspect.

Both *Afwah wa aranib* and *Laylat al-qabd cala Fatima* incidentally represent Egypt outside Cairo, and outside the 'normal' male history. In the more ambitious, and later film *Laylat al-qabd cala Fatima* (1984), Fatin Hamama plays the role of Fatima, who at the outset of the film is summoned from the beach, with its purifying wind, by news that some men (agents of her brother) are looking for her. Fatima is alienated from the festivities of a wedding she attends, thinking of her dilemma, and dreams about her death as she sits in her seat. The audience can view her as paranoid, or legitimately fearful. When the agents of her brother, the villain in her life, come to take her away, she threatens to commit suicide by jumping off her roof. The horrified neighbors assemble as she recounts her life story. Orphaned, she brought up her siblings herself by dint of hard work, although that meant giving up her sweetheart, Sayyid, who went to sea. They hoped to marry some day. But her brother, Galal, anticipated Sayyid's interference with his career in selling drugs, arms, and documents for great profits during the war. Galal planted drugs in Sayyid's room, called the police, and then continued to depend on Fatima's earnings as a maid and a seamstress after Sayyid's incarceration.

When Fatima discovered that Galal was a truant, and had been dealing illicitly with the *fada'iyin*, she confronted him in the middle of an arms delivery deal. Galal had intended to keep his payment and never actually supply the weapons to the *fada'iyin*. He was a cheat, and a scoundrel. Fatima, realizing what was at stake for her nation, decided to carry the arms herself. As a result of the ensuing victory, Galal became a hero and launched a successful political career, never acknowledging his sister's role.

Then came the day when Fatima discovered Galal's previous betrayal of Sayyid, after Sayyid was released from prison. When she confronted Galal, now a very wealthy man, his two henchmen tried to drown her. After she relates this history of female responsibility and male perfidy, Sayyid talks Fatima down off the edge of the roof, but at the end of the film, another group under Galal's command capture her, and drive her off in a vehicle, ostensibly to be incarcerated in an asylum (but probably to be murdered), as Sayyid pursues.

Fatin Hamama's acting abilities add to the portrayal of a complex character, strong yet vulnerable. The voyeuristic nature of the camera and the audience on the roof (and in the theatre) is emphasized through the use of a fisheye lens revealing Fatima's attempted murder in her dream, and again near the end. She and the audience become spectators of her life story, told in order to revise the truth. She reclaims her proper role in past events, although the film suggests an ultimate silencing. Fatima's 'viewing' of her life is one level of the film, while another level employs a powerful woman's voice, revealing the male corruption of events and history.

Galal is so thoroughly dark a villain that this example of family abuse, which may on some level be fairly prevalent, may not establish a level of common experience with the audience. What they might share with Galal—tendencies to denigrate, devalue, or manipulate relatives— dissipates in his specificity. So, the cinematic text rigidifies contrasts between characters, thus providing dramatic balance, but lessens the troubling edge of its social comment.

Commercial films utilize camera-work, direction, and plot in other stories of modern women victims, including the first Egyptian film I found for this period that dealt with rape from the viewpoints of the victim, the rapist, and the victim's mother, *al-Mar'a wa-l-qanun* (The Woman and the Law, 1988, with Sharihan, Faruq al-Fishawi, and Magda al-Khatib).[15] The film features two strong female protagonists, and forms a parallel to the Gothic film form discussed by Mary Anne Doane, which in its American version has had a particular focus on women and violence and an attraction to women viewers.[16] Disaster and evil are personified in the rapist, and we know early on, from the rapist's glances and stares, from the camera-work, and the music that something terrible is imminent.

The story and camera-work center at first on the relationship between Nadia, a university student, and her mother, a nurse, who are both thrilled when Nadia passes her examinations. The camera moves above the mother and daughter as they meet in the street, circling each other in joy. Soon Nadia is engaged to her boyfriend, but her mother insists that she complete her degree before marrying (and continue living in the family flat). A neighbor, Mahmud, who is attracted to Nadia, ends up

proposing to her mother and becomes Nadia's stepfather. He is addicted to cocaine, and suffers some sort of drug-related mental and physical pain as his obsession with Nadia—especially watching Nadia—increases.

Hospitalized, Mahmud dreams that he is a pharaoh. Nadia is presented to him as a gift, wrapped in layers and layers of a ruffled veil, from which he unrolls her. He escapes from the hospital, and returns to the flat, where despite Nadia's screams and resistance, he ties her hands to the head of the bed and rapes her. The act itself is not shown, which intensifies the level of tension before and after. When her mother discovers Nadia, unconscious, she shoots Mahmud and is arrested. Although Nadia's fiancé, a lawyer, handles her defense, his family urges him to break the engagement. Nadia is not allowed to give testimony in defense of her mother and the court hands down a harsh sentence for the murder. The final scene, with the most impact, witnesses Nadia's return to her building, now scrawled on with obscene graffiti, and her encounter with the devastating scorn of her neighbors.

The film (and its title) question the morality of the New Law— modern, civil law, which prevents a mother from killing for honor. But it is the rape itself that is the center of the film. Nadia's mother's loving gaze, Nadia's glances toward her fiancé, and Mahmud's long stares at Nadia all lead up to Mahmud peering through the keyhole of Nadia's door. Nadia, a lovely young girl with long dark hair, is lit up in the camera's lens in her dim bedroom. Nadia catches Mahmud spying on her, yet she is powerless in evading his attack, like the heroines of Gothic tales, and Hitchcock's women. The rape is an extension of Mahmud's voyeurism, and thus exploits "the problematic wherein male violence is delineated as an effect of the voyeuristic gaze," or as Doane also writes, the "specular regime."[17]

The voyeurism of Mahmud's violence, or the violence in his voyeurism, is a suggestive breakthrough in the film. So, too, the somewhat anticlimactic murder, and the coverage of the trial and social ostracism that are the fate of the rape victim. Is this due to Samira Muhsin (story credits) or to the director/producer? On the other hand, the film nonetheless provides a comfortable distance for the viewer in its overly evil (hence unrealistic) characterization of the rapist. Men rape women every day without the excuse of drug addiction. Was it necessary for Mahmud to be a drug addict? Did that justify the crime, which is on the increase in Egypt, or should we at least credit the film for exploring a frequently unreported crime?

The casting of Nadia and Mahmud limit the film's message about violence against women. Mahmud is stereotypically masculine, tall and powerful with a deep, booming voice. Nadia, on the other hand is almost too beautiful; with her exceptionally long dark hair, her beauty attracts and incites, especially as Mahmud watches her fiancé carrying her

playfully. She tempts Mahmud, she is the source of *fitna*[18] in this household, where Nadia should, theoretically, be safe from sexual predators. Here again, it is Nadia's display of herself with her fiancé, and her accessibility, due to her career ambitions that provide Mahmud with the opportunity to defile her. If her mother had allowed her to marry instead of completing her education, then she would be safely ensconced in her husband's flat, instead of living within Mahmud's reach.

The public display of women's beauty is an underlying cinema theme, and is a double entendre, for there could be no cinematic image of women (and gender issues) without some visual display. Thus, the consequences of female display and temptation are an easily conjured problematic for the Egyptian audience, and differ from the limits imposed in postrevolutionary Iran, for example (see Chapter 15).

Tragic love may also be subject to violence in drama, or lowered expectations in real life, thanks to economic pressures, lack of privacy, and growing Islamization. The concept of *hubb ᶜudhri*, courtly, unrequited, and generally unconsummated love, is a special feature of Arabic (and medieval Western) literature. Love in film, as in literature and song lyrics, owes certain characteristics to the tradition of courtly love, but is also grounded in traditions of earthly, hence attainable, romantic love.

Beyond the usages of more accessible (read, more culturally authentic) social themes, and new camera techniques, commercial films utilize music quite effectively, although not always in the same manner that sound effects or 'mood' scores are employed in Western cinema. In *Afwah wa aranib*, music verifies the authenticity of scenes signaling celebration and toil. This is also true of *Laylat al-qabd ᶜala Fatima*. Class leanings can be signaled through *baladi* ('popular') segments versus different instrumentation, or clearly Westernized music elsewhere. In *al-Mar'a wa-l-qanun*, a single complex theme played on a quarter-tone keyboard modulates to an eerie *maqam* (mode) and signals Nadia's immobility.

Sometimes, music, camera, direction, and aspects of the script combine to insert a series of subliminal messages about women that contradict the notion of modernity as progress. For instance, two films cover aspects of sexuality and 'pop' psychology. One deals with female infertility and polygamy, and the other with male impotence and infidelity.

In *Dumuᶜ bila khataya* (Tears Without Fault, 1980) a sheltered upper-class woman, Fayza, falls in love with her physician. They marry, but Fayza cannot conceive. She goes to ceremonies of exorcism (*zars*), and tries various potions, which irritates her rational, scientific husband, Kamal, who is convinced that he must produce an heir. Kamal therefore marries his cousin and has a son. When Fayza discovers the truth, she leaves her home and travels to the site of her honeymoon with Kamal.

She is pregnant but does not know it. She does not experience any of the physical symptoms of her pregnancy until after a night of drunken abandon with a visiting artist. Kamal wants a reconciliation, but Fayza, racked with guilt, refuses to speak to him. Fayza's mother seeks out the artist, who proclaims Fayza's innocence. Kamal divorces his cousin and claims his son, then rejoins Fayza, who gives birth to a daughter.

The scenario strains all credulity, addressing and triumphing over polygamy, infidelity, and superstition. The film also shows how the medical, modern Kamal is as subject to family pressure as any other man, and so regards his infidelity as a licit act. Further, Kamal as physician represents technology's opposition to female-guided popular treatments and the feminine quality of illness itself. Medicine, though male-dominated in the twentieth century, is an area of a sex-segregated society where men and women may interact, as doctor and nurse, or doctor and patient. Fayza is first ill with fever and is cured by Kamal. Then she is invaded by infertility, and later immobilized by guilt. She achieves a happy outcome not through strength, but as a result of her weaknesses.

In ᶜ*Afwan ayyuha al-qanun* (Excuse Me, O Law, 1985), starring Nagla Fathi, we see Huda, the perfect, patient, feminine wife, trying to rescue her husband ᶜAli from prolonged sexual impotence (another taboo shattered in commercial film) through understanding and patient listening. ᶜAli finally describes the memory triggering his neurosis: he had discovered his mother with her lover and then witnessed his father's murder of the pair. After he recounts the event, his impotence abates.

From that reawakening of his sexual powers, ᶜAli seems bent on reenacting the crucial scene, for he is soon involved with the wife of a friend. When Huda walks in to catch them *in flagrante*, she seizes a rifle and shoots both. ᶜAli dies later, as Huda give birth to his son. The court sentences Huda to life imprisonment. ᶜAli's father claims his grandson while Huda collapses in the film's last scene.

We learn from this film that although Huda is loving, patient, selfless, and fertile, she meets her downfall through her love for her husband. It is also clear that the modern legal system continues to punish women, whether morally upright or not, more than men. Modernity has transformed the law, but justice is not necessarily available. In a brief reference to the personal status reforms, the other cuckolded husband refuses to testify against his wife, ᶜAli's girlfriend. Why? Because the new laws passed under Sadat might permit her to retain their residence upon separation or divorce, and she has locked him out. As he and his wife leave the courtroom, the wife rewards the perjurer with the house keys.

In these commercial films made in the late 1970s and 1980s, we trace a new mode of victimization of women displayed through cinema. The audience is meant to understand that past traditions, including honor-

killings, were primitive but often served to restore justice and/or the gender balance of society. These practices may be rare today, but were a part of common law and previous legal codes, and they illustrate how much 'progress' society has made. Progress, however is a double-edged sword, and does not predicate justice. Women may be condemned, albeit in seemingly justifiable circumstances, or are victimized *despite* their upright characters, or *because* of their feminine traits. Hence, traditional attitudes toward women, as flowers, or precious jewels vulnerable to life's devastation, are bolstered alongside an expanded range of actions/reactions for female protagonists.

Film makers (writers, directors, producers) often claim that they are successful when they inject a measure of fantasy into a kernel of reality.[19] This is a maxim similar to the directive given to writers to write what they know. However, the commercial industry also expects film makers to write and produce an emotional catharsis for the audience, which must necessarily be somewhat removed from reality. Thematic distancing, the simultaneous call for realism and catharsis, and the structure of the industry all interact to formulate new, yet also familiar problems for female protagonists. The social structure, and the expected audience perspectives on social structure, predicate that female protagonists will continue to be described in terms of their social roles (mother, wife, sister, daughter, and so on). Single women are significant as female protagonists when the film considers which social connections the protagonists *lack*, have *lost*, or *should find* in the film. Through these avenues, Egyptian society emphasizes various facets of women's experience through the medium of popular culture.

Clearly, the contemporary alternatives arising for women in the 1980s were perceived to threaten the prevailing gender norms, yet the film makers saw that these choices represent valid possibilities for dynamic tension in the scripts. Women, like the protagonists of these films, are linked to contemporary lifestyles, careers, and speech patterns. The modernist overview of film production means that their film counterparts may now strike out in fury, instead of consistently collapsing in grief or anxiety. However, women, as underdogs if not victims, elicit empathy so long as they retain their feminine appeal and some degree of traditional values. Yet, in a circular motion, these feminine traits and traditional values often lead, as we have seen in the examples above, to the character's downfall.

One may conclude by asking the reader to revise the old adage, and admit that *plus qu'elles changent, plus qu'elles restent les mêmes.*

Notes

1 Films were selected from sixty viewed in Egypt and/or rented on video. My initial description of this project elicited an unerring response from musicians

and video outlet operators, Ghazi and Muhammad ᶜAli Darwish, my neighborhood 'uncles' in this project.

2 Some criticized the *infitah* for making Egypt essentially more dependent on external economic powers, while others praised the regime for a difficult but necessary step. Galal Amin, "External Factors in the Reorientation of Egypt's Economic Policy," in Malcolm Kerr and El-Sayed Yassin, eds., *Rich and Poor States in the Middle East: Egypt and the New Arab Order* (Boulder, Colorado: Westview Press, 1982).

3 Ghada Helmy, "The Plight of Women in Literary Text and Filmic Adaptation," *Alif: Journal of Comparative Poetics* no. 15 (1995), 200.

4 See, for example, Fauzi Najjar, "Egypt's Laws of Personal Status," *Arab Studies Quarterly* 10, no. 3 (1988); Mervat Hatem, "The Enduring Alliance of Nationalism and Patriarchy in Muslim Personal Status Laws: The Case of Modern Egypt," *Feminist Issues* 6, no. 1 (Spring 1986); in summary, Sherifa Zuhur, *Revealing Reveiling: Islamist Gender Ideology in Contemporary Egypt* (Albany: State University of New York Press, 1992), 55–56; or for feminist reactions, Amina Shafiq, *al-Mar'a: Lan taᶜud ila al-bait* (Cairo: Dar al-Thaqafa al-Jadida, 1987).

5 Lack of political representation is a global, not only a Middle Eastern problem for women. For example, the United States, France, the U.K., and Russia elect only between 5.1 and 15 percent female representatives, the same approximate level as Syria and Iraq. Joni Seager, *The State of Women in the World Atlas* (London: Penguin, 1997), 90–91. However, under-representation in politics is being addressed in the West.

6 Guy Hennebelle, "Arab Cinema," *MERIP Reports*, no. 52, November 1976.

7 El Charkawi outlines the early official history of Egyptian cinema in "History of the U.A.R. Cinema, 1896–1962," in Sadoul, *The Cinema in the Arab Countries* (Beirut: InterArab Center of Cinema and Television, 1966).

8 Jacob Landau, *Studies in the Arab Theater and Cinema* (Philadelphia: University of Pennsylvania Press, 1958), 191–197.

9 Hennebelle, "Arab Cinema"; Qussai Samak, "The Arab Cinema and the National Question: From the Trivial to the Sacrosanct," *Cineaste*, vol. 9, no. 3 (Spring 1979).

10 Jane Gaffney, "The Egyptian Cinema: Industry and Art in a Changing Socety," *Arab Studies Quarterly*, vol. 9, no. 1 (Winter 1987), 57.

11 Margot Badran, *Feminists, Islam, and Nation: Gender and the Making of Modern Egypt* (Princeton: Princeton University, 1995), 190–191.

12 Garay Menicucci, "Changing Sexes—Changing Lives: Gender Representation in Egyptian Cinema," a paper presented to the Middle East Studies Association, 31st annual meeting, San Francisco, 24 November 1997.

13 Rivka Yadlin, "Militant Islam in Egypt: Some Sociocultural Aspects," in Gabriel Warburg and Uri Kupferschmidt, eds., *Islam, Nationalism and Radicalism* (New York: Praeger, 1983); Sherifa Zuhur, "The Theme of Social Mobility in Egyptian Film: From *Intisar al-Shabab* to *Intabihu Ayyuha al-Sada*," unpublished paper, 1986.

14 Mohammed Nowaihi, "Changing the Law on Personal Status within a Liberal Interpretation of the *Shariᶜah*," in Cynthia Nelson and Klause Kock, eds., *Law*

and *Social Change in Contemporary Egypt, Cairo Papers in Social Science,* vol. 2, no. 4, pp. 97–115.

15 Other films, including *al-Bustaji* (The Postman, 1968), deal with rape.

16 Mary Ann Doane, *The Desire to Desire: The Woman's Film of the 1940s* (Bloomington: Indiana University Press, 1987).

17 Ibid., 125.

18 The term used for social discord as explained by Fatima Mernissi, *Beyond the Veil: Male–Female Dynamics in a Modern Muslim Society* (Cambridge: Cambridge University Press, 1975).

19 In discussing the autobiographical elements in *Iskandariya Leh?* (Why, Alexandria? 1978) at a public lecture at Ewart Memorial Hall, Cairo, Winter 1981, Youssef Chahine said that the elaboration of reality, or fantasy built on reality, was an element of his success. This notion was also emphasized by the prominent, late, film maker and producer ᶜAli Reda (personal interview with ᶜAli Reda, Los Angeles, 2 June 1985).

15

IRANIAN CINEMA UNDER THE ISLAMIC REPUBLIC[1]

Hamid Naficy

Iran has a long history of cinema. The first Iranian documentary was filmed in 1900, the first public theater opened in 1904, and the first feature film was released in 1930. Despite this late start, the Iranian feature film industry caught up and in the 1960s and 1970s, during the reign of Shah Mohammed Reza Pahlavi, produced a wide variety of films, many of which won awards and recognition in international film festivals. Some of the major film makers now active in Iran or in exile made their names during this period. When the Iranian revolution in 1978–79 took out the shah and replaced his regime with an Islamist regime, the local film industry came virtually to a halt, but it soon picked up speed and is now producing over fifty feature films annually.

Anti-cinema feelings, however, run deep in Iran. Since its introduction, cinema has been condemned by religiously minded people as a morally offensive and ethically corrupting Western influence. The influence has been seen to be 'hypodermic,' that is, direct and unidirectional. It is significant that major clerical leaders appear to have considered cinema's work and influence always in the context of the overdetermination of Westernization in Iran. Accordingly, cinema is viewed as one of the ideological apparatuses imported from the West by the Pahlavi regimes (Reza and Mohammed Reza Pahlavi, 1925–79), which in tandem with other media and leisure and entertainment industries is said to produce its ideological work of interpellation. This is a significant formulation in that it considers, albeit crudely, the interconnectedness of the signifying institutions of society such as the mass media. The drawbacks of this formulation, however, are that it posits the Pahlavi regimes, Westernization, and cinema as monolithic; it elides the possibility of

resistance by film makers and viewers; it ignores the local conditions and the contradictions existing among the media; and it effaces the specificity of each medium's unique work—all of which can undermine and *mediate* the effects of the 'injection' of Westernization and of Western cinema.

It is also significant that many Islamist leaders, such as the late Ayatollah Ruhollah Khomeini, did support cinema but only if it was not 'misused'—if it was used to teach and highlight the 'Islamic values.' In his first speech upon returning from exile to Iran in 1979, Khomeini underscored this theme:

> We are not opposed to cinema, to radio, or to television . . . The cinema is a modern invention that ought to be used for the sake of educating the people, but as you know, it was used instead to corrupt our youth. It is the misuse of cinema that we are opposed to, a misuse caused by the treacherous policies of our rulers.

The idea in these and similar passages is not to proscribe cinema but to adopt it instrumentally, that is, to employ it as an ideological apparatus to combat Western culture and usher in an Islamist culture. The major concepts frequently pronounced by authorities when speaking of Islamic culture can be classified under the following categories: traditionalism, populism, monotheism, theocracy, ethicalism, puritanism, political and economic independence, and anti-imperialism.

Since periods of transition and social turmoil seem to produce some of the most innovative cinéastes and cinematic movements, there is good cause to expect the revolution of 1979 in Iran and its preconditions to have helped create a new cinema. However, for quite some time the reception of this cinema in the West was marred by the almost universal perception that Shici Islam as practiced in Iran today is antimodern and backward. The Islamic Republic's widely reported curtailment of Western-style performing arts and entertainment, its maltreatment of entertainers and women, and the widespread and harsh censorship have certainly, and justifiably, reinforced the impression of intolerance. Nonetheless, a new cinema has gradually emerged in Iran with its own special industrial and financial structure and unique ideological, thematic, and production values. It must be stressed, however, that this cinema is not a propagandistic cinema in support of a ruling ideology. It is not that monolithic. In fact, two cinemas seem to be developing side by side. The populist cinema inscribes postrevolutionary values more fully at the level of plot, theme, characterization, human relationships, portrayal of women, and mise en scène. The quality cinema, on the other hand, engages with those values and tends to critique the social conditions under the Islamic government. It is this latter form that is featured here.

The transitional period, from the prerevolution to the postrevolution cinema, lasted some three years (1979–81). This transition took many

forms, including burning down or destroying 180 cinemas nationwide (thirty-two in Tehran alone) and renaming the remaining theaters to remove Westernized names. Importing films from the United States, Turkey, and India was curtailed while the flow from the Eastern bloc countries increased (more than a third of the 213 foreign films licensed for 1981 came from this bloc). Many 'revolutionary' films were shown, including *Z, State of Siege, Battle of Algiers, Battle of Chile,* and *Mohammed, the Messenger.* However, the bulk of them, as leading dissident writer Gholam Hosain Sa'edi observed, were more remarkable for their display of military hardware than for aesthetic quality.

To purify the existing stock of films, many prerevolution films were reedited and retitled. Nudity in some films was censored by applying black ink directly to the film frames. In this, film producers and exhibitors engaged with the government in a cat and mouse game of resistance and submission. In the end, dissatisfied, the government mandated an exhibition permit for all films, which necessitated a review process, the result of which was that of 2,000 films reviewed in 1979, only 200 were approved. Entertainers and film makers were not only considered immoral and dangerous but also viewed with ideological distrust. This negative official and public attitude cast a pall of despair and uncertainty over the entire entertainment industry, forcing many of its members to seek internal seclusion or external exile. Others were banned from making or appearing in films, threatened, incarcerated, or forced to give up their property.

Despite these purification measures the transformation of cinema entailed a major cultural and ideological shift that could not take place as abruptly and totally as a cinematic cut. It had to be nurtured and brought on like a dissolve. Landmark regulations approved by the cabinet in 1982 charged the Ministry of Culture and Islamic Guidance with the responsibility for overseeing the motion picture industry. The concentration of power at the Ministry to set policy, regulate, and enforce helped both to reduce the confusion and chaos of the transitional period and to enhance government control, thereby setting the stage for the emergence of an Islamist unity out of revolutionary destruction. Further, these regulations that codify much of the Islamic cultural values noted earlier have been instrumental in facilitating the shift from prerevolution to postrevolution cinema.

Despite the gradual increase in the number of newly constructed theaters and their seating capacity, movie going has declined since the shah's era. The reasons include the following: decreased number of theaters nationwide, undesirability of theater locations, poor conditions of halls and projection systems, low quality of exhibited films, and heavy censorship. The doubling of the population since the revolution has made the inadequacy of the exhibition sytem more glaring. For the past few

years, inexpensive but unauthorized satellite dishes have cropped up throughout the country, bringing in multiple television channels from abroad. This has created a crisis both for the film industry and the morality-minded clerical establishment. To combat such a forceful competition, the government finally put its stamp of approval on video, a medium it had banned, but it continued to ban the installation and use of satellite dishes.

As far as indigenous production is concerned, all films must go through a review process at the Ministry of Culture and Islamic Guidance through which the regulations codifying postrevolutionary values are implemented. The Ministry reviews the film's synopsis, issues a production permit, reviews the completed film, and finally issues an exhibition permit. Since April 1989 the government has allowed previously censored films to be screened and, for the first time in Iranian cinema, the requirement for approving screenplays has been removed for directors of 'quality' films. Despite the generally liberal interpretation of censorship codes and the apparent support given the quality film director, the films of many directors have been banned after their completion. Bahram Baiza'i's *Death of Yazdegerd* (Marg-e Yazdegerd, 1980) and *Ballad of Tara* (Cherikeh-ye Tara, 1981) have been banned. Likewise two of Mohsen Makhmalbaf's films centering on love, *Zayandehrud's Nights* (Shabha-ye Zayandehrud, 1991) and *A Time to Love* (Nowbat-e asheqi, 1991) have been banned; this most promising of the new crop of film makers has even had to defend himself against attacks in the press and the parliament.

This situation has not remained static. Film makers, the film industry, film critics, governmental agencies, film financiers, and audiences have all been engaged in a multifaceted discourse and negotiation on the status of cinema as a cultural institution and an economical enterprise. The result has been a string of new rules and regulations. Since 1984, new ordinances have steadily encouraged local production and reduced destructive competition from imports. Municipal taxes on local films have been reduced; long-term bank loans have been made available; a film rating system that encourages quality films has been instituted; foreign exchange funds for importing equipment and supplies have been allocated; many films have been entered in and received high praise from international film festivals; and a social security system for film workers has been implemented.

The political consolidation and centralization of film regulation, censorship, export, and import since 1983 have brought cinema into line with postrevolutionary values and have encouraged a quality film movement. However, the government does not entirely monopolize the industry. Indeed, there seem to be more production centers in Islamist Iran than during the previous era, and they are not all concentrated in

Tehran. Production centers are dispersed among the public (governmental), semipublic, and private sectors. In 1987 the public sector produced one-third of all films, but given government's financial contribution through loans and credits, its impact on film production exceeds the statistics.

Women and their representation on the screen were major sources of contention, causing film makers immediately after the revolution to ignore women altogether so as to avoid controversy. However, since the mid-1980s, women's representations on the screen have gone from being background presences to becoming dominant characters. Behind the cameras, too, women have been quite active, with more of them now directing feature films (seven altogether) than in all previous decades combined. Nonetheless the 'woman question' continues to dog cultural productions under the Islamic Republic and resurfaces with every social crisis.

The application of new regulations and the sociopolitical exigencies of the time have resulted in the domination of action, adventure, war, and family drama genres. But these genres embody varying themes that, taken together, can clue us in on both the kinds of tensions the society is undergoing and the way postrevolutionary values are played out on the screen. In this essay, only a representative sample of films is discussed. Emphasis on ethical values and on spiritual rather than material rewards has been a major theme in postrevolutionary cinema, represented by *The Ship Angelica* and *Canary Yellow.*[2] Postrevolution films are imbued also with a generalized sense of morality, and in them the traditional values of rural folks are favorably compared to the consumerist ideology of urban areas. However, Iranian moralist and populist cinema, instead of concentrating on deeper values, has catered often to superficial morality, characterized by easy hopes, cheap emotions, and inexpensive good deeds. Kiarostami's engaging film *Where Is My Friend's Home?* is a film of high quality in the moralist genre that avoids the pitfalls of the populist films.

The devastating war with Iraq, which lasted some eight years, led to production of at least fifty-six feature fiction films, two-thirds of which focused primarily on fighting and military operations while the rest concerned themselves with the war's social and psychological impact. *Marriage of the Blessed* and *Bashu, the Little Stranger* are stylistically complex films that not only examine the tensions and travails of a society at war but also offer incisive critiques of that society.

Historical films have been popular. This is both because revolutions generally encourage a reexamination of the past and because the strict and widespread censorship has forced Iranian film makers to avoid the current times, choosing instead safer, bygone eras. The Qajar dynasty that ruled Iran in the nineteenth century and the Pahlavi regime that followed it are

favorite scapegoats as well as objects of examination. The past and the nostalgia for it in idealized and aestheticized form are encoded in a number of films, especially the beautifully poetic *Pomegranate and Reed* and *The Spell*, a film in the Gothic genre, which is set in the Qajar era. *In the Wind's Eye* deftly examines Iran's occupation by the allied forces during World War II by centering its story on the Qashqa'i tribes. Examples of films dealing with conditions immediately preceding the revolution are *Scabies* and *Off the Limit*. The quality cinema has almost totally avoided treating the clerical establishment or Islamic institutions, perhaps in order to escape censorship. The uncanny result is that Iranian quality cinema is empty of official Islam.

In line with the official ideology of support for the downtrodden, Iranian films have concentrated on the lower classes. The action in a number of them occurs partly in city dumps or in junk yards for cars, as in *The Peddler*; but poverty is not valorized through romanticization. Instead, the poor are shown to have a moral center that guides their action and their quest for justice (*Off the Limit*). Authoritarianism and the panoptic exercise of power and control are major issues in many of the postrevolutionary films. Often these issues are dealt with in films that star and are made for children, such as *Scabies, Where Is My Friend's Home?*, *Bashu, the Little Stranger*, and *The School We Went To*.

Unlike the popular model, the quality cinema is serious, even somber, as in the impressive *Beyond the Fire,* whose theme is the ill effects of Westernization. But there are many sparks of joy also. *Off the Limit* and Mehrju'i's two films *Tenants* and *The School We Went To* are social satires that both delight audiences and derail official views.

Family melodramas have been popular even though the rules of *hejab* (veiling and modesty) have created much ambiguity in the process of film making and in the treatment and portrayal of women. For quite some time, film makers opted to downplay women (of thirty-seven films reviewed by a magazine in 1987, the chief protagonists in twenty-five were men). When women were used, they were confined to the ideologically safe domain of home. *Hejab* rules necessitated that women actors wore scarves, wigs, or hats. These and other constraints, which gradually have been relaxed, affect the relationships among men on the screen as well, resulting in a fascinating gender reconfiguration. If women have had problems appearing in front of cameras, they apparently have had fewer problems attending film schools and working behind cameras as directors. *Off the Limit* and *Canary Yellow* are films by Rakshan Bani'etemad, the most accomplished of the women directors in Iran today. *Off the Limit* inscribes an 'aesthetic of veiling' in its visual style. Bahram Baiza'i's films *Bashu, the Little Stranger* and *Maybe Some Other Time* are complex examples of films made by men that center on strong female protagonists.

A major criticism of films made in the Islamic Republic, especially the populist films, is their low quality and their ideological earnestness and superficiality. As indicated, however, since the mid-1980s there has been a steady move toward rationalization and reorganization of the film industry with the aim of encouraging local productions. Concurrently, and equally significantly, major repositionings and shifts have occurred in social attitudes toward both cinema and its workers. Cinema, rejected in the past as part of the frivolous superstructure, has been adopted as part of the necessary infrastructure of the Islamist culture. Working in film, once disdained and disparaged, has become acceptable and respectable. Immediately after the revolution, films were judged solely on their ideological purity and instruction values; they have since begun to be reevaluated based on their ability to entertain and enlighten. Film makers and audiences have demonstrated both resolve and ingenuity in the face of incredible rancor and constraints. As a result, an active film culture is evolving. Through a process of cultural negotiation and haggling—not just hailing and interpellation—a new cinema is emerging. While this cinema embodies much of the aforementioned postrevolutionary values, there is also considerable contestation with the official ideology in the films themselves.

Selected Filmography
Bashu, the Little Stranger (Bashu, gharibeh-ye kuchak) (1985), 130 minutes.
Directed by Bahram Baiza'i and produced by the Center for the Intellectual Development of Children and Young Adults. Screenplay: Bahram Baiza'i; photography: Firuz Malekzadeh; editing: Bahram Baiza'i; cast: Susan Taslimi, Parviz Purhosaini, Adnan Afravian, Akbar Dudkar, and Farrokhlaqa Hushmand.

Baiza'i is a renowned playwright, scholar, and film maker, whose films often explore larger philosophical issues of life and portray human beings' search for meaning and identity. His vision is epic and his style displays much visual flair. A number of Baiza'i's films focus on lone figures who enter a community to disrupt it forever. In this film, a little boy, Bashu, loses his home and family in the war with Iraq and instinctively flees the war-torn southern region. He ends up far from home in the northern parts of the country, where he hides in rice paddies from what he imagines to be a total war. Na'i, a woman who works the fields, discovers Bashu and, despite language and cultural differences, takes him in. Na'i's husband is away, and Bashu's presence within her family causes much discord until her husband returns from war. Women in Baiz'i's films occupy a central position as narrative agents, and in this film Na'i works the fields, takes care of her children, and, in accepting Bashu, defies tradition and the authority of family and village elders.

Issues of national identity, ethnic diversity, dislocation, and exile are also prominently figured in this beautiful and significant film, one of the best in Iranian cinema.

Beyond the Fire (Ansu-ye atash) (1987), 97 minutes.
Directed by Kianush Ayyari and produced by First Channel, Islamic Republic Television Network. Screenplay: Kianush Ayyari; photography: Dariush Ayyari; music: Babak Bayat; editing: Kianush Ayyari; cast: Khosrow Shojazadeh, Siamak Atlasi, Mehrdad Vafadar, Atefeh Razavi, and Ne'matollah Larian.

The National Iranian Oil Company has expanded its drilling operations by purchasing the lands of a small village in southern Iran, including the home of the family that is the focus of the film. Although the family has received remuneration for their house, the cost of displacement has been extremely high, resulting in the family's total fragmentation. The father is absent, the mother lives in a junkyard for abandoned cars, and the two brothers are locked in a permanent, deadly feud. Against the perennial and surreal background of flames from oil wells and the roar of drilling, the two brothers, one an oil company guard concerned with his looks and the other a temporary oil worker, live in their private hovels and scheme to undo one another, while a love story develops between the latter and a deaf-mute milkmaid. Much ethnographic detail is revealed with the crisp photography. The girl's brother, a lively, ingenious, and good-hearted urchin, provides the only enduring spark of life amid this landscape of desolation and displacement.

Canary Yellow (Zard-e qanari) (1989), 98 minutes.
Directed by Rakshan Bani'etemad and produced by Abdollah Eskandari and Ali Sho'a'i. Screen play: Bahman Zarrinpur; photography: Hasan Qolizadeh; music: Majid Entezami; editing: Shirin Vahidi; cast: Mehdi Hashemi, Golab Adineh, Manuchehr Hamedi, Mahmud Ja'fari, and Hamideh Khairabadi.

An example of Iranian ethicalist cinema, *Canary Yellow* is directed by a woman. The central character in the film is Nasrollah, a naive and honest country man who sells many of his belongings to purchase a farm only to discover that the farm has been sold already to another man and the salesman has disappeared. Without a job or a place to stay, he and his wife and child are forced to move in with his wife's parents. As is traditional in extended family situations, in the same house live another daughter and her husband, Kamal, an unscrupulous man involved in elaborate, shady business schemes. His favorite is to sell a car painted canary yellow for a large down payment. Almost immediately after the unsuspecting customer returns home with the car, however, Kamal arranges for it to be stolen. Attempts to take legal action or to use the

police are ineffectual. Kamal offers the same business deal to Nasrollah. He may be naive, but he is honest and dogged, and when the car disappears, Nasrollah sets out on an unlikely mission to find it by searching the busy Tehran streets. All the various customers swindled out of the canary yellow car coalesce in the crashing end of the film. In this woman-directed film, the men are either naive and childlike, unscrupulous, or silent. The mother, on the other hand, rules the household and seems to control the various men through the force of her personality and acumen. She solves not only the many familial problems within the home but also those lying outside the home. Other women, such as Nasrollah's wife, are also more mature and level-headed than their men, who thoughtlessly and in a happy-go-lucky manner get themselves into trouble. Despite all this, the moral center of the film is a man, Nasrollah, who must in a defiant act demonstrate that virtue overpowers vice.

Captain Khorshid (Nakhoda Khorshid) (1986), 117 minutes.
Directed by Naser Taqva'i and produced by Pakhshiran Corporation, The Payman Film Group, and Mohammad Ali Soltanzadeh. Screenplay: Naser Taqva'i; photography: Mehrdad Fakhimi; music: Feraidun Naseri; editing: Naser Taqva'i; cast: Dariush Arjomand, Ali Nasirian, Sa'id Pursalimi, and Parvaneh Ma'sumi.

Captain Khorshid is a very free adaptation of Hemingway's novel *To Have and Have Not*, by a director who began his career as a short-story writer influenced by Hemingway's style and sensibility. For this film, Khorshid returns to his native Persian Gulf roots, where the action unfolds in an unnamed port city. The one-armed Captain Khorshid has invested his life's earnings in a major shipment of contraband cigarettes. The local crime baron, specializing in trading pearls, cannot tolerate competition. He informs the customs officials, who confiscate the captain's cargo and, after taking their own share of it, burn the rest in public. To support his family, the captain is forced to engage in smuggling human cargo by transporting out of the country a group of political exiles involved in the assassination of the prime minister. In the end, he is blackmailed into doing the same for a group of criminals exiled to the port city, with unforeseen consequences. The port city is an exile colony peopled with an assortment of criminals and lepers. It is a no-man's-land in which lawlessness, avarice, and human dignity intertwine. Taqva'i is a deft storyteller, one of the crop of 'new wave' film makers active since before the revolution. He has fashioned a fascinating story, richly textured with colorful characters and local culture that he clearly knows and loves.

In the Wind's Eye (Dar cheshm-e tondbad) (1988), 120 minutes.
Directed by Mas'ud Jafari Jozani and produced by Pakhshiran Corp. Screenplay: M. Jafari Jozani; photography: Turaj Mansuri; music:

Faraidun Shahbazian; editing: Ruhollah Ememi; cast: Ezzatollah
Entezami, Majid Mozaffari, Ferdown Kaviani, Asghar Hemmat, Shahla
Riahi, and Farzaneh Kaboli.

This film takes place during World War II when the Allies occupied
Iran, focusing on the Qashqa'i tribes who reside in south-central Iran.
This is a palimpsest of a story: one layer is the relationship among the
members of tribal nuclear families, the second is the complex intertribal
relations stemming from rivalry based on old feuds and on extended kin
structures, and a third is the antagonistic or accommodationist
relationships of the tribe leaders with both the Iranian government and the
foreign occupiers. Amir Hushang Khan, the sympathetic center of the
film, is the leader of a clan who is working with the government. The
film evokes the complex reactions that the occupation provoked in Iran;
resentment against the Allies for invading Iran, pain of losing political
independence, sympathy with Germans, hatred of neutralized local
authorities, fear of tribes, and the rise of opportunism. Amid this
cacophony of ill effects and treachery, Amir Hushang provides a singular,
mystical voice of calm and harmony with nature and with its life force. In
one scene near an enchanting waterfall he places a hand on the green
carpet of moss to feel the 'heart of the earth pulsating.' In the end the
chief is killed but his young daughter, aided by another woman, avenges
his death. This defiant act is positioned to be received by audiences not
only as revenge against the blood of her father but also as avenging the
disgrace suffered by women at the hands of tribal patriarchs and by
Iranians at the hands of local collaborators and foreign occupiers.

The Key (Kelid) (1986), 76 minutes.
Directed by Ebrahim Foruzesh and produced by the Center for the
Intellectual Development of Children and Young Adults. Screenplay:
Abbas Kiarostami; photography: Mohammad Aladpush; editing: Abbas
Kiarostami; cast: Mahnaz Ansarian, Fatemeh Asar, Amir Mohammad
Purhasan, and Emad Taheri.

A mother goes shopping, leaving her five-year-old son, Amir
Mohammad, in charge of his infant brother. The self-confident young boy
encounters many problems in feeding his bird and in feeding his infant
brother and changing his diapers—all of which he surmounts
resourcefully. Other problems loom larger, however; a pressure cooker is
dangerously hissing and the food in it is burning. Neighbors are alarmed
and attempt to help the latchkey child by communicating with him
through a window, but the advice from one of them heightens the tension
and the danger of a gas explosion.

The film's attention to the details of everyday living, seen through a
child's eyes, is wonderful, as is the young boy's self-confidence and
persistence in the face of danger.

Marriage of the Blessed (Arusi-ye khuban) (1988), 95 minutes.
Directed by Mohsen Makhmalbaf and produced by the Institute for Cinematographic Affairs, Janbazan Foundation. Screenplay: Mohsen Makhmalbaf; photography: Alireza Zarrindast; music: Babak Bayat; editing: Mohsen Makhmalbaf; cast: Mahmud Bigham, Ro'ya Nonahali, Hosain Moslemi, Mohsen Zehtab, and Ameneh Kholbarin.

Makhmalbaf's film focuses on a shell-shocked photographer as a metaphor for a nation that is itself in shock. Haji, the photographer, is released from a hospital to the family of his wealthy fiancée for recuperation. He cannot rest easy, however, as flashbacks of the scenes he has witnessed in the war (with Iraq) and images he has seen on television of poverty and drought in Africa invade his mind, disturbing him. Haji is hired back as a photojournalist for a newspaper, but the paper refuses to print some of the grim scenes of poverty, prostitution, and drug abuse that he and his fiancée have photographed. Their joint photographic projects bring them closer together against the backdrop of opposition from her powerful businessman father. On their wedding night he relapses, and in a sequence that provides a cyclical closure, he is back in the hospital. The film uses sophisticated flashback techniques and elements of surrealism to weave a complex narrative that takes the audience deeper into both the inner world of the photographer and the decaying social milieu in which he must operate. The film seems to criticize Iran's social conditions on the grounds that society has failed to live up to the high ideals of the Islamic society. Women are strongly represented in the character of the fiancée who, undaunted by the veil, chooses photojournalism as a profession.

Maybe Some Other Time (Shayad vaqti diyar) (1988), 150 minutes.
Directed by Bahram Baiza'i and produced by Novin Film. Screenplay: Bahram Baiza'i; photography: Asghar Fari'i Jam; music: Babak Bayat; editing: Bahram Baiza'i; cast: Susan Taslimi, Dariush Farhang, Ali Reza Mojallal, Jamshid Layeq, and Sirus Nasiri.

While reviewing traffic footage, a television commentator sees his wife in a car with a man he does not know. This discovery sets into motion a chain of paranoid associations heightened by the woman's mysterious behavior. His wife's every move and word, her frequent visits to a physician, and her numerous strange phone calls arouse his suspicion. He tails his wife to find the mysterious driver, whom he confronts. What he finally discovers about his wife is a revelation to him. The film raises interesting questions about the nature of selfhood and identity.

Off the Limit (Kharej az mahdudeh) (1987), 100 minutes.
Directed by Rakshan Bani'etemad and produced by the Film Makers Cooperative and the Institute of Cinematographic Affairs, Janbazan

Foundation. Screenplay: Farid Mostafavi; photography: Alireza Zarrindast; music: Mohammad Reza Aliqoli; editing: Ruhollah Ememi; cast: Mehdi Hashemi, Parvaneh Ma'sumi, Mahmud Ja'fari, Jamshid Layeq, and Mahmud Bahrami.

Director Bani'etemad is one of the half dozen women feature directors who are active in Iran. She has also made a number of shorts for the national television networks.

The film's time, conveniently, is 1972, its location, Hertabad ('Chaos City'), a burgeoning neighborhood on the outskirts of Tehran, and its topic, people living 'off the limits'—marginal people who literally live on the margins of society. Halimi, a hard working civil servant, and his wife have moved into a new home purchased after years of economizing, when one night a burglar breaks into the house. Halimi, who sleeps with a knife under his pillow, manages to catch the thief, whom, it turns out, Halimi knows and who has burglarized many of Halimi's neighbors. The friendly banter between the thief and the neighbors who gather, however, shows that thievery is considered a profession as acceptable as any other for poor people. Halimi, however, insists on seeking justice and attempts vainly to turn the burglar in to the authorities. It seems that city planners have omitted Chaos City from their zoning maps, thereby placing it outside the jurisdiction of the law and of law enforcement officials. Unprotected, the residents collaborate to protect their community themselves. If the ending seems forced and moralistic, the body of the film is rich with possiblities for discussing social and women's issues in Iran. Boundaries regulate society, whether they are legal, jurisdictional, physical (such as walls), or social (such as the veil forced upon women). In fact, an 'aesthetics of veiling' dominates: vision is constantly obstructed by the presence of objects and boundary-marking features such as fences, walls, and columns.

These visual barriers can be taken to be metaphors for *hejab* (modesty, the veil), which marks women, sets them apart from the men, and purportedly protects them from the male gaze.

The Peddler (Dastforush) (1986), 95 minutes.
Directed by Mohsen Makhmalbaf and produced by the Art Bureau of the Organization for the Propagation of Islamic Thought. Screenplay: Mohsen Makhmalbaf; photography: Homayun Paivar, Mehrdad Fakhimi, and Alireza Zarrindast; music: Majid Entezami; editing: Mohsen Makhmalbaf; cast: Zohreh Sarmadi, Esmail Soltanian, Behzad Behzadpur, and Mortaza Zarrabi.

Director Makhmalbaf spent five years in prison prior to the revolution, until he was released with other political prisoners in 1979. He founded the Art Bureau of the Organization for the Propagation of Islamic Thought and has been a prolific film maker, producing almost a film a

year (although two of his films have been banned). *The Peddler* consists of three stories, each shot with a different director of photography. The first story, "The Lucky Child," focuses on the attempts of a poor peddler and his wife (who live in a car dump) to give up their healthy infant boy for adoption, thinking that this one, like all their other children, will develop a severe physical handicap. The second story, "Birth of an Old Woman," deals with a crazy young man who lives a bizarre life with his aged (dead?) mother, reminiscent of Hitchcock's *Psycho*. The third story, "The Peddler," in a film noir style, shows a peddler accused of betraying a fellow smuggler caught in a social milieu of smuggling, corruption, and violence—all against the backdrop of Afghani immigrants displaced by the Soviet invasion of Afghanistan. With a refreshing mix of styles, the film digs deep beneath the urban life of the downtrodden in the Islamic Republic to reveal entrenched poverty, disease, injustice, and twisted human relations.

Pomegranate and Reed (Nar o-nay) (1988), 100 minutes.
Directed by Sa'id Ebrahimifar and produced by Sa'id Ebrahimifar and Hosain Iri. Screenplay: Sa'id Ebrahimifar; photography: Homayun Paivar; music: Fariborz Lachini; editing: Zhila Ipakchi; cast: Jahangir Almasi, Ghazal Elmi, Ali Asghar Garmsiri, Rasul Najafian, and Pari Assari.

This sophisticated tour de force of Iranian cinema reveals a deep understanding, appreciation, and love for Iranian cultural sensibilities and attitudes. Like a number of postrevolutionary films, this one focuses on a photographer as its chief protagonist. The photographer comes across an old man who has fallen in the street. He rushes the man to the hospital, at the same time that a pregnant woman is brought into the maternity ward. While waiting to hear about the old man's condition, the photographer reads the man's diary, which has been found among his possessions. Starting from here we relive the life of this old schoolteacher from childhood to old age through beautifully detailed and evocative photography, a poetic narration written by poet Ahmad Reza Ahmadi, and an economical style that borders on the symbolic. For example, one shot symbolizes the man's wedding (scissors cutting a gauzy material) and four brief shots symbolize the death of his father (an unattended water pipe, a calligraphy pen case without a writer, a prayer mat folded, and a dandelion seed floating in the air). This is a film of loss—of parents, childhood's innocence, traditions, and the past. It is also a film of longing and of nostalgia for things lost and for a center that once held. Much attention is paid to colors, sounds, shadows, and shapes of things in nature as though the director intended to savor each moment before it is lost. Finally, this is a film of reflection on past deeds and on hopes yet to come.

Scabies (Gal) (1986), 96 minutes.
Directed by Abolfazl Jalili and produced by Islamic Republic of Iran
Broadcasting. Screenplay: Abolfazl Jalili; photography: Ata Hayati;
editing: Alireza Khozu'i and Abolfazl Jalili; cast: Asghar
Golmohammadi, Hosain Ma'lumi, Mehdi Asadi, Mohsen and Hosain
Panahi, and Fatemeh Naqavi.

A newspaper boy accused of distributing anti-shah leaflets is arrested
and placed in a reformatory pending the completion of the legal case
against him. Life inside the institution, a cross between a prison and a
boot camp, is rigidly controlled by abusive instructors, who at the
smallest infraction mete out severe punishment to the children. The
dreary routinization of life is depicted with visual flair. A pecking order
exists among the children, sanctioned by the authorities, but the main
conflict is between the authorities and the irrepressible children, who do
not give in easily to the panoptic regime of the institution and display
humor, resistance, and verve for living.

Finally, the newspaper boy is called before the court to face the charges
against him. The film ends with him asking the judge, "When will I be
freed?" It is a question that takes on additional dimensions if the
reformatory is taken to be Iranian society.

*The School We Went To (Madreseh'i keh miraftim) (1989 [1980]) 86
minutes.*
Directed by Dariush Mehrju'i and produced by the Center for the
Intellectual Development of Chidren and Young Adults, Screenplay:
Dariush Mehrju'i and Feraidun Dustdar; photography: Farrokh Majidi;
editing: Manuchehr Olia'i; cast: Ali Nasirian, Ezzatollah Entezami,
Amrollah Saberi, Ghasem Saif, and Mahmud Mahdavi.

Mehrju'i, who received his B.A. in philosophy from UCLA, made this
film immediately after the revolution but was not permitted to screen it
until 1989 under the present title. The locus of the film is the Shams-e
Afaq school for boys in Tehran, where a student, Kaveh Kamali,
organizes a group of boys to stage a play. The assistant principal forbids
the play, setting the scene for the film's major confrontation. Authorized
by a sympathetic teacher of literature, Kaveh writes a critical article in the
school's newspaper that compares the differences between the front and
back yards of the school. The front yard, he declares is filled with justice
and friendship, while the back yard, hidden from outsiders, is filled with
lies and injustice—no freedom is allowed there. This causes the
confiscation of the newspaper, which in turn motivates students and
instructors alike to take action. The ethical center of the film is the school
librarian, who sympathizes with the students. With much humor, a sharp
eye for the children's world view, and a keen ear for their dialogue,
Mehrju'i explores the nature of repressive authority through the eyes of

youngsters, who prove to be adept at deconstructing the world of adults who say one thing and do another.

The Ship Angelica (Kashti-ye Angelika) (1988), 110 minutes.
Directed by Mohammad Reza Bozorgnia and produced by Ali Akbar Erfani and Ayeneh Co. Screenplay: Hasan Qolizadeh, Bahman Dayyani, and M. R. Bozorgnia; photography: Hasan Qolizadeh; music: Babak Bayat; editing: Abbas Ganjavi; cast: Dariush Arjomand, Majid Mozaffari, Ezzatollah Entezami, Mehdi Fathi, and Sogand Rahimi.

This is Bozorgnia's first major feature, although he has been active in cinema for a number of years. Like many films made since the revolution, this film focuses on a historical period that coincides with the decline of the Qajar dynasty and features an ailing, despotic ruler. What is added to this formula is the specter of British imperialism signaled in the presence of British forces ruling the Persian Gulf, the site of the film. An Iranian treasure hunter has obtained a map showing the location of the Portuguese ship, Angelica, sunk with gold in the Gulf waters. He persuades the local governor to support the project, which turns up quantities of gold. The local governor and his mischievous son try to hijack the gold by enlisting the help of the British navy to interdict the treasure hunter's boat. As his boat nears the harbor, a fight breaks out, resonating symbolically with anti-imperialist liberation movements in the Third World. The captain and local people unite against the local feudal lord who is allied with Britain. This film, which is rich in ethnographic detail of the region, is an example not only of anti-imperialist attitudes prevalent in Iran but also of the newly revived morality that condemns greed and material possessions. Finally, the film suggests that to gain socially one must be prepared to lose personally.

The Spell (Telesm) (1986), 90 minutes.
Directed by Dariush Farhang and produced by the Institute for Cinematographic Affairs, Janbazan Foundation. Screenplay: Dariush Farhang; photography: Alireza Zarrindast; music: Babak Bayat; editing: Ruhollah Ememi; cast: Jamshid Mashayekhi, Susan Taslimi, Attila Pessyani, Songand Rahmani, and Sami Tahassoni.

Farhang is an actor and writer who turned director after the revolution with this film, in which he shows his keen awareness of the Gothic film genre. Set in an old mansion belonging to an aging Qajar patriarch who is served by a sinister, Dracula-like servant, this is one of the few horror films made in Iran. In the classic convention of the Gothic genre, one dark night a young newly wed couple, stranded in a torrential rain on their way home, seek refuge in the Qajar mansion. Here, in elegant tracking shots and striking compositions, we explore the lush interior of this mysterious mansion and its intriguing inhabitants. The patriarch's

wife has disappeared years ago, but when the newly-wed wife also disappears, it engenders a search that solves the mystery of the woman and the mansion. Woman-as-absence and patriarchs-as-decrepitude are two of the symbolic themes of the film and of the postrevolution cinema.

Tenants (Ejarehneshinha) (1986), 130 minutes.
Directed by Dariush Mehrju'i and produced by Pakhshiran Corp. and Mohammad Ali Soltanzadeh. Screenplay: Dariush Mehrju'i; photography: Hasan Qolizadeh; music: Naser Cheshmazar and Reza Ramin; editing: Hasan Hasandust and Dariush Mehrju'i; cast: Ezzatollah Entezami, Akbar Abdi, Hosain Sarshar, Hamideh Khairabadi, and Iraj Rad.

Mehrju'i is one of the best known Iranian film makers, his films winning critical acclaim in international film festivals as well as in Iran, where the Ayatollah Ruhollah Khomeini praised his film *The Cow* (1969) as a model of the kind of film Third-World film makers should make. *Tenants* is a dark comedy about four families renting apartments in a crumbling building with absentee owners who have apparently died in an accident in Europe. Abbas Aqa, the manager, conspires with a real-estate agent to take over the property against the will of the tenants, who interpret the rent control laws in their own favor and proceed to repair the building with comic and destructive consequence. The film was hugely successful in Iran, garnering in its first run the highest box office receipt in the history of Iranian cinema. One is tempted to take the building and its quarreling inhabitants as allegories for Iran today, a society torn asunder by conflict and disharmony. The workmanship in the building is shoddy, the materials used are inferior and inappropriate, and parts and rooms have been added illegally. The threat of destruction hangs over the last half of the film, and when it eventually occurs, it resembles the gruesome popping of a giant boil or the imminent expulsion of the creature from the human body in the film *Alien.* Like many comedies of chaos, this one—despite its accommodationist ending—criticizes the society it depicts and the squalid conditions under which many people must live in overcrowded cities.

Water, Wind, Dust (Ab, bad, khak) (1985), 94 minutes.
Directed by Amir Naderi and produced by Islamic Republic of Iran Broadcasting (Channel One). Screenplay: Amir Naderi; photography: Reza Pakzad; editing: Amir Naderi; cast: Majid Nirumand.

One of the foremost Iranian cinéastes active since 1970 is Amir Naderi, whose last film made in Iran before coming to America was *Water, Wind, Dust* (his marvelous film *The Runner* is in distribution in the United States along with his latest American film, *Manhattan by Numbers*). Many of Naderi's films from before and after the revolution have won

international awards and recognition. Like its predecessor, *The Runner*, this is a film of defiant hope in the face of relentless desolation and overwhelming power. A boy (played by Majid Nirumand, who gave a wonderful performance in *The Runner*), upon hearing of a severe drought in his parents' village, returns to help them. What he finds is life in the process of decay and decimation: the lake has dried up, animal carcasses are strewn everywhere, houses are abandoned, and villagers are turned into homeless nomads forced to wander like ghostly apparitions in the blinding dust and wind of the desert. The boy refuses to move away and doggedly insists on standing his own ground. In its unyielding determination, the film creates an allegory not only for Iranian people but also for Third-World people everywhere who must fight both their fate and their oppressors.

Where is My Friend's Home? (Khaneh-ye dust kojast) (1986), 90 minutes.
Directed by Abbas Kiarostami and produced by Alireza Zarrin, Center for the Intellectual Development of Children and Young Adults. Screenplay: Abbas Kiarostami; photography: Farhad Saba; editing: Abbas Kiarostami; cast: Babak Ahmadpur and Ahmad Ahmadpur.

This and other recent Kiarostami films, such as *And Life Goes On* (1992) and *Under the Olive Tree* (1994), are examples of the ethicalist cinema emerging after the revolution, created by a director who has been active in cinema since before the revolution. He has developed a self-reflexive style that combines documentary and fictional techniques in a cleverly ironic manner that raises questions about the nature of film. Kiarostami, whose films have won high international acclaim, specializes in making films with children as chief protagonists. Generational conflict and children's relations with authority figures are seen sympathetically from the point of view of children—who, incidentally, comprise the majority of the Iranian population. In this film, Ali, an elementary school boy, arrives home to do his homework when he discovers that he has taken his friend's copybook by mistake. His friend, Mohammad Reza, has been placed on notice by their stern teacher to copy his homework in the book and not on loose sheets of paper; otherwise he will be expelled. Realizing the gravity of the situation for his friend, Ali defies his own elders and sets out on a search for Mohammad Reza's home in a neighboring village. His defiance of his familial authorities, his fear of his school authorities, and his dogged insistence on the morally correct action are highlighted.[3]

Notes
1 This article has been reprinted with minor revisions with permission from the *American Anthropologist* where it originally appeared in Vol. 97, No. 3,

September 1995, and with permission of the author, Hamid Naficy. For full details and sources see Hamid Naficy, "The Development of an Islamic Cinema in Iran," in *Third World Affairs* (London: Third World Foundation for Social and Economic Studies, 1987), 447–463; "Islamicizing Film Culture in Iran," in Samih K. Farsoun and Mehrdad Mashayekhi, eds., *Iran: Political Culture in the Islamic Republic* (London: Routledge, 1992), 173–208; Hamid Naficy, "Veiled Visions/Powerful Presences: Women in Postrevolutionary Iranian Cinema," in Mahnaz Afkhami and Erika Friedl, eds., *In The Eye of the Storm: Women in Postrevolutionary Iran* (New York: Syracuse University, 1993), 131–150.

2 For Persian-language titles of the films and for detailed information on production and content, see the selected filmography following.

3 Distributor's information in the United States: Swank, (800) 876-5577 (Elmhurst, Ill.): *Under the Olive Trees*. International Distribution Co., (800) 443-3321 (Orange County, Calif.): *Bashu, the Little Stranger*, *Beyond the Fire*, *Marriage of the Blessed*, *Off the Limit*, *The Peddler*, *Maybe Some Other Time*, *The Runner*, *White Balloon* and *Tenants*. Facets Video, (800) 331-6197 (Chicago, Ill.): *Hamoon*, *The Key*, *Life and Nothing More*, *The Peddler*, *Where Is My Friend's* Home?, *The Runner*, *The Cyclist*. Dena Films, (310) 477-3362 (Los Angeles, Calif.): *Captain Khorshid*, *The Travelers*, *Snake's Fang*, *Sara*.

16

REVERSE IMAGERY
MIDDLE EASTERN THEMES IN HOLLYWOOD

Rebecca Stone

Introduction

By the early 1920s when people spoke of American motion pictures they began to use the name Hollywood to describe a place, a people, and as many over the years have said, a state of mind.[1]

The Hollywood 'state of mind,' as seen through the motion-picture camera lens, has made a strong impression on the twentieth century. Various cultures of the world have been portrayed in Hollywood films, sometimes not quite accurately. Middle Eastern cultures have had a long history in the United States of being misunderstood and stereotyped. There is no doubt that film, of the popular American variety, has played a role in fostering this misunderstanding. Since the turn of the century, film makers have often altered Middle Eastern culture on film to suit their own purposes.

Although much of this book concerns the development of the arts in the Middle East, Hollywood's own creation of the Middle East has formed an extremely tenacious image in the popular mind. It may be useful for the reader to consider that while Arabic music, classical music, indigenous dance forms, and new forms of visual art were being explored and performed in the region, Western visions of the Middle East coalesced around certain key elements—the harem fantasy of dancing girls, the brave and romantic sheik of the desert, and other images melded from East and West.

Of all features used to represent culture, gender identity is perhaps the strongest. Most markedly in the case of representations of the Middle

East, gender identity provides a handy, simply duality: males are strong and outward or eccentric; females are passive, mysterious, and inward, or concentric. Dealing with gender in such a way is free of complexities and provides ease in adaptation to practically any story line. The danger lies in the fact that real people are being represented to another culture that knows little else about them. Such information is often taken quite literally.

To gain an understanding of Hollywood's long relationship with the Middle East, and where reality and fantasy merge or part company, it is helpful to know something of the social climate in which the relationship developed. It is also appropriate to trace the genesis of Hollywood's notions of the Middle East.

The Influence of Early Literature

From my dull and commonplace and 'respectable' surroundings, the Jinn bore me at once to the land of my predilection, Arabia, a region so familiar to my mind that even at first sight, it seemed a reminiscence of some bygone metempsychic life in the distant Past. Again I stood under the diaphanous skies, in air glorious as aether, whose every breath raises men's spirits like sparkling wine. Once more I saw the evening star hanging like a solitaire from the pure front of the western firmament; and the after-glow transfiguring and transforming, as by magic, the homely and rugged features of the scene into a fairy-land lit with a light which never shines on other soils or seas.[2]

The West has long made the Middle East an accomplice to its dreams and fantasies. The idea of the 'Orient' (the earlier term for the Middle East) was often more important to Europeans than the reality. They expressed their views of it through literature, music, painting, dance, and early photography. It was not uncommon to find that the image the nineteenth-century Orientalists painted of this region, composed geographically of North Africa and western Asia, was a romantic one, and often, an invented one.

Edward Said, in his book *Orientalism,* alludes to the fact that the 'East' held a certain magnetism for Victorian era refugees from the European cities of the Industrial Age. He states, "The Orient was almost a European invention, and had been since antiquity a place of romance, exotic beings, haunting memories and landscapes, remarkable experiences."[3]

Many Europeans ran to the East not only for adventure but to escape their own, sometimes dismal realities of the Industrial Age. Nissan Perez maintains that when they could not understand the 'Orient' and its people, or did not care for the reality, they could "fantasize about it and

create their own imaginary 'Orient.'"[4] He surmises that "for the European of the 1880s, the 'voyage en Orient' became a bourgeois rite of passage through which was sought a double goal, knowledge and the re-attainment of a lost heritage[biblical or classical]."[5] Indeed some Western travelers reacted peevishly to a Middle East that was not the Shangri-la they had imagined . . . and they blamed the local inhabitants.

Photographers in the 1800s created their own imaginative Eastern settings in their studios and some actually marketed their photographs through news agencies. Perez explains that the photographers were captives of their own fantasies of the Orient, and manipulated their subjects into those fantasies. While some photographs were objective, the captions frequently displayed their prejudices about the Middle East.[6]

It was perhaps women, especially women as dancers, that evoked the strongest image of exotic face of the 'Orient,' her beauty and mystique to be slowly uncovered. Tantalizing images materialized on paper and canvas suggesting what would be found in the region. Female models were posed topless or completely nude and became the stuff of French postcards.[7] Although Sarah Graham-Browne's text on photography of the era shows examples of other sorts of models,[8] Perez maintains that often prostitutes were the only models to which the photographers had access. He adds, "Other models appear to be blind and unaware of what was happening around them."[9]

A sun on wand in knoll of sand she showed
Clad in her outer robe of crimson net.
Of her lips' honey-dew she gave me drink
And with her rosy cheeks quencht fire she set.[10]

Said has called 'the Orient' one of Europe's "deepest and most recurring images of the Other."[11] It was this 'Other' that captured the imagination, and often in female form. While not all Americans had access to the writings of Flaubert and other literary luminaries who wrote extensively of the 'Orient,' travelers' accounts and romance novels with Oriental themes had perhaps the greatest effect on Western perceptions of the East.

The Western artists and writers continued for some time to portray the dancers of the 'Orient' they encountered in an erotic, romantic, and almost supernatural light. Dancers in such renderings were often called 'houris,' 'sylphs,' and 'witches.' Such fantastic creatures were also embodied in literary works such as *The Tales of the One Thousand and One Arabian Nights*, translated into English by Sir Richard Burton and published in 1885. In their original form the tales were considered, in reviews such as that of the *Court Circular,* as "not fit reading for women and for young people."[12] However, Lady Isabel Burton, Sir Richard's wife, prepared her

own edition for 'household reading' in 1886, wherein she guarantees that "no mother shall regret her girl's reading this 'Arabian Nights.'"[13]

Arabian Nights themes have long been popular in Hollywood films. Through the constant retelling of these tales from a Western perspective, stereotypical images have been heavily reinforced; the Middle East is a place of adventure, mysterious beauties, untold riches, and unbridled lust. It is possible that turn-of-the-century Westerners took literature such as the Burtons', as well as photographs and paintings, as cultural fact or something close to it. Little else was available to them in the way of information on lands so distant. Then the great fairs, such as the Columbian Exposition in Chicago in 1893, imported performers from the Middle East. Sol Bloom, the impresario who was responsible for bringing Middle Eastern performers to the Midway Plaisance of the Columbian Exposition, remarked:

> It is regrettable . . . or, if anyone should choose to disagree, it is at least a fact . . . that more people remember the reputation of the *danse du ventre* than the dance itself. This is very understandable. When the public learned that the literal translation was 'belly dance' they delightedly concluded that it must be salacious and immoral. The crowds poured in. I had a gold mine.[14]

It was Middle Eastern women who attracted the most—not always kind—attention. Regardless of what romantic notions of the 'Other' were cultivated in America by popular stories and visual material, fantasy and reality collided at such events. The flesh and blood performers did not resemble the fantastic images many Americans had come to expect. The cultural differences between performers and audience were vast. It was, especially, the women who performed as dancers who incurred Victorian wrath. While American women were covered and corseted from head to toe and limited in body movement, the dancers, by comparison, were sometimes scantily clad, slightly plump, wore their hair down, and moved their bodies freely. They were not the nymphs from the pages of the Arabian Nights, and judging by the reaction to these performances, it is likely that some Americans felt they had been swindled.

> Writers of Oriental stories have created the impression among the uninformed that houris of the East are sylph-like and beautiful, but close contact reveals them as we behold them here, destitute of animation, formless as badly-stuffed animals, as homely as owls, and graceless as stall-fed bovines.[15]

Film and Middle Eastern Themes

Early motion-picture cameras were often exhibited at the same fairs where Middle Eastern performers were featured. Many performers for early film

came from the arenas of fairs, carnivals, vaudeville, and burlesque. Since the advent of the motion-picture camera in the late 1800s, dance was a favorite subject of early film makers. Of the dancers immortalized on film, some of the first were fair dancers from the Middle East.

The very nature of the 'Oriental dance' (the preferred term among the initiated for what is known as belly dance) made it an excellent subject for motion-picture explorations of the day. The dancers moved in a highly visible, complex fashion. Again, unlike Western women, the Eastern dancers wore no corsets and were free to move their bodies, including their hips and torsos or 'bellies'—body parts whose exposure, at the time, was considered by North Americans to be the height of indecency.

No ordinary Western woman looked on these performances with anything but horror, and at one time it was a matter of serious debate in the councils of the Exposition whether the customs of Cairo should be faithfully reproduced, or the morals of the public faithfully protected.[16]

Two early film dancers who were quite possibly from the Middle East were Fatima and Raja. Fatima performed her 'Coochee-Coochee' dance for early film makers from Thomas Edison's Kinetoscope Company circa 1893 and possibly later, in 1897, for the Mutoscope Company. Stills from these short films in which she appeared can be found in several books on film history. Raja, according to vaudeville historian, Joe Laurie, was a former Coney Island dancer who became "a vaude headliner" and "danced holding a chair in her teeth at Huber's Museum, when Willie Hammerstein discovered her there and booked her, which started her on a big-time career."[17]

At the time such dances first appeared on film, they were generally consigned to Coney Island-type peep shows, in appropriately censored form. Both of these dancers utilized rather delicate shoulder shimmies in their performances. In the censored versions of Fatima's dance, white grids block from view nearly everything but the dancer's head. The shimmy was considered to be the most wicked and even the most unhealthful dance of the day. But it was scintillating enough to rake in the profits at any penny arcade where the kinetoscopes were housed.

Issues of morality could not, however, be totally ignored by film makers. The first motion picture ever to be banned in the United States was performed 'á l'Orientale' by an American dancer named Dolorita, whose 'Passion Dance' (circa 1896) created a furor on the boardwalks of Atlantic City, New Jersey. According to dance researcher and author Wendy Buonaventura, the main objection to the dance was "the boldness of its pelvic movements."[18] Prior to the 1930s, it was often the local

chief of police who determined whether or not a film warranted censoring. The banning of 'Passion Dance' and the censoring of Fatima were a preface to later Hollywood concerns and 'morals clauses.'

Eventually films expanded from peep shows and shorts shown in vaudeville and burlesque houses to feature-length stories. These films, also called photoplays or screenplays, were shown in luxurious surroundings, in theaters created specifically for movie viewing. According to Robert Sklar, S. L. 'Roxy' Rothapfel was initially responsible for greatly improving theaters. Whereas early movie viewing had taken place in burlesque houses or dark, tawdry rooms,

> Rothapfel's credo was 'Don't give the people what they want . . . give 'em something better,' and he did it with spectacular flair: special lighting, orchestral music, uniformed ushers, restrooms fitted and furnished in royal splendor. Theaters run by 'Roxy' were more memorable for their service than for their design.[19]

Many such theaters carried the promise of exoticism in their names. Countless theaters bearing names like 'The Egyptian,' 'The Baghdad,' 'The Oriental' still exist today. These theaters not only showed movies but featured whole pageants with themes often connected to the film being shown. 'Harem-style' revues were apparently common, featuring acts like 'Lola and her Lotus Dance' and accompanied by musical groups with names like 'The Red Hot Mummies,' 'Amneris and her All-Girl Jazz Band,' or 'Rube Wolf and his Tomb Twisters.' At Hollywood's Egyptian Theater (owned by Sid Grauman and in operation before the famous Chinese Theater) there was a regular character who dressed up 'Arab-style' and carried a staff. His job was to pace the length of the breezeway leading to the theater and announce the coming attractions.[20] It is interesting to note that America was still turning to the romanticized East for the fulfillment of its fantasies, not only in films but in theaters as well.

As screenplays have tended to come from popular novels and plays, it is not difficult to see how this literary fascination was transferred to film. The pre-twenties vogue of the 'Oriental' theme persisted throughout the decades in varying forms and was accessible to film makers, who turned to popular plays, novels, and even the Bible for inspiration and story material. In fact, the most common genres of film employing Middle Eastern themes are the adventure romance, the biblical epic, and the espionage-intrigue thriller.

Within film genres, Hollywood created escapist stories populated by characters with whom the audience could identify on some level (good vs. evil, rich vs. poor, the righteous but downtrodden fighting and winning against all odds). The stories were exotic enough to make the

audience forget, for a while, the cares of the world, whether economic depression, a major world war, or just a rainy day.

To create the illusion that enabled escape, a convincing atmosphere was necessary. While Hollywood provided the basis for settings through some historical/cultural research, imagination was not neglected as a source. Artists joined to create pseudo-Oriental, quasi-mythical bygone eras of a sometimes equally mythical 'Middle East.' Like other artists of their time, early film makers often injected the romantic vision of the East into costumes, music, setting, dance, even the personalities of their characters.

As in the other arts, Orientalism in film has been very much alive. Adventure-romance movies (sometimes playfully referred to as 'sex and sand' pictures) were rich in 'Oriental' themes and often borrowed from the *One Thousand and One Arabian Nights*, using the stories of Ali Baba and the Forty Thieves, the Thief of Baghdad, Sinbad the Sailor, Aladdin, and Scheherazade. In turn, biblically oriented stories and tales of ancient history have made much use of characters such as Salome, Solomon and Sheba, and Cleopatra. Even Mata Hari provided a model for characters involved in tales of intrigue, often set in Middle Eastern contexts. Parodies of any of these themes were not unknown, as may be seen from titles such as *Salome vs. Shenandoah* (1919), *The Shriek of Araby* (1923), *Ali Baba Goes to Town* (1937), or *Babes in Baghdad* (1953).

Often, before authentic location shoots took place, the deserts of California, Arizona, and Utah served as the Sahara. Set designers created fantasy worlds with American sand. Composers did their best to make film scores sound exotic, but not too foreign, by throwing in a few minor chords here and there. Unfortunately, sometimes picture and sound track would not really complement each other, as when whole symphonies would appear to emanate from a single reed instrument.

Costume designers concocted ultra-glamorous costumes, often based on the kinds of costumes fair dancers wore and accented by bits of Middle Eastern jewelry. Great pains were taken to disguise belly buttons, which were deemed obscene. This is where the jewel in the navel is thought to have originated.

Dance was one of the most important ingredients used to breathe life into the imaginary landscape of film. When Oriental dance was staged, it was modified to suit Western aesthetics and sensibilities, as most Westerners still preferred the Orientalist vision over the authentic dance forms. Ruth St. Denis, one of the mothers of modern dance, presented the perfect blend of 'Orientalia' for her American audience. She mixed ethnicities in her costume designs, but her audience was not perturbed. Most were unaware of the appropriate ethnic or national features of costume and dance, or as Elizabeth Kendall put it, they "preferred her to be American, like their home brand of Orientalia."[21] St. Denis, her husband Ted Shawn, and their company of dancers, Denishawn, made

their mark in film, particularly those of D. W. Griffith. Even more influential in film was a Denishawn protégé, Jack Cole. Like St. Denis, he had an affinity for the East, and did study some forms of Eastern dance. He injected serpentine movement motifs into his choreography and emphasized hip isolations. The resulting movement style was often performed to jazz music accompaniment. Cole, often regarded as the father of American modern jazz dance, was less interested in being 'ethnically correct' than in making the movement 'swing.' Cole became a major film choreographer in the film industry of the 1940s and 1950s.

Other choreographers, or dance directors as they were first called, liberally mixed the dance movement vocabularies of different regions. In one dance it might be possible to see bits of Persian, Egyptian, and Spanish styling laid, like a veneer, over Western Broadway show dance or ballet. In some films, even of more recent decades, such as *The Man Who Would Be King* (1975), we are presented with a discrepancy of locale; Guedra dancers of Morocco are placed in the Himalayan mountain ranges.

All of these elements were the unique creations of artists employed to work on the film, who in some cases had researched the time period and place they are presenting in painstaking detail. Often a compromise was reached; combining 'authentic' elements with the creative renderings of the artist, in anticipation of audience reaction. Successful films seemed to depend upon elements of familiarity with which an audience could identify. This complicated the task of presenting a story set in a foreign locale, about a foreign culture, and in a historical time period. The challenge was to mix the exotic with the familiar, and to blend historical accuracy with dramatic appeal. In a sense, the exotic must be rendered familiar.

Instead we may observe that the familiar became increasingly exotic. If films were born of popular culture, both they and their stars sometimes had a significant impact on culture, that is on their audiences. Although other art forms showed an interest in the Middle East (especially in the early part of the century), and subsequently influenced popular culture—in interior decor, popular and classical music, ballet and modern dance, and spiritualism and the occult—movies seem to have had a perhaps more intimate influence.

Some film makers and actresses inadvertently set trends with their efforts to enhance their features for the camera in these films. For example, Robertson credits D. W. Griffith with the invention of false eyelashes, worn by Seena Owen for her role as the Babylonian Princess Beloved in *Intolerance* (1916). The origins of the modern style of wearing eye makeup can be traced to film vamps Theda Bara and Pola Negri.[22] Negri, who starred in films such as *One Arabian Night* (1921), is said to have initiated the fashion of painting fingernails. Bara, whose name, it

was noted, is an anagram of 'Arab Death,' built her career as a dark-eyed, exotic *femme fatale*, a vampire (a woman who sucks men dry). Countless myths were constructed around her: that she was an Egyptian, born in the shadow of the Sphinx, and raised on serpent's blood, a seeress and unspeakably evil. She was actually Theodosia Goodman from Ohio, but as far as movie audiences were concerned she was and always would be the Great Vamp. Her films included *Cleopatra* and *Salome*, both made in 1918.

After World War I, American culture entered a new phase. According to Stuart Flexner,

War-jaded youth [went] on a rampage, releasing pent-up emotions and reacting to the dazzling new stimuli of peacetime prosperity, speakeasies, movies, cars, radios, and the newly popular 'Sunday Supplements' and confession magazines. It was the first young generation to take itself seriously as a separate, distinct group and the first to be analyzed, egged on, and exploited by the books, movies, newspapers, and magazines of its own day, which shocked and titillated the public with stories of flappers and sheiks. [23]

Flappers were also called Shebas, after Betty Blythe's image in *The Queen of Sheba* (1921). They were unrestrained young women, who cultivated the exotic Theda Bara look, wore fringed, uncorseted dresses, and indulged in dancing the shimmy. They were symbols of the Roaring Twenties. Their male counterparts called themselves sheiks, fashioning themselves after Rudolph Valentino's movie persona. They slicked back their hair, wore raccoon coats, and carried hip flasks. Together, flappers/Shebas and sheiks drank, smoked (usually cigarettes with names like 'All Turkish,' 'Egyptian Deities,' and 'Fatima'), and danced to jazz.[24]

In an impressive example of the process of popular mythmaking, "American youth equated these two figures in time [the Sheik and the Queen of Sheba]—though they were actually separated by two thousand years—on the simple score that both were Oriental and, therefore, ardent and unashamed in their sexuality.[25]

Film historians illustrate the sociocultural needs of early audiences and relate them to film production. It is interesting to note what kinds of films were in demand earlier in this century. In 1926, a contest was run by Cecil B. De Mille in association with the Los Angeles Times, to elicit ideas for films from the public. Stories with biblical settings topped the list. John Flinn wrote:

In 1922 there was an almost frenzied demand from parents for preachments against the 'flapper.' The 1926 contest contains hardly a

suggestion of this nature, indicating that in the four intervening years the pubic has either accepted twentieth century ideas or has come to the knowledge that the paternal fears of 1922 were ungrounded."[26]

Rudolph Valentino became the greatest lover ever known on film with his appearance in *The Sheik* (1921). This silent film earned Paramount Studios millions and was even popular when rereleased with musical accompaniment in 1938, when it had to compete with sound pictures.[27] *The Son of the Sheik* (1926) was the last, and according to some, the best film Valentino made, continuing the tradition of the pseudo-Eastern setting and characters: "Like all youths, he loved a dancing girl. Like all dancing girls, she tricked him" (*The Son of the Sheik,* 1926).[28]

In adventure-romance films like *The Son of the Sheik* and *The Desert Song* (1929), hero and heroine were usually not of Eastern descent but secretly of European heritage and usually aristocratic. These characters possessed characteristics of strength, beauty, honesty, and goodness not normally credited to the Easterner in Hollywood film. If ever an Eastern character displayed these traits, he or she was often doomed for some kind of martyrdom by the end of the film. More often than not, Middle Easterners were portrayed like Gabah the Moor in *The Son of the Sheik*, "whose crimes outnumber the sands," and Middle Eastern settings were like the Café Maure: "The night was young at the Café Maure. Not a knife had been thrown—so far" (*The Son of the Sheik,* 1926).

The discovery of Tutankhamun's tomb in 1922, World War I, World War II, the creation of the state of Israel, as well as widespread Western colonization of the Middle East, all served to bring the West into closer contact with the East. Semi-familiarity led to perceptual changes, and the role of the Arab as a film character underwent some transformation. Fantasy incorporated haphazard bits of historical fact and culturally biased impressions. Woll and Miller saw changes in the role of Arabs in film:

> The success of *The Sheik* spawned a series of exotic melodramas associating Arabs with violence and sexuality, but the charm of Valentino's sheik quickly played out. Movie Arabs who abducted white women became increasingly lustful, apparently because they were not Europeans in disguise. The Arab-as-lover theme vanished from the movie screen after the 1920s, except as a comedic stereotype. Arab sexuality, such as it was, survived in the form of harem girls and belly dancers, ornaments in the male-dominated world of film Arabs. Modern movie Arabs seemed more interested in the Westerner's money than their women.[29]

Meanwhile, in the 1930s, Hollywood toned down the splendor and movies became rather dark, as film makers focused on stories that people

in the grip of the Depression could relate to.[30] Not all lavishness was dead, however. Cecil B. De Mille produced *The Sign of the Cross* in 1932 and *Cleopatra* in 1934. In 1930 the first Production Code came to affect film and the images of the Middle East. Due to pressure from groups such as the Legion of Decency, The Motion Picture Producers and Distributors of America, headed by Will H. Hays, became a regulatory agency. Hays attempted to purge the industry of all potentially dubious characters and story lines, which affected the 'Oriental' scenes of abandon: "Allah curse all dancing girls. Their hips full of abandon, make young men full of nonsense" (*The Son of the Sheik*, 1926).

As Oriental dance was an important vehicle for establishing context in Middle Eastern themed films, it is important to understand how the Code affected its presentation, and as a result, film. The Code specified in section VI, #4 that "Dancing costumes intended to permit undue exposure of indecent movements in the dance are forbidden." And in section VII, #1, "Dances suggesting or representing sexual actions or indecent passion are forbidden; #2, Dances which emphasize indecent movements are to be regarded as obscene."[31]

In 1939 the Code was revised to allow "costumes, nudity, indecent or undue exposure and dancing costumes . . ." that were part of "authentically photographed scenes in a foreign land, of natives of such foreign lands, showing native life, etc." The following qualification for dance also appeared:

Dancing in general is recognized as an art and as a beautiful form of expressing human emotions. But dances which suggest or represent sexual actions, whether performed solo or with two or more; dances intended to excite the emotional reaction of an audience; dances with movement of the breasts, excessive body movements while the feet are stationary, violate decency and are wrong.[32]

This last revision is most probably a direct reference to Oriental dance. This dance form was often criticized by Westerners for its stationary performance style and lack of footwork. In fact, it was often not seen as dance, but as some kind of gymnastic contortion. If such a dance was to be used without violating Code laws, it had to be modified. Consequently, the dance became uncharacteristically mobile, footwork was added, and isolations (of the shoulders, rib cage, hips), a hallmark of Oriental dance, were toned down, if not eliminated.

Due apparently to the Code, films became much more focused on wholesome themes set in idealized contexts. As they became less starkly realistic, they also became big star vehicles. Perhaps these changes were also in reaction to the Depression. In this period, Middle Eastern themes continued to be used in musical comedies and romantic melodramas.

The 1940s and 1950s were peak decades for Oriental themes. Films made as morale boosters to the war effort were frequently musicals which featured 'harem' scenes as in *Hey Rookie* (1944). In this film, Ann Miller performs 'Streamlined Sheik,' a dance number complete with Oriental dance costume, finger cymbals, and tap shoes. The intrigue film *Casablanca* (1942) starring Humphrey Bogart and Ingrid Bergman was released just after the American landings in North Africa. The film eventually gained a cult following and status.

During, and especially after, the war, countless 'B' films built around Middle Eastern themes were made. Several starred Yvonne DeCarlo, as in *Slave Girl* (1947), or Maria Montez in vehicles such as *Arabian Nights* (1942). These two actresses were known as the 'B' queens. A sample of other similar films might include *Princess of the Nile* (1954) starring Debra Paget and Jeffrey Hunter, *Zarak* (1956) with Victor Mature and Anita Ekberg, and *Solomon and Sheba* (1959) starring Yul Brynner and Gina Lollobrigida. Even John Wayne appeared in one of these films, *The Conqueror* (1955), in which he played Genghis Khan. Although Khan was a Mongol, Middle Eastern themes dominate the film. The 'Samarkand' dances in this film are a mixture of Thai, Arab, and Broadway styles and the dancers wear large spring-like devices on their heads. The accompanying music is abstract and jazzy. Wayne is reported to have requested this role, saying, "The way the screenplay reads, this is a cowboy picture, and that's how I am going to play Genghis Khan. I see him as a gunfighter."[33]

One of the major challenges for Hollywood film during the fifties was television. Champlin says, "Many of the memorable films surviving from the 1950s have a dramatic power rooted in social realism, but it was sheer spectacle that the studio tycoons seized on as their best weapon against television."[34] Indeed this competition provided the impetus for the development of bigger screens and better sound systems and color techniques in order to present films made on a grand scale. Musicals and epics, often involving biblical/historical or Middle Eastern themes, were popular at this time. Some of these films, such as *The Ten Commandments* (1956), *Ben Hur* (1959), *Spartacus* (1960), and *Lawrence of Arabia* (1962), have recently been restored and rereleased to packed houses. Audiences are still impressed, today, in the age of industrial Light and Magic, with the scale on which these films were made. The films also reimplement many of the exotic elements and Orientalism employed by early Hollywood.[35]

Middle Eastern themes in films seem to diminish after the early sixties except for films like Elvis Presley's *Harum Scarum* (1965) and occasional forays into the Sinbad stories, such as *The Golden Voyage of Sinbad* (1973), and *Sinbad and the Eye of the Tiger* (1977). The espionage stories, such as those involving James Bond, sometimes used Middle

Eastern contexts or backgrounds such as Cairo, or, in *Octopussy* (1983), Oriental dancers who are martial artists. More current films have shifted from the early swashbuckling Sheik to the oil baron and the fanatical terrorist, trading scimitars, horses, camels, and flowing robes for guns, bombs, military fatigues, and luxury cars. Before the independence of Middle Eastern states, there were 'Mummy' films, films about the Crusades, and films about the dangerous Arabs with swords and guns that implied that 'European colonialism in the Arab world was a good thing.' After 1948, there were films that applauded "the creation of modern Israel, . . . depicted Arabs as the 'bad guys,' and lent 'credence' to film stereotypes of Arabs as kidnappers, terrorists and murderers."[36] The Middle East is now portrayed as the hotbed of terrorism and religious fanaticism. The 1994 movie *True Lies* featuring Arnold Schwarzenegger and Jamie Lee Curtis cultivated the Arab-as-terrorist theme. Arab and Muslim community representatives have protested:

> Bashing Arabs and Muslims is the Hollywood wave of the past, the present, and who knows how far into the future. The image—the false image—held by most Americans is a result of selective reporting by the news media, . . . which is then exploited by the entertainment media (because movies need villains). That's how we, and our kids, learn what Arabs and Muslims look like and how they behave.[37]

Bustany and al-Marayati, the authors of the comment above, also acknowledge Hollywood's power, which could be used to heal the damage from stereotypes rather than to perpetuate them.

Jack Shaheen has come to attribute Hollywood's treatment of the Arabs to a lack of knowledge. Shaheen recounts a story editor's comment—"I can't write what I don't know [a respectable Arab character?]"—and is more optimistic about the media, as journalists provide more balanced reportage, ". . . but the ugly 'Arab image' in popular culture remains." He suggests that in order to erase the preexisting imagery, those who create these stereotypes should "see for themselves what Arabs really are."[38]

The terrorist theme is not the only treatment of Arab or Middle Eastern characters. There has also been a nostalgia for the adventure romance, hence the filming of *Raiders of the Lost Ark* (1981) and *The Last Temptation of Christ* (1991), a controversial rendering of the biblical genre. In these films, there was an effort to stay close to some semblance of reality. Some Americans were able to view filmic visions of the Middle East that are further from Hollywood's model: *Torn Apart* (1990), *Sheltering Sky* (1991), and even *A Wedding in Galilee* (1988). [Editor's Note: One must also consider *Aladdin* (1993) a mixed blessing, popularizing the exotic but also featuring lyrics like "It's barbaric [the

Middle East] but hey, it's home," and more recently *Operation Condor* (1997), in which Jackie Chan fights the terrorist Arabs, and *G.I. Jane* with Demi Moore (1997).]

Conclusion

Film is a significantly powerful medium. It is both an expression and a reflection of culture. Rarely, however, do film historians comment on the popularity of the Middle Eastern theme, although a look at the annual top-grossing films from the 1930s to the 1960s attests to this fact.[39] *Mata Hari* (1932), *Road to Morocco* (1942), *David and Bathsheba* (1951), *Salome* (1953), *Solomon and Sheba* (1960), and *King of Kings* (1962) were all top box-office draws.

The West has had an enormous impact on the Middle East, geographically, politically, economically, and culturally. Media such as popular film have heightened this impact during the twentieth century. The effect of the Middle East on Western film seems less forceful. Arabs as a culture or race have received curious and often unfair treatment in film; men and women as representatives of that culture have been stringently and bizarrely type-cast. Edward Said explains:

> One aspect of the electronic, postmodern world is that there has been a reinforcement of stereotypes by which the Orient is viewed. Television, the films, and all the media's resources have forced information into more and more standardized molds. So far as the Orient is concerned, standardization and cultural stereotyping have intensified the hold of the nineteenth-century academic and imaginative demonology of the 'the mysterious Orient.'[40]

The one-dimensional characterization of Arab males, from romantic nomads to fanatics and terrorists, is matched by a relative absence of Arab women. They have moved from the Oriental dancer to an anonymous black-shrouded background, or nothing at all. Earlier visions of the dancing beauty may be due in part to the predominance of male film makers. Still, with more and more information about Middle Eastern and Arab women, and more women film makers, why is there such a lack of characters, both Arab and women?

We must not condemn all of Hollywood's actions. Film acts as a preserver. Despite the liberties taken, popular Hollywood films have promoted some solid production research on details ranging from the intricacies of Cleopatra's hairpins to the way that Americans of the 1930s held their cigarettes. This sort of historical and cultural information is not normally available in books.

Film has also preserved early dance movement of the Middle East as it was performed in America. In the jerky, flickering black-and-white

images of Fatima and Raja, one can see the rudiments of costuming and the movement vocabulary of the day. These films provide valuable documentation that would be otherwise unavailable. When films were shot on location, they preserved earlier images of Middle Eastern countries, and in some cases, cultural practices. Sometimes local residents were hired to work in films. For some Americans, films have served to pique their curiosity, prompting further and more careful investigation of the Middle East.

Films have also preserved Western attitudes and testify to the ideas of the Middle East during the course of the twentieth century. Westerners rarely understand the impact that the Middle East has had on them, borrowing from its cultural life, and injecting elements into their fashions, architecture, interior decoration, ballets, paintings, classical and popular music, theater and films.

The Middle East in Hollywood film could be a place of extremes: good vs. evil. This is true as well for the moralizing of commercial film made in the Middle East; that film has been a place to situate hopes and fears. Film as a popular medium has the capability to generate, reinforce, and even sometimes to challenge beliefs, attitudes, and ideas. It has the power to create and nurture stereotypes, and Hollywood's stereotypes were certainly remote from the images made in the Middle East about itself. Yet, we should remember that Hollywood also has the power to dispel stereotypes, if only it could be motivated to do so.

Notes

1 Robert Sklar, *Movie-Made America* (New York: Random House, 1975), 69.
2 Richard Burton, introduction to Isabel Burton, *The Tales of the One Thousand and One Arabian Nights*, Justin Huntley McCarthy, trans. (London: Chapman and Hall, 1886), vii.
3 Edward Said, *Orientalism* (New York: Pantheon Books, 1978), 1.
4 Nissan Perez, *Focus East: Early Photography in the Near East 1839–1885* (New York: Henry Abrams, 1988), 64.
5 Ibid., 49. Brackets mine.
6 Ibid., 50.
7 Malek Alloula, *The Colonial Harem* (Minneapolis: University of Minnesota Press, 1986 and Manchester: Manchester University, 1987).
8 Working women and family portraits are shown in addition to Orientalist and missionary images. Sarah Graham-Browne, *Images of Women: The Portrayal of Women in Photography of the Middle East 1860–1950* (New York: Columbia University, 1988).
9 Perez, *Focus East*, 107.
10 Burton, *The Tales*, 193.
11 Said, *Orientalism*, 1–2.
12 *Court Circular*, 11 September 1886.
13 Burton, *The Tales*, 448.

14 Sol Bloom, *The Autobiography of Sol Bloom* (New York: Putnam's Sons, 1946), 135.

15 Caption from unbound photograph of dancers of the Midway Plaisance, circa 1894.

16 N. D. Thompson, ed., *Dream City: A Portfolio of Photographic Views of the World's Columbian Exposition*, photos by Marius Bar (St. Louis, Mo.: N. D. Thompson Publishing Co., 1893).

17 Joe Laurie, *Vaudeville from the Honky-Tonks to the Palace* (New York: Henry Holt and Company, 1953).

18 Wendy Buonaventura, *Bellydancing: The Serpent and the Sphinx* (London: Virago Ltd., 1983), 104.

19 Sklar, *Movie-Made America*, 45.

20 Ben Hall, *The Best Remaining Seats* (New York: Clarkson N. Potter, Inc., 1961), 225.

21 Elizabeth Kendall, *Where She Danced* (New York: Alfred Knopf, Inc., 1979), 78.

22 Patrick Robertson, *The Guinness Book of Movie Facts and Feats* (Middlesex, England: Guinness Publishing, 1988).

23 Stuart Flexner, *I Hear America Talking: An Illustrated Treasury of American Words and Phrases* (New York: Van Nostrand Reinhold, 1976), 309.

24 Ibid., 309–310; Stuart Flexner, *Listening to America* (New York: Simon and Schuster, 1982), 144–145.

25 Richard Griffith and Arthur Mayer, *The Movies* (New York: Simon and Schuster, 1970), 191.

26 John C. Flinn, "Biblical Subjects Lead in Film Story Contest," article dated 4 April 1926, in *New York Times Encyclopedia of Film 1896–1928* (New York: Times-Mirror, 1984).

27 Griffith and Mayer, *The Movies*, 140.

28 *The Son of the Sheik*. A United Artists film. George Fitzmaurice, producer and director, Hollywood, 1926.

29 Allen Woll and Randall Miller, *"Arabs," Ethnic and Racial Images in Film* (New York: Garland, 1987), 180–181.

30 Ralph A. Brauer, "When the Lights Went Out: Hollywood, the Depression and the Thirties," in Michael Marsden, John Nachbar, Sam Grogg, eds., *Movies as Artifacts* (Chicago: Nelson-Hall, 1982).

31 Cited in Robertson, *Guinness Book of Movie Facts*, 393.

32 Ibid., 396.

33 Leslie Halliwell, *Halliwell's Film Guide,* 7th edition (New York: Harper and Row, 1989), 218.

34 Charles Champlin, *The Movies Grow Up: 1940–1980* (Ohio: Swallow Press, 1981), 48.

35 For description and analysis of the stereotypical portrayal of the Arab in television see Jack Shaheen, *The TV Arab*; or Jack Shaheen, "The Arab Image in the American Mass Media," in Edmund Ghareeb, ed., *Split Vision* (Washington D.C.: Arab-American Affairs Council, 1983.); or Laurence Michalak, *Cruel and Unusual: Negative Images of Arabs in Popular American Culture*, Washington, D.C.: American-Arab Anti-Discrimination Committee, Issue Paper 19, 1984.

36 Woll and Miller, *"Arabs,"* 181.
37 Salam al-Marayati and Don Bustany, "Hasta la Vista Fairness: Media's Line on Arabs," *Los Angeles Times* (8 August 1994), F3.
38 Jack Shaheen, "The Arab Image in the Mass Media," 335.
39 Cobbett S. Steinberg, *Film Facts* (1980), 28.
40 Said, *Orientalism*, 26.

17

FARIDA FAHMY AND THE DANCER'S IMAGE
IN EGYPTIAN FILM

Marjorie Franken

Introduction

Egyptian movies, like those of India, are well known for their music and dance sequences, which appeal to large popular audiences. In Egypt this format draws on a much older, preindustrial tradition of hired singers and dancers at public celebrations such as weddings and circumcisions. In Western terminology, the dancers were of the so-called 'Oriental' variety, or 'belly dancers.'

Such public female dancers, performing hip and torso undulations, have been regarded as low class and risqué figures since the nineteenth century in Egypt.[1] However, for one brief interlude during the Nasser era of new independence and patriotism, one dancer, Farida Fahmy, challenged this erotic and disdained image of the female dancer. This period of the 1950s and 1960s is now widely regarded as a 'golden age' of Egyptian arts; Egyptian film was one popular art that flourished as never before. Egyptians saw new images of themselves in these often heroic and nationalistic films. One of these images was the female dancer, newly rehabilitated as a folkloric dancer, the personification of the new Egyptian nation.

Farida Fahmy, principal dancer of the Reda Folkloric Troupe, epitomized the sweet Egyptian girl, the *bint al-balad*, 'daughter of the country.' She was extremely popular in Egypt throughout the 1960s and 1970s. Although the majority of ordinary Egyptians never saw her in a live performance, her dancing image was, and still is, familiar all over Egypt, largely due to two movies that were made by and about the Reda Troupe. Although only two films were made, Farida Fahmy became as

well known as any movie star. These films have been shown over and over on Egyptian television. '

Farida Fahmy presented an image that was the antithesis of the risqué belly dancer so popular in films. Because middle-class Egyptians habitually perceived and interpreted women on screen in certain ways, the ground was laid for a female in an alternative role, suggesting modern images and possibilities for postcolonial Egyptian society.

With the introduction and spread of modern media, it became possible for women performers to attain national, and even international, renown—Umm Kulthum as the star radio performer of the entire Arab world is an outstanding example. Farida Fahmy became her counterpart as a dancer, her image spread by the cinema and television.

Dance in the Development of Egyptian Cinema

The invention of modern media—photography, radio, and film—coincided in the late nineteenth and early twentieth centuries with the last wave of European colonial expansion. This coincidence was to have a profound and lasting influence on the evolution and content of Egyptian cinema.[2] Motion pictures were shown in Cairo and Alexandria very soon after their invention in 1896. The Westernized Egyptian elite and the expatriate community were natural audiences for this sophisticated new entertainment.

The first cinema theater opened in 1900, and by 1911 there were eight theaters in Cairo and three in Alexandria, all showing American and European films. The first real Egyptian feature film is generally agreed to be *Layla*,[3] released in 1927. Between 1927 and 1945 a total of 170 feature films were shot in Egypt, which has since remained far ahead of other Arab countries in film production.[4]

When sound came to moving pictures, it was inevitable that Oriental song and dance, so much a part of Egyptian social life, would appear in films; but the first musical movie[5] was a commercial failure. It was found that the repetitious style of *al-takht*, the Arab orchestra for formal performances, was too slow and ponderous for films. In 1933, Muhammad ᶜAbd al-Wahhab, the premier male Egyptian singer and composer of the twentieth century, sang in a successful film, *al-Ward al-bayda* (The White Rose) directed by Muhammad Karim. Umm Kulthum also sang in several early musical movies, beginning with *Widad* in 1933.[6]

For the period 1939–44, al-Charkawi tells us that "musicals took pride of place" in Egyptian cinema production.[7] Farid al-Atrash, another famous singer, "emphasized musical comedy scenes marked by Oriental color with an intermingling of Egyptian, Syrian, and Lebanese folk dances."[8] Belly dancers appeared on movie screens in 1936 with Badia Masabni, a Cairo cabaret owner and performer, in *Malikat al-masrah* (The

Queen of the Theater). Film makers continued to use the singing and dancing stars of the day to draw audiences to theaters, and from the 1930s on "film producers' predilection for singing, dancing, etc., almost amounted to an obsession. . . . [Between 1935 and 1965] Arab films with no musical prop are exceedingly rare."[9]

Out of this attempt to achieve maximum financial return by inserting Oriental songs and dances in an artificial way, with no relation to the action, there emerged a standard format or plot line. "For instance, the seduced girl, the repudiated wife or the poor woman looks for a way of earning an honest living and the author invariably makes her work as a singer or a dancer (depending on the star concerned)."[10] But the heroine singer/dancer, however goodhearted and generous she might be, was never respectable, and she usually lost her man at the end of the movie to the ideal girl, sheltered and virginal. In this respect, cinema accurately reflected offscreen attitudes toward dancers. The prejudice is deeply entrenched, its origins stemming partly from Islamic theological prescriptions.[11]

Although female public dancers seem to have been less than respectable before the 1830s,[12] it was during that decade that the status of all female performers went into steep decline. Even the ᶜa*walim*, the highly respected and well-paid female singers who performed in strict seclusion in upper-class harems, began their decline to their low twentieth century status as risqué dancers and organizers of wedding entertainments for the lower urban classes.[13]

Another transition that cemented the identification of dancers with prostitutes in the Egyptian urban consciousness began with the British occupation of 1882. As more Europeans poured into Cairo to make their fortunes under colonialism, and as more British troops maintained that regime, a nightclub district grew up in the Ezbekiya Garden district of Cairo.[14] Theaters and music halls were built—Western-style venues, with entertainment and alcohol. Some European performers appeared in these establishments, but they were filled chiefly by Egyptian entertainers—musicians, singers, and dancers. When the British took control of licensing brothels, many prostitutes shifted to nightclubs as hostesses and dancers. Hence any woman who worked in these places was assumed to be a prostitute.[15] As Egyptian movies began to rely on music and dance scenes, the nightclub and theater became familiar settings for the film narrative. Real life prejudices against dancers, singers, and even male musicians, were part of the narrative as well.

After Badia Masabni's first dancing film success, the format was set and many similar movies were produced. This is not to say that cinema dancers were carbon copies of each other. The best of them brought their own style and personality to their movie roles, and achieved stardom based on this creative individualism.

Tahia Carioca, who began her dancing career in Badia Masabni's *sala* (theater/music hall),[16] made the transition to the movies in the 1940s and became known for her subtle and elegant style of dancing. She helped establish the cinema dancer as the good-hearted cabaret performer, but later moved beyond this stereotype. She often played the *bint al-balad*, a lower-class woman of traditional Cairo who dances (at home!) for her man. In one such role, in *Shabab imra'a* (A Woman's Youth) she was a corrupting figure, a widowed landlady who seduces a naive young student by dancing. This role is said to have bridged the two phases of her career, from seductive dancer to serious actress.[17] She went on to play mature old women in her own old age. In addition Tahia Carioca gained respect for her political and religious activities, and eventually transcended the negative images of the cinema belly dancer.

Opposite Tahia Carioca in some of her 'woman of the people' roles was another dancer who made explicit the contrast between acceptable female social dance and dangerous, seductive, illicit dance. Nagwa Fu'ad brought strength and energy to her roles as the prostitute who dances to seduce the husband of another woman (Tahia Carioca). Her career has also extended over fifty years, but she has remained a cabaret dancer to the end, albeit one of the most exclusive sort. In recent years she has organized and produced large shows at five-star tourist hotels, backed by troupes of dancers and other entertainers.

Samia Gamal, who also started at Sala Masabni,[18] had perhaps the most refined screen image. She added more expressive hand movements, almost balletic in form, to the hip and torso movements of belly dance. Her hair style, make-up, and European high fashion clothing marked her as sophisticated, modern, and lady-like. But her private life seemed at odds with this almost proper image, as she was widely rumored to be involved romantically with King Faruq, Farid al-Atrash, and others.

Na°ima °Akef was a dancer's dancer. Born into a family of entertainers, she was more than a belly dancer. Her performance of tap dance, and Latin and European dance forms allowed her to deviate from the stereotyped Oriental dancer role. (She once played an orphaned student dancing at school with her girl friends.) Perhaps her most famous role was as the lower-class street dancer in *al-Tamarahina,* in which she pays a fearful price for trying to marry above her status as a public dancer. Although there were other cinema dancers of note, such as Hagar Hamdy, Hikmat Fahmy (no relation to Farida Fahmy), and Nabawiya Mustafa, the four described above encompassed a wide range of roles for dancers and dance styles in Egyptian movies.

The success of Egyptian film making relative to that of other Arabic-speaking countries was due in part to the country's more advanced economy and level of technological development. Another powerful influence, however, was the nationalist spirit in society, a force that

became evident in the 1919 revolution and continued to grow. As Armes points out, Bank Misr's support in 1925, through its director Talaat Harb, was an important impetus for Egyptian film. Talaat Harb aimed to create a company "capable of making Egyptian films with Egyptian subjects, Egyptian literature, and Egyptian aesthetics, worthwhile films that can be shown in our own country and in the neighboring Oriental countries."[19]

Nationalism continued to smolder under the British occupation and was to become yet more influential on Egyptian cinema in the coming decades, when even a female dancer could portray nationalistic themes.

A new era began after the Second World War. The output of Egyptian films increased dramatically: from 1939 to 1944 there were 106 new films; from 1945 to 1951 there were 364, more than three times the prewar output. Samir Farid calls this the period of "war profiteers," since "Film making at this time was the simplest, quickest, and surest way of making a fortune in Egypt."[20]

In many cases the actual quality of films did not improve, but this stagnation was a complicated result of market economics and a format dictated by Hollywood's proven successes. In the 1940s, Hollywood came to dominate foreign film releases in Egypt and other African countries. The educated elite continued to prefer American and European films, and Egyptian film makers often imitated the fads of Hollywood. For example, when Western musicals went through a Latin American phase, Egyptian musicals followed suit, combining chorus lines in Carmen Miranda costumes with a solo belly dancer in front. These extremes constituted the image of the female dancer on screen—a very Oriental image or a very Westernized one, the former indigenous but disreputable, the latter imported and sophisticated.

As illustrated by the contrasting characters played by Tahia Carioca and Nagwa Fu'ad, the same movements can be seen as acceptable or reprehensible depending entirely on the context. Furthermore, an individual woman dancer sends a very different message than a group of women dancers. The former is seductive, solo, and dangerous, while the latter is quotidian, ensemble, and harmless. Malkmus and Armes describe the dancing in *Shabab imra'a* as "implicit seduction for the film viewer . . . [which] acts also as explicit seduction within the story itself. Not only does the landlady, shot in angles from above and below, entice the young student by dancing for him, but this dance filmed as a circular movement around him, suggests the spinning of a web."[21] The message here is that dancing is an invitation to sex, by women who are themselves the evil influence, the entrappers of men.

By contrast, in other movies dance is seen as an ordinary social activity, social intercourse rather than a prelude to sexual intercourse. This is especially common in wedding scenes. In *al-Futuwa* (The

Bully),[22] the characters are of the *awlad al-balad* class, residents of the old traditional quarters of Cairo, the epitome of authentic Egyptians, as discussed by Sawsan al-Messiri.[23] "This type of dancing, called belly dancing in the West, can also occur in public celebration . . . in the context of a wedding. . . . Waiting for the bridegroom, the women dance in one room, the men sing in another."[24] The dance movements are exactly what the evil landlady did in *Shabab imra'a*, but here it is done as "a public celebration."

Context, then, makes all the difference, a difference again illustrated by the format and success of the ensemble folkloric dance of the Reda Troupe films. Surprisingly enough, the dance movements can be exactly the same, but the intent of a single female dancer and a group of women dancing is interpreted in diametrically opposing terms. The solo dancer is destructive of society, while the group dancers are recreating and celebrating social life.

Cinema Themes beyond the Fallen Dancer

As well as using dancers in the musical interludes, other cinematic traditions were established in Egyptian films. A standard role for actresses to play was the sufferer. For instance, "Faten Hamama has for so long played the long-suffering woman that when people call her 'the lady of the screen' *(sayyidat al-shasha)* it is not clear if this refers to her acting ability or to her embodiment of an ideal."[25]

This suffering woman has at least two levels of meaning. Arab societies traditionally regard women as destined for very different roles in life than men. Part of this difference of fate is based in Islamic theology, but much more comes from local tradition. The traditional beliefs about women—that they lack of self-control, are ineffectual, dependent on men, and wanton and dangerous temptresses—are regularly illustrated by female characters in films of all periods.

> If a woman staggers around [in a film] in public emotional displays . . she is assumed to be in a state of terminal disarray, rather than temporarily unhinged. . . . The blame for this disarray will be attributed not to some neutral outside force . . . but rather sanctimoniously on her own doorstep, on her inability to stay at home, or to find her proper place in society. . . . Usually, however, she is not in her proper place because of the absence of a male.[26]

Old ideals that developed in the harem system still inform standards of conduct for women: "It is still a woman's place that counts. Even inside [a building], if it is not a family home, is a dubious place for her to be. Any woman living on her own must be kept by a man."[27]

Women depend on men so completely that for them sin is not even a choice, but inevitable. Malkmus and Armes explain the woman's adultery

in ᶜ*Arais min qasab* (Reed Dolls) as a consequence of her lack of a man. In the absence of men, women are understood to be insecure, and their unfaithfulness "is very rarely a question of their own desire."[28] But women will nevertheless pay for these sins they cannot escape. Again tradition and legal status are the forces that keep women in their place. Malkmus and Armes also point out that "The titles of many of the films concerned with women . . . imply the illegal (using such words as morals, licit, proof, law, arrest) and many of those concerned with men imply the asocial (bully, smoke, hashish, beasts, bums)."[29]

In Arab films about women there is often a court scene: "Some may say that this is simply a reflection of reality, that a woman's inferior status in society and law in many Arab countries means that sooner or later a heroine will appear before a judge."[30] The consequences of a heroine's actions can be even more severe. "In many films . . . girls forced to find their own place in society lose both their integrity and their life. Lies and cheating must always be paid for."[31] Other women are shown as "driven mad by injustice."[32]

These films show women as the bearers of tradition, as the family members whose behavior is held to a different standard in order to maintain the family's stability and propriety. It is a logical sequence of symbols from the individual sufferer in the family unit to the sacrificial group within society, and then to symbolizing an oppressed nation in the world community.

When realistic films dealing with real social situations were introduced in the late 1930s, with *al-ᶜAzima*, written and directed by Kamal Salim (1939), there occurred an interesting conjunction of cinematic conventions and political aspirations. It became common for the suffering woman to be equated with the oppressed nation. This image has persisted long past the end of colonial oppression. "In films like [the] Egyptian film *al-ᶜIsaba* (The Gang)[33] . . . rescue means rescue of the fair damsel and the fair damsel means, of course, Egypt. This is crystal clear, because it is apparent as well that 'the gang' is Israel and the U.S.A."[34]

There is one notable exception to the suffering, passive, female victim role, "a lively female character, a rather florid woman of the people *(bint al-balad)* who does not take things lying down. She usually has a 'heart of gold,' and always a loud mouth. [Nevertheless] she is always subsidiary, even when . . . she is the hero's wife."[35]

This brief consideration of female roles and images in Egyptian film demonstrates that bad women (dancers) suffer and good women (wives and mothers) suffer too. Bad women symbolize the temptations and pitfalls of life, good women symbolize home, family, and nation.

Could any film dancer challenge, recombine, or transcend these cinematic stereotypes, reinforced as they were by social traditions and political conditions? Farida Fahmy as a folkloric dancer was able to do so

for a brief period, but only because she was the right woman—a member of the Westernized urban elite—in the right place—post-independence Cairo—at the right time—during Gamal ᶜAbd al-Nasir's expansion of television broadcasting.

Mass Media and Social Context

In order to understand the alternative presentation of dance and dancers seen in the two Reda movies of the early 1960s, we have reviewed the cinematic traditions and social attitudes that prevailed in Egypt at the time. One more background element falls into place with the revolution of 1952, which raised nationalism and patriotism to new heights.

The 1952 revolution finally freed Egypt not just from Britain, but from two thousand years of colonial status, imposed by conquests and alien governments. Gamal ᶜAbd al-Nasir, who emerged the leader of the Free Officers, had extraordinary foresight in his aggressive expansion and use of broadcast and film media. In the words of Douglas Boyd:

> Nasser devoted Egyptian administrative energy and . . . extensive economic resources to the establishment of what is still the Arab world's largest and most influential broadcast service. . . . [He] came from a modest rural environment and understood and was able to capitalize on his knowledge of the oral Arab culture and the power and emotionalism of the Arab language. . . . Nasser had a wider vision of his leadership than most people initially thought.[36]

ᶜAbd al-Nasir's message began as pan-Arabism and aspired to grow into pan-Africanism and ultimately to a pan-Islamic level. Egypt constructed high-powered medium-wave and short-wave radio transmitters, which reached the common people and conveyed ᶜAbd al-Nasir's pan-Arab views to the Arab world. With the establishment of television, the regime utilized the existing movie industry and tradition of live theater to staff and conceptualize programming.[37]

The government eventually began to formulate policy and established several controlling boards and institutions to promote socialist ideas in and through the film industry. In July 1957 the Ministry of National Culture and Guidance established the National Organization for the Consolidation of the Cinema with an annual budget of 150,000 Egyptian pounds.[38] This organization gave annual prizes for achievement, embarked on cooperative ventures with both foreign and private Egyptian producers, and regulated hours and wages in the industry. The censor could "ban a film on the grounds of poor artistic, dramatic, or technical qualities."[39] After nine years of these reforms, according to al-Charkawi, Egyptian critics felt that "the result of the State's interest in the cinema was remarkable. . . . Arab films left the drawing room, the bedroom, and the

nightclub behind and moved into the streets of Cairo, the docks of Alexandria and Port Said, the Suez and Sinai deserts."[40]

A fairer social balance was emerging, al-Charkawi continues. "The fellah is no longer a serf; he is now a small land-owner. The worker is employed in a factory. There is no longer vast wealth and atrocious poverty. . . . The political situation of the United Arab Republic is well known and Cairo has become a symbol for those countries which are struggling to achieve independence."[41]

With hindsight, the explicit goals of ᶜAbd al-Nasir's government seem both ambitious and idealistic, including as they did the reform of all public services in rural areas. But as Munir Abdel Wahab wrote at the time, the state also realized the need for "guidance and information activity in order to enlighten the country people, to enable them to understand better the era in which they live, and to direct them towards productive labour so as to create a new society." Cinema was an important means of achieving this, "so last year we built four cinemas in four villages. . . . During the five coming years, . . . 1965/66 to 1969/70, our plan provides for the annual construction of 100 cinemas in the villages."[42]

Nearly thirty years later, Malkmus noted that although the level of film production fell in the 1970s, the quality of earlier films was good, and "later Egyptian film makers were to look back on the 1960s as a 'golden age of nationalized, protected cinema' and as 'one dedicated to Egypt and the Arabs in the name of the land and to solidarity and integrity in the name of the family.'" [43] The two movies featuring the Reda Troupe, discussed below, were if anything even more optimistic and patriotic than most films of the period.

Movies had a double life in Egypt after the introduction of television in 1959. Egyptian television broadcast many Egyptian feature-length films in the traditional genres of romance, comedy, and musical. However, these films also related the new socialist values, "education, dedication, and hard work . . . to better the Arab world."[44]

The Reda Troupe participated in this building of socialist, nationalist idealism through mass media with their two movies, and in interviews and demonstrations on television, which were often repeated. I now turn to a brief history and description of Egyptian folkloric dance and the Reda Troupe's development of it.

Indigenous Arts and the Reda Troupe

It is important to describe the circumstances of Farida Fahmy's Anglo-Egyptian childhood and early performing experience in order to establish the social context of the Reda Troupe. Farida, or Melda to use her given name, was born to an Egyptian father and an English mother. As a teenager, she went to the English School that had been established for the children of the small, elite community of Anglo-Egyptians and others.

Melda had first, however, attended a neighborhood Egyptian primary school at the insistence of her father, Hasan Fahmy. Indeed her father, until his death in 1982, was the most powerful influence on her life. He was an outspoken and famous Egyptophile, using his position and influence as a professor in the faculty of engineering at Cairo University to promote and praise indigenous Egyptian culture, talent, and most of all the Egyptian people themselves.

Another powerful socializing influence in Melda's childhood and adolescence was the Heliolido Club. This was a middle-class sports club in the suburb of Heliopolis. Melda and other children often participated at the club in amateur productions that included dance. Melda was known for her wonderful *baladi* (Egyptian folk) dancing, and was always encouraged by her father to represent Egyptian culture on stage.

Another member of Heliolido Club was Mahmoud Reda, a member of the gymnastics team. Through amateur productions at the club, Mahmoud Reda and Melda Fahmy began performing together. In 1957, when Egypt was courting the Soviet Union for diplomatic reasons, Mahmoud and Melda traveled to a folk-dance festival there and danced as part of the Egyptian team. Again, Hasan Fahmy encouraged his daughter to represent the Egyptian culture and people to a world audience through dance.

The idea of forming a professional Egyptian folkloric dance troupe was born in Mahmoud's mind, and two years later, August 16, 1959, the first performance was given in Cairo, starring Mahmoud Reda and Melda, dancing for the first time as Farida Fahmy. That first night, as troupe members tell the story, the audience consisted only of men. The theater-going public had no idea what to expect of a performance of Egyptian dance in a theater setting. Dance performances in Cairo had previously been one of four types: cabaret dances by a risqué belly dancer, folk or *baladi* dances done by street dancers at weddings, etc., forms such as ballet or flamenco by European touring companies, and the cinema dancing described above. The first night, then, it must largely have been the name and prestige of Melda's father, Hasan Fahmy, that attracted the audience. On succeeding nights, however, the men came again and this time brought their wives and children. The Reda performance was respectable, neither cabaret nor street dancing, and of a caliber to qualify as artistic family entertainment.

In 1959, a dance troupe modeled on the Eastern European troupes so popular within the Soviet bloc, but performing Egyptian folk dance, seemed appropriate to the patriotism and nationalism of the era. Thus, in 1961, the Reda Troupe came under government sponsorship. This gave them the opportunity to perform at home for diplomatic functions as well as on tours of provincial towns; they also were sent on international tours.[45]

Mahmoud Reda did not depend on adaptations of traditional Egyptian dances to create his choreographies; neither did he simply add Egyptian costumes and details to Western dance forms. He was able to bridge the gap between indigenous movement—dance movements and the culturally specific details of posture and carriage—and choreographed performances for a Western stage. He incorporated existing dance movements whenever possible, and filled in with movements of his own invention that harmonized and synthesized the whole into dance that was recognizably Egyptian. In one case these staged movements were so accurate that peasants from the countryside identified the town, Sohag, where that exact style of men's stick dance was performed. At other times, the social situation portrayed was so quintessentially Egyptian that the movements, although invented, seemed just right. An example is the dance of the licorice drink seller, a street vendor whose movements are limited by the huge container and the other paraphernalia he carries. Sometimes the costumes themselves marked the performance as Egyptian, as in the sugar doll dance. Female dancers wore stiff pastel skirts and large circular pleated fans framing their upper body that imitated a sugar confection sold during local folk festivals. Here again the movement was not taken directly from any existing folk dance, but the invented movements appropriately presented an image familiar from everyone's childhood. Mahmoud Reda in fact created a novel performance genre in Egypt; he invented theatrical dance that drew on the participatory folk dances of the streets and homes of the Egyptian people, and gave it a new polish and respectability that drew also on Western, audience-oriented dance forms.[46]

These sorts of details, including actual dance 'steps,' familiar social scenes, and images from Egyptian life, resonated with audiences of all social backgrounds. Peasants identified with the dancers performing 'their' stick dances, urban audiences recognized characters from their childhoods, and all audiences regardless of education, income, social class, or regional origin, could see aspects of their lives, their culture, and the concept of Egyptian life itself celebrated, even honored on the stage.

Farida Fahmy's image was one of a daughter or a sister, happy and wholesome, extroverted but modest, talented but not exhibitionist, a sweet Egyptian girl, a true daughter of the country. This was the antithesis of the image of the belly dancers that appeared in cabarets and films. The belly dancer was, to the chagrin of many Westernized Egyptians, the sole dance image that characterized Egyptian culture at home and abroad. Farida, by contrast, was seen as morally irreproachable. She was always modestly dressed, legs, arms, and hair covered in appropriate regional costume. Above all, her stage dancing was not the 'up close and personal encounter of the erotic kind' that is the stock in trade of the cabaret or street dancer. She was clearly dancing as part of a group celebrating traditional Egyptian life, and not as an independent

woman dancing alone for dubious purposes. She always danced as part of a group, just as an 'honorable' woman is always surrounded by her family. Farida, from the bosom of her family, was above all a respectable dancer, a seeming oxymoron in Egyptian thought.

The Reda Troupe made two movies early in their development, in 1961 and 1964, directed by ᶜAli Reda, Mahmoud's older brother and Melda's husband. More than actual live performances, these films popularized the troupe and especially Farida in every village and region of Egypt. *Igazat nuss al-sana* (Mid-Year Holiday) and *Gharam fi-l-Karnak* (Love in Karnak) showed Egyptians a new image of themselves, their dance and folklore, and of female dancers.

In the first film, a group of youthful, attractive college students visit a provincial farm, dancing and laughing their way through a boy-meets-girl plot. This was not a movie about urban people involved in sophisticated, even decadent, encounters with Western influences or risqué dancers. Here were sophisticated urban people celebrating their roots and homeland.

The second Reda Troupe movie, *Love in Karnak,* portrays the backstage life of rehearsals, high jinks, and romance as the troupe prepares for a performance in the provinces at Luxor in Upper Egypt. The story line this time concentrates squarely on the troupe, with no narrative about wicked landlords and rural engagements. The first scene takes place in the central Cairo train station, where the troupe are embarking on a journey. While performing a very Westernized choreography, the troupe sing about their life together. The dancers are dressed quite true to life, as Westernized middle-class Cairenes. Mahmoud Reda plays himself, the leader of the troupe; he sings his instructions, rules of conduct, troupe philosophy, and even personal grooming standards to his 'boys and girls.' Melda is introduced as the 'star,' but immediately replies, "The troupe is the star. We all make one." This statement is then tested by the events of the plot as it unfolds.

Mahmoud Reda also took this opportunity to complain a little about the difficulty of running an independent dance troupe in Egypt in the 1960s. He is seen sitting alone worrying about money, specifically about how to pay the dancers and crew. However, the main theme soon reasserts itself when it appears that Melda as Amina, the star, is going to desert the troupe on the very night of the performance because of a broken heart. Finally, she changes her mind, appearing costumed and ready at the proper time, and the movie ends with several dances from the Reda repertoire, featuring Melda's and Mahmoud's characters with their romance restored.[47] The cause, the mission of the troupe, is demonstrated to be more important than individual problems; by implication, individual Egyptians should likewise put the cause of the new nation foremost.

We are prepared for this moral by a key scene earlier in the movie. The scene takes place in Karnak Temple, not as the temple appears now, but restored to its former glory. In a dream, Mahmoud Reda and his troupe are transported back to the days of Egypt's ancient glory, and there in the sumptuous corridors of the pharoah's palace they perform their contemporary folkloric dance. We see these youthful, talented, energetic, modern Egyptians demonstrating their creativity, artistry, and competence to a charmed (if comic) pharoah. The glory of the ancient meets the hope of the future. Old Egypt, the pharoah, gazes in enchantment at New Egypt, Farida Fahmy. The dancers wear two types of costumes. Three are in sophisticated Western dresses—sleeveless, fitted, scooped neck, hemline at the knee, a swath of fringe on the right side from hip to knee. And Farida—how is she dressed to meet the pharoah? In a sequined peasant-style dress, with traditional veils on her head hanging down her back—the *bint al-balad*, daughter of the country, genuine Egyptian girl. Ancient glory is introduced to modern, authentic identity and new hope.

These two movies were the only feature films that included the entire Reda Troupe and told its story along with a conventional device of romance. Melda did however make two other films independently of the troupe, both directed by her husband ᶜAli Reda. In these films she played—what else?—a good girl who has to dance to support herself through college, and to support her family as well. These movies, which conformed to old clichés, were only moderately successful, and have not achieved the lasting appeal of the two troupe movies.

In supporting and showcasing the Reda Troupe, ᶜAbd al-Nasir illustrated his awareness of the role the arts can play in nationalism. By presenting the Reda Troupe on state occasions the government further emphasized the integrity, validity, and artistic worth of indigenous Egyptian culture, free in Egyptian eyes from Western themes and ideals. The new rulers wanted to show the world, but more importantly the upper classes of Cairo, that they could be patrons and connoisseurs of the arts just as the elite and royal families of the former regime had been.

Part of the fascination of the Reda Troupe for people of all class origins was precisely the assumption of the *baladi* identity by people who were members of the urban elite. Westernized and highly educated, many of these families had been part of the Turkic ruling class under Muhammad ᶜAli in the nineteenth century. The 1919 revolution, staged and directed by Westernized urban elites, brought no change in their Western life styles and tastes, their use of the French language, their trips to Europe, and so forth. After the 1952 revolution, a people's revolution led by a man of lower middle-class background, the new government promoted a socialist solution to Egypt's problems. The urban elite were not unaware of their anomalous position. A few hundred wealthy families suffered sequestration of their property in the name of socialism. The Reda

dancers set a new style and definition for themselves and the former effendi class. Youth, health, education, and a wholehearted embrace of *baladi* traditions and images became their hallmark. Significantly, the Reda movies were not produced or directed under government auspices; both were private ventures, illustrating the founders' own heartfelt commitment to building a new Egypt.

Melda herself was aware that her social status was central to her fame and acceptance by the Egyptian public. She recalls that on the frequent occasions when she was recognized in public, people congratulated her on her role in the Reda Troupe.

> They didn't comment on my dancing as much as they were pleased to see me and commented on me as a human being and how great and wonderful what I was doing was. It was never what I did as far as movement, 'I liked you when you did that turn or pirouette or something,' no, no, no. It was all 'What a fine artist, what an intellectual': there was more stress on the social aspect than the artistic.[48]

Farida Fahmy, daughter of a university professor, graduate of the elite English School and Cairo University, whose mother was English and paternal grandfather an estate manager for King Faruq, married to a film director—Farida Fahmy danced in the dress of a Delta peasant girl, covered her head with traditional veils, wore her hair in long plaits that whirled as she danced like any village girl. This was a spectacle indeed, and Egyptians of all ranks were drawn by curiosity, wonder, admiration, and above all a sense of affinity, to see Farida and the Reda dancers.

Conclusions

Old movies never die in the Middle East, thanks to television. With export to other Arab-speaking countries, these films spread their messages and new ideas about dance and society beyond Egypt. Mahmoud Reda often explained his concepts and methods in television interviews. Old performances were taped and are rebroadcast today. The film medium was fundamental to the level of popularity and esteem that the troupe, and especially Melda, achieved throughout the Arabic-speaking world. The Reda Troupe achieved a wider international reputation as well:

> Since its inception the troupe has visited more than forty countries, paying return visits to many of them as well. It has participated and won prizes in folk festivals in the U.S.S.R., Yugoslavia, Bulgaria, Indonesia, Tunisia, Turkey, Italy, Belgium, and England. Besides giving command performances, the four principal artists, Mahmoud Reda, Ali Reda, the late Ali Ismael (the composer and orchestra leader), and Farida Fahmy were decorated by King Hussein of Jordan in 1965.

They were also honored by the late Gamal Abdel Nasser in 1967 for services rendered to the state through art, and in 1973 by President Bourguiba of Tunisia.[49]

The Reda Troupe symbolized the new Egypt both at home and abroad. They inspired the formation of folkloric troupes in Lebanon, Jordan, Saudi Arabia, and other Arabic-speaking countries. Their two movies and Mahmoud's television interviews kept their image before the public more than live performances.

The troupe itself has now fallen on hard times due to the shrinking value of government salaries, bureaucratic mismanagement, and most especially the deaths and retirement of the founders. However, the folkloric dancer has become a generic figure in Egyptian popular culture. Folkloric troupes of all levels of ability and training are commercialized, appearing on television selling tea and cheese. They are for hire in *zaffat al-ᶜarusa* (wedding processions) and, in the most sincere acknowledgment of their commercial value, belly dance stars include folkloric pieces in their nightclub acts. What began as an elevation of the folk dance of Egypt by a Westernized elite in the nationalism of the postrevolutionary period has ended in the spread and adoption of this dance into various popular entertainments. The aesthetic achievement born of patriotism now turns a profit for the lowest common denominator of Egyptian performers (as it never did for the Reda founders). Folkloric dance, once the symbol of newly independent Egyptian society returning to its roots, is now well and truly 'folklorized,' readopted by ordinary people making a living from its familiar, friendly, home-grown image.

Farida Fahmy's challenge to the cinematic traditions of the female dancer—the belly dancer—was unique. No other female dancer has approached the fame and esteem that she earned as the figurehead of the Reda Troupe.[50] Cinema dance sequences have returned to the ubiquitous and often suspect belly dance image. Farida Fahmy's alternative image— the educated young urban sophisticate presenting herself as the humble, dancing *bint al-balad*, daughter of the country, was never to be repeated. Her talent was unique, as were the political and social circumstances in which the Reda Troupe was born. Egyptian audiences, in theaters, cinemas, and in front of televisions in their homes, saw her as the personification of the New Egypt, a perfect symbol of their renewed pride and glorious hopes for authentic Egyptian culture. If Farida Fahmy could rehabilitate and make respectable the image of the female dancer, then Egypt too could rise anew and go forward into a new age.

Notes

1 Edward William Lane. *An Account of the Manners and Customs of the Modern Egyptians* (New York: Dover Publications, 1973), facsimile of the

1860 edition; Karin Van Nieuwkerk, *"A Trade like Any Other": Female Singers and Dancers in Egypt* (Austin: University of Texas Press, 1995, and Cairo: The American University in Cairo Press, 1996).

2 Lizbeth Malkmus and Roy Armes, *Arab and African Film Making* (London and New Jersey: Zed Books, 1991), 3.

3 Directed by Istephane Rosti, starring Aziza Amir.

4 Malkmus and Armes, *Arab and African Film Making*, 197–198.

5 *Anshudat al-fu'ad* (The Song of the Heart, 1932), directed by Mario Volpi.

6 Directed by Fritz Kramp.

7 Galal al-Charkawi, "History of the U.A.R. Cinema, 1896–1962," in Georges Sadoul, ed., *The Cinema in the Arab Countries* (Beirut: InterArab Centre of Cinema and Television, 1966), 86.

8 Ibid., 87.

9 Salah Ezzedine, "The Role of Music in Arabic Flims," in Sadoul , ed., *The Cinema in the Arab Countries*, 48.

10 al-Charkawi, "History of the U.A.R. Cinema," in Sadoul, ed., *The Cinema in the Arab Countries*, 91.

11 Fatima Mernissi, *Beyond the Veil: Male–Female Dynamics in Modern Muslim Society* (Bloomington: Indiana University, 1987).

12 Edward Lane, *An Account of the Manners and Customs of Modern Egyptians*, 1836.

13 Carolee Kent and Marjorie Franken, "A Procession Through Time: The Zaffat al-ᶜArusa in Three Views," in this volume.

14 Virginia Danielson, "Shaping Tradition in Arabic Song: The Career and Repertory of Umm Kulthum," Ph.D. Dissertation, University of Illinois, 1991.

15 Van Nieuwkerk, *"A Trade like Any Other."*

16 Edward Said, "Homage to a Belly Dancer," *Arabesque* 8 (May/June, 1994), 8–10.

17 Ibid.

18 Van Nieuwkerk, *"A Trade like Any Other,"* 46.

19 Roy Armes, *Third World Film Making and the West* (Los Angeles: University of California Press, 1987), 198.

20 Cited in Malkmus and Armes, *Arab and African Film Making*, 31.

21 Ibid., 129.

22 Directed by Salah Abu Seif, 1954.

23 Sawsan al-Messiri, *Ibn al-balad: A Concept of Egyptian Identity* (Leiden: E. J. Brill, 1978).

24 Malkmus and Armes, *Arab and African Film Making*, 129.

25 Ibid., 101.

26 Ibid., 103. Also see Sherifa Zuhur, "Victims or Actors? Centering Women in Egyptian Commercial Film," in this volume.

27 Malkmus and Armes, *Arab and African Film Making*, 98.

28 Ibid., 99.

29 Ibid., 106.

30 Ibid., 100–106.

31 Ibid., 97.

32 Ibid., 72.

33 Directed by Hisham Abu al-Nasif, 1986.

34 Malkmus and Armes, *Arab and African Film Making*, 73.

35 Ibid., 71.

36 Douglas Boyd, *Broadcasting in the Arab World* (Philadelphia: Temple University Press, 1982), 13

37 Ibid., 18.

38 Hasan Fahmy, Farida's father, served as director of the Higher Institute of Cinematography in the 1960s.

39 al-Charkawi, "History of the U.A.R. Cinema" 94.

40 Ibid., 97.

41 Ibid.

42 Munir Abdel Wahab, "The Industry in the U.A.R., 1964–65," in Sadoul, *The Cinema in the Arab Countries*, 168–169.

43 Malkmus, in Armes, *Third World Film Making*, 51.

44 Boyd, *Broadcasting in the Arab World*, 35.

45 For a partial list see Farida (Melda) Fahmy, "The Creative Development of Mahmoud Reda: A Contemporary Egyptian Choreographer," Master's Thesis, Department of Dance Ethnology, University of California, Los Angeles, 1987, Appendix.

46 Fahmy ,"The Creative Development of Mahmoud Reda."

47 In real life Melda married ᶜAli Reda, Mahmoud's older brother. Mahmoud himself had married Melda's older sister, Nadeeda, five years earlier.

48 Personal interview with Farida Fahmy, Cairo, January 1994.

49 Personal interview with Farida Fahmy, Cairo, January 1994.

50 Fahmy, "The Creative Development of Mahmoud Reda."

51 Qumaya, another government-sponsored troupe, closely followed Russian choreographies. They featured a series of female performers, none of whom achieved the individual fame and recognition of Farida Fahmy.

18

TERRORISM AND KABAB
A CAPRAESQUE VIEW OF MODERN EGYPT

Walter Armbrust

Sharif Arafa's film *Terrorism and Kabab* opened in 1992 and immediately caught everyone's attention. Egyptian critics praised it, while the public flocked to see it. The film portrayed an Egyptian government building known as the *mugamma*ᶜ—twelve forbidding stories on Cairo's main square, full of grimy corridors leading to offices staffed by underpaid and justifiably sullen bureaucrats. *Mugamma*ᶜ translates appropriately enough as the 'combine,' and it makes Weber's iron cage of bureaucracy look like a walk in the sun: it is all cage, unbelievable bureaucracy, but no apparent rationality. ᶜAdil Imam, the lead actor in the production, was said to have received death threats for his part in the film's forthright denunciation of excessive prayer in the workplace.[1] It was bold, it was sassy, and it was not long before Westerners also sat up and took notice. The Middle East Studies Association showed the film at its 1994 annual meeting, and an American-based distribution company made it available to campuses all over the United States. One could almost hear the cries of relief: "Finally, an interesting Egyptian film, one that breaks the mold of all that unwatchable commercial garbage."

Terrorism and Kabab is becoming familiar to Americans. It tells the story of a man who goes to the *mugamma*ᶜ to arrange for his children to be moved to a school closer to where he lives. This simple errand proves to be a mission impossible. One woman in the office never stops talking to her friends on the phone. Another office worker is apparently a fundamentalist, who wears a beard (a fashion statement that can get one arrested in Egypt these days) and never works because he is always praying. The man is told that the bureaucrat he needs to see is never there because he is too refined to use the *mugamma*ᶜ toilet, and is therefore

always out using the toilet in one of the fancy establishments nearby. Our hero searches the bathrooms of five-star hotels, the Arab League, and the Egyptian parliament, but to no avail. Finally he is mad as hell and not about to take any more of it. He returns to the original office in the *mugammac*, yells at the woman who never stops talking on the phone, disturbs the fundamentalist in his prayer, and ends up in a fight with him. Security is called. The frustrated man struggles with a soldier, who holds his gun high above his head. The gun goes off. Nobody gets hurt, but everybody in the building flees, including the soldiers, and the humble man who went to the *mugammac* to move his kids to another school is left holding a gun and in possession of a handful of cowering 'hostages.' Eventually a few other disaffected citizens join him, and together they hold off the might of the government until morning. In the course of the night each of the 'terrorist's' allies tells his or her tale of woe. When the government issues its ultimatum, the 'terrorist,' who of course is just an average citizen, lets everyone go. By this time the hostages feel sympathetic, and they insist that their erstwhile captor leave with them. When the government troops finally storm the building there are no 'terrorists' to be found.

The film criticizes both the state and its Islamist opponents, and though all the usual caveats about an audience's multiple perspective pertain, on the whole American viewers would probably suspect that the film maker had put himself in an untenable position between angry militants on one hand and an offended regime on the other. Presumed political boldness expressed by directors such as Arafa works in favor of Egyptian films trying to break into foreign markets. There is no doubt that *Terrorism and Kabab* was selected for exhibition in the United States under the assumption that it transcends the usual generic conventions of Egyptian cinema—that it says something that could not be said before. Otherwise the film would have remained in Egypt with all the other commercial films deemed too melodramatic, too vulgar, or too simplistic to be of interest.

I propose that *Terrorism and Kabab* does not in fact convey a bold new social and political criticism, but rather a bold neoconservatism that attempts to recoup notions of modernity and national community that had fallen out of favor in recent Egyptian films. Contrary to the usual implicit assumptions made in the West about the irrelevance of all Egyptian films except for the few selected for exhibition there, viewing *Terrorism and Kabab* in the context of the generic conventions that immediately precede it gives a valuable perspective on the film's politics. One film in particular reveals much about the background that *Terrorism and Kabab* tries to play itself off against. The title of that film is *Ramadan on the Volcano*. *Ramadan* lends itself to a comparison with *Terrorism and Kabab* because in some ways it is its predecessor, and in

certain other ways its opposite. *Ramadan* is less well known outside Egypt than *Terrorism and Kabab*, but both films star the same actor—ᶜAdil Imam—and both were set largely in the same location—the enormous and alienating *mugamma*ᶜ—the 'combine.' *Ramadan* was made in 1985, seven years before *Terrorism and Kabab*, and gives in many ways a darker portrayal of the *mugamma*ᶜ and its denizens—and by extension contemporary Egyptian society—than the later film. Viewing *Terrorism and Kabab* intertextually, in a broader context of works produced in its historical period, gives us a valuable perspective on the film's significance.

Ibn al-Balad Goes to the *Mugamma*ᶜ

A good analogy for understanding the place of *Terrorism and Kabab* in the contemporary Egyptian discourse on modernity, secularism, and the increasing importance of politicized religion is the work of Frank Capra, in particular the screwball comedies he made between 1933 and 1941; films like *It Happened One Night*, *Mr. Smith Goes to Washington*, and *Meet John Doe*. Of course there are limits to a comparison of Depression-era American cinema and contemporary Egyptian cinema, but as a heuristic device Capra's screwballs and the milieu from which they emerged are quite useful. One interpretation of the screwballs' success sees them as an escapist response to Depression-era alienation, thereby tarring them with the same brush used to blacken the reputation of such films as *Bringing Up Baby* and *Nothing Sacred*. Such accusations are very familiar in discussions of Egyptian cinema, although usually not in discussions of Sharif Arafa's films, particularly not *Terrorism and Kabab*. Another tendency in analyzing American screwballs, however, is to emphasize the backdrop of Capra's comedies—fear of unemployment and the terrible poverty of the Depression—and see the films as documents of social awareness.[2] This is closer to the way that *Terrorism and Kabab* has been received, but neither the 'social awareness' view nor the 'escapist' argument is entirely satisfactory, either for American screwballs or for *Terrorism and Kabab*.

American film scholar Andrew Bergman had a more subtle view of what screwball comedies were about:

The overwhelming attractiveness of the screwball comedies . . . had to do with the effort they made at reconciling the irreconcilable. They created an America of perfect unity: all classes as one, the rural-urban divide breached, love and decency and neighborliness ascendant.[3]

In other words, the films did not so much express a social point of view as attempt to engineer one. This makes sense in terms of Jimmy Stewart's lonely filibuster in *Mr. Smith Goes to Washington* or Gary

Cooper's repudiation of demagoguery in *Meet John Doe*. Good people—
and the films are constructed so that all people of all social backgrounds
can plausibly construe themselves as such—eventually recognize and
support the inherently righteous causes of the films' protagonists. The
similarity to *Terrorism and Kabab* is obvious. In the Egyptian film
everybody ends up friends or at least understands each other better than at
the beginning of the film. In the final scene an Islamist walks elbow-to-
elbow with a putative secularist; government officials are shown to be at
least sincere, if somewhat overmatched by the problems they face.
Everybody else gets a chance to air his or her grievances, and all the
characters end up back in their proper places ready to make another go of
it. Society looks workable if everybody just tries a little harder to get
along with everybody else.

But there is more to a comparison of *Terrorism and Kabab* and a
screwball like *Mr. Smith Goes to Washington* than a common concern
with depicting social unity. With regard to the American films, Bergman
also emphasizes that Capra's Depression screwballs came on the heels of,
and to some extent overlap, a very different kind of Depression comedy—
the hard-edged cynicism of W. C. Fields and the Marx Brothers. The
relatively gentle screwball tradition developed out of a slapstick mayhem
that celebrated vulgarity and the acquisition of money by any means, but
mostly through chicanery. As it happens, *Terrorism and Kabab* developed
out of very much the same background. In both cases there is much to be
gained by approaching the later films intertextually; they were not made
in a vacuum, but as part of a discursive field conditioned by authorial
intent. The films are also affected by the socioeconomic conditions in
which they were made and, even more importantly, by the active
influence of audiences. Frank Capra, of course, was not deliberately
trying to create intertextual works in his screwball comedies; he was not
seeking, as Robert Stam puts it, to "focus on the filmic intertext"
between his work and that of other film makers.[4] The usual categories of
intertextuality, such as allusion, parody, pastiche, and imitation,[5] were
not overtly a part of Capra's goal. But they did not have to be because
the Depression-era audiences who 'read' Capra's texts could produce their
own intertextuality—parody, pastiche, imitation, and allusion can come
from angles other than that of the writer. At a minimum, audiences
viewing the warm and cuddly *It Happened One Night* in 1934 might very
well have been fresh from the Marx Brothers' *Duck Soup*. The contrast in
a single genre (comedy) between the caustic deconstruction, or really just
plain destruction, of government in the Marx Brothers and the hopeful
message of unity and reconstruction in Capra was almost inevitable.
Neither film by itself gives a satisfactory account of the relationship
between film production and audience consumption during the
Depression; but the two films considered together in the context of their

audiences show the beginnings of an outline of a Depression-era comic discourse defined by the centrifugal tendencies of the Marx Brothers' cynical slapstick, and the centripetal tendencies of Capra's hymns to social unity.

We can also look at a film like *Terrorism and Kabab* intertextually. How readers negotiate the meanings of film texts tends to disappear in American-centered analyses of Egyptian film texts. Naturally, American viewers cannot do a fine-grained analysis from afar of how Egyptian audiences negotiate these meanings. One elementary condition of such an analysis would be to gain some appreciation of what else, beside the films screened in the United States, is being consumed by large segments of the audience in Egypt. I should emphasize that I raise this point precisely because typically in the context in which Egyptian films are shown in America—film workshops or festivals—the intertextuality of the film is one of the first things lost. Nobody on these occasions, including sizable numbers of Egyptian intellectuals, has much time for Egyptian films other than the few identified as standing outside a cinematic tradition that is generally despised. The films one sees are not presented as statements embedded in a discursive field, but as lucky fugitives from an unexamined world of oddly unanalyzable industrial leisure products.

cAdil Imam

One area in which the analogy between Depression-era American films and contemporary Egyptian cinema starts to break down is the degree to which directors intend to create intertextual references in their films. Robert Stam suggests that a director such as Woody Allen, who intentionally seeks to employ intertextuality, "does not obscure his borrowings; rather, he suggests that . . . pilfering is a fundamental part of the process of creation."[6] This is plainly not what Frank Capra was doing in his 1930s comedies; Capra's intertextuality was not consciously that of the writer, but rather an intertextuality of the reader.[7] By contrast, what Sharif Arafa was doing in *Terrorism and Kabab* was somewhere between Woody Allen's self-conscious quotation of other films and Frank Capra's implicit skill at contrasting his own sunny optimism with the nihilism of the Marx Brothers and W. C. Fields. The key to Arafa's brand of intertextuality was casting: in particular, his casting of cAdil Imam in the lead.

Prominent actors in a commercial cinema are like texts in and of themselves—extremely complicated texts conditioned, of course, by the multiplicity of social positions inherent in any audience, by the audiences' association of the star with previous roles, and also by subsidiary venues such as 'fanzines' and gossip.[8] Think, for example, of John Ford's *The Searchers* with someone other than John Wayne in the

lead. Ford's depiction of frontier brutality with overtones of incest might have been an excellent film with any competent male lead; with John Wayne as the protagonist it was shocking and unforgettable. Why? Because we were not seeing just the grim *Searchers*, but also *Stagecoach*, *The Long Voyage Home*, *The Quiet Man*, and *They Were Expendable*, not to mention numerous films Wayne had done with directors other than Ford. The 'meaning' of John Wayne was not a strictly textual matter; it had to do with when people saw the films and under what conditions. The overall effect was to make John Wayne into an icon of a certain kind of American ideology, an ideology that privileged masculinity, toughness, and honor. Therefore to see him mutilating corpses and lusting after his niece in *The Searchers* added a complex layer of emotion to a film that, by a purely formal textual analysis, was already richly nuanced. No other actor could have played the role the same way, or one suspects, as effectively.

The point is that commercial film audiences view films through actors, not through directors. Until recently film scholars despised this tendency.[9] Pierre Bourdieu, however, takes a more sociological approach to the relationship between film texts and audiences. Bourdieu notes that in France recognition of directors goes up proportionally with the audience's educational achievement.[10] Very likely a similar relationship between educational level and the tendency to think of films as the product of individual artistry exists in Egypt, although there is no survey data comparable to Bourdieu's to make such speculation more concrete. But if we want to understand the social significance of a film like *Terrorism and Kabab* then we must follow Bourdieu's lead and allow some of the *auteur's* aura to be transferred to the actors, at least if we intend to expand our perspective beyond a consideration of elite audiences. If we do this in the case of *Terrorism and Kabab* we begin to uncover a certain ambiguity in the film which is probably not evident to most Americans viewers. I'll come back to this ambiguity shortly.

Return, for a moment, to my screwball comedy analogy. Frank Capra's films were works of directorial brilliance: often he made the star, not the reverse. Clark Gable was a second-rank star before *It Happened One Night* vaulted him to the top. But the comedies against which Capra's screwballs were historically juxtaposed were actor-driven: the Marx Brothers' *Horse Feathers* or W. C. Fields's *Million Dollar Legs*. Such films relied on vaudevillian sight gags and word play that often seemed silly to critics, but were attractive to audiences, particularly in the early years of the Depression. Eventually the director triumphed. The anarchy of cinematic vaudeville reached high tide with the Marx Brothers' *Duck Soup* and W. C. Fields's *The Fatal Glass of Beer,* and though screwball and vaudeville coexisted throughout much of the 1930s, there was no doubt as to which one would ultimately triumph.

Turn back to our Egyptian films again: what is the relation between actors and directors in *Terrorism and Kabab* and its predecessor, *Ramadan on the Volcano?* In this case the distinction is not clear cut. It would be easy to argue on formal grounds that the work of Sharif Arafa, director of *Terrorism and Kabab,* is superior to that of Ahmad al-Sab'awi, who directed *Ramadan.* Arafa is Egypt's Frank Capra, while al-Sab'awi is just someone who has directed some ᶜAdil Imam films. The problem, however, is that ᶜAdil Imam is the lead actor in both films. He is the six-hundred-pound gorilla of Egyptian cinema—so big that he overshadows both of them. ᶜAdil Imam got to be so big by creating a particular historically conditioned screen image, which he inevitably carries with him to any film he chooses to appear in. From the perspective of a commercial film audience, for whom directors are not necessarily the major selling point, casting ᶜAdil Imam in the lead of *Terrorism and Kabab* might be analogous to putting Groucho Marx in the lead of *Meet John Doe.* Even if Groucho does his utmost to play the role straight, there is no guarantee that when the protagonist makes his bold stand against big money and demagoguery, the audience is not still going to find the whole thing ridiculous, because it still sees Rufus Firefly, the Groucho Marx character in *Duck Soup,* gleefully doing his utmost to run the Republic of Freedonia into the ground. Similarly, a director can show John Wayne mutilating corpses and make ironic commentary on all of Wayne's heroic roles, but one could never have put him in a Jerry Lewis role. The point is that ᶜAdil Imam, like Groucho Marx and John Wayne, comes to his roles carrying certain baggage. Imam's reputation was built on absurdism with a strong dose of nihilism.[11] Of course putting him in *Terrorism and Kabab* is nowhere near as extreme as casting Groucho in place of Gary Cooper or John Wayne in a Jerry Lewis role, but the same general principle applies. To use Imam requires taking account of his history. *Terrorism and Kabab* retains the absurdism upon which Imam built his career, but can it completely dispel the nihilism?

Nihilism brings us back to *Ramadan on the Volcano,* the predecessor of *Terrorism and Kabab* and ᶜAdil Imam's first film in which the action takes place in the bureaucratic hell known as the mugammaᶜ. The film is the last installment of a trilogy: *Ragab on a Hot Tin Roof* (made in 1979), *Shaban below Zero* (1980), and *Ramadan on the Volcano* (1985). All were made by different directors, but they are linked in several ways. For one thing, the protagonist in the title role of each film—Ragab, Shaban, and Ramadan (each played by Imam)—is named after an Islamic month (sequentially the seventh through ninth months of the Islamic calendar). Always the title character is above or below something that conveys a sense of precariousness. All together the films describe a movement toward an urban center, and each successive film starts closer to the center than the last. Also the educational level of each successive

character is slightly higher (although never to the point of being a 'finished' educational product). *Ragab on a Hot Tin Roof,* the film that began the trilogy, is an Egyptian version of *Midnight Cowboy,* and therefore features a peasant who comes to the city (ᶜAdil Imam plays the Jon Voigt role). The second film, *Shaban below Zero,* was a 1980s remake of an Egyptian film from the 1940s, and tells the story of a secondary school dropout who works as a bureaucrat in a Delta town for the department of land reclamation. *Ramadan on the Volcano,* made in 1985, is about a bureaucrat who works in the *mugamma*ᶜ, which, as mentioned above, is perhaps the best known and most notorious complex of bureaucracy in Egypt, and of course is also the setting for *Terrorism and Kabab* in 1992. To recapitulate briefly, the focus of the films shifts from illiterate peasant in the first film, to semi-literate rural bureaucrat in the second, to semi-college-educated urban bureaucrat in the third; from countryside, to small town, to urban center; and each step closer to the center is accompanied by a slightly higher level of educational attainment.

The problem is that in each case the urban core toward which the protagonist moves is thoroughly rotten. Each successive character gives in to the rampant corruption of the city, and the result is always the same—Ragab, Shaban, and Ramadan all end up in prison. The utter rottenness of the city is significant because for the past eighty or ninety years of Egyptian history the ideological emphasis of official discourse has always been on the value of education, institutions, industry, and modernity. These, of course, are the building blocks of what we might characterize as secularism, and in this context, they are all urban building blocks. The privileged position of the city has long been reflected in films and other mass media. Bureaucrats, doctors, lawyers, students, airplane pilots, army officers, and government officials were both the center of attention and the bearers of morality from the beginning of Egyptian cinema in the early 1930s until the 1970s. Less often it was some representative of the common man—truckdrivers, soldiers, farmers—but they too were frequently depicted in the throes of change, moving toward an imagined national center in which progress and authenticity coexisted harmoniously.

The period in which ᶜAdil Imam became popular was not that of constructive modernism, but rather the post-1970s period. He was active in plays and movies from the mid-1960s, but his breakthrough came in a 1972 play called *School of Troublemakers.* As a text, *School of Troublemakers* revolved around a female teacher's efforts to tame a group of wild, undisciplined students. Primarily she had to come to terms with the students' ringleader, the wildest troublemaker of all, who was played by ᶜAdil Imam. The students' resistance is chronicled in a number of colorful antics, but in the end their teacher convinces them of the value of

education, thereby transforming them into useful citizens—a typically affirmative view of modernity. However, as a performance, *School of Troublemakers* was very different. The actors literally hijacked the script, turning a ninety-page text into a four-hour play through shameless ad-libbing, much of which was of a political nature. They downplayed the ending in which all problems were neatly resolved and the value of education affirmed. Not only did they treat education—a key modernizing institution—with utter disrespect, but they also made jokes about the recently deceased Gamal ᶜAbd al-Nasir, and even laced the performance with mockery of the 1960s free-market economic policies of Sadat. Audiences appreciated Imam's subversion of the text; critics did not. Reviews of the play ignored Imam's character and wrote mostly in praise of the school administrators, who in the performance were nothing more than straight men for Imam and his gang of troublemakers to send up. Establishment intellectuals grumbled about cheap sensationalism in the commercial theater, which they always compared unfavorably with the golden era of state-subsidized theater in the 1960s. And by most formal criteria the critics were right: *School of Troublemakers* was a terrible play. Nonetheless it was a defining moment in the career of ᶜAdil Imam, and indeed of post-1960s Egyptian culture. The floodgates were open and torrents of a new kind of subversion began to flow through. In terms of cinematic comedy, it was like the early Depression work of W. C. Fields; a surly spirit of cynicism and divisiveness reigned supreme. The primary targets were the old modernist institutions and the new economy. In recent years, when ᶜAdil Imam has been made into the establishment's man of the hour, mostly because of his stand against Islamist radicals, it has become easy to overlook the fact that for most of his career he was a pariah in the eyes of critics, an emblem of vulgarity, not the savior of the state.

Ramadan on the Volcano is typical of ᶜAdil Imam in his heyday. Imam plays the character of Ramadan, the payroll cashier at the *mugammaᶜ*. The *mugammaᶜ*, it should be emphasized, is a real place, not a movie set. Most people know at least its exterior, since it occupies one side of the main transportation hub of Cairo, and many have had to do business in it. Making it a site of absurdity took very little effort on the part of the film makers because it already has very much an 'abandon all hope' reputation.

Ramadan on the Volcano is about the unmitigated humiliation of the middle class, followed by a conscious capitulation to materialism, and with no attempt to recoup conventional values or to suggest feelings of remorse on the part of the protagonist. The first third of the film establishes the humiliation. In the first scene we see Ramadan with his sidekick Bashbishi, a janitor who makes tea on the side for the *mugammaᶜ* employees, and thereby earns more than Ramadan. They are

at the bank picking up the payroll, which consists of 400,000 Egyptian pounds in small bills. Ramadan loads the cash into a brown suitcase made so heavy by the money that he can barely lift it. He and Bashbishi cannot afford a taxi fare to the *mugamma*ᶜ, so they are forced to lug the suitcase full of cash along the street. When they arrive at the *mugamma*ᶜ the elevator operator will not let them ride up to the top floor where the payroll office is located; the elevator is reserved for decent folk, which means people who might tip the operator. Ramadan and Bashbishi wrestle the suitcase up thirteen flights of stairs, which lead to circular landings around an open space on each floor. When you enter the *mugamma*ᶜ, the first thing you see is these circular landings spiraling up from below like a giant corkscrew, a view that featured prominently in both *Ramadan on the Volcano* and *Terrorism and Kabab*. When Ramadan and Bashbishi reach the payroll office Ramadan sits at his desk, with the suitcase full of cash open to one side. Bashbishi calls the employees, and they come like a herd of buffalo. At their head a pregnant woman trudges along with great difficulty, but the herd of bureaucrats (mostly men in suits, and eager for their pay) shove her rudely to the side in their stampede to Ramadan's desk. The disgusted Ramadan makes them wait while he gives the pregnant woman her pay first. He shows himself to be basically decent, and in some of the earlier scenes, incorruptible. But the point of the film is not his incorruptibility, which quickly ends, but rather the fact that his good reputation earns him no respect.

The payroll sequence is only a small sample from the film—no more than five minutes—but it is enough to suggest a very harsh view of modern society. Harsher, in fact, than that of *Terrorism and Kabab*, or at least meaner and more cynical. The film drives home the absurdity of Cairene life by exploring Ramadan's relationship with his fiancée and her mother. Ramadan lives in their building, but in a marginal rooftop apartment—the sort of place that servants often live in. And like a servant is exactly how his prospective mother-in-law treats him. She sends him out on endless tiring errands, each of which shows another aspect of his humiliating existence. At one point we see Ramadan talking with his fiancée's oppressive mother, who speaks with a voice that could crack glass. He tells her that in five years he has saved only six hundred Egyptian pounds, which he refers to bitterly as *baratish* (worn out old shoes). She reacts with scorn. "You want my daughter to live on the rooftop? Let me tell you something, you're totally unfit for marriage."

"Totally unfit?" replies Ramadan. "Why? I'm missing a hand? A leg? A . . . nose?"

"No," she interjects, "you're missing money. If she were your sister, would you scandalize her by marrying her to someone like yourself?"

"Scandalize?" he repeats. "I'd keep my eye on her" (i.e., take care of her).

"We don't want your eye," she says scornfully, "we want your pocket. We live in the age of money. Do you have money?"

"No," he says, "all I have is six hundred old shoes."

"All right then, you're not good enough for her."

The plot of *Ramadan on the Volcano* revolves around embezzlement; Ramadan finally cracks and steals the payroll rather than deliver it to the rude employees of the *mugamma*[c]. Unfortunately, he picks the same day to steal the payroll as his sidekick Bashbashi, who is in league with a group of professional thieves. Bashbishi and company switch Ramadan's cash-filled suitcase with a similar one stuffed full of date paste. But Ramadan has a more complex plan than just stealing the payroll. Without ever opening the suitcase he buries it in a secret place. Then he turns himself in. The reason Ramadan turns himself in is that he is a failed law student—another dig at the educational establishment—who remembers only one thing from his law books: that the penalty for embezzlement is only six to ten years. At worst he will be out in ten years and with far more money than he could ever make working honestly.

It works like a charm. Suddenly Ramadan, the confessed embezzler, is the toast of the town. The police let him out briefly in the hope that he will be foolish enough to lead them to the money. When he goes home Ramadan's harridan prospective mother-in-law, who earlier told him he was good for nothing, now treats him with the deepest warmth. The neighborhood grocer greets him with a brass band. He is a hero.

In prison, the guards try to bribe Ramadan, thinking he has enormous wealth stashed away. His fellow prisoners, when they learn his story, make him their leader. They sing him a gleeful little song that begins with *"Salam makhsus li-usta il-lusus"* (a special salute to the chief of thieves). Most of the song recapitulates the general admiration for Ramadan's deed, but at one point it becomes political. The convicts roll out a carpet, which Ramadan walks down in an obvious parody of the president greeting dignitaries in a government newsreel. Beside him in his 'red carpet walk' is another convict, playing the secret service guard muttering into a hidden microphone. Ramadan greets various 'officials,' whom the singer identifies as 'crooks' and 'pickpockets.' Then the singer, who is one of the convicts, turns toward the camera and points outside of the prison, singing, "Those are the crooks who are at large, and they've made the world lousy for us."

The first time I saw the film, in 1991, I watched it on video with a group of college students. In the copy we had, the visuals to the song—only the song—were erased, either damaged or censored. All we saw was a blank screen, although the words to the song could still be heard. The students assumed it was censorship because they remembered from a previous occasion the red carpet and the parody of the president, and told me immediately what was happening even without being able to see it.

Ramadan on the Volcano does not end with the protagonist's first entry
into prison. Eventually the authorities discover that he hasn't really
stolen the *mugamma*^c payroll. Bashbishi takes Ramadan's place in
prison, but Bashbishi's partner is never caught, and the money is never
recovered. Ramadan spends the rest of the film tracking down the thief
who stole his stolen money. Along the way he manages to parlay the
still-widespread belief that he has hundreds of thousands of pounds
stashed away into a pyramid scheme. He rents a furnished apartment—
always a danger sign in Egyptian films because furnished apartments are
equated with foreigners and illegal activities—and forms a fake import-
export company, "Ramadanko li-A'ali al-Bahhar" (the Ramadan
Company for Maritime Trade). His friends from prison dress up in chic
Western suits and bustle about the office pretending to work in front of
the impressed customers. One ex-con sits at a desk with a telephone in
his hand saying, "Yeess . . . noooo . . . yeess yes yes . . . noooo no no."
The idea is to give the impression of close connection to powerful foreign
business interests. Another ex-con comes in and announces loudly, so the
'customers' can hear him, that he is the director of customs and he has
come to beg three minutes of the boss's time to discuss the arrival of his
latest ship. Later another crook gets out of prison and comes to Ramadan
seeking employment. Ramadan asks him what he had been in prison for.
"Pickpocketing" is the answer. "Do you know how to read and write?"
Ramadan asks. No. "Can you work with numbers?" No. "Okay," says
Ramadan to a confederate, "assign him to the board of directors."

The scheme works like a charm. Greed and gullibility combine to keep
the money of hopeful investors rolling into Ramadan's hands, including
the estate of his fiancée's mother and all the savings of a coarse uncle
from the countryside who had earlier refused to lend Ramadan money so
he could get married. The film ends when Ramadan tracks down and
recovers the original *mugamma*^c payroll money. He combines it with his
pyramid scheme money, buries it, and once again turns himself in to the
police. Since his erstwhile sidekick Bashbishi is already serving time for
the theft of the payroll, this time he confesses to the pyramid scheme,
which carries a sentence of only two years instead of the seven he was
originally to serve for embezzlement. In the final scene we see Ramadan
back in prison, respected by all, as they all sing a reprise of "Special
Salute to the Chief of Thieves."

The last lines in the film are *"tahya il-hurriya . . . il-hurriya sawa
malayin"* (long live freedom, freedom is the same as millions). Freedom,
in other words, is a simple matter of millions of pounds, or dollars—
nothing but a question of money. In *Ramadan on the Volcano* the point
isn't just that the ends justify the means but that the means are
completely irrelevant.

Conclusion

As I move toward my conclusion I should add a small disclaimer. Of course by any formal standards *Ramadan on the Volcano* was not as clever a film as *Terrorism and Kabab*. It would be foolish to suggest that if one had to choose between seeing *Ramadan* and *Terrorism and Kabab* one should choose the former. Nonetheless, it would be better still to take both films into account. If we take a reflexive look at what is going on with Egyptian films shown in the United States, it becomes apparent that all Egyptian films shown in metropolitan cities are made into honorary art films, whether or not they were intended as such. In an American context a film like *Terrorism and Kabab* looks like a bold political statement—maybe even a progressive statement. Progressive statements, after all, are what Americans tend to look for in their foreign films—the assumed conservatism of most star-oriented commercial cinema[12] is one of the things that assure its failure in the 'art-film' segment of the American market. But of course *Terrorism and Kabab is* a star-dominated commercial film. Paul McDonald, writing about the place of stardom in film studies, suggests that such films are best analyzed "within the context of a broader network of other texts which were in circulation during the same period."[13] In other words, it is a mistake to accord honorary art-film status to a film like *Terrorism and Kabab*. To do so is to discard one of the most potent means of analyzing it, namely the intertextual nexus through which its intended audience views it. Of course the social context of the film ultimately consists of far more than other films, but the presence of a star, the 'star of stars' as ᶜAdil Imam is called in Egypt, should perhaps direct one's initial inquiries.

ᶜAdil Imam had much to do with *Terrorism and Kabab*'s popularity in Egypt, but he certainly was not the reason the film was selected for exhibition in the United States. For most of his career his films were absolutely the least likely to be shown outside of Egypt. The film was a blockbuster in Egypt, but many of ᶜAdil Imam's films have been blockbusters without sparking the slightest interest in foreign audiences. Nor was the film's success in the West entirely due to the skill of Sharif Arafa; Arafa had directed at least one interesting film before he hitched his star to ᶜAdil Imam, and *Terrorism and Kabab* was the second of four films Arafa did with Imam. All of them have conveyed the same optimistic spirit of social unity as *Terrorism and Kabab*. And though the fourth Arafa/ᶜAdil Imam collaboration, *Birds of Fire*, seems to be catching on a bit, the other two are virtually unknown.

The real reason the film is available in the United States is, of course, the presence of the 't' word in the title: terrorism. And of course the 't' word in the title is nicely matched in the film by a clever dig at Islamists in the form of the endlessly praying bureaucrat in the *mugammaᶜ*. The

film therefore plays nicely into Western obsessions with terrorism and the rise of Islamic politics, without veering into crude anti-Islamist hysteria. On the local level ᶜAdil Imam was able to transform himself in the establishment media from the vulgarian intellectuals loved to hate into the man of the hour, the hero of the secular state. The media transformation actually began with Imam's first Sharif Arafa film, *Playing with the Grownups*, which was made one year before *Terrorism and Kabab*, was equally popular, and was well received by critics, unlike anything else Imam had appeared in during the previous twenty years. And, in 1993, one year after *Terrorism and Kabab*, Imam made another film with the 't' word in it: *The Terrorist*. In this case, praise for ᶜAdil Imam gushed forth in the establishment media. In fact the praise was so effusive that many assumed—probably incorrectly—that the government must have funded the film. *The Terrorist* will probably never be shown in the West as much as *Terrorism and Kabab*. The Middle East Studies Association, for example, had no interest in showing it at its annual conference. The film is so blatantly progovernment that the usual reluctance about showing conservative commercial films in what are implicitly art-film venues comes into play. And there is absolutely no doubt in anyone's mind that *The Terrorist* is an incredibly conservative film. *Terrorism and Kabab*, by contrast, makes a Western audience feel hip—like it's getting an inside tip on the real nature of social attitudes toward Islamic politics.

But in one important way *The Terrorist* and *Terrorism and Kabab* are cut from the same conservative cloth. As texts they both stand out from the centrifugal tendency of post-1960s Egypt. Post-1960s cinema was often about the destruction of the middle class, about everything flying apart, the widening of gaps between rich and poor, the impotence of institutions. From the 1970s to 1991 ᶜAdil Imam was a key player in the centrifugal cinema. Certainly not all of his films were as cynical as *Ramadan on the Volcano*, but *Ramadan, Ragab,* and *Shaban* were among his most successful, and enough of his other films were made in the same spirit that the establishment media largely shunned him. Since 1991 he has sought to reassemble the social center; now the middle class, in Sharif Arafa's films at any rate, is problematized and beleaguered, but it holds firmly to its values. The difference between these films and earlier ᶜAdil Imam films is *not* their opposition to Islamist politics, which is, in any case, quite indirect in *Terrorism and Kabab*. Such opposition is consistent with ᶜAdil Imam's past. Even *Ramadan on the Volcano* in 1985 took a swipe at religious politics. When Ramadan and his convict friends activate their pyramid scheme, the film makes an implicit connection to Islamic investment ventures such as the infamous Rayyan Company of the mid-1980s, which the government accused of running a pyramid scheme, but which many people still believe was shut down

because of its connection to the Islamists. In the film, Ramadan is shown sitting at his desk raking in the money of unsuspecting marks. Behind him a framed Quranic verse hangs conspicuously on the wall; he conspicuously mouths pious phrases; the camera zooms in on the prayer beads Ramadan fingers as he entices people to give him their money.[14] Oblique digs at disapproved incursions of religion into what the state has designated a secular domain have long been permissible in Egyptian cinema.

What is different about *Terrorism and Kabab* in the context of the historically and socially mediated creation of ᶜAdil Imam's stardom is that it is Capraesque; it tries to engineer a kind of social harmony that had been subdued in Egyptian cinema for some time—not entirely eliminated, and not even completely absent from all of ᶜAdil Imam's previous work, but definitely subdued.

Andrew Bergman suggests that juxtaposing mid-1930s American screwball comedy with the anarchy of early 1930s comedies helps us understand the social significance of the screwballs.[15] By contrast *Ramadan on The Volcano*, a different kind of ᶜAdil Imam vehicle, recalls the spirit, and to some extent the plot of the W. C. Fields short film, *The Fatal Glass of Beer*. *The Fatal Glass of Beer* is about a man (played by Fields) whose only son runs away to the city, drinks some beer, and then commits embezzlement. Fields is grief stricken. However, the son somehow avoids disaster and comes home to a joyous reunion with his parents. All seems to have ended well until the boy tells his father that he has thrown away all the stolen money. Fields then beats his son and throws him out into the freezing night.[16] Fields, of course, is the perfect analog to Ramadan's prospective mother-in-law, who despises him and treats him like a servant when he is honest, but greets him like royalty when she thinks he has large sums of money, and never mind that the money was stolen.

Cinematic anarchy reached its limit with *The Fatal Glass of Beer*, which was not a hit, possibly because the course of the Depression was changing; people were starting to become hopeful as the government under Roosevelt took a new course. As the socioeconomic outlook brightened, a new kind of film began to appear. In 1934, the year that *The Fatal Glass of Beer* bombed at the box office, the first big screwball hit marked the ascendance of a new civic spirit. *It Happened One Night*, with its imagery of unity and healing, was an antidote to the caustic anger of early 1930s American cinema.

The relationship of *Terrorism and Kabab* to the intertextual nexus of Egyptian comedy is more ambiguous. Which film are audiences seeing? The Capraesque work of Sharif Arafa that gropes toward a spirit of social healing? Or the *Fatal Glass of Beer* ᶜAdil Imam prevalent before 1991? Since the early 1970s, many Egyptians would have little difficulty with

the proposition that their economy has been in something like a state of depression. It would not, however, be difficult to locate vigorous opposition to the notion that there has been anything like an Egyptian New Deal to inspire a sense of optimism. Of course, other factors could also facilitate a paradigm shift in Egyptian cinema from the centrifugalism of *Ramadan on the Volcano* to the centripetalism of *Terrorism and Kabab*. Once again the 't' word looms large: terrorism, political violence, the possibility of the culture war between the government and its Islamist opponents spinning out of control into an out-and-out shooting war. One certainly cannot dismiss the idea that cinematic visions of social unity are once again popular because of a genuine and widespread repudiation of the horrifying possibility of civil war. But neither can one assume that the film audiences see in Egypt is quite the same one viewed in the United States. The Capraesque vision of *Terrorism and Kabab* might be just another ᶜAdil Imam film in its home country. The question for American viewers is what exactly does an ᶜAdil Imam film signify?

Notes

1 There is, however, no hard evidence that Islamists were not in fact among the crowds flocking to theaters to see the film; they may have been laughing with the film rather than fulminating at it.

2 Andrew Bergman, *We're in the Money: Depression America and its Films* (New York: New York University Press, 1971), 762.

3 Ibid.

4 Robert Stam, *Subversive Pleasures: Bakhtin, Cultural Criticism, and Film,* (Baltimore: Johns Hopkins University Press, 1989), 198. Stam uses the phrase in the context of an analysis of Woody Allen films, which aim quite deliberately, and with full ironic intent, to quote other films. Allen's intent was obviously quite different from that of Capra.

5 Chris Rojek, *Decentring Leisure: Rethinking Leisure Theory* (Thousand Oaks, California: Sage Publications, 1995), 10.

6 Stam, *Subversive Pleasures*, 198.

7 This is not to say that Capra's texts existed in a vacuum either. If one accepts poststructuralist assumptions about the dialogical nature of all texts—that texts are inevitably the products of other texts—then of course the same applies to Capra. But of course the issue here is intentionality, not the ontological status of all linguistic utterances.

8 Paul McDonald identifies four main methodologies for studying mass media stars: semiotics, intertextuality, psychoanalysis, and audience studies. Obviously the first two, semiotics and intertextuality, are most relevant to this paper. McDonald suggests that these methodologies need not be regarded as mutually exclusive. McDonald, "Star Studies," in Joanne Hollows and Mark Jancovich, eds., *Approaches to Popular Film* (Manchester: Manchester University Press, 1995).

9 There is, however, a relevant and growing literature in mass media studies on 'reader response theory.' See Ian Ang, *Watching Dallas: Soap Opera and the Melodramatic Imagination* (London, Methuen, 1985); Tania Modleski, *Loving with a Vengeance: Mass-Produced Fantasies for Women* (New York: Methuen, 1984); David Morley, *The Nationwide Audience* (London: BFI, 1980); Stuart Hall, "Encoding/Decoding," in D. Hobson, S. Hall, A. Lowe, and P. Willis, eds., *Culture, Media, Language* (London: Hutchinson, 1980). Much of this analysis revolves around explorations of multiple perspectives in an audience—i.e., how audience perspective is shaped by gender, class, or ethnicity. The general direction of this material is to break down the notion of a neat 'encoding/decoding' model of mass media production and consumption.

10 Pierre Bourdieu, *Distinction: A Social Critique of the Judgment of Taste* (Cambridge, Mass.: Harvard University Press, 1984), 26–27.

11 For the most part the nihilistic tendency in Imam's films began after *Ragab on a Hot Tin Roof* in 1979. The cynicism of Imam's post-*Ragab* film work, however, was foreshadowed in some of his earlier stage work, particularly *School of Troublemakers* in 1972. See Walter Armbrust, *Mass Culture and Modernism in Egypt,* (Cambridge: Cambridge University Press, 1996).

12 McDonald. "Star Studies," 80.

13 Ibid., 83.

14 A year later another ᶜAdil Imam vehicle, *Police Station in the Street* (1986, directed by Ahmad Yahya), repeated the Islamic-investor-as-swindler scenario, and this time the connection between superficial Islamic symbolism and fraud was made more explicit. The Quranic verse on the walls was much more elaborate and obvious, the Islamic investment office featured a stern female secretary in *higab* (the head covering worn by many Egyptian women, but which is rarely shown in Egyptian films), and the swindler himself was dressed in ostentatious *gallabiya* (a man's robe) and beard.

15 Bergman, *We're in The Money,* 30-41.

16 Ibid., 38–39.

BIBLIOGRAPHY

Compiled by Sherifa Zuhur

The sources below represent some, but not all, of the material utilized by the authors of this volume, in addition to other material on dance, music, film, and painting that may be of interest to readers. The bibliography is divided into two sections: "Books and Chapters in Books" and "Articles and Unpublished Material."

Books and Chapters in Books

ᶜAbassi, Hamadi and Sleh Hamzaoui. *Tunis Chante et Danse 1900–1950.* Tunis: Alif, Les Éditions de la Méditerranée, 1991.

ᶜAbd al-Wahhab, Muhammad. *Mudhakarat Muhammad ᶜAbd al-Wahhab.* Edited by Muhammad Rifᶜat al-Muhami. Beirut: Dar al-Thaqafa, n.d.

ᶜAbd al-Wahhab, Muhammad and Mahmud Sharif, George Ibrahim al-Khuri, Baligh Hamdi, Muhammad B. Sarfiyah, Muhammad al-Mawji, Ahmad Fu'ad Hasan, Mahmud Lutfi. *Dhikrayat Farid al-Atrash.* Cairo: Dar al-Maᶜaraf bi Misr, 1975.

Abousenna, Mona. *Conference Papers on Literature and Culture.* Cairo: The Anglo–Egyptian Bookshop, 1986.

Abu al-ᶜAinain, Saᶜid. *Asmahan . . . Laᶜbat al-hubb wa-l-mukhabarat.* Cairo: Dar Akhbar al-Yawm, 1996.

Abu-Lughod, Janet L. *Cairo: 1001 Years of the City Victorious.* New Jersey: Princeton University Press, 1971.

Abu-Lughod, Lila. *Veiled Sentiments: Honor and Poetry in a Bedouin Society.* Berkeley: University of California Press, 1986.

Abu Saif, Salah, ed. *Mawsuᶜat al-aflam al-ᶜarabiya.* Cairo: Bayt al-Maᶜarafa, 1994.

Ahmed, Leila. *Women and Gender in Islam: Historical Roots of a*

Modern Debate. New Haven: Yale University Press, 1991, and Cairo: American University in Cairo Press, 1993.

ᶜAli, Wijdan. *Modern Islamic Art: Development and Continuity.* Gainesville: University Press of Florida, 1997.

ᶜAli, Wijdan and Suhail Bisharat (Royal Society of Fine Arts). *Contemporary Art from the Arab World.* London: Scorpion, 1986.

Altorki, Soraya. *Women in Saudi Arabia.* New York: Columbia University Press, 1986.

Amrusi, Majdi. *Muhammad ᶜAbd al-Wahhab: al-Insan wa-l-fannan.* Cairo: Dar al-Haya, 1996.

Ang, Ian. *Watching Dallas: Soap Opera and the Melodramatic Imagination.* London: Methuen, 1985.

al-ᶜAris, Ibrahim. *Rihla fi-l-sinima al-ᶜarabiya.* Beirut: Dar al-Farabi, 1979.

Armbrust, Walter. *Mass Culture and Modernism in Egypt.* Cambridge: Cambridge University Press, 1996.

Armes, Roy. *Third World Film Making and the West.* Los Angeles: University of California Press, 1987.

Attiya, Naᶜim. *Inji Aflatun.* Cairo: State Information Service, Artists Series, 1986.

Awad, Louis. *Tahiya Halim.* Cairo: State Information Service, Artists Series, 1985.

Badran, Margot. *Feminists, Islam, and Nation: Gender and the Making of Modern Egypt.* Princeton: Princeton University Press, 1995.

Badran, Margot and Miriam Cooke, eds. *Opening the Gates: A Century of Arab Feminist Writing.* Bloomington and Indianapolis: Indiana University Press, 1990.

Baer, Gabriel. *Egyptian Guilds in Modern Times.* Jerusalem: Israel Oriental Society, 1964.

al-Bahnasi, ᶜAfif. *al-Fann al-hadith fi-l-bilad al-ᶜarabiya.* Beirut: Dar al-Janub li-l-Nashr, 1980.

―――. *Ruwwad al-fann al-hadith fi-l-bilad al-ᶜarabiya.* Beirut: Dar al-Ra'id al-ᶜArabi, 1985.

―――. *Muᶜjam al-ᶜimara wa-l-fann.* Beirut: Maktabat Lubnan Nashirun, 1995.

Baram, Amatzia. *Culture, History, and Ideology in the Formation of Baᶜthist Iraq, 1968–89.* New York: St. Martin's Press, 1991.

Becker, Carol. *Social Responsibility and the Place of the Artist in Society.* Chicago: Lake View Press, 1990.

al-Biladi, ᶜAtif bin Ghaith. *al-'Adab al-shaᶜabi fi-l-Hijaz.* Damascus: Maktabat Dar al-Bayan, 1977.

Blok, A. "Infamous Occupations." In *Essays on Structural Change: The L. H. Morgan Symposium,* edited by T. Vuyk. Leiden: ICA Publications, 1985.

Booth, Marilyn. *Bayram al-Tunisi's Egypt: Social Criticism and Narrative Strategies.* Oxford: Ithaca Press, 1990.

Bourdieu, Pierre. *Distinction: A Social Critique of the Judgement of Taste.* Cambridge, Massachusetts: Harvard University Press, 1984.

Boyd, Douglas A. *Egyptian Radio: Tool of Political and National Development.* Lexington, Kentucky: Association for Education in Journalism, 1977.

———. *Broadcasting in the Arab World.* Philadelphia: Temple University Press, 1982.

Brauer, Ralph A. "When the Lights Went Out: Hollywood, the Depression, and the Thirties." In *Movies as Artifacts,* edited by Michael T. Marsden, John G. Nachbar, and Sam L. Grogg. Chicago: Nelson-Hall, 1982.

Browne, W. G. *Niewe reize naar de binnenste gedeelten van Afrika, door Egypte, Syrie en le Dar-Four waar nimmer te voren eenig europeaan heeft gereisd, - gedaan in den jaare 1792–1798.* Amsterdam: Johannes Allart, 1800. (*Travels in Africa, Egypt and Syria: From the Year 1792 to 1798.* London: printed for T. Cadell and W. Davies, 1799.)

Buonaventura, Wendy. *Serpent of the Nile: Women and Dance in the Arab World.* London: Al-Saqi, 1989.

Burckhardt, John Lewis. *Notes on Bedouins and Wahabys.* London, 1841.

———. *Arabic Proverbs, or the Manners and Customs of the Modern Egyptians Illustrated from Their Proverbial Sayings Current at Cairo.* 1875; reprint London: Curzon Press, 1972.

al-Bustani, Karam. *al-Nisa' al-ᶜarabiyat.* Beirut: Dar Sadr, 1964.

Butrus, Fikri. *Aᶜlam al-musiqa wa-l-ghina' al-ᶜarabi.* Cairo: al-Hay'a al-Misriya al-ᶜAmma li-l-Kitab, 1976.

Cachia, Pierre. *Popular Narrative Ballads of Modern Egypt.* Oxford: Clarendon Press, 1989.

Caton, Steven. *Peaks of Yemen I Summon.* Berkeley: University of California Press, 1990.

Champlin, Charles. *The Movies Grow Up: 1940–1980.* Ohio: Swallow Press, 1981.

al-Charkawi, Galal. "History of the U.A.R. Cinema, 1896–1962." In *The Cinema in the Arab Countries,* edited by George Sadoul. Beirut: InterArab Center of Cinema and Television, 1966.

Connelly, Bridget. *Arab Folk Epic and Identity.* Berkeley: University of California Press, 1996.

Danielou, Alain, and Jacques Brunet. *The Situation of Music and Musicians in Countries of the Orient.* Translated by John Evarts. Florence: Leo Olschki, 1971.

Danielson, Virginia. "Artists and Entrepreneurs: Female Singers in Cairo during the 1920s." In *Women in Middle Eastern History,* edited by

Nikki Keddie and Beth Baron. New Haven: Yale University Press, 1991.

———. *The Voice of Egypt: Umm Kulthum, Arabic Song, and Modern Egyptian Society*. Chicago: The University of Chicago Press, 1997, and Cairo: The American University in Cairo Press, 1997.

Darwish, Mustafa. *Dream Makers on the Nile: A Portrait of Egyptian Cinema*. Cairo: The American University in Cairo Press, 1997.

Denon, V. *Reize in Opper en Neder Egipte Gedurende den Veldtocht van Bonaparte*. Amsterdam: Johannes Allart, 1803. (*Travels in Upper and Lower Egypt*. London: printed for T. N. Longman, O. Rees, and R. Phillips by T. Gillet, 1803.)

Doane, Mary Ann. *The Desire to Desire: The Woman's Film of the 1940s*. Bloomington, Indiana: Indiana University Press, 1987.

Duff Gordon, Lady. *Letters from Egypt*. London: R. Brimley Johnson, 1902.

d'Erlanger, Baron Rodolphe. *La musique Arabe*. Paris: Guethner, 1930–1959.

Ezzedine, Salah. "The Role of Music in Arabic Films." In *The Cinema in the Arab Countries*, edited by George Sadoul. Beirut: InterArab Center of Cinema and Television, 1966.

Farid al-Atrash: Mudhakirat (wa) majmu^cat aghani. Beirut: Maktabat al-Hadithiya, n.d.

Farmer, Henry. *A History of Arabian Music to the XIII Century*. London: Luzac, 1929.

al-Faruqi, Lois Ibsen. *An Annotated Glossary of Arabic Musical Terms*. Westport, Connecticut: Greenwood Press, 1981.

Fernea, Elizabeth and B. Bezirgan, eds. *Middle Eastern Women Speak*. Cambridge, Massachusetts: Harvard University Press, 1978.

Festschrift for Gamal Abdel Rahim. Cairo: Binational Fulbright Commission, 1993.

Flaubert, Gustave. *Flaubert in Egypt*. Edited by F. Steegmuller. Chicago: Academy Chicago Limited, 1979.

Fu'ad, Ni^cmat Ahmad. *Umm Kulthum wa ^casr min al-fann*. Cairo: al-Hay'a al-Misriya al-^cAmma li-l-Kitab, 1976 (1983, 2nd edition).

Gharib, Samir. *Le surrealisme en Égypte et les arts plastiques*. Cairo: Prism, 1988.

Graham-Browne, Sarah. *Images of Women in the Photography of the Middle East, 1860–1950*. New York: Columbia University Press, 1988.

Griffith, Richard and Arthur Mayer. *The Movies*. New York: Simon and Schuster, 1970.

Hale, Sondra. *Gender Politics in the Sudan: Islamism, Socialism, and the State*. Boulder, Colorado, and Oxford: Westview Press, 1995.

Hafiz, Muhammad Mahmud Sami. *al-Musiqa al-misriya al-haditha wa ᶜalaqatuha bi-l-gharb*. Cairo: Maktabat al-Anjlu al-Misriya, 1982.

Hasanayn, ᶜAdil. *Muhammad ᶜAbd al-Wahhab: Labbayka allahumma labbayk*. Cairo: Tabiᶜa ᶜala Matabiᶜ Sharikat Tirikirumi li-l-Tabaᶜa, n.d.

Haskell, Molly. *From Reverence to Rape: The Treatment of Women in the Movies*. Chicago: The University of Chicago Press, 1987 (2nd edition).

Henni-Chebra, Djamila and Christian Poche. *Les danses dans le monde Arabe: ou l'heritage des almées*. Paris: L'Harmattan, 1996.

Hickmann, Hans and Charles Grégoire Duc de Mecklembourg. *Catalogue d'Enregistrements de musique folklorique Égyptienne*. Baden-Baden: Verlag Valentin Koerner, 1979.

Himad, Muhammad ᶜAli. *Sayyid Darwish: Haya wa naghm*. Cairo: al-Hay'a al-Misriya al-ᶜAmma li-l-Ta'lif wa-l-Nashr, 1975.

Hooglund, Eric, ed. *Crossing the Waters: Arabic-Speaking Immigrants to the United States before 1940*. Washington, D.C. and London: Smithsonian, 1987.

Hug, Charlotte. *Margo Veillon, The Bursting Movement: Artworks from 1925-1996*. Lausanne and Paris: Acatos, and Cairo: The American University in Cairo Press, 1996.

Ibn Majah. *Sunan Ibn Majah*. Cairo: ᶜIsa al-Babi al-Halabi, 1952.

Ibrahim, Mustafa Fathy and Armand Pignol. *L'Extase et le transistor: Aperçus sur la chanson Égyptienne contemporaine de grande audience*. Cairo: Centre d'Études et de Documentation Économique Juridique et Sociale, 1987 (Dossier 2, 1986).

ᶜĪd, Yusuf. *Rihlat al-tarab fi aqtar al-ᶜArab*. Beirut: Dar al-Fikr al-Lubnani, 1993.

Iraqi Culture Center. *Iraqi Art of the 50s*. London: 1979.

———. *Seven Iraqi Artists*. London: May–June, 1979.

———. *The Influence of Calligraphy on Contemporary Arab Art*. London: February–March, 1980.

———. *Contemporary Arab Art*. London, 1981.

al-Jabaqji, Abdul Rahman. *al-Qism al-awwal min diwan al-musiqat Farid al-Atrash*. Beirut: Maktabat Dar al-Sharq, 1990.

Jarkas, Riyad. *Fayruz: al-Mutriba wa-l-mishwar*. Beirut: Sharikat Ashtarut, 1989.

Jargy, Simon. *La Musique Arabe*. Series "Que sais-Je." Paris: PUF, 1977.

al-Jawadi, ᶜAbd al-Karim ᶜAbd al-ᶜAziz. *Farid al-Atrash*. Beirut: Dar al-Kitab al-ᶜArabi, 1992.

Jereb, James. *Arts and Crafts of Morocco*. London: Thames and Hudson, 1995.

al-Jundi, Adham. A^clam al-adab wa-l-fann. vols. 1 & 2. Damascus:
 Matba^cat Majalat Sawt Suriya, 1954.
———. Tarikh al-thawra al-suriya fi ^cahd al-intidab al-faransi. Damascus:
 Dar al-Kitab al-Jadid, 1965.
al-Jaza'iri, Sa^cid. Asmahan al-lahn al-khalid: Dhahiya al-istakhbarat.
 London: Riad El-Reyyes Ltd., 1990.
Kalter, Johannes, Margareta Pavaloi, and Maria Zerrnickel. The Arts and
 Crafts of Syria. London: Thames and Hudson, 1992.
Kamil, Mahmud. Muhammad al-Qasabji. Cairo: al-Hay'a al-Misriya al-
 ^cAmma li-l-Kitab, 1971.
———. al-Masrah al-ghina'i al-^carabi. Cairo: Dar al-Ma^carif, 1977.
Karnouk, Liliane. Modern Egyptian Art: The Emergence of a National
 Style. Cairo: The American University in Cairo Press, 1988.
———. Contemporary Egyptian Art. Cairo: The American University in
 Cairo Press, 1995.
Kendall, Elizabeth. Where She Danced. New York: Alfred A. Knopf,
 Inc., 1979.
Kennedy, Jean. "Desert Light: Sudan." In New Currents, Ancient Rivers:
 Contemporary African Artists in a Generation of Change, edited by
 Jean Kennedy. Washington: Smithsonian, 1992.
Khal, Helen. The Women Artists in Lebanon. Beirut: Beirut University
 College, Women's Studies in the Arab World, 1987.
al-Khula^ci, Muhammad Kamil. Kitab al-musiqa al-sharqi. Cairo:
 Maktabat al-Dar al-^cArabiya li-l-Kitab, n.d.
Koskoff, Ellen, ed. Women and Music in Cross-Cultural Perspective.
 Urbana, Illinois, and Chicago: University of Illinois, 1989.
Labib, Fumil. (As told by Fu'ad al-Atrash.) Qissat Asmahan. Beirut:
 1962.
———. Farid al-Atrash: Lahn al-khulud. Cairo: Dar al-Sha^cb, 1974 (1st
 edition?). (2nd edition, Cairo: Dar al-Shuruq, 1975, attributed by
 Sahhab to Fumil Labib. Another book exists with the same title
 (different text, not Labib's), Beirut: Dar al-Mafaq al-Jadida, 1977.)
Lahoud, Edward. Contemporary Art in Lebanon (L'Art contemporain au
 Liban). English edition, Philippe Michaux (French edition, René
 Lavenant). New York: Near East Books, 1974; Beirut: Librairie
 Orientale, 1974.
Landau, Jacob. Studies in the Arab Theater and Cinema. Philadelphia:
 University of Pennsylvania Press, 1958.
Lane, E. W. Manners and Customs of the Modern Egyptians. 1836;
 reprint The Hague, London: East West Publications, 1978.
Laurie, Joe. Vaudeville from the Honkey-Tonks to the Palace. New York:
 Henry N. Abrams Inc., 1953.
Lebanon—The Artist's View: 200 Years of Lebanese Art. Exhibition
 catalogue. London: Barbican Centre, 1989.

al-Mahallawi, Hanafi. ᶜ*Abd al-Nasir wa Umm Kulthum: Alaqa khassa
jiddan.* Cairo: Markaz al-Qada li-l-Kitab wa-l-Nashr, 1992.
Mainguy, Marc-Henri. *La musique au Liban.* Beirut: Dar al-Nahar, 1969.
Malti-Douglas, Fedwa. *Woman's Body, Woman's Word: Gender and
Discourse in Arabo-Islamic Writing.* Princeton: Princeton University,
1991, and Cairo: American University in Cairo Press, 1992.
Malkmus, Lizbeth and Roy Armes. *Arab and African Film Making.*
London and New Jersey: Zed Books, 1991.
Mardukh, Ibrahim. *al-Haraka al-tashkiliya al-muᶜasira bi-l-Jaza'ir.* al-
Jaza'ir: Haya'a al-Wataniya li-l-Kitab, 1988.
McDonald, Paul. "Star Studies." In *Approaches to Popular Film,* edited
by Joanne Hollows and Mark Jancovich. Manchester: Manchester
University Press, 1995.
Megherbi, Abdelghani. *Les Algériens au miroir du cinéma colonial.*
Algiers: Éditions S.N.E.P., 1982.
————. *Le Miroir apprivoix: Sociologie du cinéma Algérien.* Algiers:
ENAL, 1985.
Mernissi, Fatima. *Beyond the Veil: Male–Female Dynamics in a Modern
Muslim Society.* Cambridge: Cambridge University Press, 1975.
————. *Dreams of Trespass: Tales of a Harem Girlhood.* New York:
Addison-Wesley, 1994.
Merriam, Alan. *The Anthropology of Music.* Chicago: Northwestern
University Press, 1964.
el-Messiri, Sawsan. *Ibn al-Balad: A Concept of Egyptian Identity.*
Leiden: E. J. Brill, 1978.
————. "Traditional Urban Women in Cairo." In *Women in the Muslim
World,* edited by Lois Beck and Nikki Keddie. Cambridge,
Massachusetts: Harvard University Press, 1978.
Michalak, Laurence. *Cruel and Unusual: Negative Images of Arabs in
Popular American Culture.* Washington D.C.: Arab-American Anti-
Discrimination Committee, Issue paper 19, 1984.
Modleski, Tania. *Loving with a Vengeance: Mass-Produced Fantasies for
Women.* New York: Methuen, 1984.
Moftah, Ragheb, compilation, Martha Roy, text editor, Margit Toth,
transcription. *The Coptic Orthodox Liturgy of St. Basil.* Cairo: The
American University in Cairo Press, forthcoming, 1998.
Moghadam, Valentine, ed. *Identity Politics and Women: Cultural
Reassertions in Feminisms in International Perspective.* Boulder:
Westview Press, 1994.
Mukhtarat sanadiqi: Faqidat al-fann al-marhuma "Asmahan." Damascus:
Matbaᶜat al-Najah, (n.d., c. 1944).
Musées d'Algérie. Vol. 2. *L'Art populaire et contemporain.* Algiers:
Ministère de l'Information et de la Culture, Société Nationale
d'édition et de diffusion, 1973.

Mustafa, Zaki. *Umm Kulthum: Ma^cbad al-hubb.* Cairo: Dar al-Tab^ca al-Haditha, 1975.

Naficy, Hamid. "Islamicizing Film Culture in Iran." In *Iran: Political Culture in the Islamic Republic,* edited by Samih Farsoun and Mehrdad Mashayekhi. London: Routledge, 1992.

———. *The Making of Exile Cultures: Iranian Television in Los Angeles.* Minneapolis and London: University of Minnesota Press, 1993.

———. "Veiled Visions/Powerful Presences: Women in Post-revolutionary Iranian Cinema." In *The Eye of the Storm: Women in Post-revolutionary Iran,* edited by Mahnaz Afkhami and Erika Friedl. New York: Syracuse University Press, 1993.

Naficy, Hamid, Ella Shohat, and Jonathan Friedlander. *The Cinema of Displacement: Middle Eastern Identities in Transition.* Los Angeles: Gustave von Grunebaum Center for Near Eastern Studies, UCLA, 1995.

al-Najmi, Kamal. *al-Ghina' al-misri.* Cairo: Dar al-Hilmi, 1966.

———. *Aswat wa alhan ^carabiya.* Cairo: Dar al-Hilal, 1968.

———. *Mutribun wa mustami'un.* Cairo: 1970.

———. *Muhammad ^cAbd al-Wahhab: Mutrib al-mi'at ^cam.* al-Muhandisin, al-Giza: Awraq li-l-Nashr wa-l-A^clam, 1990s.

———. *Turath al-ghina al-^carabi: Bayna al-mawsili wa ziryab wa Umm Kulthum wa ^cAbd al-Wahhab.* Cairo: Dar al-Shuruq, 1993.

Nashashibi, Salwa Mikdadi. With contributions by Laura Nader, Etel Adnan, Shehira Davezac, Todd Porterfield, and Wijdan ^cAli. *Forces of Change: Artists in the Arab World.* Lafayette, California, and Washington D.C.: International Council for Women in the Arts and the National Museum of Women in the Arts, 1994.

Nettl, Bruno. *The Study of Ethnomusicology: Twenty-one Issues and Concepts.* Urbana, Illinois: University of Illinois, 1983.

———. *The Western Impact on World Music: Change, Adaptation, and Survival.* New York: Schirmer, 1985.

Niebuhr, C. *Reize naar Arabie en andere omliggende landen.* 2 vols. Amsterdam: S. J. Baalde, 1776. (*Travels through Arabia and Other Countries in the East.* Translated by Robert Heron. Edinburgh: R. Morrison & Son, 1792.)

van Nieuwkerk, Karin. *"A Trade Like Any Other:" Female Singers and Dancers in Egypt.* Austin, Texas: University of Texas Press, 1995, and Cairo: American University in Cairo Press, 1996.

Nuri, Shakir. *A la recherche du cinéma iraqien: Histoire, infrastructure, filmographie (1945–1985).* Paris: L'Harmattan, 1985.

La peinture en Tunisie des origines à nos jours. Catalogue d'exposition. Tunis: Centre d'Art Vivant de la Ville de Tunis, n.d.

Perez, Nissan N. *Focus East: Early Photography in the Near East 1839–*

1885. New York: Henry N. Abrams, Inc., 1988.

Pines, Jim and Paul Willemen, eds. *Questions of Third Cinema.* London: BFI, 1989.

Philipp, Thomas. *The Syrians in Egypt 1725–1975.* Stuttgart: Franz Steiner, 1985.

Rihani, Ameen. *Ibn Sa'oud of Arabia.* Boston: Houghton Mifflin, 1928.

al-Rabᶜia, Shawkat. *al-Fann al-tashkili al-muᶜasir fi-l-watan al-ᶜarabi (1885–1985).* Cairo: al-Hay'a al-Misriya al-ᶜAmma li-l-Kitab, 1988.

Racy, ᶜAli Jihad. "Legacy of a Star." In *Fayrouz, Legend and Legacy,* edited by Kamal Boullata and Sargon Boulus. Washington D.C.: Forum for International Art and Culture, 1981..

———. "Music." In *The Genius of Arab Civilization: Source of Rennaisance.* Edited by J. R. Hayes. Cambridge, Mass.: MIT Press, 1983. 2nd. ed

Rasmussen, Anne and Kip Lornell, eds. *Musics of Multicultural America.* New York: Schirmer Books, 1997.

Raymond, André. "Cairo." In *The Modern Middle East,* edited by Albert Hourani, Philip Khoury, and Mary Wilson. Berkeley: University of California Press, 1993.

Rihani, Ameen. *Maker of Modern Arabia.* New York: Houghton Mifflin, 1928.

Rizq, Qustandi. *al-Musiqa al-sharqiya wa-l-ghana' al-ᶜarabi.* 4 vols. Cairo: al-Matbaᶜa al-ᶜAsriya, 1934–1938 and reprinted in 2 vols., Cairo: Dar al-ᶜArabiya li-l-Kitab, 1993.

Rojek, Chris. *Decentring Leisure: Rethinking Leisure Theory.* Thousand Oaks, California: Sage Publications, 1995.

Ross, Heather Colyer. *The Art of Arabian Costume.* Freibourg: Arabesque Commercial, 1981.

Royal Society of Fine Arts, National Gallery of the Arts. *al-Fann al-misri al-muᶜasir.* 21 Tishrin al-Tahni 1985/10 Kanun al-Thani 1986. Amman: al-Malakiya li-l-Funun al-Jamila, 1986.

Saad El-Din, Mursi, ed. *Gazbia Sirry: Lust for Color.* Cairo: The American University in Cairo Press, 1997.

Saᶜd, ᶜAbd al-Munᶜim. *al-Mukhrij Ahmad Badr Khan: Uslubuhu min khilal aflamihi.* Cairo: al-Hay'a al-Misriya al-ᶜAmma li-l-Kitab, 1975.

Saᶜd, Kamal. *Umm Kulthum wa Zakariya Ahmad qamam al-qada.* Cairo, Dar al-Shaᶜab.

Sadoul, Georges, ed. *The Cinema in the Arab Countries.* Beirut: InterArab Center of Cinema and Television, 1966.

Sahhab, Fiktur. *al-Sabaᶜa al-kibar: al-Musiqa al-ᶜarabiya al-muᶜasira.* Beirut: Dar al-ᶜAlam li-l-Milayin, 1987.

Sahhab, Ilyas. *Difaᶜan ᶜan al-ughniya al-ᶜarabiya.* Beirut: al-Mu'asasa al-ᶜArabiya li-l-Nashr, 1980.

Saiah, Ysabel. *Oum Kalsoum: l'Étoile de l'Orient.* Paris: Denoel, 1985.

Said, Edward. *Orientalism*. New York: Pantheon Books, 1978.

———. *Culture and Imperialism*. New York: Alfred Knopf, 1995.

Salim, N. *L'Art contemporain en Iraq*. Lausanne: 1977.

Samak, Qussai, ed. *Cinéma du Moyen-Orient et du Maghreb*. Montreal: Le Cercle de la Culture Arabe, 1979.

Savary, M. *Lettres sur l'Égypte*. 3 vols. Amsterdam, Leiden, Rotterdam and Utrecht: Les Libraires Associés, 1787.

al-Sayyid, ᶜAfaf Lutfi. *Egypt's Liberal Experiment 1922–1936*. Berkeley and Los Angeles: University of California Press, 1977.

Seale, Patrick. *The Struggle for Syria: A Study of Post-War Arab Politics, 1945–1958*. London: Oxford University Press, 1965.

Shafik, Viola. *Arab Cinema: History and Cultural Identity*. Cairo: The American University in Cairo Press, 1998.

Shaheen, Jack. "The Arab Image in the American Mass Media." In *Split Vision*, edited by Edmund Ghareeb. Washington D.C.: Arab-American Affairs Council, 1983.

Shamut, Ismail. *al-Fann al-tashkili fi Filastin (Art in Palestine)*. English section translated by Abdul-Qader Daher. Kuwait: the author, 1989.

al-Sharif, Samim. *al-Ughniya al-ᶜarabiya*. Damascus: Wizarat al-Thaqafa wa-l-Irshad, 1981.

———: *al-Musiqa fi Suriya: Aᶜlam wa tarikh*. Damascus: Wizarat al-Thaqafah wa-l-Irshad, 1991.

———. *al-Sunbati: wa jil wa al-ᶜamalaqa*. Damascus: Dar al-Tlas, 1992 (2nd edition), 1993 (3rd edition).

El-Shawan, ᶜAziz. *al-Musiqa taᶜbir naghmi wa mantiq*. Cairo: General Book Organization, 1986.

Shushah, Muhammad al-Sayid. *Umm Kulthum: Hayat Naghm*. Cairo: Maktabat Ruz al-Yusuf, 1976.

Sijelmassi, M. *L'Art contemporain au Maroc*. Paris, 1989.

Sklar, Robert. *Movie-Made America*. New York: Random House, 1975.

Slyomovics, Susan. *The Merchant of Art: An Egyptian Hilali Oral Epic Poet in Performance*. University of California Press, 1987.

Stam, Robert. *Subversive Pleasures: Bakhtin, Cultural Criticism, and Film*. Baltimore: The John Hopkins University Press, 1989.

Sultan, Mahmud. *ᶜAbd al-Wahhab muᶜjaza al-zaman*. Cairo: al-Hay'a al-Misriya alᶜ-Amma li-l-Kutub, 1986.

al-Tabaᶜi, Muhammad. *Asmahan tarwi qissatha*. Beirut: al-Maktaba al-Tujari li-l-Tabaᶜa wa al-Tawziᶜ wa-l-Nashr, 1961, 1st edition (2nd edition, Cairo: Ruz al-Yusuf, 1965).

Tarabulsi, Fawwaz. *Ghirnika—Bayrut: al-Fann wa-l-haya bayna Judariya li Bikasu wa madina ᶜarabiya fi-l-harb*. Beirut: al-Mu'asasa al-ᶜArabiya li-l-Dirasat wa-l-Nashr, 1987.

Tawfiq, Saᶜd al-Din. *Qissat al-sinima fi Misr: Dirasat naqdiya*. Cairo: Dar al-Hilal, 1960.

Thompson, N. D. ed. *Dream City: A Portfolio of Photographic Views of the World's Columbia Exposition.* Photographs by Marius Bar. St. Louis, Missouri: N. D. Thompson Publishing, 1893.

Touma, Habib Hassan. *The Music of the Arabs.* Portland: Amadeus, 1996.

Tucker, Judith. *Women in Nineteenth-Century Egypt.* London: Cambridge University Press, 1985.

Umm Kulthum told to ᶜAwwad, Mahmud. *Umm Kulthum allati la yaᶜrifuha ahad.* Cairo: Akhbar al-Yawm, 1969.

Veillon, Margo. *Nubia: Sketches, Notes and Photographs.* London: Scorpion, 1994.

Villoteau, M. "De L'État Actuel de L'Art Musical en Égypte." In *Description de l'Égypte* XIV. Paris: Panckoucke, 1822.

Wikan, Unni. *Behind the Veil in Arabia.* Chicago: The University of Chicago Press, 1982.

Woll, Allen and Randall Miller, "Arabs." In *Ethnic and Racial Images in Film.* New York: Garland Publishing, 1987.

Young, William C. "The Body Tamed: Tying and Tattooing among the Rashaayda Bedouin." In *Many Mirrors: Body Image and Social Relations,* edited by Nicole Sault. New Brunswick, N.J.: Rutgers University Press, 1994.

———. *The Rashaayda Bedouin: Arab Pastoralists of Eastern Sudan.* Fort Worth, Texas: Harcourt Brace College Publishers, 1996.

al-Yusuf, Fatima. *Dhikrayat.* Cairo: Kitab Ruz al-Yusuf, 1953.

Zaki, ᶜAbd al-Hamid Tawfiq. *Aᶜlam al-musiqa al-misriya ᶜabra 150 sana.* Cairo: al-Hay'a al-Misriya al-ᶜAmma li-l-Kitab, 1990.

———. *al-Muᶜasirun min ruwwad al-musiqa al-ᶜarabiya.* Cairo: al-Hay'a al-Misriya li-l-Kitab, 1993.

Zuhur, Sherifa. *Revealing Reveiling: Islamist Gender Ideology in Contemporary Egypt.* Albany: State University of New York Press, 1992.

———. *Asmahan's Secrets: Woman, War, and Song.* Austin, Texas: Center for Middle Eastern Studies, University of Texas; and London: Al-Saqi, 2000.

———. "Women Embrace Islamic Gender Roles." In *Islam,* Opposing Viewpoint Series. Edited by Paul Winters. San Diego, California: Greenhaven Press, 1995.

Articles and Unpublished Material

Abu al-ᶜAinain, Saᶜid. "Asmahan wa-l-Tabaᶜi." *Akhbar al-hawadith,* 21 April 1994.

Abu-Lughod, Lila. "Movie Stars and Islamic Moralism in Egypt." *Social Text* 12, Spring 1995.

Alif: Journal of Contemporary Poetics 15 "*Arab Cinematics toward the*

New and the Alternative." 1995. (Some articles are listed individually in this bibliography but the entire bilingual issue is useful).

Armbrust, Walter. "The Nationalist Vernacular: Folklore and Egyptian Popular Culture." *Michigan Quarterly Review* 31, Fall 1992.

Assim, Madhat. "Umm Kulthum: al-Ustura al-khalida." *al-Kawakib* no. 2082, 8 February 1975.

Azzam, Nabil. "The Change in ᶜAbd al-Wahhab's Music, based on *Rasasah fi al-Qalb.*" Master's thesis, Hebrew University of Jerusalem, 1984.

———. "Muhammad ᶜAbd al-Wahhab in Modern Egyptian Music." Ph.D. dissertation, University of California, Los Angeles, 1990.

al-Bahnasi, ᶜAfif. "Tatawwur al-fann al-suri khilal mi'at ᶜamm." *al-Hawliyat al-ᶜathariya al-ᶜarabiya al-suriya* 23, nos. 2 and 3, 1973.

Baker, Raymond. "Combative Cultural Politics: Film Art and Political Spaces in Egypt." *Alif: Journal of Comparative Poetics* 15, 1995.

Barbir, Karin. "Popular Arts in Africa." *African Studies Review* (London) 30:3, September 1987.

Baron, Beth. "Unveiling in Early Twentieth-Century Egypt: Practical and Symbolic Considerations." *Middle Eastern Studies* 24, no. 3, 1989.

———. "The Iconography of Egyptian Nationalism." A paper presented to the symposium Women, Culture, Nation, Egyptian Movements. New York University, April 1995.

Bielby, Denise and William Bielby. "Women and Men in Film: Gender Inequality among Writers in a Culture Industry." *Gender and Society* vol. 10, no. 3, June 1996.

Brunson, Janice. "Dancing Sixsome Are the Party Highlight." *Saudi Gazette,* 25 May 1978, 5.

Cachia, Pierre. "The Egyptian Mawwal: Its Ancestry, Its Development, and Its Present Forms." *Journal of Arabic Literature* 8, 1977, 77–103.

Campbell, Kay Hardy. "Arabian Wedding Nights." *Arab News,* 1 August 1979.

———. "Why Sarah ᶜUthman Wants to Expand beyond Wedding Party Audiences." *Arab News,* 4 August 1980.

——— "Heritage Without Boundaries: Simon Shaheen, Tradition and Creativity." *Aramco World* vol. 47, no. 3, May/June 1996.

Chorbachi, Wasma'a. "Arab Art Twenty Years Later," *Arab Studies Quarterly* 11, nos. 2 and 3, 1989.

CinémAction. "Youssef Chahine l'Alexandrine." 33, 1985.

CinémAction. "Les Cinémas Arabes." 1987.

Danielson, Virginia. "The Qur'an and the Qasidah: Aspects of the Popularity of the Repertory of Umm Kulthum." *Asian Music* 19:1, 1987.

———. "Cultural Authenticity in Egyptian Musical Expression: The Repertory of the Mashayikh." *Pacific Review of Ethnomusicology* 5, 1989.

———. "Min al-Mashayikh: A View of Egyptian Musical Tradition." *Asian Music* 22:1, 1991.

———. "Shaping Tradition in Arabic Song: The Career and Repertory of Umm Kulthum." Ph.D. dissertation, Dept. of Music, University of Illinois, 1991.

———. "Umm Kulthum Ibrahim." *Harvard Magazine,* July 1997.

Dissuqi, ᶜAdil. "Asmahan bayna ightiyal al-sawt al-ᶜadhb wa ikhtilal ᶜajla al-qiyada." *al-Hayat* 11500, Sat. 13 August 1994.

al-Dissuqi, Muhammad. "Farid al-Atrash: Rabiᶜa al-ughniya al-ᶜarabiya al-da'im." *Fann* 204, 27 December 1993, 29–54.

Downs, Susannah. "Egyptian Earth between the Pen and the Camera: Youssef Chahine's Adaptation of ᶜAbd al-Rahman al-Sharqawi's *al-Ard.*" *Alif: Journal of Comparative Poetics* 15, 1995.

Fahmy, Farida (Melda). "The Creative Development of Mahmoud Reda: A Contemporary Egyptian Choreographer." Master's thesis, Department of Dance Ethnology, University of California, Los Angeles, 1987.

al-Faruqi, Lois Ibsen. "The Nature of the Musical Art of Islamic Culture: A Theoretical and Empirical Study of Arabian Music." Ph.D. dissertation, Syracuse University, 1974.

———. "Dances of the Muslim People." *Danscope* vol. 11, no. 1, 1976.

———. "Dance as an Expression of Islamic Culture." *Dance Research Journal* vol. 10, no. 2, 1978.

———. "Ornamentation in Arabian Improvisational Music: A Study in Interrelatedness in the Arts." *World of Music* 20, 1978, 17–32.

———. "The Status of Music in Muslim Nations: Evidence from the Arab World." *Asian Music* 12, 1979, 56–84.

———. "Music, Musicians, and Muslim Law." *Asian Music* 17, 1985, 3–36.

Gaffney, Jane. "The Egyptian Cinema: Industry and Art in a Changing Society." *Arab Studies Quarterly* vol. 9, no. 1, Winter 1987.

Ghattas, Marwan. "Asmahan: Sawt ghadirna bakiran . . . wa yabqi fi asmaᶜna." *Fann* no. 180, 16 July 1992.

Hafiz, Nahid Ahmad. "al-Ughniya al-misriya wa tatawwuruha khilal al-qarnayn al-tasiᶜ ᶜashr wa-l-ᶜishrin." Ph.D. dissertation, Helwan University, 1977.

Hale, Sondra. "Arts in a Changing Society: Northern Sudan." *Ufahamu* 1:1, 1970.

———. "Musa Khalifa of Sudan." *African Arts* 6:3, 1973.

Hale, Sondra with Mohamed Omer Bushara. "In Search of a Face: Salih Abdou Mashamoun—the Sun and the Eclipse." *Ufahamu* 6:2, 1976.

———. "Art and Dialectics." *Africa Today* 28:2, 1981.

Hatem, Mervat. "Through Each Other's Eyes: Egyptian, Levantine–Egyptian and European Women's Images of Themselves and of Each

Other (1862–1920)." *Women's Studies International Forum* 12, no. 2, 1989.

Hennebelle, Guy. "Arab Cinema." *MERIP Report* 52, November 1976.

Kent, Carolee. "Arab-American 'Zaffat al-Arusah' in the Los Angeles Area." *UCLA Journal of Dance Ethnology* 13, 1989.

al-Khalifi, ᶜAisha. "al-Murada: Raqsat al-nisa' fi-l-khalij al-ᶜarabi." *al-Ma'thurat al-shaᶜabiya* vol. 1, no. 3. Doha, July 1986, pp. 105–129.

Malkmus, Lizbeth. "The 'New' Egyptian Cinema: Adapting Genre Conventions of a Changing Society." *Cinéaste* XVI:3, 1988.

Marcus, Scott. "Arab Music Theory in the Modern Period." Ph.D. dissertation, Department of Music, University of California, Los Angeles, 1989.

el-Messiri, Nur. "Art and the Egyptian Environment." *Arts and the Islamic World*, Summer 1986.

Murad, Radwan. "Farid al-Atrash wa Asmahan yaqaduman: *Intisar al-shabab.*" *Huriya* 2:18, 2 January 1993.

Nabaraoui, Ceza. (Saiza Nabarawi). "Le Conservatoire de musique Orientale." *L'Égyptienne: Revue mensuelle, feminisme, sociologie, art* 6, 1930, 2–6.

Nader, Laura. "Orientalism, Occidentalism, and the Control of Women." *Cultural Dynamics* 2, 1989.

Naficy, Hamid. "The Development of an Islamic Cinema in Iran." In *Third World Affairs.* London: Third World Foundation for Social and Economic Studies, 1987.

Nassar, Zain. "Itijahat fi-l-musiqa al-misriya al-muᶜasira." *al-Fann al-muᶜasir*, Winter 1986.

Nasr, Ahmad Abd al-Rahim. "Madkhal li-l-dirasat al-fulkluriya fi-l-Mamlaka al-ᶜArabiya al-Saᶜudiya." *al-Ma'thurat al-shaᶜabiya* vol. 2, no. 7, Doha, July 1987.

Parker, Judith. "Egyptian Music: An Historical Study with Curriculum Model for American Elementary Grades." Ph.D. dissertation, University of Utah, 1979.

Poche, C. "Les Archives de la musique Arabe." *Revue d'Études Palestiniennes* 60, no. 8, 1996.

Racy, ᶜAli Jihad. "Funeral Songs of the Druzes of Lebanon." Master's thesis, University of Illinois, 1971.

———. "The Record Industry and Egyptian Traditional Music 1904–1934." *Ethnomusicology* 20, no. 1, 1976.

———. "Musical Change and Commercial Recording in Egypt, 1904–1932." Ph.D. dissertation, University of Illinois, 1977.

———. "Musical Aesthetics in Present Day Cairo." *Ethnomusicology* 26, no. 3, September 1982.

———. "Music in Nineteenth-Century Egypt: An Historical Sketch." *Selected Reports in Ethnomusicology* 4, 1983.

———. "The Waslah: A Compound-Form Principle in Egyptian Music." *Arab Studies Quarterly* 5, 1983, 396–403.

———. "Music and Dance in Lebanese Folk Proverbs." *Asian Music* 17, no. 1, Fall/Winter 1985.

———. "Lebanese Laments: Grief, Music, and Cultural Values." *World of Music* 28, no. 2, 1986.

———. "Aesthetic Characteristics of the Traditional Music of the Arabian Gulf and the Peninsula." *al-Ma'thurat al-sha^cabiya* vol. 1, no. 2, Doha, April 1986.

———. "Sound and Society: The Takht Music of Early Twentieth-Century Cairo." *Selected Reports in Ethnomusicology* 7, 1988.

Rasmussen, Anne K. "Individuality and Social Change in the Music of Arab Americans." Ph.D. dissertation, Department of Music, University of California, Los Angeles, 1991.

———. "'An Evening in the Orient:' The Middle Eastern Nightclub in America." *Asian Music* vol. 23, no. 3, Spring/Summer 1992.

———. "Theory and Practice at the 'Arabic org:' Digital Technology in Contemporary Arab Music Performance." *Popular Music* 15:3, 1996.

———. "Made in America: Historical and Contemporary Recordings of Middle Eastern Music in the United States." *Middle East Studies Association Bulletin* vol. 31, no. 1, December 1997.

Reynolds, Dwight. "Heroic Poets, Poet Heroes." Ph.D. dissertation, University of California, Los Angeles, 1991.

Roland, Vicki. "Torrents of Arabia: A New Wave of Arab Women's Art." *Atlanta Weekly*, March 1995.

Samak, Qussai. "The Arab Cinema and the National Question: From the Trivial to the Sacrosanct." *Cinéaste* vol. 9, no. 3, Spring 1979.

Sawa, Suzanne Myers. The Role of Women in Musical Life: The Medieval Arabo-Islamic Courts." *Canadian Woman Studies: Les Cahiers de la Femme* vol. 8, no. 2, Summer 1987.

El-Shawan, Salwa. "al-Musiqa al-^cArabiya: A Category of Urban Music in Cairo, Egypt, 1937–1977." Ph.D. dissertation, Columbia University, 1980.

El-Shawan Castelo-Branco, Salwa. "Some Aspects of the Cassette Industry in Egypt." *World of Music* 29, 1987.

al-Shimi, Farial. "Mu'alifat al-pianu ^cind ruwwad al-ta'lif al-musiqi al-mutatawwur fi Misr." *al-Fann al-mu^casir* issues 1 and 2, 1988.

Weir, Hilary. "Ramses Wissa Wassef." *Arts in the Islamic World* 2:2, Summer 1985.

Young, William C. "The Effect of Labor Migration on Relations of Exchange and Subordination among the Rashyida Bedouin of Sudan." *Research in Economic Anthropology* 9, 1987.

———. "From Many, One: The Social Construction of the Rashayida Tribe in Eastern Sudan." *Northeast African Studies*, forthcoming.

NOTES ON CONTRIBUTORS

WALTER ARMBRUST is visiting assistant professor of anthropology in the Center for Contemporary Arab Studies at Georgetown University. He is the author of *Mass Culture and Modernism in Egypt*.

FARIDA BEN LYAZID is a film maker, writer, and producer who lives in Morocco. Her films include *Bab al-sama' maftuh*, which won the Palme d'Or at Cannes.

KAY HARDY CAMPBELL is a banker and independent scholar in Hingham, Massachusetts. She researched Saudi and Gulf folk music while living in Saudi Arabia for eight years, where she wrote for the English-language press and produced four recordings of traditional Saudi Arabian music.

VIRGINIA DANIELSON is the keeper of the Isham Memorial Library and curator of the Archive of World Music at Harvard University. Her publications include *The Voice of Egypt: Umm Kulthum, Arabic Song, and Modern Egyptian Society*.

MARJORIE FRANKEN is research anthropologist at the University of California, Riverside. She is the author of *Revolutionary Images: Farida Fahmy and the Reda Troupe of Egypt* (forthcoming).

SONDRA HALE is adjunct professor of anthropology and women's studies at the University of California, Los Angeles. She is the author of *Gender Politics in the Sudan: Islamism, Socialism, and the State*.

CAROLEE (SAHRA) KENT performs, teaches, and writes about dance in the United States and in Europe, and is director of Ya Amar Middle Eastern Dance Troupe in the Los Angeles area.

HAMID NAFICY is associate professor of film and media studies in the Department of Art and Art History, Rice University, Houston. His

317

publications include *The Making of Exile Cultures: Iranian Television in Los Angeles.*

SALWA MIKDADI NASHASHIBI is the founder, curator, and president of the International Association for Women in the Arts, Lafayette, California, and writes and lectures on contemporary Arab art. She is the editor of *Forces of Change: Women Artists of the Arab World.*

ANNE K. RASMUSSEN is assistant professor of music and ethnomusicology at the College of William and Mary in Williamsburg, Virginia. She is the coeditor of *Musics of Multicultural America* and has produced a CD entitled *The Music of Arab Americans: A Retrospective Collection.*

SELIM SEDNAOUI is a concert pianist and music critic who performs internationally and resides in Paris and Cairo.

SIMON SHAHEEN is a composer of Arabic music and a virtuoso of the ᶜud and Arabic violin residing in Brooklyn. He is the founder and director of the Near Eastern Music Ensemble of New York.

REBECCA STONE is a commercial publisher with an MA in dance ethnology and interests in archival research and film history. Her articles have appeared in academic journals in the United States and Great Britain.

CHAÏBIA TALAL is a painter and muralist who has exhibited in Morocco, France, Denmark, Germany, Spain, and the United States.

KARIN VAN NIEUWKERK is lecturer in social anthropology at the University of Nijmegen in the Netherlands. Her publications include *"A Trade Like Any Other": Female Singers and Dancers in Egypt.*

WILLIAM YOUNG is an anthropologist, and editor of publications of the American Anthropological Association. His publications include *The Rashaayda Bedouin: Arab Pastoralists of Eastern Sudan.*

SHERIFA ZUHUR is a historian, and affiliated with the Center for Middle Eastern Studies, UC Berkeley and the von Grunebaum Center, UCLA. Her publications include *Revealing Reveiling: Islamist Gender Ideology in Contemporary Egypt* and *Asmahan's Secrets: Woman, War, and Song.*

INDEX

Asmahan (al-Atrash, Amal), 10, 16, 81–107; and "Asqiniha bi Abi, Inta wa Ummi," 88; and "Ayyuha al-Na'im," 87; and "Ya Bad^ca al-Ward," 89; and cinematic themes, 98; and "Dakhalit Marra bil-Ginaina," 96; and "Ya Dairati," 91–92; and "Hadith ^cAinain," 96; and "Hal Tayam al-Bann," 87; and "Imta Hata^craf Imta?" 94–96; and "Laita lil-Barraq," 88; and "Layali al-Uns fi Fiyanna," 93–94; and lyrics, emphasis on, 84–85; and "Mahlaha ^cAisht al-Fallah," 89; "al-Muhammal al-Sharif," 89–90; and musical *alwan* (colors/genres), 86, 88, 90, 93; parents of, 81; "Taghrid al-Balabil," 97; "Yalli Hawak Shaghil Bali," 93
al-Atrash, Farid, 10, 81, 82, 92, 93, 143, 266, 268
^cawalim, 7, 21, 22–23, 27, 30, 75–78, 267; confusion with public dancers, 22–23, 76, 78; in eighteenth century, 22, 23; and extortion, 77; image of, 27–29, 75, 78; meaning of, 23; and Muhammad ^cAli Pasha, 23, 76; and Muhammad ^cAli Street, 25, 27, 77; term in modern weddings, 78; as singers, 76; turn-of-the-century, 24
al-^cAzima, 271

Baiza'i, Bahram, 232, 234, 235, 239
Bani'etemad, Rakshan, 234, 236, 240
Bara, Theda, 254–55
Basho, Ginane Makki, 179
Bashu the Little Stranger (Bashu, gharibeh-ye kuchak), 234, 235–36
'belly-dancer,' 5, 7–8, 21, 26–27, 28–34, 147; cultural significance of 7, 71, 73–75; in early

American film, 250–52; in Egyptian films, 266–70; in Hollywood films, 253–54, 257; ritual significance of, 73, 76, 78–79; in weddings, 8, 24–25, 71–80, 269–70
Ben Lyazid, Farida: background, 15, 206–9; films of, 15, 207–9
Beyond the Fire (Ansu-ye atash), 236
Bittar, Doris, 176–77
Une brèche dans le mur (A Hole in the Wall), 207–8
Bunai, Russell, 141–42, 143, 144, 147, 150
Bushara, Mohamed Omer, 191–95

Capra, Frank, 285–87, 288
Captain Khorshid (Nakhoda Khorshid), 237
Carioca, Tahia, 268, 269
Casablanca, 205, 258
Chahine, Youssef, 14, 215
Chorbachi, Wasma'a, 177
Choucair, Salwa, 178
cinema: and anarchy, 297–98; comedy, 217, 289, 297; Egyptian, 14–15, 16, 98, 211–28, 265–99; and escapism; Frank Capra's films, 285–87, 288; commercial and policy shifts, 217–18; heroines, 213–16, 217–26, 233, 234, 235, 270–72; Hollywood's 'Middle East,' 16, 205. 247–64; Hollywood's influence on Middle Eastern, 16, 216, 266, 269; Iranian, 15–16, 229–46; Marx Brothers and W. C. Fields, 286, 287, 288, 289, 297; Middle Eastern, general background of, 13–16, 216–17, 229, 266; Moroccan, 205–10; music, 87, 90–91, 93–96, 224, 266–67; nihilism in, 289; social comment, 213–14, 215, 225–26, 233–35, 270–71, 284, 287, 290–91, 295–98; urban corruption, 218, 240–41, 244, 289–90